MW00979492

TREASURES
OF THE
NATIONAL
ARCHIVES
OF
CANADA

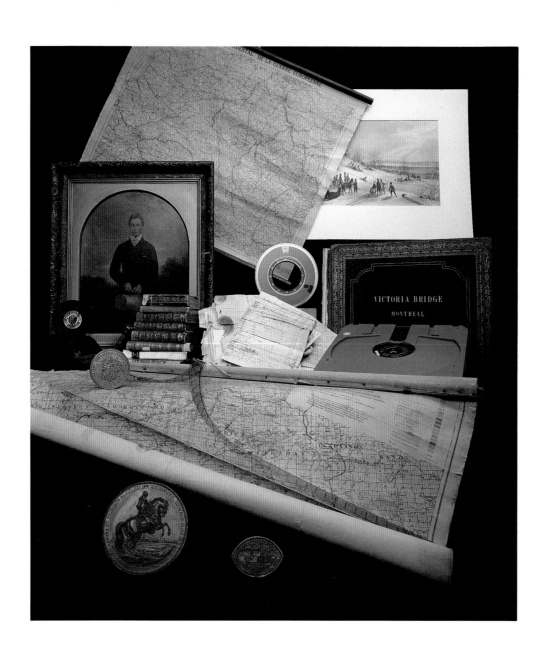

TREASURES
OF THE
NATIONAL
ARCHIVES
OF
CANADA

UNIVERSITY OF TORONTO PRESS
TORONTO / BUFFALO / LONDON

© Minister of Supply and Services Canada 1992

Written by the National Archives of Canada

Translated into French by the Secretary of State

Catalogue number SA2-228/1991E

ISBN 0-8020-5022-0

Co-published by the University of Toronto Press in

cooperation with the National Archives of

Canada and the Canada Communication Group –

Publishing, Supply and Services Canada

Canadian Cataloguing In Publication Data
National Archives of Canada
 Treasures of the National Archives of Canada

 Issued also in French under title: Trésors des
Archives Nationales du Canada.
 Includes index.
 ISBN 0-8020-5022-0

 1. National Archives of Canada. 2. Canada – History
– Sources. 3. Canada – Archival resources.
 I. Title.

CD3623.N37 1992 026'.971 C92-094203-2

PRINTED IN HONG KONG

BOOK ART INC., TORONTO

PRINTED ON ALKALINE PAPER

The excerpt from Lady Macdonald's diary is used
with permisson of Mrs. Zan (T.J.) Critelli. The minutes
of the Dominion Council of Women for Canada are
used with permission of the National Council of
Women of Canada. Lucy Maud Montgomery's letter
is used with permission of the heirs of Lucy Maud
Montgomery. Marshall McLuhan's manuscript of
'The Mechanical Bride' is used with permission of
Mrs. Marshall (Corinne) McLuhan.

Contents

Foreword

Through the course of Canada's history, a precious record has been preserved. It helps us to understand who we are and where we come from. Archives are the keepers of these collective memories, where the proud symbols and difficult lessons of our past reside.

The National Archives of Canada has been acquiring and caring for archival records of national significance for over a century. As one of Canada's oldest federal cultural institutions, created in 1872, its vast holdings are an integral part of our nation's heritage – reflecting the work of our creators, the rights of our citizens, the richness of our multicultural heritage, and the sources of our distinctive Canadian identity.

The year 1992 is a significant one for the National Archives. With all Canadians, we observe the 125th anniversary of Confederation, and, with the archivists of the world, we hold the xiith International Congress on Archives. Held every four years in a major capital city, this conference of world archivists will meet in 1992 for the first time in Canada. In order to draw the attention of our fellow Canadians to this anniversary year and to introduce our institution to archivists in other countries, the National Archives has planned the publication of this volume.

Treasures of the National Archives of Canada brings together a selection of some of the most valued documents of Canada's past. Historical researchers have long known at least part of these treasures. This book shares these unique and eloquent traces of our history with a broader public. It reminds us that these cherished treasures belong to all Canadians.

THE HONOURABLE PERRIN BEATTY

Minister of Communications

Preface

In our ongoing responsibilities for Canada's national archival heritage, we are privileged to come face to face with the valued records of our country's past. As archivists, the nature of our work reminds us constantly of this cultural wealth. With *Treasures of the National Archives of Canada* we reach out beyond the walls of research rooms and storage areas to bring a sampling of these treasures to you.

This publication was borne of the desire to feature the holdings of the National Archives of Canada, highlighting the special items that illustrate the depth and richness of the collections. The challenge of confining the selection to these pages, from the ever-growing volume of historically significant material, was daunting. We have chosen unique documents that mark the milestones of political history as well as eloquent records that reflect experiences of daily life. We have found our past recorded in artworks of beauty, in objects of great rarity, and in more common formats that speak humbly, yet eloquently. Whatever the medium or category, precious treasures abound among the holdings of manuscripts, government textual records, maps, plans, photographs, documentary art, and philatelic, audio-visual, and machine-readable records.

The National Archives holds the records of the complex historical evolution of our country, its peoples, its institutions, and the federal government. From indigenous cultures to the individuals and groups that settled Canada, archives document the events, the rights, the claims, the collective symbols, and the distinctive elements of the many cultures that contribute to our national identity. By preserving the past and making it accessible, archives help us understand the present, and provide a basis from which to view the future.

As this country's collective memory, archives provide the continuity of culture and the building blocks of nationhood. They are a vital public resource, not only for historians, but for all citizens – those who govern, educate, create, and participate. As the past continues to be interpreted and reinterpreted from the perspectives of changing times, the archival record is preserved as the constant resource for the use of future generations.

Canada's history is a multiplicity of many readings. While we celebrate archival treasures on the pages of this book, we are aware that they record not only proud achievements and valued symbols, but also remind us of injustices and past mistakes. We are a nation built over hundreds of years of effort, conflict, hardship, success, compromise, tolerance, and will power. The rights, democratic institutions, hard-won freedoms, and the often-difficult paths we have taken to obtain them, are reflected in these documents.

As the essential record of our evolving nation, these documents are available to all Canadians, who can contribute their own perspective to the understanding and interpretations of this country's past. Archival documents are used to inform government decisions, to illustrate our history books, to trace our ancestors, to support land claims and diverse rights, to produce films and broadcasts, and in a vast range of cultural and academic endeavours that bring new knowledge and, in turn, become a part of the collective memory.

This national, public legacy has come from institutions and individuals across the country, as transfers from federal government offices, purchases and donations from private sources, and repatriations from abroad. It has been built over many years – thanks to the awareness of those who recognized records of national significance and brought them to the attention of the National Archives; thanks to the legislators who have ensured that formal structures exist for the protection of these records; and thanks to the dedication and persistent efforts of the National Archives' staff.

The treasures represented on these pages are a small part of the vast collections of the National Archives, which in turn are but a small part of the documentary heritage found in archives across the nation. As we marvel at how much of our country's past is revealed in these records, we are reminded that this is a fragile legacy threatening to vanish as inks fade, paper crumbles, and film stocks degenerate. Together with the community of archival institutions across Canada, we are striving to protect this heritage for future generations.

JEAN-PIERRE WALLOT

National Archivist

Acknowledgments

The tremendous challenge in producing a publication of this size, complexity, and quality could not have been realized without the assistance of many individuals and institutions. The difficult task of choosing a small representation from the multitude of treasures in the National Archives of Canada required an exerted effort by those making the selection, not to mention the subsequent research and writing of the accompanying texts. The dedication, creativity, and expertise of the staff who were involved became the driving force behind this project, and their ultimate reward is this attractive showpiece of archival treasures that all Canadians can be proud of.

We would like to acknowledge the following individuals for their contributions in each treasure group:

Cartographic, Architectural, and Engineering Records
Edward Dahl researched and prepared the descriptions for many of the treasures in this chapter. Other texts were researched and written by David Brown, Louis Cardinal, Robert Grandmaître, Brian Hallett, Betty Kidd, Norma Mousaw, Thomas Nagy, and Bruce Weedmark. Catalogue entries were prepared by Velma Parker and Anne-Marie Pépin. Support was provided by Marguerite Cummings and Paulette Guénette. In addition to those individuals mentioned above we would like to acknowledge the contributions of Linda Camponi, Dorothy Franklin, Nadia Kazymyra-Dzioba, Gilles Langelier, and Joan Mattie.

Documentary Art Records
Jim Burant was responsible for coordinating the selection and writing of the introductory text, as well as for preparing a number of the individual descriptions of items. Several archivists were involved in the preparation of texts, including Lucie Dorais, Lydia Foy, Eva Major-Marothy, Martha Marleau, Terresa McIntosh, and Susan North. The assistance of Collections Management staff,

including Elizabeth Krug, Mae Borris, and Gilbert Gignac, in the selection and in having items photographed is gratefully acknowledged.

Philatelic Records
Ken R. Johnson of the Canadian Postal Archives selected and wrote the descriptions for the philatelic treasures.

Government Records
Glenn Wright selected and described the documents from the extensive holdings of government records. This task was made easier by the knowledgeable assistance, advice, and encouragement of his many colleagues both in and outside the Government Archives Division, including James Whalen, Nancy McMahon, Elizabeth Moxley, Lisa Patterson, Doug Whyte, Terry Cook, Martin Tétreault, Paulette Dozois, Paul Marsden, Eldon Frost, Tom Hillman, and Sheila Powell.

Manuscripts and Private Records
John Bell served as the coordinator and editor for the chapter and also wrote the introduction and one of the treasure descriptions. The other descriptions were prepared by Robert Albota, Patricia Birkett, Colleen Dempsey, André Desrosiers, Anne Goddard, Maureen Hoogenraad, Patricia Kennedy, Andrée Lavoie, Marc Lebel, Larry McNally, Brian Murphy, Walter Neutel, Christian Rioux, M. Stephen Salmon, and Lawrence Tapper. Ian McClymont and Paul Fortier helped with the selection and the preparation of the introduction. Wilma MacDonald coordinated activities relating to copyright and photography. Andrée Lavoie assisted with the finalization of the French-language text.

Genealogical Records
Mary Munk, Janine Roy, and David Enns collaborated in selecting the documents and writing the text for the genealogical treasures.

Moving Image and Sound Records

We are grateful to the archivists and staff of the Audio-Visual and Cartographic Archives Division who took on the task of representing moving image and sound treasures in a printed text and in presenting both the essence of the physical treasures themselves and their historical value. The project was coordinated by Andris Ķesteris with contributors Rosemary Bergeron, Andris Ķesteris, Richard Lochead, Steve Moore, Jean-Paul Moreau, Micheline Morisset, William S. O'Farrell (Moving Image Data and Audio Conservation Division), Sylvie Robitaille, D.J. Turner, and Jana Vosikovska. In addition, support and further research carried out by Rachel Charron, Caroline Forcier, and Marlene Pratt made it possible to bring this production to a successful conclusion.

Photographic Records

The chapter 'Canada through the Camera' was coordinated and revised by Joan M. Schwartz. Individual entries were researched and written by Andrew Birrell, Brian Carey, Sylvie Gervais, Lilly Koltun, Leslie Mobbs, Peter Robertson, Andrew Rodger, Melissa K. Rombout, Joan M. Schwartz, Guy Tessier, and Edward Tompkins. The National Archives is indebted to Canadian photographers Louise Abbott, Struan Campbell-Smith, Ted Grant, V. Tony Hauser, Yousuf Karsh, Harry Palmer, Orest Semchishen, and Fiona Spalding-Smith. They kindly granted permission to reproduce their work and/or supplied the necessary prints to do so. We also acknowledge the cooperation of Anna Vanderpant Ackroyd, Carina Vanderpant Shelley, and Catharin Ackroyd, who granted permission to reproduce the work of John Vanderpant.

Preserving the Records of the Past

Many staff members of the Conservation Branch assisted generously in the preparation of the chapter on archival preservation. We wish to thank Sandra Wright, who wrote the text for this chapter. A special note of appreciation is also extended to John Holmes and Ken Foster, whose insight enriched the text, as well as to Claude Ouellet, who chose the illustrations and provided the captions. Finally, we cannot overlook the staff of the Conservation Treatment Division, who meticulously restored many of the treasures highlighted in this volume, or the Preservation Copying Division, who painstakingly photographed many of these priceless records.

We wish to acknowledge all those in the Public Programs Branch and in other branches who contributed to the production of this publication. In particular, we would like to thank Theresa Rowat and David Matley for their assistance.

We also extend our appreciation to Photography Services of the National Archives, especially Karen Clack, for making reproduction copies that do justice to the originals. We are also grateful to Dan Maruska of Maruska Studios Limited for his suggestions, skill, and sensitivity in the photographic reproduction of over fifty special images that appear in this publication, and to Peter Dudley of Visual Services for his expertise in reproducing many of the frame enlargements in the moving-image section of the book.

The National Archives would especially like to thank University of Toronto Press and Les éditions du Septentrion for their attentiveness to this project. In particular, we wish to mention Ian Montagnes, Laura Macleod, Frank Newfeld, Denis Vaugeois, and Solange Deschênes.

Finally, we wish to thank all those individuals, organizations, and employees of the National Archives, past and present, who have contributed to the building of this unique collection of historical documentation, which constitutes the 'collective memory' of our nation. The product of their work will endure for centuries to come.

JAY ATHERTON

Director General
Historical Resources Branch

RICHARD HUYDA

Director General
Public Programs Branch

The
National Archives
of
Canada

For the first time, the National Archives presents in a single volume a selection of its most treasured items. By doing so, we hope to give readers a glimpse into our holdings and perhaps also to help them understand what archives are and the role they play in society.

The nature and purpose of archives are often not well understood. For a variety of reasons, archives have not been particularly successful in making themselves known to the general public. The perception is still widely held that such institutions are quiet, musty places (the adjective 'dusty' is very often used), peopled by elite scholars with white beards, who sift through mountains of paper in pursuit of some obscure matter to be interpreted in an article for a learned journal.

That stereotype contrasts sharply with the reality of a modern archives. At the end of the twentieth century, archives are vibrant institutions, acquiring the current and complex records of modern society and dealing on a daily basis with the spiralling volumes of recorded information in a bewildering array of formats characteristic of the 'information age.' Depending on the type of institution, whether part of a university, a government, a municipality, a church, or a business corporation, archives today collect materials; they choose what is to be retained and what can be destroyed; they store records of long-term value in conditions that ensure they will be preserved as long as human ingenuity will allow; and they strive to make those documents accessible for use by all.

In contrast to the stereotypical image, archives now acquire and care for a complex variety of documentary materials. These include huge mounds of paper, of course, but also photographic and film materials; microfilm in a variety of forms; maps, charts, plans, and architectural drawings, some on paper and some in digitized format; paintings, prints, and sketches; computer-generated records containing both text and images, some on tape and some in disc format; and all manner of recorded information produced by modern technology and likely to be of value to future generations.

Not only are the holdings of the modern archives complex in their format, but they are also voluminous. It is evident that the nature of archives is such that they constantly grow. Modern society is 'information based,' and it produces records and documentation at a rate never imagined in the past. The impact of that phenomenon on archives has been spectacular. The information age has already made its presence felt dramatically in archives, the reality being that the rate of growth of archival collections has been greater in the past four decades than in the preceeding four centuries. As this growth is reflected in archival collections, archivists have come to question conventional practices and to look for new ways to cope with the challenges of the information age.

Modern institutions are staffed by a broad range of specialists who acquire, select, describe, and conserve this avalanche of documentary records, and make the end product accessible to users from all walks of life. Although the university professor and the graduate student are frequent users of the modern archives, an examination of user statistics reveals that they are the minority. Archives today are used widely by professional writers, contract researchers, film producers, radio and television news departments, government agencies, native people, city planners, and a variety of other people interested in some aspect of their past. Most people would be surprised to know, however, that by far the greatest number of users of archival collections are the general public. They make use of archives for personal reasons, including establishing land claims, securing pension benefits, obtaining military medals and verifying war service, searching family histories, or writing historical accounts of companies, churches, or local communities.

In spite of this reality, the nature and potential use of archives are still not widely understood. It is remarkable how often one meets people, even generally well-informed people, who are surprised to discover that material in archival collections may be of interest or of value to them and that they are encouraged and welcome to make use of it. At least part of the reason for this phenomenon is that archives, unlike museums and libraries, have not by tradition had a public face. Most archives do not have a high profile. They are not usually situated in locations that are frequented by the public; they do not have the kind of collections that are easily presented to the casual visitor; advertising and public programming budgets simply do not exist; and the nature of archival material challenges the ingenuity of staff to make the contents of archives relevant and entertaining to children and school groups. Whereas libraries are used by young people from the time they are of school age, and museums are often seen as places of enlightenment and entertainment, especially on rainy days, archives and their collections are not generally well known and understood by the public.

One of the primary purposes of *Treasures of the National Archives* is to help overcome this anonymity. By presenting in a single volume a sample of the variety and complexity of documentation held by the National Archives, we hope to make the institution and its work better understood and the variety, beauty, and great cultural value of its holdings better appreciated.

Archives have been called 'the memory of a nation,' and the analogy is an excellent one. The documentary records preserved by the National Archives of Canada constitute a large part of the collective memory of the people of Canada. Taken together with collections of other archives in the country, these records document our origins and our growth as a nation. Without this evidence, the nation's sense of itself is faulty; without that unclouded memory, the truths of history can be distorted and misrepresented to suit the purposes of charlatans, demagogues, and single-minded leaders of all kinds.

As the report of the Symons Commission pointed out in 1975, it is of critical importance that a country 'know itself.'[1] The report went on to emphasize, moreover, that this essential knowledge cannot be preserved, substantiated, and verified without proper archives. Archives are the foundation of a national self-awareness, and all civilized societies make an effort to preserve their records and to make them accessible to the people. Further, this freedom of access is one of the foundations of democracy. It is not surprising that one of the first actions of a dictatorship is to control information, including historical information, for access to knowledge is power.

The importance of creating and maintaining a 'collective memory' for the new country of Canada was impressed upon the government of Sir John A. Macdonald shortly after Confederation. In a petition submitted to the government in 1871, the Literary and Historical Society of Quebec pointed out the importance of gathering and saving the records of the past as well as making provision for preserving the records of the new Confederation.[2] In direct response, the Public Archives of Canada was created in 1872 and Douglas Brymner was appointed as the first dominion archivist. Thus began Canada's national archival program, modest as it was; Brymner recalled that he set out with 'three empty rooms and very vague instructions.'[3]

From these humble beginnings one of the most effective national archival programs anywhere has developed. The details of Canada's past have been methodically gathered, classified, conserved, and made freely available for public use for more than one hundred and twenty years. There have been periods of neglect and hard times, but there has also been more than one 'golden age,' when programs flourished, new buildings were constructed, and funding was provided seemingly for the asking. And, throughout, archivists and support staff have worked diligently, sometimes quietly and sometimes amidst controversy, to build a key element of Canada's collective national memory.

The size and complexity of the collection have made the process of selection of items to be included in this volume difficult. Some of the items are indeed 'treasures' in the usual sense of the word for, because of their physical beauty and their value to collectors, they are of great monetary worth. Two examples are the 1824 Peter Rindisbacher painting and the 1508 Ptolemy atlas. Others, such as the 1869 Great Seal of Canada, the Constitution Proclamation of 1982, or the land surrender document of the Chippewa Nation signed in 1822, are valuable for symbolic reasons. Still others are noteworthy for their poignancy; the last letter of Louis Riel to his wife and children before his hanging in 1885, a 1936 live radio broadcast recording of the Moose River mine disaster in Nova Scotia, film coverage of the Canadian Army liberating Antwerp in 1945, or the gentle scene of harvesting hay at Sussex, New Brunswick, painted by William

[1] Thomas H. B. Symons, *To Know Ourselves: The Report of the Commission on Canadian Studies*, vols. 1 and 2 (Ottawa: Association of Universities and Colleges of Canada 1975)
[2] National Archives of Canada, RG37, B, vol. 104
[3] Douglas Brymner, 'Canadian Archives,' a paper presented to the American Historical Association, December 1888, as cited in *Report on Canadian Archives, 1889* (Ottawa 1889), p x

Hind in 1880. In their own way all these documents are 'treasures.'

The wide variety of documents in the custody of the National Archives of Canada reflects its collecting mandate from the earliest years. Not surprisingly, the oldest documents have to do with exploration. There is, for instance, the Ruysch world map in the Ptolemy atlas of 1508 as well as an agreement signed by Sir Humphrey Gilbert relating to the settlement of Newfoundland in 1582. Thus it is clear that the Archives collected actively in Europe from the beginning. Douglas Brymner, early in his term of office, surveyed archival collections in Europe and set up small offices in London and Paris for the purpose of locating archival documentation relating to Canada. Thereafter, the Archives has searched for, copied, or purchased originals of family papers, colonial records, maps and plans, and documentary art of all descriptions relating to Canada's history. At first, reproduction was done by hand, but since the Second World War virtually all copying has been by microfilm.

In addition to the maps and charts of explorers such as Champlain, Cook, Hudson, and Palliser, a great variety of fortification drawings, architectural plans, survey maps, and urban planning documents can be found in the Archives. Collected from the beginning, this type of documentation has been supplemented in the modern era by copies of all the major mapping work done by the Canadian government, including digital mapping information transmitted by orbiting satelites.

As for private manuscripts, considered more traditional archival fare, the range of holdings is nothing short of spectacular. Manuscript and private records reproduced in this volume include the articles of association of the Company of New France signed in Paris in 1627; a letter signed in Quebec in 1759 by Montcalm; the remarkable journals of Alexander Henry relating to his travels and the fur trade in the North West; documents on the rebellion of 1837; the diaries of Lady Macdonald; a telegram from Van Horne to Macdonald announcing the completion of the CPR on 7 November 1885; a paper by Sir Sandford Fleming, an outstanding Canadian whose accomplishments are virtually unknown in Canada today; and writings by Lucy Maud Montgomery and Marshall McLuhan. This selection represents only a small fraction of the papers of individuals collected over the years by dedicated archivists.

The administrative records of departments and agencies of the government of Canada are naturally a key part of the documentation held by the National Archives. Indeed, the Archives has a specific legislated mandate to acquire and care for the historical records of the government, and these records constitute the largest segment of the Archives' holdings. From some sixty kilometres of

documents, a few items have been selected to illustrate several themes in Canada's history: constitutional affairs, developments in agriculture, natural resources, and the environment, northern administration, cultural affairs, business, communications, rail and air travel, the military, external affairs, and matters of health and welfare. The diversity of these documents reveals the vast range of activities of a modern government as well as the challenge faced by archives in selecting and preserving the historical records of a national government.

The Archives also collects motion picture film and recorded sound, although it is difficult to present this medium adequately in print. These documents date from the late nineteenth century to an Inuit television production of 1989; they cover commercial and government film production as well as radio broadcasting, and include productions in both of Canada's official languages as well as in native languages.

Some fifteen million photographs in the Archives provide the researcher with marvellous visual insights into Canada's history. The material selected for presentation here is representative and covers such areas as 'official' photos from government collections, including war-time photography from the Department of National Defence; some of the oldest examples of photography in Canada, including daguerreotypes from the 1840s; the later period of exploration; portraits of prominent Canadians; amateur and professional photography, including the work of Yousuf Karsh; as well as photojournalism and modern advertising photography.

It is undoubtedly in the area of documentary art that an archives finds its most spectacular work for purposes of exhibition and publication and the work exhibited in this volume is no exception. From earliest days, pictorial material has been collected by the Archives, both as acquisitions from departments and agencies of government and from private sources. Some of the best examples of paintings, prints, drawings, caricature, medals and seals, and philatelic materials are reproduced here. The documentary art collection contains thousands of items. There are, for example, illustrations of modes of transportation, clothing, and interiors of buildings; landscapes in various seasons; war art; postage stamp plate proofs, first day covers and sheets of rare stamps; caricatures poking fun at famous and infamous people, and posters dripping with blatant propaganda.

Finally, this volume contains a special chapter on genealogical records, which is only fitting because so many Canadians use archives for genealogical research. The documents chosen to illustrate these 'treasures' are devoted to native Canadians, settlers, and immigrants, and also include government documents relating to the lives of individual citizens. It is instructive to note how

documents created for one purpose can sometimes be used for an entirely different purpose – a fact that presents a particular challenge to archivists as they select materials to add to their collection.

Sir Arthur Doughty, dominion archivist from 1904 to 1935, once described archives as 'the gift of one generation to another,' a phrase that nicely captures the idea that archives are a sacred trust. Documents are passed from one generation to another as the collective memory of a people and, as such, they must be preserved with the best attention a nation can afford. It has been said that a people that neglects its history will almost certainly lose it. And they may also lose their direction, their sense of purpose, and their will to survive as a nation.

As the present generation at the National Archives of Canada we are proud of the trust placed in us to preserve the nation's memory and to pass on that precious legacy to the generations that follow. We hope this publication will contribute not only to a better understanding of archives but to a heightened appreciation of our great good fortune to live in a country such as Canada.

MICHAEL SWIFT

Assistant National Archivist

I

Charting the Waters,
Mapping the Land,
Designing Its Structures

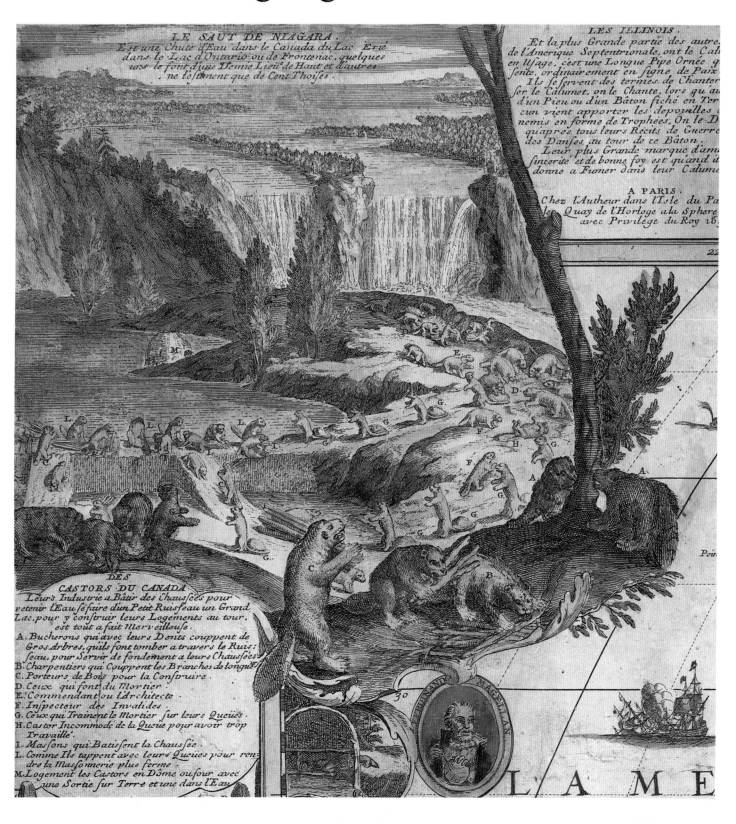

Cartographic, Architectural,
and
Engineering Records

As a form of communication that predates even the written word, maps have long provided a graphic representation of the land and water features of our communities, whether that community is a small geographical area or the planet as a whole. Maps are the source of much of our understanding of the shape of the world – land and water, mountains and lakes, islands and continents, cities and countries.

Architectural plans and drawings focus our attention on the individual building or building complex, which is usually geographically referenced. Engineering plans and drawings, however, may represent a geographically based structure – for example, a bridge, a canal, or a dam – but equally one that has no geographic reference point, such as an airplane or an engine.

Cartographic, architectural, and engineering records have attracted researchers to the National Archives of Canada for well over a century. Maps and plans contain information that cannot be found elsewhere, and they contain it in a unique form. These records have been collected by the Archives since the institution was founded in 1872. They can be categorized into several distinct areas: the federal government's cartographic, architectural, and engineering records, private architectural records, early cartography, and current cartography. The majority of divisional holdings are either records or publications of the government of Canada. As a land-owner, a land developer, an administrator, an employer, and as a sovereign state, the government has produced and continues to produce and use extensive numbers of cartographic, architectural, and engineering documents.

The total holdings are fast approaching two million items, consisting of maps, charts, atlases, globes, architectural and engineering drawings, blueprints, and plans. The cartographic holdings range from Ptolemy's atlas of 1490 to the most current maps from the printing presses of government and private industry. Architectural holdings date from Champlain's perspective view of his 'Abitation' at Quebec and plans of early fortifications in Canada to twentieth-century records of architectural firms and of the government of Canada.

The cartographic, architectural, and engineering documents reproduced in the following pages are but a glimpse into the Archives' vast and diverse holdings. Many were also selected for the 1982 exhibition 'Treasures of the National Map Collection, Public Archives of Canada – An exhibition of 100 original maps, atlases, globes and architectural plans, 1490–1982 (17 August 1982 to 9 January 1983).' It has been difficult in making this selection to eliminate many favourites, for each document is a treasure in its own right. Thus the documents chosen have the added responsibility of representing a larger group, a rich and intriguing part of our documentary heritage.

The earliest original image of Canada

This map of the world by Johannes Ruysch holds a special place in the collections of the National Archives. It is the institution's earliest original document that relates to Canada.

The New World had already appeared on earlier maps – as early as 1500 on a large manuscript world map drawn by Juan de la Cosa depicting the explorations of Columbus and, for the Canadian area, of John Cabot; and in 1506 on a printed world map by Contarini and Roselli that showed an unnamed northeastern land mass attached to Asia. On this map, the words 'Terra Nova' and several place names appear, but the half-moon-shaped land area is still attached to northeastern Asia. Greenland appears to the north, and a gulf is shown which seems to represent Cabot Strait. 'In[sula] Baccalauras' on the east coast of Terra Nova is one of the earliest appearances in this area of this Portuguese word for codfish.

The map shows knowledge of Columbus's explorations in the Caribbean, including his misconception that the islands he saw were merely an archipelago past which Asia could be reached. The scroll across the western end of what appears to be Cuba states that this is as far as the ships of Ferdinand, the king of Spain, have gone. The scroll's position leaves open the possibility that the land is part of the mainland rather than an island. The depiction of the polar regions as four large islands apparently influenced Mercator when he prepared his 1569 world map, and later the North Pole map in his 1595 atlas.

Very little is known about the cartographer Ruysch, who was born in Antwerp. According to the editor of the Ptolemaic atlas, which was published in Rome and in which this map appeared, Ruysch claimed to have sailed from southern England to the land he described. It is quite probable that Ruysch sailed on a fishing expedition, but it has also been said that if he did make the trip it had no influence on this map, which draws largely on various Italian and Portuguese sources. The map is closely related to the Contarini-Roselli map of 1506 and a 1511 manuscript map by Vesconte Maggiolo.

In drawing it, Ruysch had to decide where to place the new lands. As Contarini had done before him, he chose to attach them to Asia rather than depict them as a separate continent. Two decades later the embryonic Terra Nova was joined with South America, but more than a half-century elapsed before the continent was eventually shown as separate from Asia.

The Ruysch map was printed from two copper plates, with the two sheets joined at the centre. The National Archives of Canada holds two originals of the 1508 Rome edition of Ptolemy's *Geographia*; both atlases contain the final version of the several states of the map that have been identified. The map reproduced here is from the atlas in the Alexander E. MacDonald collection, purchased in 1981.

Vniversalior cogniti orbis tabula ex recentibus confecta observationibus. — Scale [c. 1:80 000 000]. — 1 map; 35.4 × 53.1 cm. — *In* Claudius Ptolemaeus. [Geographia] In hoc opere haec continentur geographiae Cl. Ptolemaei a plurimis viris utriusq[ue] linguae doctiss. ... Rome : [Impressum per Bernardu[m] Venetu[m] de Vitalibus, expe[n]sis Eva[n]gelista Tosino Brixiano Bibliopola], 1508. NMC 19268

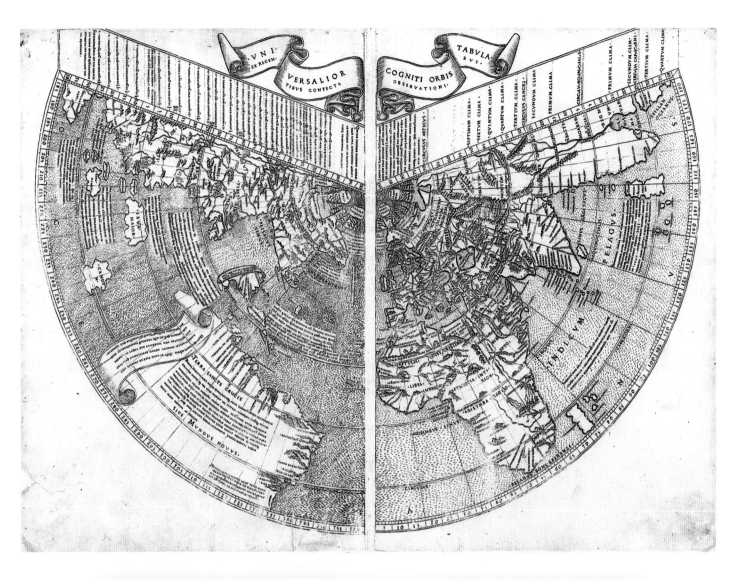

The word 'Canada' first appears on a printed map

Cartography in the first half of the sixteenth century undeniably belonged to the Italians. Their engraving and designs were exquisite, while the content of their maps reflected an attempt to be modern – that is, to include new knowledge from actual overseas exploration, both coastal and interior, and to gather information systematically, in both ways breaking from classical traditions that were more theoretical than pragmatic in approach. At first, contemporary maps produced in Italy appeared as *tabulae modernae* or supplements to the traditional Ptolemaic maps; slowly a new independent industry developed.

In Venice and Rome, the two principal centres of map production in the sixteenth century, geographical information was compiled from diverse sources, engraved mostly on copper plates, and printed. The printed sheets were distributed singly or were bound into 'atlases,' usually at the request of a purchaser rather than as an 'edition' by the publisher.

This map was engraved by Paolo Forlani using a 1546 Gastaldi map as a model, but is not one of the finest products of the Italian map printing houses. However, it is of special interest to Canadians because it is the first *printed* map (and thus the first for public distribution) bearing the name 'Canada.' That name came from the Huron-Iroquois *kanata*, meaning village or settlement. It had previously appeared on a manuscript map of the world by Desceliers in 1546 but, because there would have been only a single copy, that map would have been seen by few people.

Forlani's world map is drawn on an oval projection with North America still joined to Asia. Three major river systems drain the northeastern part of the continent, though at least two may represent the St Lawrence River. The southernmost of the three appears to be most directly connected with the actual St Lawrence River since it flows past 'Stadacone' (Montreal). Saguenay, Labrador, Newfoundland (including several islands), and Cape Breton appear in a confusing amalgamation, labelled with place names from Jacques Cartier and Giovanni Battista Ramusio.

This example of Forlani's map is the first of five known states published between 1560 and 1751. It was purchased in 1987 with assistance from the Department of Communications under the terms of the Cultural Property Export and Import Act.

[Il mondo] / Paulus de Furlanis Veronensis opus hoc ex.^{mi} cosmographi D[omi]ni. Iacobi Gastaldi Pedemontani instauravit, et dicavit ex.^{ti} iur. Vt doct[iss] et aurato aequiti D[omi]no Paulo Michaeli Vincentino. — Scale [c. 1:50 000 000]. — Venetiis : Ioan. Francisci Camotii aereis formis, Ad signum Pyramidis, 1560. — 1 map : hand col. ; 28.9 × 51.2 cm. NMC 97953

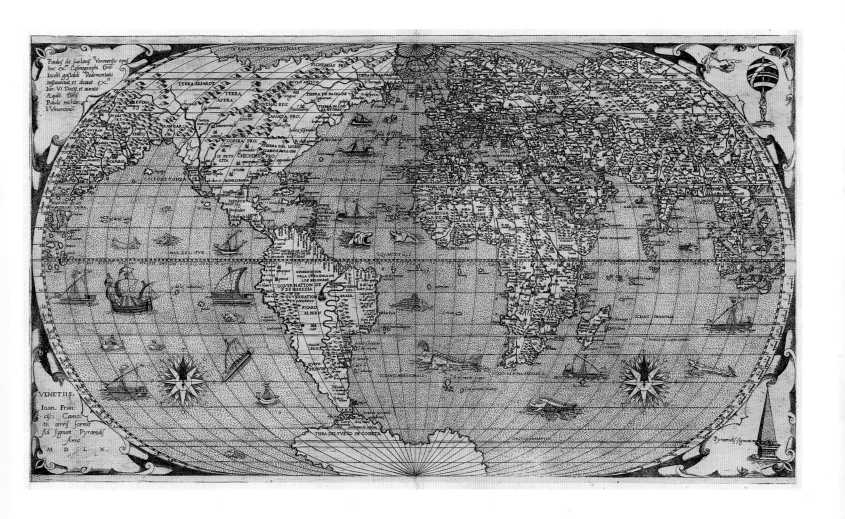

How Mercator imagined the North Pole

The nature of the world's northern regions – whether they were, in fact, a solid land mass or a penetrable sea – was one of the major scientific questions of the sixteenth century. Gerard Mercator, geographer, cartographer, astronomer, and mathematician, was one of many who spent much effort attempting to understand, accurately describe, and map this vast expanse. Fame and fortune was to be gained if evidence could be found pointing to a Northeast or Northwest Passage. Mercator's concept of the arctic regions was shaped by his theories and beliefs about the genesis and evolutionary development of the Earth; but he also attempted to support his theories empirically by introducing new geographic evidence.

This 1595 map incorporates evidence of Martin Frobisher's voyages (1576–8) and John Davis's three expeditions (1585–7) in search of the Northwest Passage to China. In support of such a passage, the map shows a 'Mare glaciale' linked to 'El streto de Anian,' a strait that was thought to separate Asia from North America. Mercator shows the region of California to be within the Arctic Circle and states that it was the Spaniards who had knowledge of the area. The large bay that one might think delineates Hudson Bay – well before its exploration in 1610 by Henry Hudson – is more likely a reference to the Great Lakes; the inscription states that the 'Canadenses' call these waters sweet (that is, fresh) but do not know their limits.

The map shown here is Mercator's last map dealing with the North Pole and was published posthumously in 1595 by his son, Rumold. In 1569 Mercator had included the North Pole in an inset on his great world map, *Nova et aucta orbis terrae descriptio*. On that map, as here, a massive rock is at the centre surrounded by four large islands separated by four rivers. One island is identified as the home of the Pygmies, while another is purported to have most salubrious conditions. The remaining inscriptions pertain to the nature of the four water routes; the waters, described according to a prevailing theory, were drawn constantly northward to the rock and absorbed into 'the bowels of the Earth.'

Mapping of the Canadian Arctic can be examined in great detail at the National Archives through hundreds of maps that show the area from early in the sixteenth century to the present. This map was purchased in 1980.

Septentrionalium terrarum descriptio / per Gerardum Mercatorem. — Scale [c. 1:20 000 000]. — 1 map ; hand col ; 33.5 cm in diam., image 36.4 × 38.9 cm. Includes 3 insets. — Text on verso: Polus Arcticus, ac terrarum circumiacentium descriptio. — From: Gerardus Mercator. Atlas sive cosmographicae meditationes de fabrica mundi et fabricati figura. [[Rupella] : Typographus sumptibus haeredum Gerardi Mercatoris Rupelmundi, 1595].
NMC 16097

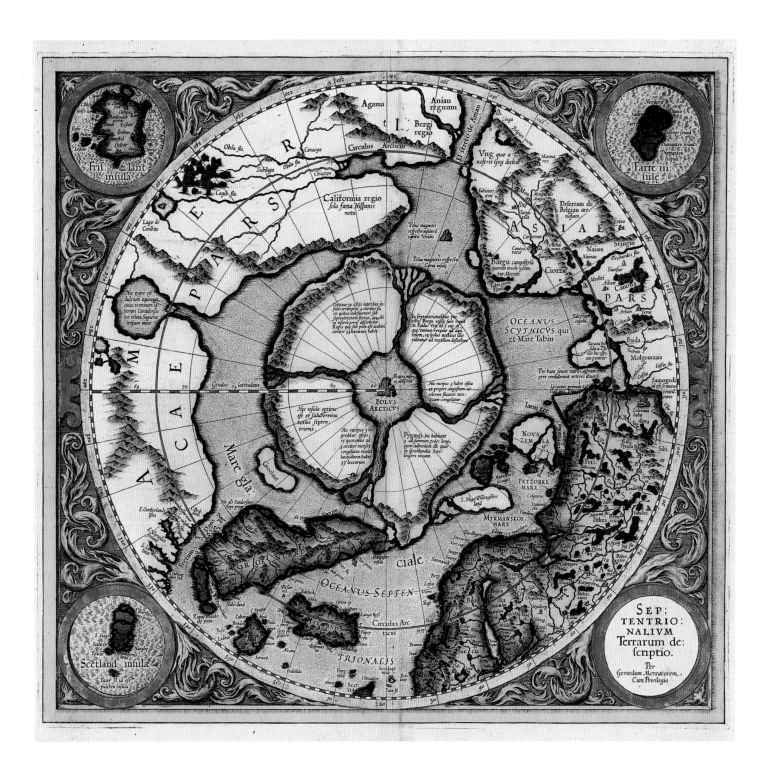

23

Champlain maps New France

Samuel de Champlain's final large map stands out among the early maps of Canada as a magnificent compilation of geographical information about New France as it was known in 1629, the year the French were expelled from the St Lawrence River valley by British privateers. At a time when proof of exploration was indispensable for a European country's claim to an area, Champlain's maps enabled the French to consolidate their claim to Acadia and the St Lawrence River valley, the route to the heart of the interior and its wealth. The information for the map was gathered between 1603 and 1616. During those years Champlain journeyed thousands of miles by ship, canoe, and on foot. To his own observations he added what he could by interviewing native people, whose knowledge contributed significantly to Canada's early mapping.

This was not Champlain's only important map. Three other major maps, and numerous minor ones published from 1612 onwards, had already communicated much detail about the coast and the interior of northeastern North America. What is new on this map is that the interior of the continent west of the Lachine Rapids appears for the first time based on European exploration. Not all the Great Lakes appear, and distortions are pronounced. 'Lac St. Louis' is Lake Ontario. Lake Erie appears as a waterway below 'Mer douce.' 'Mer douce' is actually a combined Georgian Bay and Lake Huron. 'Grand Lac,' at the western extremity of the map, is often assumed to be Lake Superior, but is more likely a combined Lake Michigan and Lake Superior. Champlain obtained information about the location of Lake Michigan from an Ottawa chief, whereas he probably obtained details about the characteristics and location of Lake Superior from Étienne Brûlé, who was an interpreter of Huron language and the first European to travel the Great Lakes. Champlain assumed that their reports referred to the same body of water, and the result in this map is Grand Lac. Only in 1650 was this error corrected by Nicolas Sanson on his map of North America. A detailed legend to help identify noteworthy places was printed in Champlain's *Les Voyages*. From it we learn, for example, that at Niagara Falls ('90' on the map) 'many kinds of fish are stunned in descending.'

The areas Champlain explored (principally the coastal areas from Cape Cod to the Strait of Canso, the Gaspé area, the St Lawrence and Ottawa rivers, into Georgian Bay via the French River, and then to the lands bordering eastern Ontario in New York State) are as a rule represented more accurately than the areas he mapped from information received from others, although this always depended on the quality of his informants' descriptions and his ability to interpret them. Information he borrowed from other Europeans included a map showing Henry Hudson's explorations published in 1613. In the upper left, Champlain gives us a 'Mer du Nort Glacialle,' based on Indian accounts.

Champlain's 1632 map is printed from two copper plates; it is from the Alexander E. MacDonald collection, purchased in 1981. A second state of this map accompanied the 1640 edition of *Les Voyages*, with several changes such as a different configuration of Bras d'Or Lake in Cape Breton Island. Both states of the map are held at the National Archives of Canada.

Carte de la nouvelle france, augmentée depuis la derniere, servant a la navigation faicte en son vray meridien / par le Sr. de Champlain. — Scale [c. 1:5 700 000]. — [S.l. : s.n.], 1632. — 1 map ; 51.8 × 84.9 cm. — Accompanies an edition of: Samuel de Champlain. Les voyages de la Nouvelle France occidentale, dicte Canada ... A Paris, 1632. NMC 51970

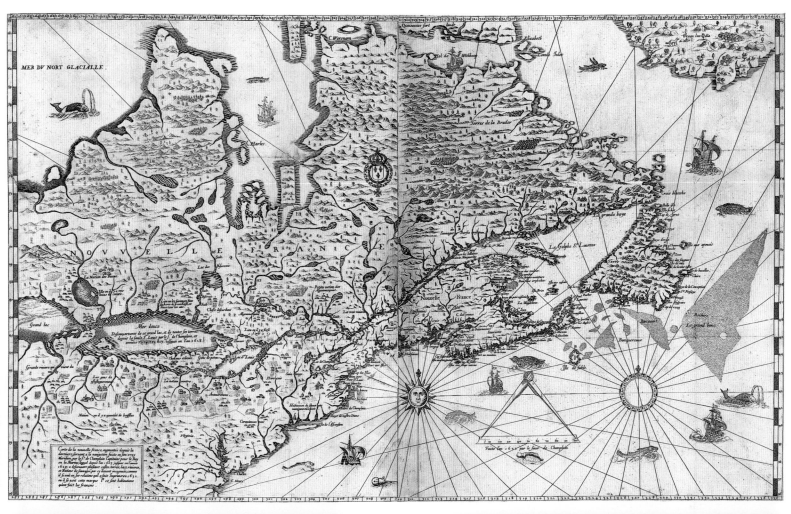

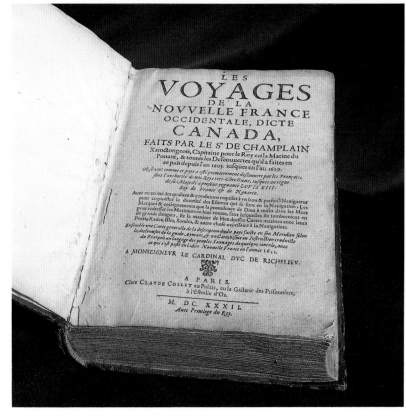

The industrious beaver appears

By including pictures in their work, early commercial mapmakers helped to ensure the success of their publishing ventures. This dramatic wall map of North and South America, published by Nicolas de Fer in 1698, includes two images by Nicolas Guérard that have become popular in Canada. An inset in the upper left (reproduced on the opening page of this section) shows a large colony of beavers constructing a dam; Niagara Falls is in the background, copied from a 1697 view by Jean-Louis Hennepin. In the upper right, another scene depicts the catching and processing of codfish.

In the beaver scene, Canada's national emblem bears little resemblance to an actual beaver, although this certainly does not detract from the animation in the picture. These creatures, an odd assortment of shapes, sizes, and appearance, are engaged in varied and at times quite improbable activities. The engraved text presents an exaggerated belief in the beavers' 'higher intelligence.' Their teamwork, it suggests, extends to felling trees, cutting them into smaller pieces, and transporting them to the building site where 'masons' prepare mortar and carry out the actual construction. A beaver designated as a 'commander or architect' supervises the various tasks of the crew – here apparently giving instructions with the help of a raised forepaw.

When drawing this map, de Fer borrowed freely from cartographers who preceded him, especially Coronelli. Although de Fer is not known for his originality, but rather for his ability to popularize the work of others, this map is not simply a copy of any other person's work. He clearly had access to some primary information from explorers, since a close examination of this map reveals differences from previously published material.

This copy, purchased in 1982, has been printed on four sheets and assembled to form a wall map. It was coloured in the twentieth century, perhaps to 'enliven' it just as colourists would have done at the time the map was published. Unfortunately, it was executed with considerably less sensitivity than it deserved to the style in vogue three centuries ago.

L'Amerique, divisée selon letendue de ses principales parties ... / dressée par N. de Fer ; gravée par H. van Loon. — Scale [c. 1:15 000 000]. — A Paris : Chez l'autheur dans l'Isle du Palais sur le Quay de l'Horloge a la Sphere Royale avec privilege du Roi, 1698. — 1 map : hand col. ; 88.8 × 98.2 cm, sheet 111.0 × 137.0 cm. — Numerous illustrations: 'N. Guérard inv. et fecit.' NMC 26825

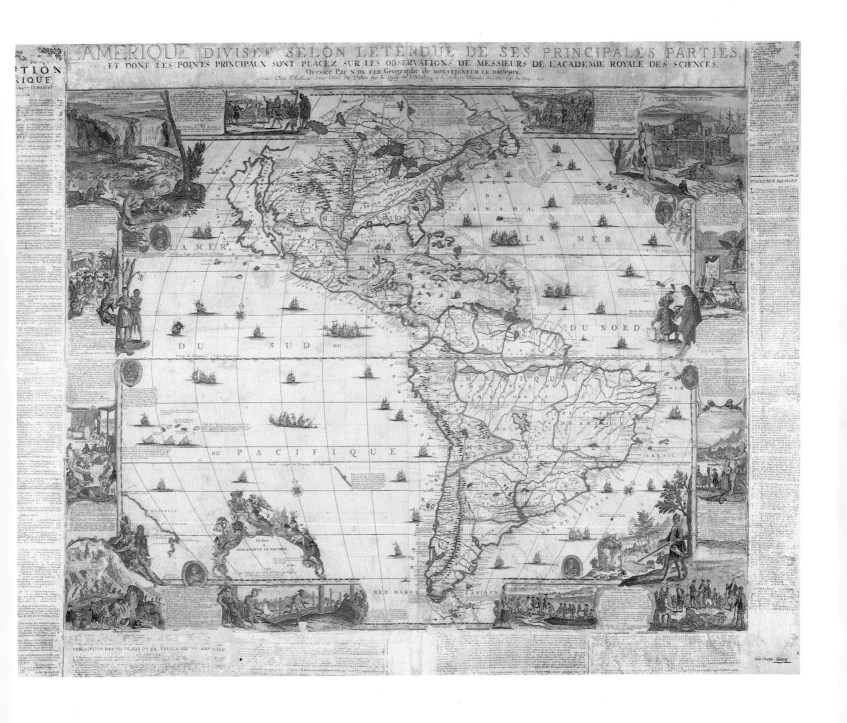

A rare wall map

This 1718 map of New France, a recently acquired cartographic treasure, has not yet received the scholarly scrutiny undergone by maps that have long resided at the Archives. Consisting of four sheets of paper assembled to form one large map, it is probably the single most influential map of New France published between those by Claude and Guillaume Delisle (1700–3) and those of Jacques-Nicolas Bellin (c. 1744). Nicolas de Fer synthesized geographical information – some old, some new – available to him in various archives in Paris, such as the Académie des sciences. The rarity of his wall maps today may indicate that sales were not brisk, although wall maps throughout history have never survived as well as smaller maps issued in books or in atlas form. De Fer's concepts were disseminated further by other publishers who issued many of his maps in reduced formats (in the case of this 1718 map, notably by Zacharias Châtelain in Amsterdam in 1719).

A comparison of this 1718 map with maps that preceded it reveals that works by the leading French cartographer Guillaume Delisle, the Venetian cartographer Vincenzo Coronelli, and also the Dutch cartographer Herman Moll influenced de Fer's work. In synthesizing the work of others, however, de Fer was not afraid to make modifications as he saw fit, at times supplying some of his own interpretations based on written, and probably oral, accounts. His maps are never mere copies of his predecessors'; they are compilations of some distinction.

In northern Quebec and Labrador, seen in the upper right of the map, de Fer gives a unique interpretation to the location of various presumed waterways dividing that area into several large islands. Maps had been published before this date with other configurations. Further research will doubtless reveal the source of this concept.

These early maps of exploration and discovery gave Europeans their first impression of the New World. Today we may be amused by their inaccuracies. On another level, these maps present a challenge to the scholar attempting to unravel the real from the imagined.

This map was purchased in 1989 with assistance from the Department of Communications under the terms of the Cultural Property Export and Import Act.

La France occidentale dans l'Amerique septentrional ... / par N. de Fer, geographe de sa Majesté catolique. — Scale [c. 1:5 000 000]. — A Paris : [N. de Fer] dans l'Isle du Palais sur le Quay de l'Orloge a la Sphere Royale avec priv.ᵉ du Roy, 1718. — 1 map : hand col. ; 94.1 × 103.5 cm, image 96.4 × 104.3 cm. — Added title cartouche: Le cours du Mississippi, ou de St. Louis ... — Includes 3 insets. NMC 117150

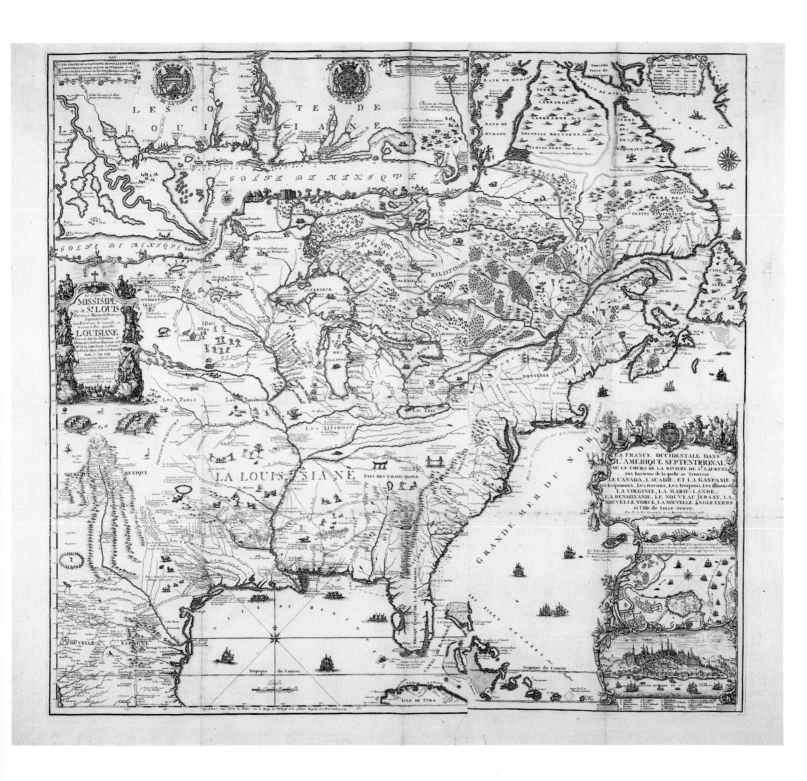

Charting the Gulf of St Lawrence

Jacques-Nicolas Bellin, whose prolific production of superior maps has won him a place as one of the principal French cartographers of Canada, is represented at the National Archives of Canada by numerous printed maps, c. 1744–64, and by an atlas of seven manuscript charts and maps ('dresses par le Sr. Bellin Ingenieur de la Marine,' c. 1752), of which this is one.

The Gulf of St Lawrence was an area of intense French activity during the seventeenth and eighteenth centuries. Both the Gulf and the River St Lawrence were of strategic importance to the French in that these waterways controlled access to French territories in North America. Reliable hydrographic charts therefore were essential. The numerous versions of French charts held by the National Archives of Canada are evidence of the continuing attempt by that nation's hydrographic office, as well as private publishers, to keep maps as up to date as possible to meet the demand. As is common for hydrographic charts, only the coastal areas are mapped, while the interior is left largely blank.

On this one, 'La Pointe Riche' appears along the northwestern coast of Newfoundland. The label also appears on a chart of the Gulf by Bellin published two years later, but was quickly deleted from the plate and, for future printings, was re-engraved at the southwestern tip of the island as an alternate name for 'Cap de Ray.' In this way, French cartographers did their part to create persuasive documents that would help push southwards the area along the Newfoundland coast where they were permitted by treaty to fish.

The atlas was part of a gift from the British government to the Canadian government on the occasion of the centennial of Confederation in 1967. Taken from French government holdings at an unknown time, the atlas contains the bookplates of two owners, one unidentified and the other Philip Dormer Stanhope, fourth Earl of Chesterfield (1694–1773).

Golphe de Saint Laurent, contenant l'Isle de Terreneuve, Detroit de Belle-Isle, entrée du Fleuve St. Laurent, Isle Royale, et partie de l'Acadie, & ca. — Scale [c. 1:2 137 000]. — [c. 1752]. — 1 map: ms., col. ; 52.3 × 78.3 cm. — Seal at upper right: Depôt des cart. pl. et journ. de la Marine. — From: Jacques-Nicolas Bellin. Cartes de la Nouvelle-France ou Canada. 1752. — Manuscript atlas. NMC 15012

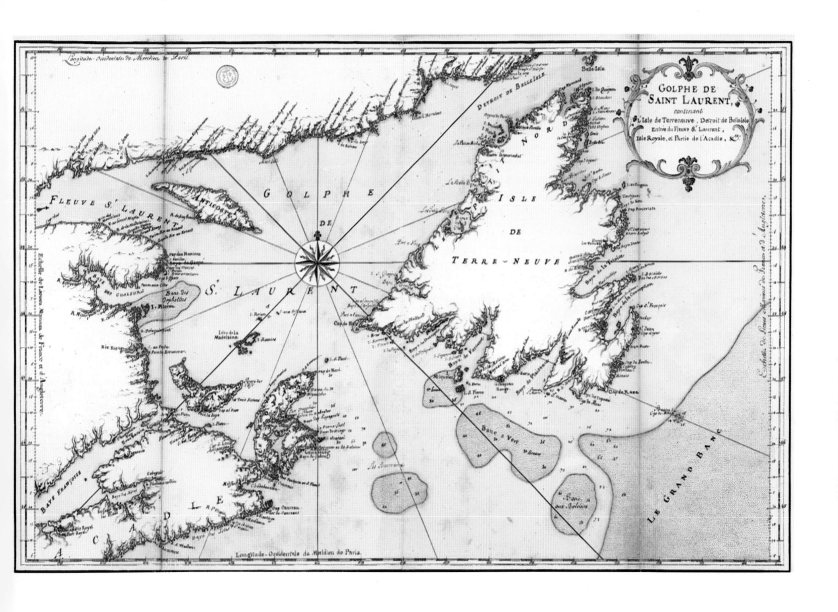

False Northwest Passage: part error, part hoax

Joseph-Nicolas Delisle, an astronomer and geographer, worked in England and Russia. Upon his return to his native France he teamed up with his nephew, the cartographer Philippe Buache. They produced a series of maps with an entirely fictitious northwest coastline of America. For those in the middle of the eighteenth century who were convinced of the existence of a Northwest Passage, Delisle's fascinating but aberrant map, drawn to his directions by Buache, must have been a most welcome document. Delisle incorporated two major geographic configurations (one the result of a hoax, the other an honest misunderstanding of various reports) in Canada's West and North that were ridiculed at the time, and were determined several decades later to be mere conjectures.

The honest mistake is the mapmaker's inclusion of a large inland sea, labelled 'Mer ou Baye de l'Ouest,' covering much of present-day British Columbia. Explorers in eastern Canada had been told by natives that by travelling westward they would reach a large body of water. Since Juan de Fuca was reported to have entered the strait that now bears his name in 1592, and was convinced he had entered a large body of water, it is understandable that European mapmakers might portray a large sea before they had first-hand knowledge of the area.

It is more difficult to excuse Delisle for his inclusion of the alleged discovery of a Northwest Passage by a certain Admiral Bartholomew de Fonte in 1640. This 1752 map shows a series of interconnected lakes and rivers forming an inland passage from Hudson Bay to the Pacific Ocean. A map showing this phenomenon had previously been published in London in 1749, but it was Delisle and Buache's map that gave the concept credence. A vigorous debate ensued, and it was not until explorers such as James Cook had carried out their investigations along the British Columbia coast several decades later that the idea of such a passage was laid to rest. Such erroneous conceptions abound in the early cartography of Canada. Most have a grain of truth in them; all help us see how our vast land was perceived in times past.

This map is from the Alexander E. MacDonald collection, purchased in 1981.

Carte des nouvelles découvertes au nord de la Mer du Sud, tant à l'est de la Siberie et du Kamtchatka, qu'à l'ouest de la nouvelle France / dressée sur les mémoires de Mr. de l'Isle ... par Philippe Buache ... — Scale [c. 1:21 000 000]. — [Paris] : Se vend à Paris, Quay de l'Horloge du Palais, avec les cartes de Guill. Delisle et de Phil. Buache, [1752]. — 1 map : hand col. ; 36.8 × 62.6 cm. NMC 21056

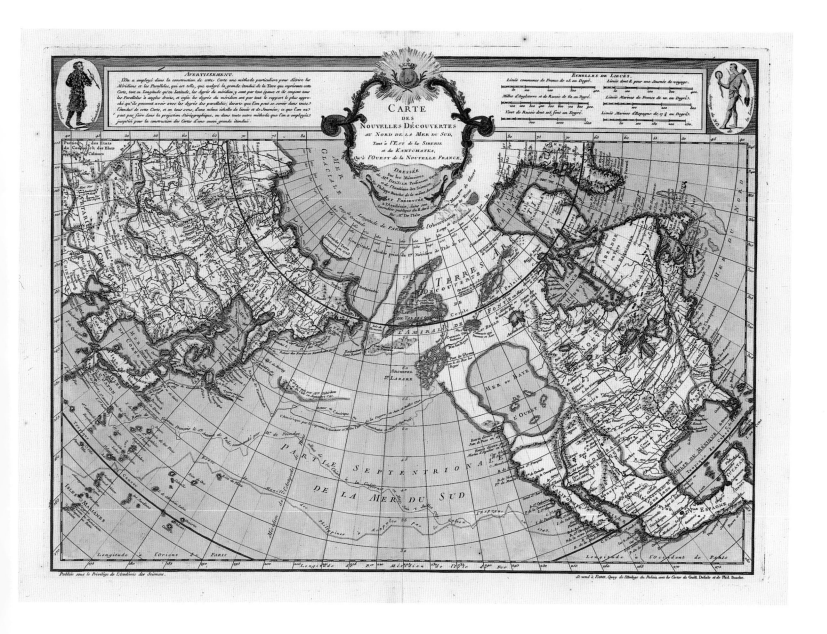

Cook charts the river for the British conquest

Probably one of the greatest navigators of his day, James Cook (1728–79) is primarily known for his circumnavigations and for exploring Australia and the west coast of North America. He was also a meticulous and painstaking surveyor who charted part of the Gaspé, the coast of Newfoundland, and the St Lawrence River during the Seven Years' War (1756–63). His making of this map has taken on the proportions of a heroic undertaking. Often under the cover of darkness or in the face of enemy fire, and with little else but his instincts and genius to rely on, Cook is said to have single-handedly charted the hazardous St Lawrence River.

The truth falls slightly short of such glory, yet Cook's hydrographic and navigational skills were formidable. In his early years, his men swore he could smell unseen land before anyone else even suspected its proximity. His work eventually enabled James Wolfe's armada to navigate the river, sail to Quebec, confront the French forces on the Plains of Abraham, and ultimately gain New France for England.

The ascent of the British fleet up the St Lawrence River during the Seven Years' War required reliable charts, especially above Green Island where the river narrows and small channels are the only safe course. The French, to thwart the English, had removed buoys and navigational aids, and a rough chart Cook had earlier helped to prepare was certainly inadequate for navigating the fleet, especially through the difficult narrow 'Traverse,' shown at the lower end of the 'Island of Orleans.'

At the traverse, the masters of all the boats spent two days taking soundings and determining a 'New Traverse,' so indicated. Cook then recorded without fanfare in his log: 'Retd. [returned] satisfied with being acquainted with ye Channel.' The course the masters had chosen provided a route that the fleet followed without incident. During the ensuing months of military activity leading to the capitulation in September, Cook continued taking soundings, returning again in 1760 and 1761.

Cook's 'Remarks' at the lower right demonstrate his concern for the reliability of his chart; he points out, for example, that a lack of time kept him from personally making all necessary observations and that he may have committed errors. This attention to detail in navigational matters helped make Cook's later extensive hydrographic surveys of Newfoundland an invaluable contribution to our knowledge of that area.

Three examples of this chart are known to exist. This one is signed by Cook and, except for the two sets of remarks, is drawn in his own hand. (The other copies are located in England: one, in Cook's hand, is in the National Maritime Museum, Greenwich, and the second, not in his hand, is in the Hydrographic Office, Ministry of Defence, in Taunton.) According to a note on the verso, the map once belonged to Byam Martin. It was placed with Christie's in London for auction by Admiral Sir William Fanshawe Martin in January 1923, and was purchased by Henry Stevens Son and Stiles for Robert W. Reford, Montreal. In 1967 Reford placed it for auction, again with Christie's. On that occasion it was purchased by H.R. MacMillan of Vancouver, who donated it to the Archives in the same year. The National Archives' extensive file on the provenance of this chart includes news of others' attempts to buy it, and includes Reford's remarks in a letter of 1948 explaining his determination to bring the map to Canada and, by all means, 'not to let the Anzacs get it.'

A plan of the River St. Laurence from Green Island to Cape Carrouge / by Jams. Cook. — Scale [c. 1:72 000]. — [between 1759 and 1761]. — 1 map : ms., col. ; 55.4 × 299.1 cm. — Inset: Bason of Quebec. NMC 21353

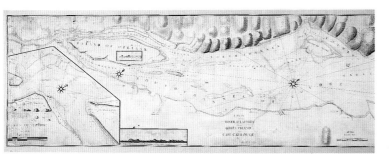
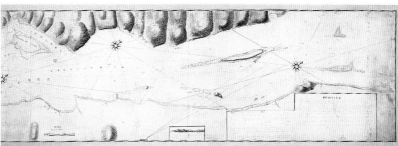

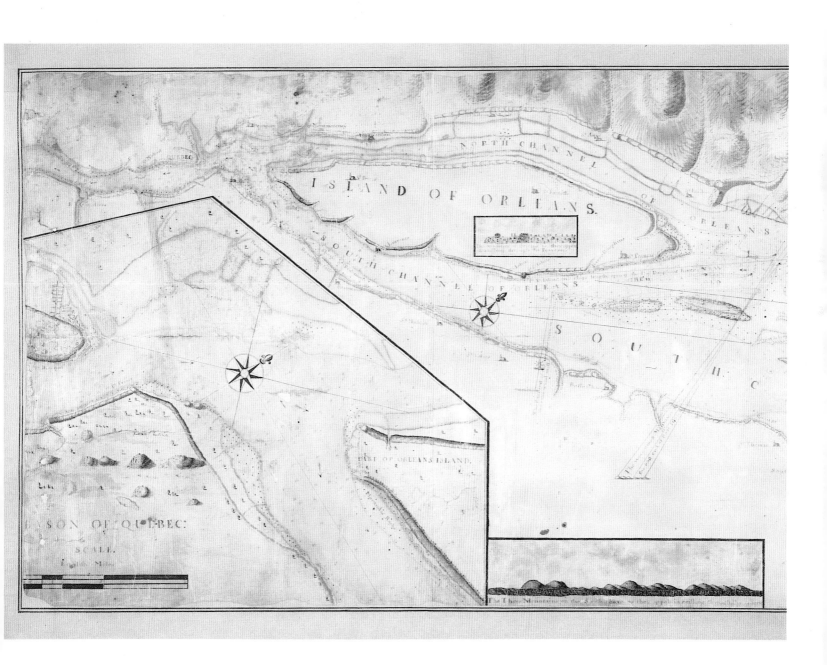

A portable guide to the St Lawrence settlements

The British military made a major contribution to the mapping of Canada in the eighteenth and nineteenth centuries. One of its most ambitious early surveys led to what is now known as the 'Murray Map,' based on a survey of the parishes along the St Lawrence River between Coteau-des-Cèdres (near Montreal) and Isle-aux-Coudres (below Quebec City), although other rivers and land routes were also included. The survey was carried out under the direction of Colonel, later Major General James Murray (1721–94), the first British governor of Quebec after the Seven Years' War.

The work was a survey and an examination of the terrain plus a record of settlement giving population figures, land ownership, and land use. It was done mainly by Murray's engineers, John Montresor, Samuel Holland, and Charles Blaskowitz. Completed in late 1762, it provided the best available cartographic record of the most settled part of Canada as it appeared after the demise of the French Empire in North America.

Quebec City occupies only a small area of the sheet; of equal importance is the attention paid to roads, fortifications, swamps, and churches in the surrounding region. Cleared land is indicated, but with uncertain accuracy. The wealth of information this map provides makes it one of the principal historical documents about the region for the second half of the eighteenth century.

Five original manuscript versions of the map exist today, two of which are held by the National Archives of Canada. One was used by the Board of Ordnance, whose task it was to supply munitions and equipment as well as maps to British military forces at home and abroad. This copy consists of twenty-three very large and cumbersome sheets. The second original, believed to have been Murray's personal copy, was presented to the Archives by the British Admiralty in 1921 and is unlike the others: the survey was drawn on forty-four smaller, separate sheets of paper and was constructed on a grid system with a key sheet making it an easy and highly portable reference tool. The Quebec sheet reproduced here (coded 'Em') comes from this latter copy.

[Town and environs of Quebec] / drawn by Di. Hamilton.
— Scale 1:24 000. — 1 map : ms., col. ; 62.2 × 94.6 cm. — *In*
Plan of the settled part of the Province of Quebec ... [1761].
[Sheet Em]. NMC 10842-Em

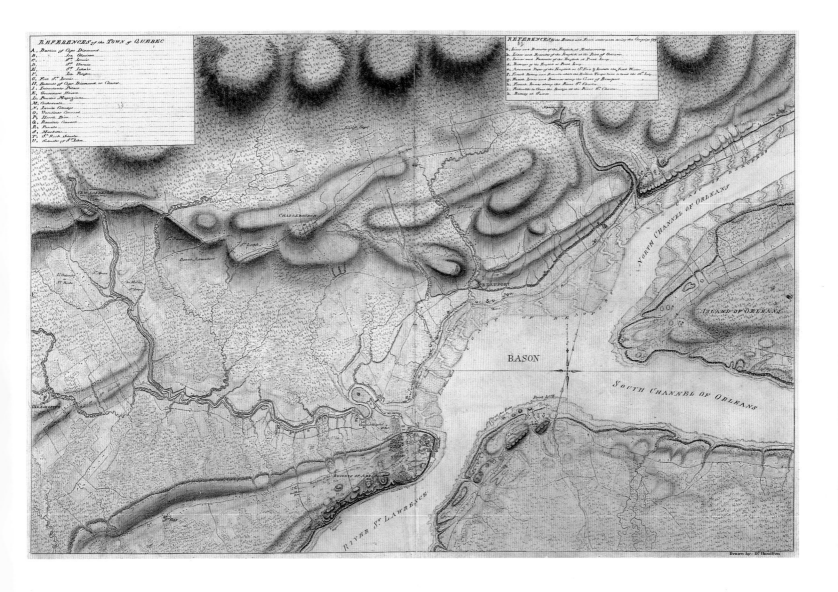

Record of a vanished people

The atrocities committed by European settlers against the North American Indian, and the diseases brought from Europe that further decimated the indigenous population, come to the fore in John Cartwright's map of the Exploits River. By the time Cartwright arrived in Newfoundland the Beothuk, who had occupied portions of the island for more than a thousand years, were on the verge of extinction. Their numbers had dwindled as a result of disease and barbaric acts committed by European fishermen and Micmac who had migrated from Nova Scotia. The last-known Beothuk, Shawnandithit, died in 1829; a portrait of her aunt appears in the Documentary Art section, page 89.

By the middle of the eighteenth century, certain responsible individuals, such as Captain John Cartwright, RN, a British Parliamentarian, humanitarian, and well-known reformer, were criticizing the cruelties inflicted upon the indigenous people. Cartwright is also remembered for his avid support of American independence and the abolition of slavery. During his five-year stay in Newfoundland as magistrate of the fishing colony, while still a lieutenant, he set out to explore the interior, not only to ascertain the feasibility of travelling across the island, but also to learn more about the life of the Beothuk and to win back their trust and loyalty. On a twelve-day inland expedition, he explored the Exploits River as far as Red Indian Lake, which he named Lieutenant's Lake. Upon his return, he sent a lengthy report to the Earl of Dartmouth, secretary of state for the colonies, hoping to elicit aid for the Beothuk. Little did he know that his manuscript map, which was included with his report ('Remarks on the Situation of the Red Indians, natives of Newfoundland ... taken on the spot in the year 1768') would one day provide significant archaeological evidence of the lifestyle and habitations of the Beothuk.

The locations of wigwams and square dwellings are marked, although they are now quite faded. The map also shows caribou fences, stretching for miles along the river, that channelled migrating caribou through narrow apertures where waiting hunters killed them. Other illustrations, considered to be the most detailed depictions of Beothuk artifacts now in existence, include a distinctive canoe and paddle, a wigwam, a bow and arrow, quivers, an axe, and containers.

It has been stated that in Canadian history, Cartwright stands apart as a severe critic of the brutal cruelties inflicted upon the Beothuk. Although too late, successive governors imposed severe penalties for those found guilty of barbarities against them.

A sketch of the River Exploits and the east end of Lieutenant's Lake in Newfoundland. — Scale indeterminable. — 1 map : ms., col. ; 38.8 × 30.4 cm. — From: John Cartwright. Remarks on the situation of the Red Indians, natives of Newfoundland ... together with such descriptions as are necessary to the explanation of the sketch of the country they inhabit, taken on the spot in the year 1768. 13th January 1773. (Manuscript Division: MG23 AI(1), vol. 3) NMC 27

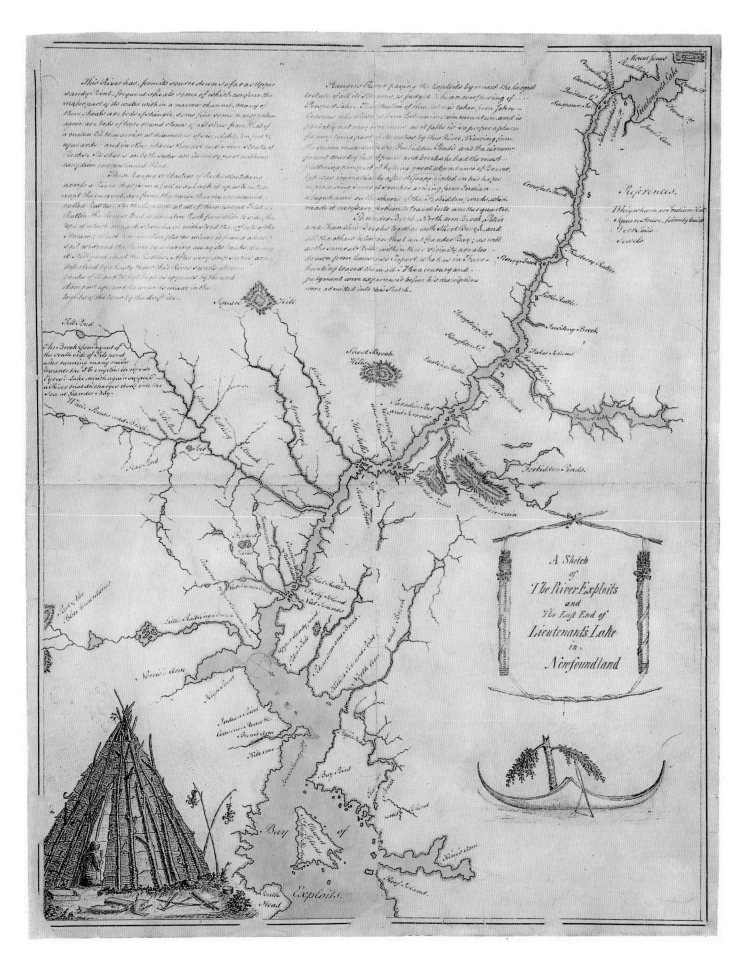

A Sketch
of
The River Exploits
and
The East End of
Lieutenant's Lake
in
Newfoundland

Halifax in *The Atlantic Neptune*

The lack of reliable charts of British North America following the Seven Years' War (1756–63) was a matter of great concern, and with some sense of urgency Britain began major surveys of both the coast and the interior. Joseph F.W. DesBarres, who had been an engineer and hydrographer during the war, was appointed by the Admiralty to carry out a survey of the coast of Nova Scotia, which at the time included New Brunswick.

In nine years, DesBarres and others completed the survey of the coast, the Bay of Fundy, and Sable Island. But the several hundred detailed charts were all in manuscript form, and DesBarres resolved to see them printed in a series of sea atlases for wider use by the navy. In 1774 he began a ten-year sojourn in London. There he supervised the publication of his work and that of other officers who had been, and were still, engaged in surveying along the Atlantic coast.

DesBarres's earliest charts appeared in 1777, folded and bound into four volumes titled *The Atlantic Neptune*. He continued to publish his charts until 1781, correcting and adding new information to the plates and engraving additional plates. As a consequence of this constant revision, almost no two copies of the atlas appear to be identical. The charts were invaluable for navigation, although, as might be expected, later surveys with more advanced equipment revealed many inaccuracies.

Shown here is one of the large sheets with a chart of the harbour of Halifax and a plan of the town. Halifax was enjoying prosperity because of its strategic importance as a base for Britain's operations against the American colonies then in rebellion to the south. This chart appears to be the earliest version printed, since it does not include seven forts that appear on a version printed later in 1777. The Archives also holds the later three states of this chart, as well as more than 700 charts, views, title pages, and text pages of *The Atlantic Neptune*, along with thirty of the original copper plates.

In April 1947 the Canadian government received from the government of the United Kingdom thirty of the sixty-four DesBarres copper plates still held by the British Admiralty; the other thirty-four were sent to libraries and historical societies in the United States. The chart reproduced is from the W.II. Coverdale collection, purchased in 1970.

[Plan of the town of Halifax]. — Scale [c. 1:4 800]. — [London] : Survey'd and publish'd according to Act of Parliament ... by J.F.W. Des Barres, Dec.ʳ 11, 1777. — 1 map ; 80.7 × 58.5 cm. — From: The Atlantic Neptune. London: Published for the use of the Royal Navy of Great Britain by Joseph F.W. Des Barres ..., 1777. Vol. 1, pl. [28?]. NMC 18358

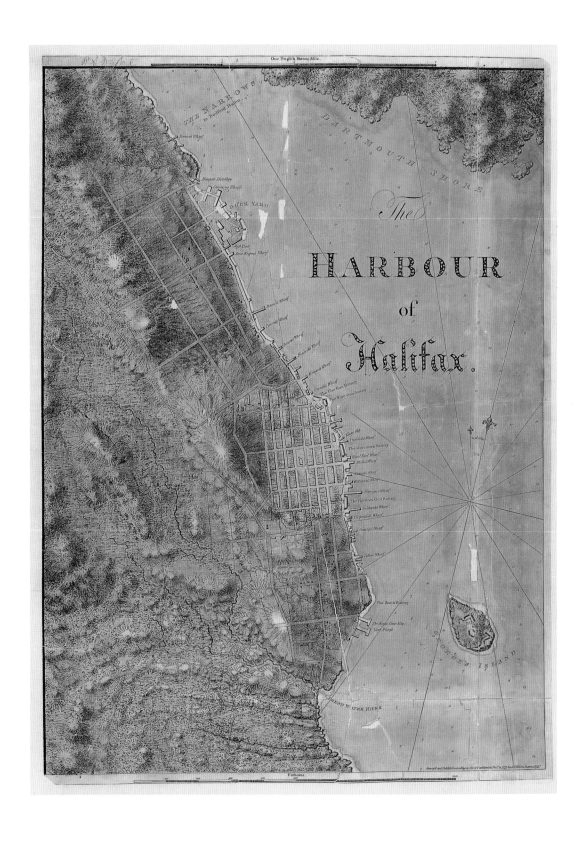

One English Statute Mile.

THE NARROWS
to Bedford Halifax.

DARTMOUTH SHORE

The

HARBOUR

of

Halifax.

DUCK YARD

GEORGES ISLAND

Fathoms.

The Canada Company and early Upper Canada

In the eighteenth century, Upper Canada was inundated by United Empire Loyalists seeking refuge from the United States following the War of Independence. For many years, these people dominated the settlement of Upper Canada, which was shaped by many factors, including government policy; land grants; the location of crown, clergy, and Indian reserves; government attitudes towards land speculation; and the construction of roads, railways, and canals. Growth was influenced by physical features such as the location of rivers and the natural transportation system they provided for diffusion to the interior.

At the end of the Revolutionary War in 1783, members of the militia and other citizens who could prove their loyalty to the British sovereign were entitled to 'free grants' of land under the terms and conditions of royal instructions. In 1788 the size of these grants was increased. The policy changed again in 1791 when the Constitutional Act was passed in response to Loyalist petitioners who were increasingly discontented with the rules and regulations under which they received lands from the crown. This land-granting system continued until 1826, when it was replaced with an open land market.

The Constitutional Act also required that one-seventh of the land granted in each township be set aside for clergy reserves. Although it was not stipulated in the act, the imperial authorities decreed that crown reserves, equal in extent to the clergy reserves, be set aside during the creation of every township. The revenues from the clergy reserves were intended for the Church of England, and the crown reserves were created to raise funds for the government. In order to accommodate both kinds of reserves, a 'chequered plan' was created. The pattern is displayed at the bottom left of this map.

Although the location of crown and clergy reserves may have had an impact on settlement, by the 1820s the government was in financial trouble. Part of the problem was that few people would lease reserves when other land was plentiful.

To raise money for the Colonial Office, the Canada Company was created in 1824 to buy the crown reserves not already leased or applied for in townships then surveyed. The Company received the lands at a rate of three shillings six pence per acre, and made annual payments that went to the civil expenses of Upper Canada. In 1827, all the leased crown reserves were endowed to King's College, predecessor of the University of Toronto. The Canada Company purchase amounted to 1,384,413 acres, and it was given an option to purchase additional lands, which it exercised to the amount of 1,322,010 acres. The purchase of these lands made the Canada Company the first private land corporation to be responsible for administering the colonization and settlement of Upper Canada.

The general location of Canada Company lands can be found in this map, prepared by James Chewett and Thomas Ridout, surveyor general of Upper Canada from 1805 to 1829. The map was completed in 1825, published in 1826, and used by the Company to help administer its vast land holdings. Upper Canada is shown divided into districts, counties, and townships; Indian reserves and clergy reserves are also indicated. Each township is marked, representing areas where lots were acquired by the Canada Company in accordance with the Royal Charter and Act of Parliament in 1826.

The map also records water routes that existed in the period to 1825. The length, number of rapids, ferry crossings, canals, portages, and height and number of waterfalls are marked for each route. The outline of Lake Huron and Lake Erie is based wholly on the recent British Admiralty hydrographic surveys of W.F. Owen and H.W. Bayfield. Since the charts based on these surveys were not published until 1828, it is likely that the Canada Company had access to the hydrographers' rough notes or manuscript charts.

The Canada Company map remained the most comprehensive general map of Upper Canada for thirty years, until it was superseded by Thomas Devine's 1859 *Government Map of Canada*. The map reproduced here is the second of several known states published between 1825 (an incomplete version) and c. 1834. It came to the Archives from the Library of Parliament at an undetermined date.

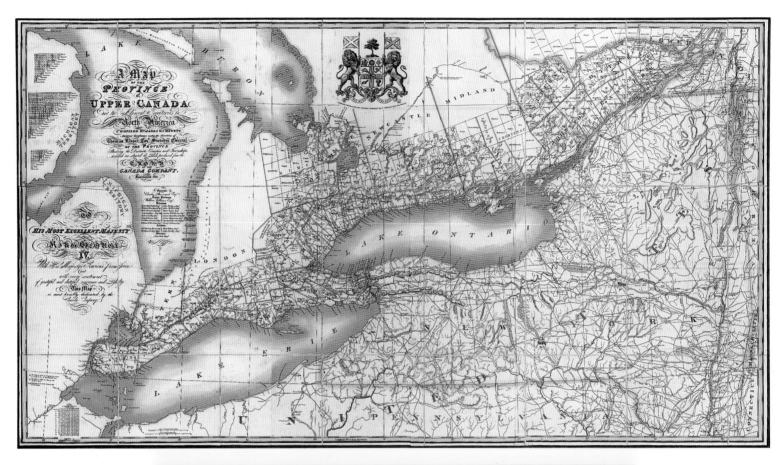

A map of the Province of Upper Canada and the adjacent territories in North America : shewing the districts, counties and townships in which are situated the lands purchased from the Crown by the Canada Company, Incorporated, 1826 / compiled by James G. Chewett … under the direction of Thomas Ridout … ; engraved by I.S. Cox for the Canada Company. — Scale [c. 1:520 000]. — London (172 Strand) : Published for the Canada Company by C. Smith & Son, [1826]. — 1 map : hand col. ; 94.9 × 174.6 cm, image 97.9 × 178.0. NMC 126160

Exploring the Canadian Arctic

Since the fifteenth century, the search for a northern route to China, India, and the Spice Islands had been pursued primarily by England and Holland. Portugal and Spain had already claimed the southern course. Originally, a Northeast Passage was sought along the Russian and Siberian coasts; after numerous attempts, the idea was abandoned in favour of a passage north of the American continent. It took centuries before the Northwest Passage was traced and sailed, mostly by British expeditions. Conditions in the Arctic made exploration and mapping extremely difficult. Access to the area was inhospitable; many islands had contorted coastlines, jutting peninsulas, and long bays; the weather and the ice made it difficult to distinguish between bays and sounds; visibility was often reduced and the sailing season was short. Exploration was slow and deceptive.

During the Elizabethan period (1558–1603) and the early seventeenth century, Frobisher, Davis, Weymouth, Hudson, Button, Gibbons, Bylot, and Baffin explored the eastern entries to the North American Arctic, bringing to light the coastline along most of Baffin Bay, Hudson Strait, and Hudson Bay. Entries from the west were still almost unknown. For the next two centuries, there would be no more expeditions until new political, economic, and scientific needs again aroused interest in the area. In 1819–20, Edward Parry was commissioned by the British Admiralty, and he sailed to Melville Island, far in the Arctic Archipelago, through Lancaster Sound, Barrow Strait, and Viscount Melville Sound. In two expeditions (1819–22 and 1825–7), Sir John Franklin travelled overland and surveyed large portions of the North American mainland arctic coast between Harrison Bay, Alaska, and Boothia Isthmus. Others like Simpson, Beechey, Richardson, Ross, and Rae would also explore along the coast from Bering Strait and adjacent islands.

In 1845, Franklin was asked by the Admiralty to find the missing links between these discoveries and to trace the Northwest Passage. Sailing from England and entering the Arctic from Lancaster Sound, he went west of King William Island, where the ships were frozen in. He was very close to connecting with earlier surveyed coastlines and completing the passage. However, the expedition never returned; it perished in 1847. In the next twelve years, numerous British and American expeditions went in search of Franklin and, as a byproduct, considerably increased our knowledge of the Arctic. Finally in 1853–4, Sir Robert John Le Mesurier McClure, a British naval officer who had previously explored the Arctic, traced the Northwest Passage using ship and sledge over sea ice. Other expeditions completed the mapping of the islands and gave shape to the various coasts. Later, Americans, Scandinavians, and British would explore and map the rest of the Arctic farther north. The Northwest Passage would not, however, be used because of the harsh conditions of the Arctic and the short sailing season. It was not until 1903–6 that it was navigated by Norway's Amundsen.

This map by John Arrowsmith shows some of the expeditions sent in search of Franklin. Although dated 1852, the map contains a note on Commander Richard's voyage to Bathurst Island in 1853 and Commander McClure's explorations of 1851–3 around Banks Island and the Prince of Wales Strait. The information gathered during McClure's trip was not available to Arrowsmith until 1854, when McClure returned to England. On Devon Island (to the left of the title) is an enlargement of the bay where Franklin's ships, the *Erebus* and the *Terror*, were sighted for the last time on 26 July 1845. The legend in the upper right corner lists the expeditions that took place between 1847 and 1853; the numbering system and colouring help to trace each of these expeditions. The fate of Franklin was discovered by John Rae in 1854, who concluded from Inuit reports and physical evidence that the expedition had perished around King William Island. Not everyone was convinced, however, and the search for Franklin has continued well into this century.

Arrowsmith had a keen interest in the exploration of the Arctic. He updated his maps of the area with information he obtained from various sources, among them the Hudson's Bay Company and expeditions returning to England.

This map is from the Alexander E. MacDonald collection, purchased in 1981.

Discoveries in the Arctic Sea, between Baffin Bay, Melville Island, & Cape Bathurst; shewing the coasts explored by the officers of the various expeditions ... in search of Sir John Franklin / drawn ... by John Arrowsmith. — Scale [c. 1:2 500 000]. — London (10 Soho Square) : John Arrowsmith, 1852 [i.e. c. 1854]. — 1 map : hand col. ; 44.6 × 78.5 cm. — Inset: Enlarged plan of Erebus & Terror Bay ... / sketched by Lieut. Osborne.
NMC 21054

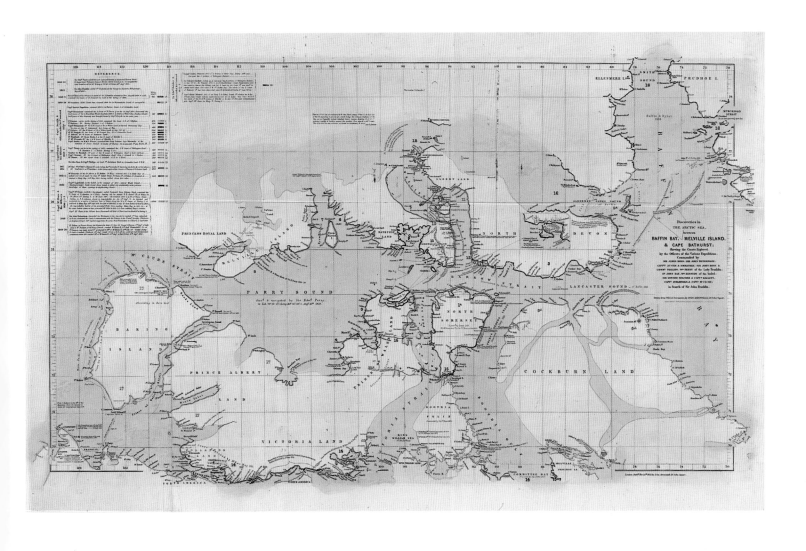

Palliser maps Western Canada

In the mid-nineteenth century, the British government was considering the future of the immense area of British North America owned by the Hudson's Bay Company, but was hampered by the scarcity of information available. At the same time, the Canadian government was concerned about the future of the West. The British North American Exploring Expedition (1857–60) led by John Palliser and the Canadian expeditions led by George Gladman (1857) and by Henry Youle Hind and Simon James Dawson (1858) provided detailed reports and informative cartography that proved crucial in determining policy for Canada west of the Great Lakes.

In 1857 Captain John Palliser was commissioned by the government of Great Britain to undertake a daunting task. He had himself suggested it, however, to the Royal Geographical Society, which had then sought funding from the Colonial Office. His mandate, expanded from his original proposal, was nothing less than to explore the resources of the region between Lake Superior and the Rockies in order to determine the area of arable land and the extent of the forest, to study the flora and fauna, to prospect for coal and other minerals, to provide geological and climatic data, and to consider the feasibility of constructing a railway to the Pacific Ocean entirely through British territory.

Palliser's interest in the West had been aroused by a hunting expedition to the American prairies in 1847–8. In 1857 he was joined by several knowledgeable scientists, including Dr James Hector, a geologist, naturalist, and physician. The detailed report of their findings – including geological, astronomical, meteorological, and biological data as well as interpretive evaluations of settle-

ment and transportation capabilities – was published in 1863. Among other things, it expressed doubt about the feasibility of a transcontinental route through British territory. The passage from the head of Lake Superior to the Red River, it argued, was extremely difficult: it would be much easier for settlers and their livestock to go by way of the United States. The report was also sceptical about building a railway from the Rockies to the Pacific entirely in Canada because of the enormous costs involved.

The regions through which the group had travelled were portrayed on the map accompanying the report. Published in 1865, it includes notes on the topography of the land, its geology, quality of soils, passes explored through the Rocky Mountains, and the itineraries of the expedition's various groups. Of special interest is the semi-arid region in Alberta and Saskatchewan, now known as Palliser's Triangle. Palliser had pointed out that it was arid, and that settlement would be difficult if not impossible. The area surrounding it was judged to be a 'fertile belt,' well suited to stock raising and agriculture; this conclusion was contrary to what the Hudson's Bay Company had long asserted in its own interests, for settlement would harm the fur trade.

For some time after its publication, Palliser's report and this comprehensive map were the most important body of information available on the Canadian West. In the ensuing years, they were essential in making decisions about the use of prairie land, the construction of the transcontinental railways, and the establishment of the North-West Mounted Police patrol network.

This map is from the Alexander E. MacDonald collection, purchased in 1981.

A general map of the routes in British North America explored by the expedition under Captain Palliser during the years 1857, 1858, 1859, 1860. — Scale [c. 1: 2 300 000]. — London : Stanford's Geographical Estabt., 1865. — 1 map : col. ; 30.3 × 126.6 cm. — Cover: Index and maps to Captain Palliser's reports ... London : Printed by George Edward Eyre and William Spottiswoode, 1865. — 'Compiled from the Observations and Reports of Captain Palliser and his

Officers, including the Maps constructed by Dr. Hector, and other authentic documents.' — Accompanies: The journals, detailed reports, and observations relative to the exploration, by Captain Palliser of that portion of British North America ... during the years 1857, 1858, 1859, and 1860. London : Printed by George Edward Eyre and William Spottiswoode, 1863. NMC 126159

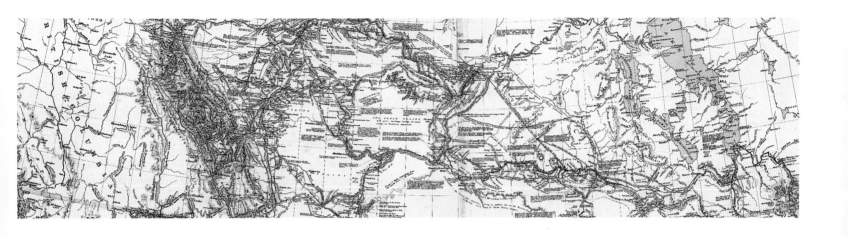

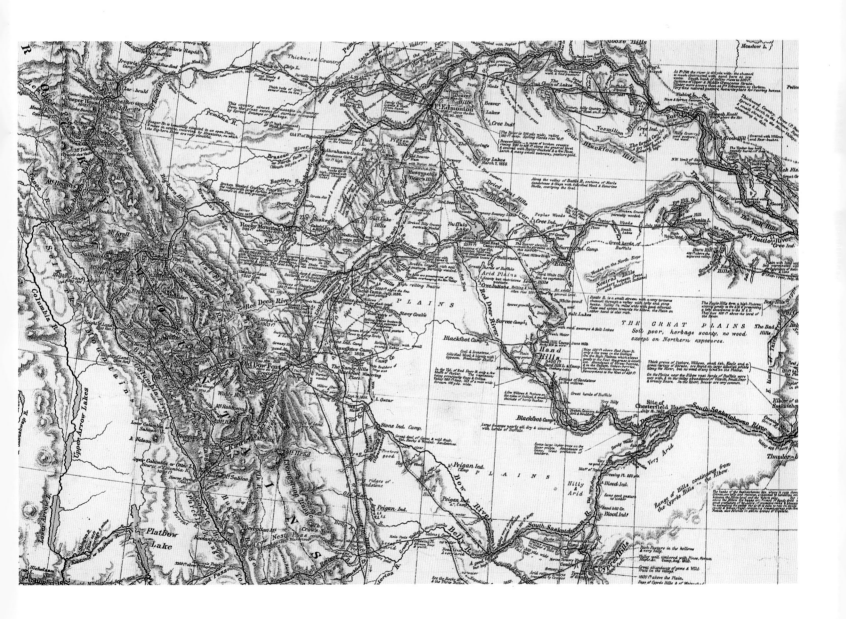

Where the Bow and the Elbow meet

The Canadian prairie provinces bypassed the 'wild west' phase because the land had been largely surveyed before the settlers arrived. As a rule, a township was not opened for settlement until the land agents had been supplied with copies of a plan that could be distributed to potential settlers.

The creation of these plans constitutes one of the most ambitious mapping projects ever undertaken in Canada. In 1870 the vast area known as Rupert's Land was acquired by the Dominion of Canada from the Hudson's Bay Company. The government's intention was to have this area settled as quickly as possible, and reliable surveys were considered a prerequisite. The prairie's flat topography lent itself readily to a rigid geometric format like that already in use in the United States. A system of uniform townships of six miles square was adopted, with townships arranged along base lines and meridians. Each township contained thirty-six sections of one square mile each; sections were further divided into quarter-sections of 160 acres. This constituted the Dominion Lands Survey. The bulk of the surveying activity took place between 1871 and 1885. The township plans were produced at the scale of 1:31 680.

Surveyors employed by the Department of the Interior marked the perimeters of each township on the ground and also recorded major topographical features such as streams, trails, and sloughs; the agricultural potential for all surveyed areas was also assessed. From the information supplied by the surveyors, it was possible to compile in Ottawa the individual township plans at two miles to the inch. These individual plans were later used in the preparation of a series of maps at a scale of three miles to an inch (1:190 080) known as the Three-Mile Sectional Maps of the Canadian Prairies.

This township plan shows the settlement that had sprung up at the junction of the Elbow and Bow rivers, now the city of Calgary. Some of the trails shown, such as the McLeod Trail, are today major thoroughfares, yet retain the names in use when this plan was drawn.

The National Archives of Canada holds several editions of this township plan of Calgary, and more than 20,000 other township plans of the Canadian West.

Plan of township no. 24, range 1 west of fifth meridian / compiled from surveys by Chs. Eug. LaRue ... [et al.]. — 4th ed., corr. — Scale [1:31 680]. 40 chains to 1 in. — Ottawa : Dominion Lands Office, 1889. — 1 map : col. ; 32.2 × 32.4 cm, on sheet 48.0 × 35.2 cm. — Compiled from surveys, 1880–87. — Signed: E. Deville, Surveyor General. — Ms. additions. NMC 26423

FOURTH EDITION (CORRECTED)
PLAN OF
TOWNSHIP Nº 24
RANGE 1 WEST OF FIFTH MERIDIAN

Scale 40 Chains to an inch.

Contents:

Land in Sections 22,408.50 Acres

Compiled from surveys by

Chs. Eug. Larue	D.L.S.	1883
L. Kennedy	" " "	1881
M. Aldous	D.T.S.	1880-81
Geo. Ross	D.L.S.	1884
T.D. Green	" " "	1887
C.A. Bigger	" " "	1886
P.R.A. Belanger	" " "	1885

Dominion Lands Office
Ottawa

28th June 1889

Approved and confirmed

E Deville
Surveyor General

Roads 433.80 "

Water 631.50 "

Total Area 23,473.80 "

EXPLANATION OF COLORS:

Woods Green. Scrub, or Prairie and Woods: Dotted green. Water Blue.

Marshes: Yellow with small strokes of black. Hills or Slopes: Etching or Grey Shade.

Brulé (Burnt Woods) Brown. Settler's Improvements: Pink.

A panoramic view of Dawson

In the late nineteenth and early twentieth centuries, major Canadian cities and urban centres followed a North American trend in having panoramic maps – more commonly called bird's-eye views – prepared. These non-photographic illustrations viewed cities from above at an oblique angle – a remarkable achievement in the days before airplanes were available for such endeavours. They showed street patterns, major landscapes, and a variety of structures, including churches, mansions, single dwellings, industrial plants, office blocks, retail and wholesale businesses, and government buildings. Relatively cheap to produce, bird's-eye views became increasingly fashionable. Traditional processes of engraving were gradually replaced by lithographic printing. The introduction of steam power and later of photolithography also helped to reduce cost, and more and more colour printing was introduced.

This promotional view of Dawson City was drawn by H. Epting in 1903. Before the panoramic map could be drawn, the 'artist' had to decide on the perspective or angle from which his projection would focus. He would then have to walk the streets to sketch every building, tree, and other pertinent features of the town. He would also try to gather information on street patterns, location, and appearance of every building. While the artist was busy filling his sketch-book, an agent was recruiting subscriptions for what was essentially a commercial venture. Although individuals were approached to subscribe, more emphasis was placed on getting financial support from businesses and sometimes from city councils. This popular form of advertisement was used by railway companies and by government officials to promote the development of new cities.

The Dawson City bird's-eye view is a perfect example of promotion for a booming town. Its lithographers accomplished a masterpiece in highlighting the view with yellow to represent the gold mines of the Yukon, thus attracting newcomers to the area. The White Pass and Yukon Railway bought more than six thousand copies, which were sent to potential tourists in eastern Canada and in the United States. The territorial government mailed another thousand copies.

These bird's-eye views are still popular today. As in the past, people buy them mainly to have on their walls. They depict life of small towns or major urban centres near the turn of the century. Although none of these views are free from error or some exaggeration, they do represent a fairly accurate image of a given community at one point in time. Bird's-eye views are one of several reliable sources researchers use in trying to understand the historical context of this period. They reveal the history of various buildings (public, commercial, industrial, and private), city planning, transportation, urban geography, toponomy, and printing technologies. Facsimiles of such panoramic maps are now available and prove to be as popular as they were when originally produced.

The National Archives holds more than 200 bird's-eye views of major Canadian cities and smaller centres.

Birdseye view of Dawson, Yukon Ter., 1903 / H. Epting. — Scale indeterminable. — Vancouver : B.C. Print. & Engr. Corp., 1903. — 1 view : col. ; 46.9 × 88.5 cm. — 'Entered according to Act of Parliament of Canada, in the year 1903, by W.F. Thompson, at the Department of Agriculture.' NMC 21044

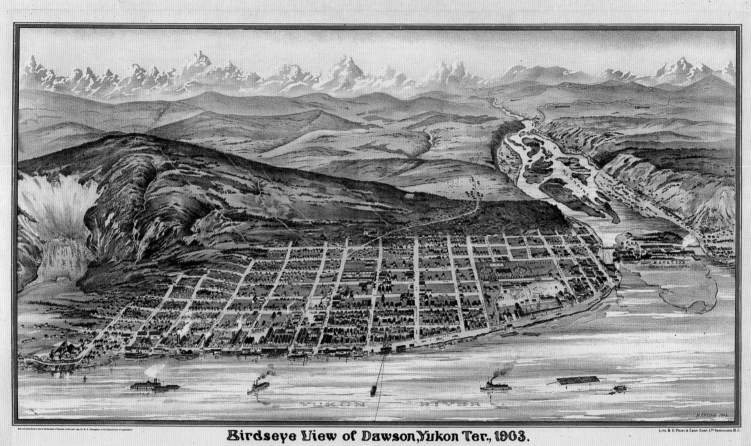

Birdseye View of Dawson, Yukon Ter., 1903.

Getting down to details

Detailed maps have long been acknowledged as essential tools for the effective planning and administration of countries, including national defence, environmental protection, education, outdoor recreation, and the development and analysis of transportation systems, cities, and natural resources. Topographic maps, which cover a specific area at a uniform scale and which show altitude through the use of contour lines, are the best maps on which to find the necessary details. National topographic series maps, at various scales, now exist for most countries.

In Canada, before the twentieth century and the creation of the national series, the country had to rely on a hodgepodge of general and detailed maps that did not compare favourably with the great topographic mapping achievements of the United States and many European countries. Britain had systematically produced detailed charts of the Canadian coast and major inland waters because they were essential to the control and defence of the colony. However, neither in London nor in the provinces of British North America were there the resources for the comprehensive mapping of the complete Canadian territory. As a result, mapping was haphazard, based on specific projects with no connection between them. Many of the projects were privately funded, such as the county maps and atlases produced in Ontario, Quebec, and the Atlantic provinces. Parts of the prairies and the railway lands of British Columbia were mapped by the federal government in a series – not topographic – at a scale of three inches to a mile. This series, and the township plans of the West (see page 48), were necessary for the controlled opening and settlement of the West.

Real topographic maps were few. They included a set of almost two hundred maps known as the Fortification Surveys, produced in the 1860s at a scale of 1:2 500 for the immediate vicinities of such cities as Quebec, Montreal, and Kingston. There was as well the *Topographical Survey of the Rocky Mountains* made between 1888 and 1892. Geologists with the Geological Survey of Canada also produced, for their own needs, topographic maps on which to base their geological works. The Chief Geographer's series (1904–48) was produced to give detailed information for the settled parts of eastern Canada. These maps were produced without contour lines and at scales of 1:250 000 and 1:500 000. A national topographic mapping project was needed.

In 1904, the federal government assigned the Department of Militia and Defence the task of starting a series of true topographic maps for Canada. The maps were drawn at a scale of one inch to a mile, and the Ottawa sheet shown here was one of the first to be published. Concurrently, the Topographical Surveys Branch, Department of the Interior, and the Topographical Division, Geological Survey of Canada, were also involved in topographic surveys. There was no coordination between the three agencies in map design and scales, and often their areas of responsibility overlapped. The Board on Topographic Survey and Maps was established in 1922 to solve this problem and to standardize topographic mapping. The Militia and Defence one-inch style, based on Britain's Ordnance Survey maps, was adopted by the board, which also decided on the various scales of the National Topographic System. From then until today, about 11,500 sheets have been published first at the one-inch scale and, since mid-century, at the metric scale of 1:50 000. Many of the sheets have been revised and republished several times. Large numbers of topographic maps at both smaller and larger scales have been published in the National Topographic System. Provincial governments also issue very large-scale topographic maps.

Canada's topographic maps at the scales of one inch to one mile and 1:50 000 have been produced to standards that have won praise from many corners of the globe. The National Archives of Canada holds probably the most complete set of all these sheets and their various editions, as well as series at other scales.

Ottawa sheet. — Scale 1:63 360. — [Ottawa] : Department of Militia and Defence, 1906. — 1 map : col. ; 43.4 × 61.0 cm, on sheet 58.3 × 74.8 cm. — ([Canada 1 inch to 1 mile]; no. 14). — At head of title: Topographic map, Ontario-Quebec. — 'Topographical Section, General Staff, no. 2197.' NMC 18372

TOPOGRAPHIC MAP
ONTARIO – QUEBEC
OTTAWA SHEET

Department of Militia and Defence. 1906.

Topographical Section, General Staff, No 207.

Contours determined with Aneroid and Climometer
based on Lines of Levels.
Magnetic Declination Sept 1906 at Experimental Farm 12.55 W.
Polyconic Projection.
Elevations in feet above Mean Sea Level, New York.
Surveyed in 1906

Scale 63360 or 1 Inch to 1 Mile

Contour interval 25 Feet.

Kingston's city hall

In 1841 the British Parliament united Upper and Lower Canada under one government and established one parliament with equal representation from each of the constituent sections. The union was received with mixed feelings and had to be championed by the governor general, Lord Sydenham. Subsequent opinions on the union are also mixed. While it forged a system of responsible cabinet government and the party mechanisms needed to operate it, the duality remained. The act only linked the French and English communities, without fusing the two former provinces.

Another contentious issue was the seat of government. Lord Sydenham chose Kingston the same year. This decision instantly elevated the town's status and changed its character from a shipbuilding and military centre. It was proclaimed a city in 1846. In step with this momentous change, Kingston began planning a new town hall and market building. George Browne, the architect responsible for fitting up many of Kingston's buildings for the governor general, the legislature, and the civil service, won the competition to design the new municipal headquarters. Unfortunately for Kingston, shortly before the building was completed in 1844 the government functions were moved to Montreal, where the capital remained until 1849. Between 1849 and 1857, a rotating system was established between Quebec and Toronto; finally a permanent site was chosen at Ottawa.

The city hall remains one of the finest pieces of nineteenth-century architecture in Canada and certainly was the crowning achievement in George Browne's career. He did not see the building through to its completion, being replaced as architect by William Coverdale, but the building deviates little from his design. The rear wing or market 'shambles' (not shown on this drawing, one of a set of eight design drawings) was destroyed in 1865. A hundred years later, the building underwent major renovations, including the portico that was replaced as authentically as possible. It stands today, an imposing structure dominating the Kingston waterfront and serving as a poignant reminder of the city's brief moment of glory when it was destined for greatness as the centre of Canada's government.

Front or principal elevation of a Town Hall proposed to be erected in the town of Kingston / designed and drawn by George Browne. — Scale [c. 1:126]. — [1842]. — 1 architectural elevation : ms., col. ; 21.9 × 68.3 cm, on sheet 48.0 × 70.7 cm. NMC 8889

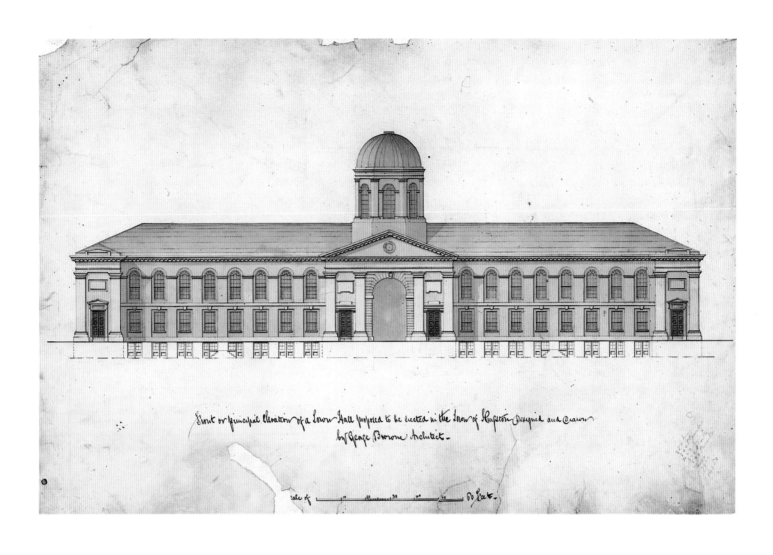

Front or principal elevation of a Town Hall proposed to be erected in the Town of Kingston Designed and Drawn
by George Browne Architect.

Scale of _____ feet.

A Parliament for the new nation

In 1857, Queen Victoria designated the small lumber town of Bytown as the site of the permanent capital of the Province of Canada, and a design competition was announced for appropriate buildings to house the government. Thomas Fuller and Chilion Jones were the design winners for the original Centre Block and Library, and Thomas Stent and Augustus Laver for the East and West Block buildings. When construction was completed, these buildings formed an impressive complex on an imposing site, a twenty-nine acre tract of ordnance property known as Barrack Hill on a promontory overlooking the Ottawa River.

The government's choice of the Gothic Revival design was not surprising, since it had also been chosen as the style of the British Houses of Parliament, completed only seven years earlier. But the Canadian buildings were no copy of Great Britain's prototype. By 1859 tastes had changed considerably towards a free interpretation of Gothic motifs and a concern for an overall picturesque effect. This elevation is drawing number nine of a set that Fuller and Jones prepared in October 1859, incorporating changes to their competition plans as instructed by the Department of Public Works.

Construction began in November 1859, but by 1861 the money appropriated for construction was exhausted. It was not until 1865 that government employees were able to occupy portions of the premises. The Parliament Buildings were finally ready in 1867 for the government of the newly formed Dominion of Canada, although they had been designed to accommodate a smaller governmental body.

During the construction and financial difficulties, Stent and Laver were dismissed, Chilion Jones became involved with other projects, and it was left to Thomas Fuller to complete the work. He was appointed the sole supervising architect to oversee construction. Fuller is also known for his design of the State Capital at Albany, New York, and the Langevin Block in Ottawa, which now houses the offices of the prime minister. Fuller became the dominion chief architect in 1881.

The sixteen-sided Library of Parliament, seen at the right of this elevation, was not completed until a decade later. Resembling the chapter house attached to a Gothic cathedral, it recalls the reading room of the British Museum (now the British Library) in its polygonal form and its elegant flying buttresses. Only the library was saved when fire destroyed the Centre Block of the Parliament Buildings in 1916. Although the cause of that fire was suspicious because it occurred at the height of the First World War, nothing conclusive could be shown to prove that it was an act of sabotage.

Shortly after the fire, John A. Pearson of Toronto and J.O. Marchand of Montreal were asked to submit a report on reconstruction costs. Pearson concluded that the remaining walls could not support an extra storey, so what remained of the walls was razed. Using Pearson's design, the new Centre Block was constructed between 1916 and 1922, and the Peace Tower between 1919 and 1927.

This plan was transferred to the National Archives of Canada from the Chief Architect's Office, Department of Public Works, in 1962.

Parliament buildings, Ottawa : east and west elevation / Fuller & Jones. — Scale [1:120]. — [1859?]. — 1 architectural elevation : ms., col. ; 44.4 × 98.6 cm. — Signed: Fuller & Jones archite[...], Ottaw[a ...]. 'No. 9.' NMC 16004

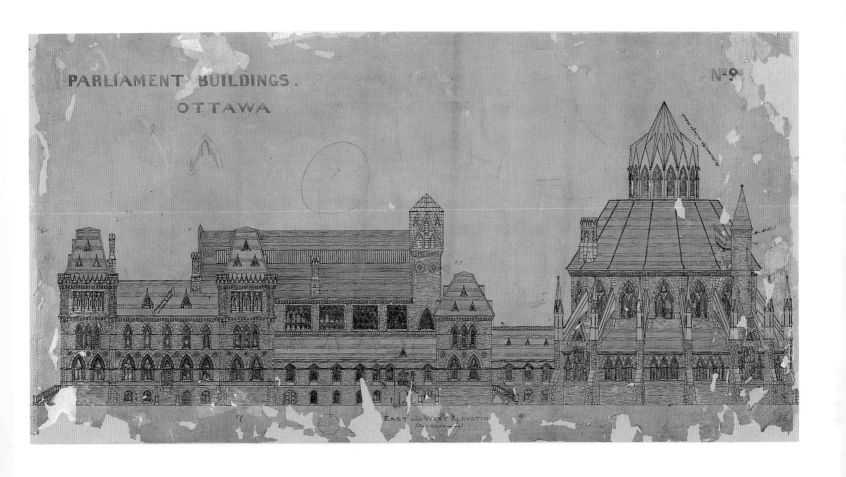

A villa in the Ottawa suburbs

During the late nineteenth and early twentieth centuries, Frederick J. Alexander designed a number of residential, commercial, and public buildings in the city of Ottawa. However, he is more widely known for his designs of the interior fittings and decorations of the Library of Parliament and the enclosures and wrought iron gates surrounding Parliament Hill in Ottawa.

Alexander referred to this residence for Mrs Caroline Gibbs as a 'villa.' The term is indicative of wide-ranging developments in the area of domestic architecture. In the nineteenth century, a 'villa' referred to a comfortable residence situated on a large, well-landscaped lot away from the urban core.

Traditionally in England and Europe, grand country places similar to this one were often meant to be seasonal retreats for wealthy aristocrats who also retained fine city homes. Alexander designed this house (at the corner of Cartier and McLaren streets) for a newly developed area of Ottawa that was still considered to be well removed from the often boisterous, brawling, and muddy downtown, its character still strongly influenced by the booming lumber industry.

The style of this residence is associated with the Queen Anne style as developed in England in the 1870s by Richard Norman Shaw and is thought to be evocative of the era of that British monarch. Features include contrasting textures in wall and roof treatments, elaborate gable decorations, tall chimneys, coloured and patterned glass panels in the windows, a projecting pavilion, and a porch. The heavy arch over the main door suggests the Romanesque Revival, a style contemporary with the Queen Anne, and the mansard-type roof is drawn from earlier French prototypes.

This plan was donated to the National Archives by Mrs R.V. Rosewarne, granddaughter of Frederick J. Alexander, in 1977.

Villa-residence for Mrs. C.L. Gibbs, cor. Cartier & McLaren Sts., Ottawa / Fred. J. Alexander. — Scale [1:96] and [1:48]. — 1887. — 3 architectural drawings on 1 sheet : ms., col. ; 41.1 × 64.5 cm. — Components: Ground plan — First floor plan — Front elevation. NMC 19042

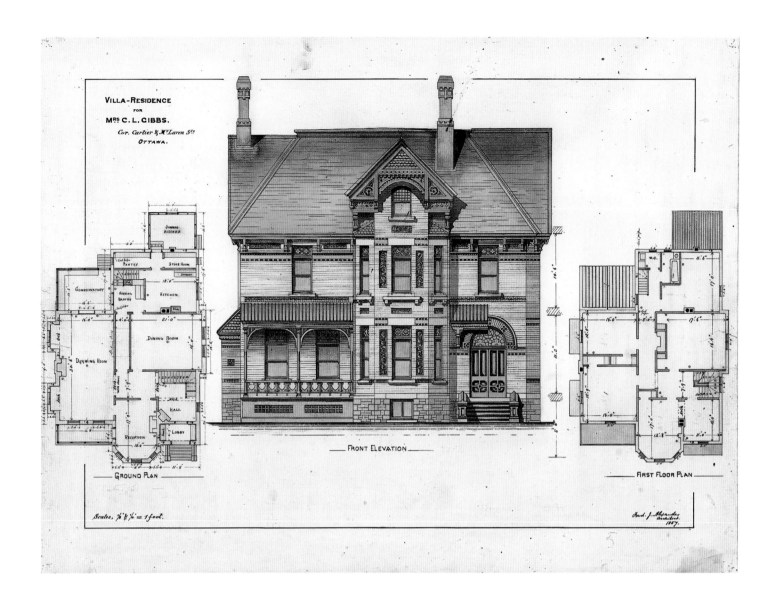

VILLA-RESIDENCE
FOR
Mrs C. L. GIBBS.
Cor. Cartier & McLaren Sts.
OTTAWA.

GROUND PLAN

FRONT ELEVATION

FIRST FLOOR PLAN

Scales, 1/8 & 1/6" = 1 foot.

Fred. J. Alexander
Architect
1887.

A railway station that was never built

For more than a century, railway stations have constituted an important part of Canada's architectural heritage. Some expressed a grandeur intended to correspond with their central role in transportation; others were simply functional in design and basic in construction. Although many stations have been demolished in recent decades, new uses have been found for others. Their restoration frequently begins with research into the drawings and accompanying documents that have been preserved at the National Archives.

Bonaventure Station, which acquired its name from Bonaventure Street in Montreal, was constructed in 1847 as the terminus for the Montreal and Lachine Railway. In 1864 the Grand Trunk Railway (GTR), since its inception in 1851 eager to secure a downtown location in Montreal, leased and later purchased Bonaventure Station.

Several factors spurred the GTR to replace the inadequate, shed-like structure in 1886–8. These included the brisk architectural activity in Montreal during the 1870s and 1880s, competition with the Canadian Pacific Railway, which was planning Windsor Station in Montreal, and the fact that the rival city of Toronto had had a new station since 1873. The new Bonaventure Station, designed by the GTR's chief engineer, E.P. Hannaford, was an impressive building in the Second Empire style, manifested in the building's mansard roof with iron cresting, weather-vanes, and pinnacles.

The same prosperity that culminated in the reconstruction of the Bonaventure Station seemed to return by 1900 and again the GTR considered rebuilding their station. Charles S. Frost and Albert Hoyt Granger of Chicago prepared several proposals. The Archives holds two drawings of a three-storey building and three drawings of an eight-storey one, each in both the classic and Gothic styles.

The eight-storey building depicted in this perspective drawing was probably intended to house the general offices of the GTR as well as the passenger terminal and train shed. The florid decoration and the eclectic mix of motifs from historical and more recent sources are characteristic of what has been described as Edwardian Free-style, although architects of the time called it Free Renaissance. But the company's anticipated prosperity failed to materialize, its energies were diverted to constructing the Transcontinental Grand Trunk Pacific Railway, and construction of a new station was shelved.

The roof and top floor of the Bonaventure Station were destroyed by fire on 1 March 1916 and the splendid mansard roof was never replaced. The flat roof that was constructed in its place left the building appearing as an ill-proportioned box. In 1948 Bonaventure Station endured a second major fire. Demolition began in 1952, and by December of that year nothing remained of one of Montreal's prized architectural possessions.

This plan is from the Frost and Granger collection, donated by the Toronto Public Library in 1973.

Sketch for proposed terminal station for the Grand Trunk Railway
Co. Montreal, Canada : scheme D / Frost and Granger Architects. —
Scale indeterminable. — [c. 1905]. — 1 architectural rendering :
ms., col. ; 64.4 × 115.2 cm, on sheet 88.5 × 109.4 cm. — Perspective
drawing of proposed Bonaventure Station. — 'CHRUB'?
in lower righthand corner. NMC 18486

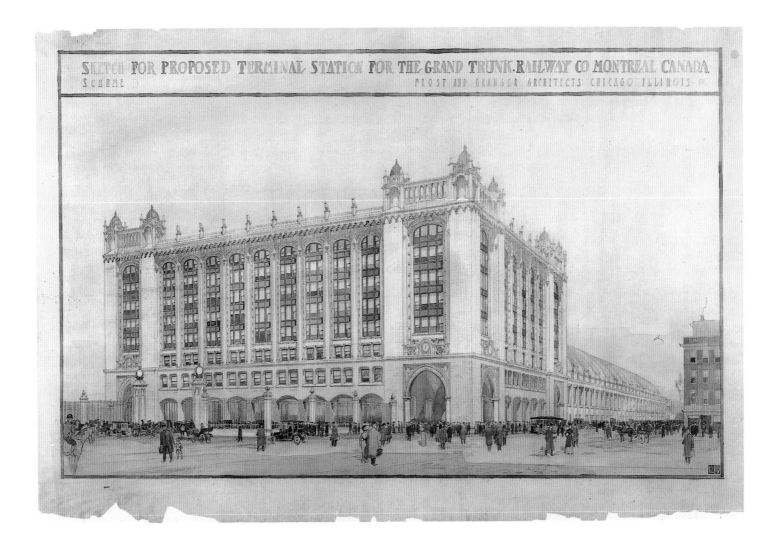

SKETCH FOR PROPOSED TERMINAL STATION FOR THE GRAND TRUNK RAILWAY CO MONTREAL CANADA
SCHEME D FROST AND GRANGER ARCHITECTS CHICAGO ILLINOIS

Across the Ottawa: union by suspension

Canada's myriad waterways have made necessary the construction of bridges throughout its history, but it was not until the nineteenth century that their design advanced beyond logs placed across streams, arched structures of stone and brick, and small suspension bridges using ropes. Early in the nineteenth century, a type of suspension bridge was developed that featured a rigid deck, a feature necessary for vehicular traffic. A bridge based on this new design was built by Colonel John By and the Royal Engineers in 1828 at the Chaudière Falls at Bytown (Ottawa), but collapsed when a link in the wrought-iron chain broke in 1836.

In 1843, the Union Suspension Bridge was built across the Ottawa River following a design by Samuel Keefer, the first chief engineer of the Board of Public Works of the Province of Canada. The bridge and its name have some symbolic significance because it connected Upper and Lower Canada, which had been united in law and government two years previously. The Act of Union was unpopular in both Upper and Lower Canada. The bridge lasted ten years longer than the act, which became null and void with Confederation. Keefer's Union Suspension Bridge was replaced in 1877 by a far less exotic steel-truss structure.

It is shown here on a drawing by staff architect F.P. Rubidge. In its design a stronger, more flexible, and elastic medium than chain was used, namely, wire cables that were anchored below ground. The bridge measured 73.4 metres. Its cables were suspended on towers that were described as being of Egyptian design because of their tapered or battered profile and flaring capitals. The motif is carried through on a smaller scale in the doorway of the tollkeeper's house.

The National Archives holds an extensive collection of bridge plans, especially for the nineteenth and twentieth centuries, along with a broad range of engineering drawings used for the construction of such works as canals, dams, docks, and railways. This plan was transferred to the National Archives of Canada from the Department of Public Works in 1909.

Details, Union suspension bridge, Ottawa River / F.P. Rubidge. — Scale [1:72]. — [1844]. — 5 technical drawings on 1 sheet: ms., col. ; sheet 57.8 × 82.7 cm. — Contents: Fig. 1. Toll-keepers house — Fig. 2. View of tower (south side), cable vault &c. — Fig. 3. End view of towers, and section through centre of platform — Fig. 4. Plan of platform — Fig. 5. Plan of towers, roadway &c. — *In* A series of diagrams, plans, elevations, sections, and details illustrative of the various local public improvements authorized by the legislature of the Province of Canada, and carried into execution, and completed, by the provincial Board of Works. 1844. [Sheet] 41. NMC 16940

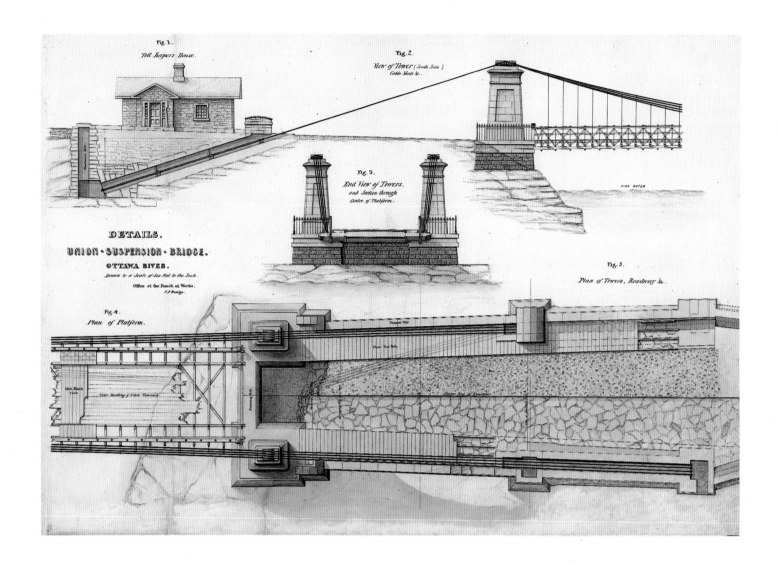

Fig. 1.
Toll Keepers House.

Fig. 2.
View of Tower (South Side)
Cable Nuts &c.

Fig. 5.
End View of Towers.
and Section through
Centre of Platform.

DETAILS.
UNION · SUSPENSION · BRIDGE.
OTTAWA RIVER.
Drawn to a Scale of Six Feet to the Inch.
Office of the Board of Works.
F. P. Rubidge.

Fig. 3.
Plan of Towers, Roadway &c.

Fig. 4.
Plan of Platform.

HIGH WATER

Defending Canada against invasion

In its early years, British North America was very much a military society and the problem for British commanders was how to safeguard its vast and underpopulated territory. The key post strategically for the Royal Navy was the fortress and dockyard at Halifax on which construction had begun in 1749. These fortifications steadily deteriorated until 1794, when George III's son, Prince Edward of Kent, took command. Work began immediately on improving the fortifications and, in the spring of 1796, with the fear of an imminent attack by the French West Indies fleet, construction began on a stone tower. Prince Edward christened it the Prince of Wales Tower upon its completion in 1798.

This imposing structure was the first of sixteen martello towers constructed between 1796 and 1848 in British North America at four defensive locations – Halifax, Saint John, Quebec, and Kingston – to counteract threats from French naval attack during the Napoleonic Wars or from American invasion.

Martello towers were the most popular and enduring type of work in this era of British imperial fortification, an economical and permanent solution to fortifying strategic positions in the colonies. The Prince of Wales Tower was a prototype of the martello towers constructed primarily on the southeast coast of England, 1805–8, but also throughout the empire. Typically, the martello tower was a squat, round, stone fortification designed to support rooftop artillery and was quite impregnable, at least in the first half of the nineteenth century. By the second half of the century, improved artillery had rendered the towers vulnerable and obsolete. This, however, is conjecture, because the Canadian martello towers were never subject to attack. They continued to serve as ordnance and supply depots and to house garrisons until the British left Halifax in 1906. Today, the Prince of Wales and a few of the eleven remaining towers serve as museums to illustrate the era when Britain defended Canada from foreign invasion.

These records are part of the collection of admiralty charts, 'Ordnance or Barracks Books,' and fortification plans that the Army Engineering Office turned over to the superintendent of the Halifax Citadel, National Parks Branch, and subsequently transferred to the National Archives in 1963.

Halifax, N.S. Prince of Wales tower : plans, sections & photographs / drawn from original by J.G. Jamieson. — Scale [1:120] and [1:180]. — Dec. 22, 1880. — 1 item : mainly ms., col. ; on sheet 63.5 × 96.4 cm. — '(Sd) E. Belfield, Col. C.R.E. 23rd July 1880.' — 'Compared with original and found correct, E[or G] Wilkinson[?] … 23-12-80.' — 'Scale for plans 15 feet to one inch. Scale for sections 10 feet to one inch.' Stamp in upper left corner: Commanding Rl. Engineer's Office, Canada, B no. 39. — 'Record plan no. 1.' NMC 21039

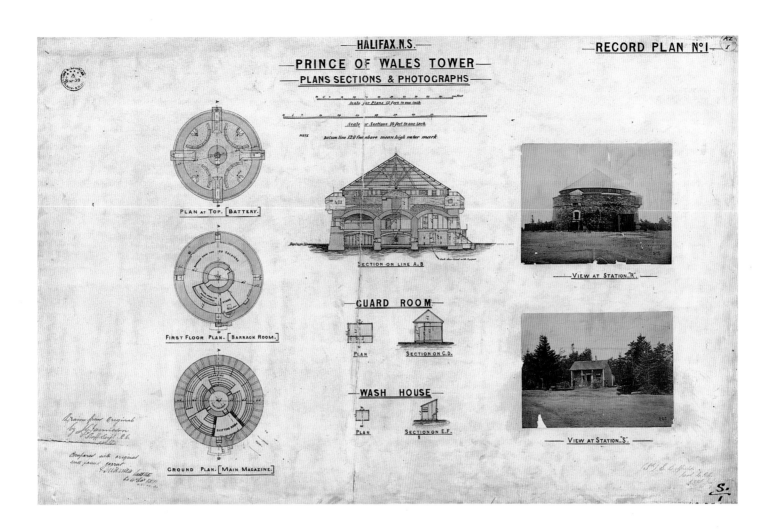

PRINCE OF WALES TOWER
PLANS SECTIONS & PHOTOGRAPHS

Scale for Plans 15 feet to one inch.

Scale for Sections 10 feet to one inch.

NOTE Datum line 120 feet above mean high water mark

PLAN at TOP. [BATTERY.]

FIRST FLOOR PLAN. [BARRACK ROOM.]

GROUND PLAN. [MAIN MAGAZINE.]

SECTION ON LINE A.B.

GUARD ROOM

PLAN SECTION ON C.D.

WASH HOUSE

PLAN SECTION ON E.F.

VIEW AT STATION "R".

VIEW AT STATION "S".

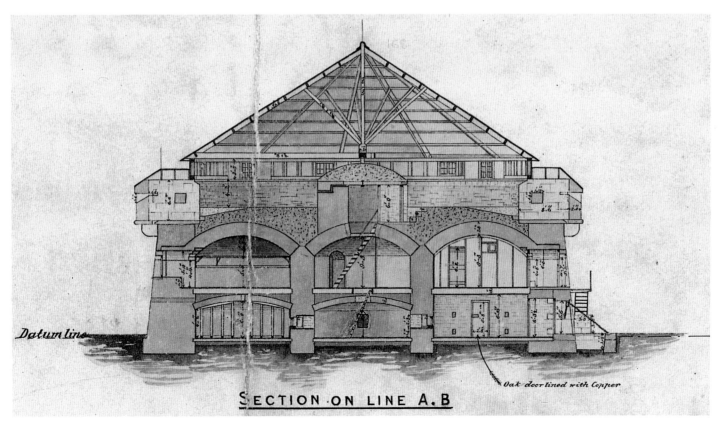

Datum line

Oak door lined with Copper

SECTION ON LINE A.B

Mapping fire hazards

The arrival of the Industrial Revolution created numerous new sources of fire hazard in growing cities. Concentration of people in urban centres and the development of new industries generated areas of high fire risk, especially in Canada where most buildings were constructed of wood. A new commercial enterprise emerged – the fire insurance company. These companies needed to calculate fair and equitable premium rates that could be to the advantage of both the insured and the insurer. Detailed plans became an invaluable asset. They showed the physical characteristics of buildings and the spatial concentration of policy holders.

This Charles E. Goad fire insurance plan of the Ogilvie Flour Mills in Winnipeg is an excellent example of this type of specialized urban cartography. The plan shows that the majority of the flour-mill buildings were of wood (shown in yellow), that the main mill was constructed in brick (red), and that the recent grain elevator, identified as number 14B, was going to be 'reinforced concrete tanks & texas.' Information on fire protection appears in the elaborate legend. It recorded the sprinkler system, pumps, hydrants, chemical extinguishers, hoses, fire alarms, watchman, and other relevant details. Also of interest is the potential the plan offers for research into the mill's operations, such as capacity, equipment used, and the number of employees on the payroll.

Chas. E. Goad Ltd. was a prolific Canadian enterprise which after 1910 had its head office in London, England, and by 1910 had surveyed more than 1300 communities in Canada. Fire insurance plans usually covered urban areas; emphasis was on depicting business, commercial, and industrial districts within a town or a city. These cartographic documents were generally drawn at 50 or 100 feet to the inch, using a colour code. They also provided street numbers, property lines, fire protection facilities (water pipes, hydrants, fire-alarm boxes, and so on), and also portrayed the vicinity of a building or a group of buildings.

The success of Goad's atlases depended on the accuracy of the data collected and on the exactness of the final print. For these reasons, surveyors were engaged to measure frontage of buildings; they also gathered information on thickness of walls, types of materials, window and door openings, types of roof, and other relevant data. Official city plans were used as well as detailed information by blocks. Rapid development in lithographic printing assured a final product within approximately four months. Charles Goad designed a unique system of distribution, in which his plans were lent to subscribing insurance agents, thus discouraging rivals from copying them. Revisions were produced on a regular basis. The corrections could be pasted onto the sheets to keep the plans up to date until a new complete edition could be published.

Although they were originally intended for evaluating potential fire hazards, his maps serve as invaluable sources for today's researchers. They are used to document urban, demographic, social, architectural, industrial, and even local history. Although minor errors or omissions were sometimes evident, most of the information was correct or was corrected in the following edition. Unfortunately, a large percentage of these plans were destroyed as they were replaced. Nonetheless, the National Archives holds some 30,000 sheets representing fire insurance plans for more than 1000 communities across Canada. This particular plan was purchased in 1973 from Chas. E. Goad Ltd., London, England.

The Ogilvie Flour Mills Co. mills & elevators, Winnipeg, Man. / Chas. E. Goad. — Scale [1:600]. — Montreal ; Toronto ; London : [Chas. E. Goad], 1909. — 1 map : col. ; 29.0 × 40.2 cm., on sheet 63.7 × 53.3 cm. — Includes 3 insets. — 'No. 212. Forming part of series of elevator & storage warehouse plans.' NMC 10577

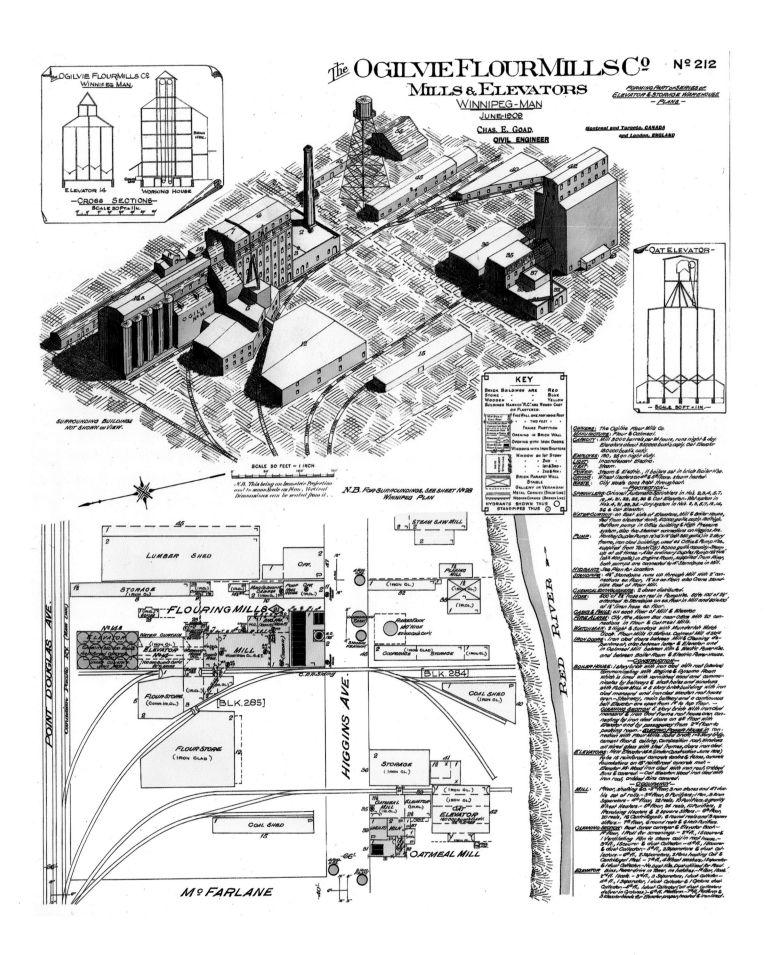

The OGILVIE FLOUR MILLS Cº Nº 212

MILLS & ELEVATORS
WINNIPEG·MAN
JUNE·1909

CHAS. E. GOAD,
CIVIL ENGINEER

FORMING PART OF SERIES OF
ELEVATOR & STORAGE WAREHOUSE
— PLANS —

Montreal and Toronto, CANADA
and London, ENGLAND

THE OGILVIE FLOUR MILLS Cº
WINNIPEG, MAN.

ELEVATOR 14 · WORKING HOUSE
—CROSS SECTIONS—
SCALE 30 FT. = 1 IN.

SURROUNDING BUILDINGS
NOT SHOWN ON VIEW.

SCALE 50 FEET = 1 INCH

N.B. This being an Isometric Projection
and to same Scale on Plan, Vertical
Dimensions can be scaled from it.

N.B. FOR SURROUNDINGS, SEE SHEET Nº 29
WINNIPEG PLAN

·OAT ELEVATOR·
SCALE 30 FT. = 1 IN.

KEY

BRICK BUILDINGS ARE RED
STONE " " BLUE
WOODEN " " YELLOW
BUILDINGS MARKED 'R.C.' ARE ROUGH CAST
OR PLASTERED.
FIRE WALL ONE FOOT ABOVE ROOF
TWO FEET
FRAME PARTITION
OPENING IN BRICK WALL
OPENING WITH IRON DOORS
WINDOWS WITH IRON SHUTTERS
WINDOW ON 1ST STORY
2ND
1ST & 3RD
2ND & 4TH
STABLE
BRICK PARAPET WALL
GALLERY OR VERANDAH
METAL CORNICE (SOLID LINE)
WOODEN CORNICE (BROKEN LINE)
HYDRANTS SHOWN THUS
STANDPIPES THUS

POINT DOUGLAS AVE.

LUMBER SHED

OFF.

STORAGE (IRON CL.)

FLOURING MILLS

Nº 14.8 ELEVATOR

ELEVATOR Nº 4

MILL

FLOUR STORE (CONN. IN CL.)

[BLK. 285]

FLOUR STORE (IRON CLAD)

COAL SHED

HIGGINS AVE.

STEAM SAW MILL

PLANING MILL (IRON CL.)

(IRON CL.)

RAISED TANK

COOPERAGE (IRON CLAD) STORAGE (IRON CL.)

BLK. 284

COAL SHED (IRON CL.)

STORAGE (IRON CL.)

OATMEAL MILL ELEVATOR (IRON CL.)

OAT ELEVATOR 180,000 BUSHELS CAP'Y.

COAL SHED

OATMEAL MILL

McFARLANE

RED RIVER

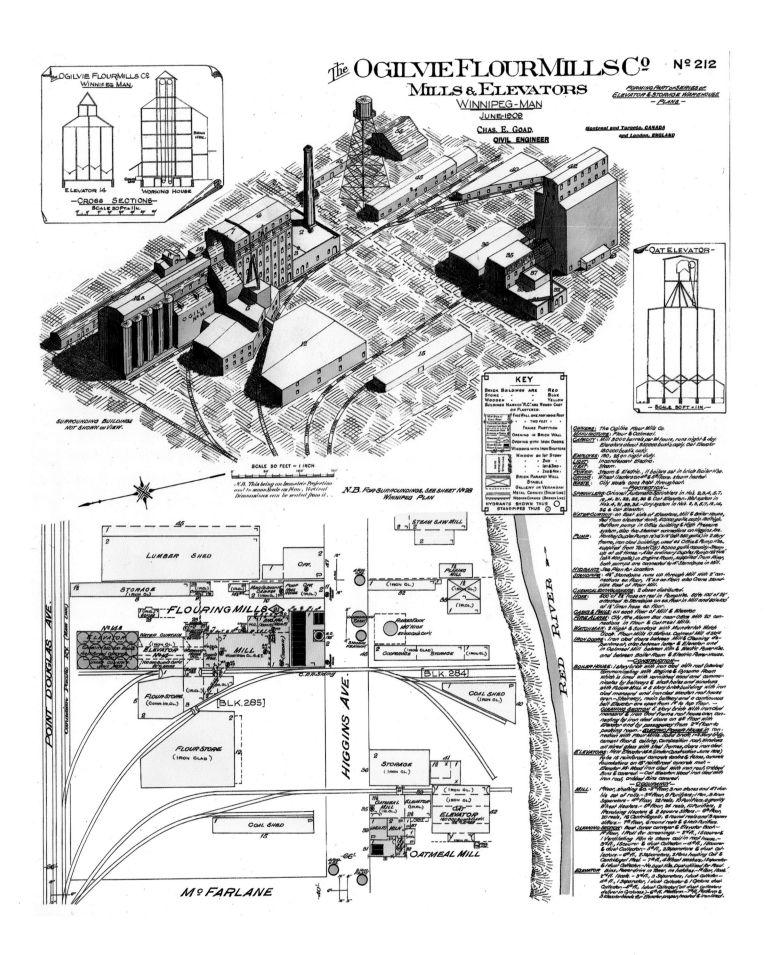

OWNERS: The Ogilvie Flour Mills Co.
MANUFACTURE: Flour & Oatmeal.
CAPACITY: Mill 3000 barrels per 24 hours, runs night & day.
LIGHT: Incandescent electric.
HEAT: Steam.
EMPLOYEES: 180, 25 on night duty.

67

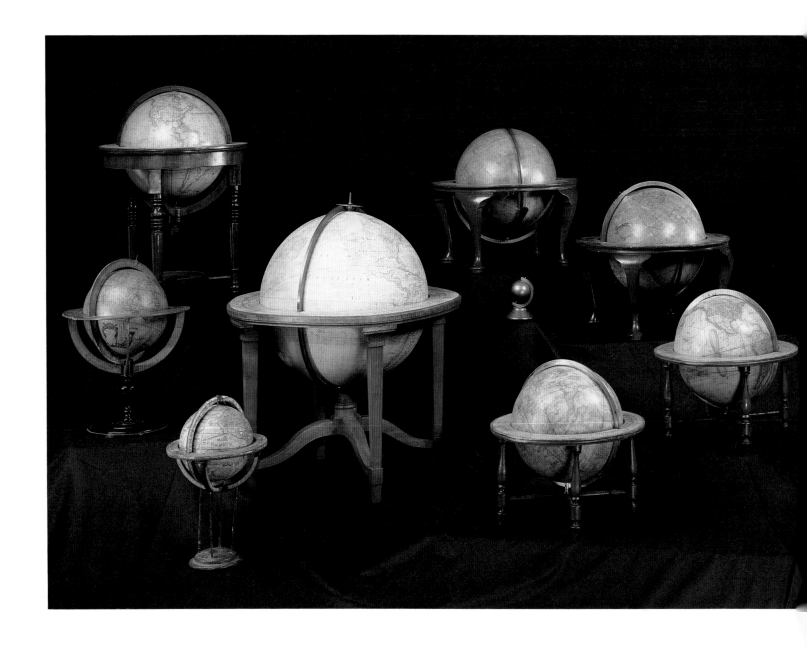

Early and unusual globes

The National Archives of Canada has acquired a small but notable collection of terrestrial and celestial globes, the earliest of which was produced at the end of the seventeenth century, and fifteen of which were made before 1850. The aim has not been to acquire one original of each known terrestrial globe, but rather to obtain a representative selection made at different periods, in a variety of countries, in different sizes and styles.

This selection comprises 1. C. Smith & Sons, London, [c. 1901]; 2. L.C. Desnos and J.B. Nolin, Paris, 1760; 3. Matthew Seutter, [Augsburg?, c. 1710]; 4. Andrea Akerman [and Fredrik Akrel], Stockholm, 1790; 5. John

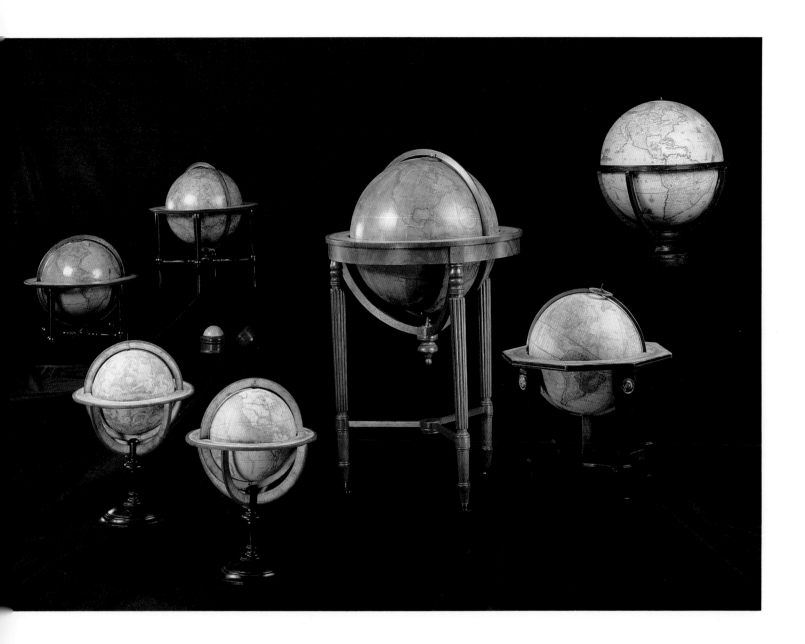

Senex (celestial globe), London, 1740; 6. John Senex (terrestrial globe), [London, c. 1745]; 7. Stahlwerke Braunschweig, Starachowice (Poland), [c. 1940–5]; 8. J. Wilson & Sons (celestial globe), Albany, NY, 1831; 9. J. Wilson & Sons (terrestrial globe), Albany, NY, [1834]; 10. John Cary (terrestrial globe), London, 1823; 11. John Cary (celestial globe), London, 1816; 12. Malby & Sons, London, [c. 1856–67]; 13. [Gilles Robert de Vaugondy and F. Delamarche, Paris, c. 1821]; 14. Gilles Robert de Vaugondy and F. Delamarche, Paris, 1821; 15. John Cary, London, [c. 1829]; 16. Johann Georg Klinger, Nürnberg, Germany, 1792; 17. Mattheus Greuter, Rome, 1695.

II

Canada through the Artist's Eye

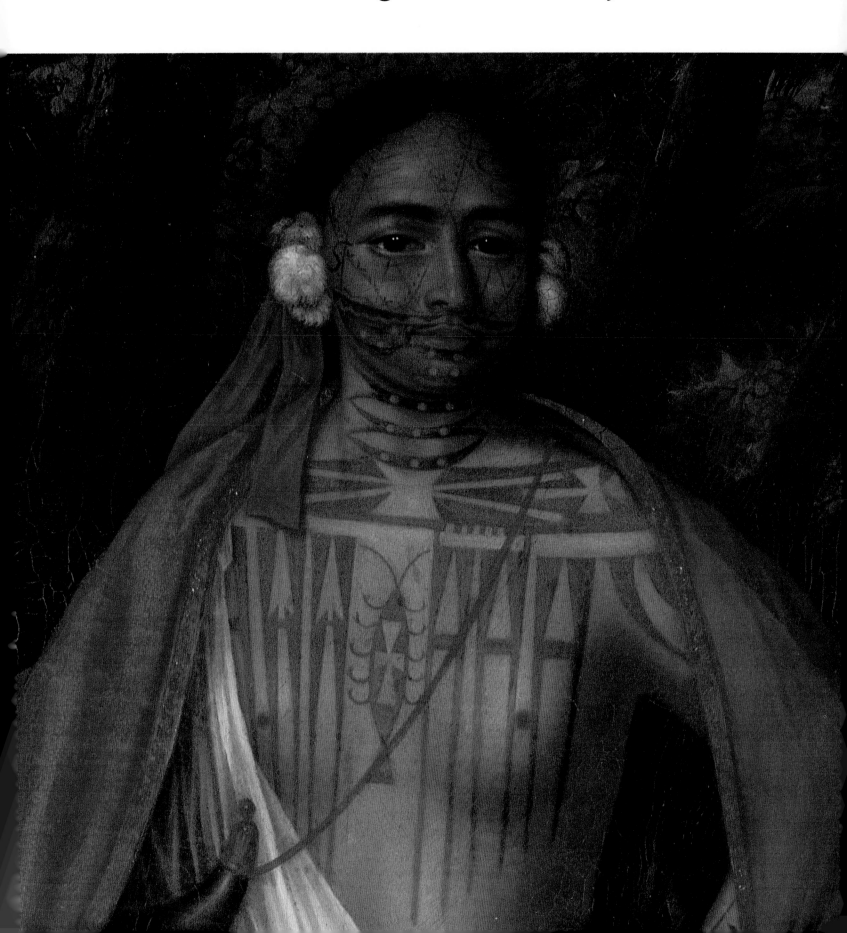

Documentary Art
Records

We are so accustomed to Canada as we see it now, and as we move in it, that we are hardly conscious of the fact that what are to us to-day thriving cities and familiar scenes, formed, only a few years ago, part of a vast wilderness untrodden by the foot of the white man. It is here that illustrations associated with the beginnings and the advance of our civilization prove such valuable aids, since they permit one to obtain a connected and systematized view of our development.

SIR ARTHUR DOUGHTY, 1925

The National Archives of Canada has the largest and most comprehensive holdings of documentary art in Canada. It has been acquired from two major types of sources. A broad range of material has been obtained through donation and purchase from private sources in Canada and abroad. Large collections of visual documents also have been created by federal government departments and agencies in Canada since 1867, particularly in the area of graphic design and advertising, and these have been transferred to the custody of the Archives.

Included in the documentary art collections are original works of art, including paintings, watercolours, drawings, miniatures, and silhouettes; original and reproduction prints, posters, postcards, greeting cards, photomechanical process prints and other types of printed objects; medals, political buttons, seals, heraldic devices and coats of arms; and related printed material. There are approximately 200,000 items.

These holdings have been built up over one hundred years. In the first seventy-five years, an attempt was made to create a 'museum' of historical personalities and views of places and events that would assist Canadians in better understanding themselves and their past. Records of martial efforts and political activities were most treasured in this period. Since the 1960s, however, there has been more serious consideration of the lives of ordinary Cana-

dians and of the experiences of native peoples, minorities, and women. This approach has resulted in important acquisitions of art that document those subjects. The result is a more balanced view of our common past, even though there are no surviving visual records of much of our history.

The documents depicted here were selected for their importance as evidence of the past, their interest for historians, their visual impact, and their own role in history. Also considered were such factors as themes in collecting documentary art (portraiture, depictions of historical events, landscapes and cityscapes, views of social, commercial, transportation and industrial development, costume history, and developments in advertising and mass imagery); different types of documents (watercolours, drawings, prints, paintings, miniatures, medals, and so on); aesthetics; historical developments, from the sixteenth century onwards; and the geographical context of the collection.

The twenty documents presented on the following pages represent the many more treasures of documentary art held in the National Archives. The Archives acquires and preserves these works, individually or as part of larger collections, because they provide that 'systematized view of our development' to which Sir Arthur Doughty, dominion archivist from 1904 to 1935, referred in an introduction to a Picture Division catalogue in 1925.

These images are a tangible link with our past: how we looked and acted and perceived ourselves to be; what we built, created, or achieved; and what we have destroyed. Occasionally, some images are poignant and heart-rending, like the miniature of Mary March, which reminds us of our unthinking cruelty to our fellow human beings; some are uplifting, like William Hind's *Harvesting, Sussex, New Brunswick,* which shows us the bountifulness of a country blessed with immense and seemingly limitless natural resources; and some are truly evocative, as is Robert Hood's beautiful watercolour showing the meeting between the two Hudson's Bay Company ships and Inuit kayaks and umiaks. At the same time, each item shown in these pages holds significance not only for a larger history, but also for a larger group of records, many of which are as beautiful, as disturbing, and as evocative.

The saintly founder of the Ursulines in Canada

Marie Guyart (1599–1672), business woman and widowed mother of a young boy, had always wanted to devote her life to God. She eventually joined the Ursulines of Tours (France) in 1632, taking the name of Marie de l'Incarnation. The Ursulines, more properly known as the Company of St Ursula, had been founded in Italy in 1535 by Sister Angela Mericia for the instruction, education, and protection of young girls and women.

After reading the Jesuit *Relations*, Marie de l'Incarnation came to Quebec City in 1639 with two companions. There she founded the Ursulines of Canada, an enclosed nunnery dedicated to the education of French and native girls, and had a convent built. A mystic with a practical turn of mind, she faced adversity with courage. All the while she did a great deal of writing. Venerated as a saint upon her death but beatified only in 1980, her cult was propagated by such means as this engraving, the frontispiece to the *Vie de Marie* that her son published in 1677.

While the National Archives of Canada has over nine thousand printed portraits, original seventeenth-century engravings based on authentic portraits are rare. The Ursulines of Quebec had commissioned a portrait of their founder before she was buried; that posthumous portrait was sent to Paris to be used as the model for the engraving. Attributed to Father Hugues Pommier, the painting belongs to the Ursulines Museum in Quebec City. Jean Edelinck, a Parisian engraver of Flemish origin, has reversed the model's pose, except for the hands. He has attempted to render all the features, colours, and textures of a painted portrait, and, in addition, has greatly elaborated the very simple setting of the painting. What might formerly have been a classical engraved portrait, generally a simple bust in an oval, is seen evolving towards the baroque in its complex framing and surround. Gérard Edelinck, Jean's brother, was the first engraver to place his subjects in such elaborate settings.

Marie de l'Incarnation, 1677
Jean Edelinck (c. 1643–80)
Engraving, 21.6 × 15.5 cm
Acquired before 1922
Neg. C 8070

La Venerable Mere Marie de L'Incarnation Premiere Superieure des Vrsulines de la
Nouuelle France; qui apres auoir passé trente deux Ans dans le Siecle, en des penitences extra
ordinaires: huict ans au Monastere des Vrsulines de Tours, dans la pratique d'une tres exacte
Observance: et trente trois ans en Canada, dans un Zele incroyable pour la Conuersion des
Sauuages, est decedée a Quebec en odeur de Saintete le dernier d'Auril 1672, âgée de 72 Ans
six mois, 12 Iours.

An Indian king received by Queen Anne

This portrait of Sa Ga Yeath Qua Pieth Tow (Brant) is one of four paintings of sachems or civil chiefs of the Five Nations Iroquois Confederacy, known as the Four Indian Kings. Brant and the other Indian chiefs journeyed to London in 1710 to plead for assistance against their French enemies.

The British monarch Queen Anne commissioned John Verelst, a Dutch portraitist, to paint official portraits of the kings for the royal collection to commemorate their visit. Souvenirs of this sensational event were sought after, and their likenesses were subsequently painted by others, with engraved copies being widely distributed. Verelst departed from previous treatment of Indian subjects, using a portrait format reserved in European painting tradition for nobility and royalty, and included emblematic symbols to allude to each sitter's origin and status. Sa Ga Yeath Qua Pieth Tow, an ancestor of Joseph Brant, the famous chief of the Grand River Mohawk, is depicted here as a great hunter. He holds a musket, and at his feet are a tomahawk and his clan totem, a bear. He also displays magnificent body tattoos.

In addition to securing military support from the British government, the chiefs were successful in obtaining aid for missionary work and funding for a Mohawk chapel and fort. Among Queen Anne's gifts were a Bible and communion silver plate. All were brought together in a special exhibition at the National Archives, opened by Queen Elizabeth II shortly after the acquisition of the portraits. This work adds to the Archives' rich art collection depicting Canada's native peoples.

Sa Ga Yeath Qua Pieth Tow (Brant), 1710
John Verelst (c. 1648–1734)
Oil on canvas, 91.5 × 64.5 cm
Purchased in 1977 with a special grant from the
Secretary of State
Neg. c 92419

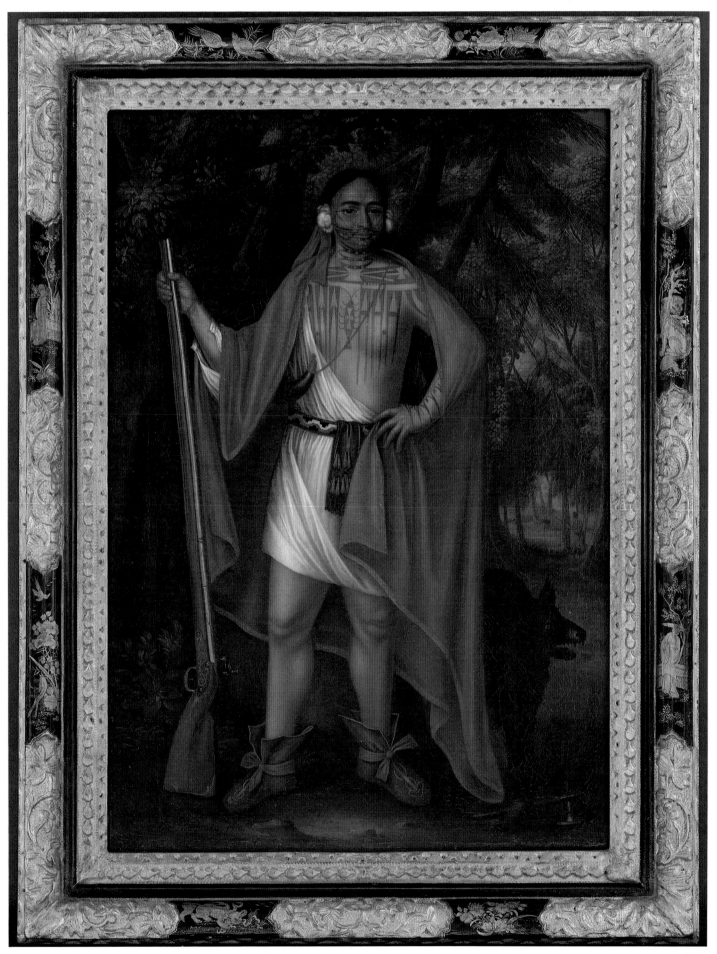

Symbol of Indian and English friendship

During the earliest periods of European-Indian contact in North America, pledges of friendship were solemn events, where gifts would normally be exchanged to express good will. The act was linked to elaborate procedures that had been developed between various Indian groups and confederacies over the centuries to form alliances and seal agreements. Although Europeans were primarily interested in trade, they found it necessary to exchange gifts with natives in order to cement their relations. Iroquois leaders in particular considered trade and peace to be the same thing. The presentation of medals as part of these European-Indian diplomatic negotiations can be traced back as far as 1661. The medals had great significance for their Indian owners, who would wear them as badges of friendship. Medals bearing the image of an English monarch, for example, would be surrendered in favour of ones bearing a portrait of the French king when allegiances changed, as oc-curred with a group of Iroquois in 1756. Similarly, when a monarch died and a successor ascended the throne, new medals would be issued to friendly chiefs.

This particular medal was commissioned by a Philadelphia Quaker group, the Friendly Association for Regaining and Preserving Peace with Indians by Pacific Means, in 1757 for presentation to Indian allies of the British in their war against the French. Although many hundreds of copies of this medal may have been issued, few examples survive.

The National Archives of Canada holds more than 12,000 medals, most of them issued by government, religious, educational, cultural, and commercial groups to commemorate specific events, persons, or activities, or to reward the recipient for a specific achievement. The holdings do not include military medals or coins, the responsibility of the Canadian War Museum and the Currency Museum of the Bank of Canada respectively.

George II Indian Chief Medal, 1757
Edward Duffield and Joseph Richardson (active 1756–7)
Bronze, 4.5 cm (diameter)
Acquired before 1971
Neg. C 43207 (reverse); C 43180 (obverse)

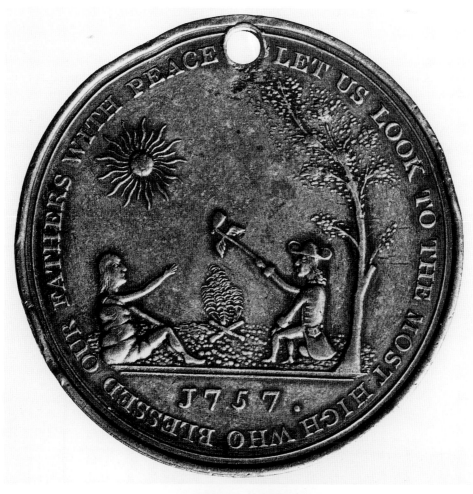

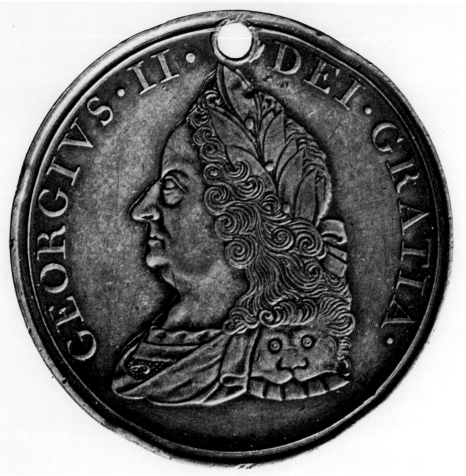

The terrible beauty of Niagara Falls

Niagara Falls, that sublime wonder of the New World, is certainly the most frequently portrayed natural site in North America. Its awe-inspiring and terrible beauty elicited sensations of fear and fascination among early visitors and represented the vitality and limitless resources of the New World. This engraved print is one of the earliest accurately recorded views of Niagara Falls. It is based on a drawing (now lost) by Lieutenant William Pierie, done in 1768 while he was posted to North America with the Royal Artillery.

In eighteenth-century England there was a growing market for exotic foreign views. Seeing this potential, Pierie, in partnership with the accomplished engraver William Byrne, set about to have his view of the falls made into a print. Richard Wilson, the prominent British landscape artist, was commissioned to produce a painting that would transform Pierie's amateur work into a fashionable classical landscape suitable for reproduction. Wilson enhanced the size of the falls and the turbulence of water below, and for scale he added tiny foreground figures, all of which serve to create an impressive landscape. The painting was then translated into a large engraving by Byrne. The resulting hybrid of Pierie's first-hand observations, Wilson's artistic vision, and the engraver's talent combines accuracy with evocative elements in a manner that would have great appeal to the British public of the period.

The print is inscribed with a dedication from Pierie to Lady Susan O'Brien. She was the daughter of the Earl of Ilchester and part of the royal social circle. In 1764 she married the Irish actor, William O'Brien, without her father's consent, and they were immediately banished to New York, then still a British colony. Although the O'Briens returned to England in 1770, Lady Susan's royal connections and her extraordinary trip to Niagara Falls in 1766 are no doubt why Pierie dedicated this print to her. Few copies of the print have survived. This impression is considered one of the rarest and earliest among the large holdings in the National Archives of Canadian topographical prints.

View of the Cataract of Niagara, with the country adjacent, 1774
Richard Wilson (1713/14–82) after Lt William Pierie (active 1759–77),
engraved by William Byrne (1743–1805)
Engraving, 41.8 × 52.2 cm (image); 46.2 × 54.4 cm (sheet);
platemark cropped
W. H. Coverdale collection of Canadiana
Purchased in 1970 with a special grant from the Canadian government
Neg. c 41378

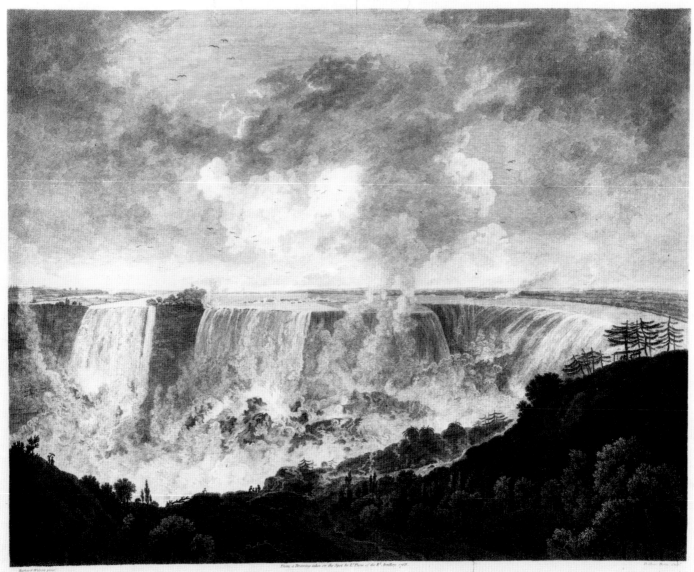

From a Drawing taken on the Spot by L.T^{ee} Pierie of the R^l. Artillery 1768.

To the Right Hon^{ble} LADY SUSAN O'BRIEN, this View of the CATARACT of NIAGARA with the Country adjacent, is most humbly Inscribed by her Ladyship's most obedient Servant, Aug^t 1st 1774.

This Stupendous Cataract is seen a Mile wide and falls over a perpendicular Rock of 150 Feet high which interrupts the Falling of the River NIAGARA for some miles between the Lakes Erie and Ontario, on the Frontier of the Province of New York in NORTH AMERICA.

81

Native women weaving on Nootka Sound

In the third and last of his great voyages of discovery, from 1776 to 1780, Captain James Cook set out to discover the elusive northern trade passage across the Arctic from the Pacific Ocean to the Atlantic. During the voyage, Cook's expedition spent nearly a month at Nootka Sound on the west coast of what would later be called Vancouver Island. Here the expedition's official artist, John Webber, recorded a number of views of the Nootka and their activities.

The artistic talent of John Webber, son of a Swiss immigrant to England, was first noticed at a Royal Academy exhibition in 1776 by Dr Solander, one of Cook's colleagues from an earlier expedition. Solander then recommended Webber to Cook. Webber's training in portraiture, landscape painting, and engraving undoubtedly made him an attractive candidate for the expedition. The National Archives holds seven of his original drawings from the journey, of which three depict Indian subjects from Nootka Sound. Here Webber has used a wonderful fluid line to capture the native women weaving various materials by hand on a frame into fabric used for garments. The written account of the expedition described their skill in this respect as 'unexpectedly sophisticated,' and the materials produced as 'flaxen,' derived from the bark of the pine tree, and 'woollen,' woven from the hair and fur of wild animals. The clothing made from these fabrics was observed to be ornamented by patches of dyed colour.

These early views of Canada's northwest coast in the late eighteenth century are complemented in the holdings of the National Archives by copies of a set of engravings made from views by Webber and others for the official publication of Cook's voyages, released in London in 1784.

Interior of a Communal House with women weaving, Nootka, April 1778
John Webber (1752–93)
Grey wash and pencil, 19.0 × 14.6 cm
Acquired before 1938
Neg. c 2821

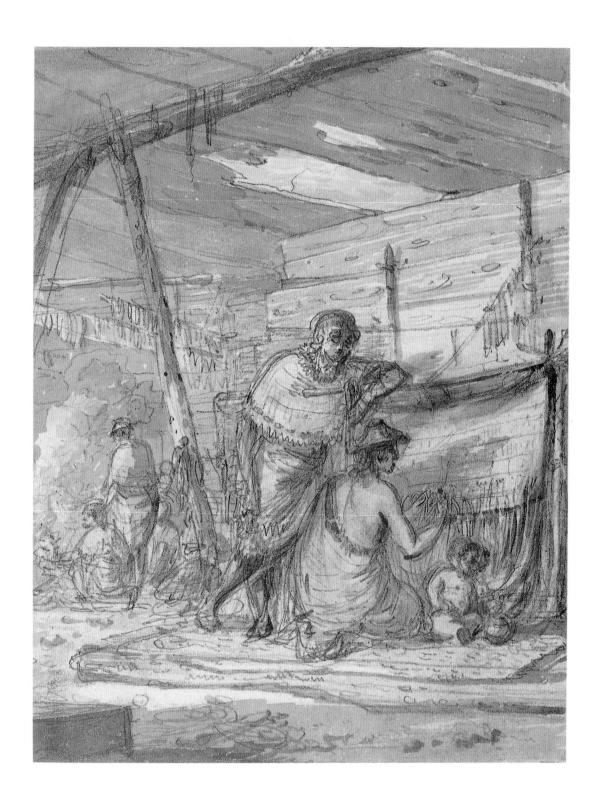

An early view of Quebec City

After the conquest of New France in 1760 and the subsequent settlement of present-day Ontario following the American Revolution, the British government set out to chart its new territories. Among its surveyor-draughtsmen was James Peachey, who was in North America on three separate occasions between 1773 and 1796. During these visits he produced maps and plans, as well as numerous handsome watercolour views of the towns, settlements, and topography of Ontario and Quebec. Between 1773 and 1775 he worked under Samuel Holland, the surveyor-general of British North America. Many of the Holland surveys and views, probably including some by Peachey, were eventually incorporated into J.F.W. DesBarres's impressive *Atlantic Neptune* (see page 40). During Peachey's second visit, from 1780 to 1784, he was involved in the survey of the north shore of Lake Ontario. His third and longest stay occurred between 1788 and 1796, during which he continued to work as a surveyor and draughtsman, this time in Ontario, Quebec, and Nova Scotia. He is believed to have died in an epidemic in 1797 while in the West Indies.

Peachey's Canadian views are now highly valued as pictorial records of eighteenth-century Canada, and since 1913 the National Archives has acquired nearly forty of his watercolours from various sources. Among the finest is this early view of Quebec City, whose dramatic setting greatly impressed early visitors. The city appears in the middle distance, with the Citadel fortification and various buildings and church spires carefully outlined on the promontory of Cape Diamond. The narrow strip farms characteristic of the St Lawrence River valley are shown in the distance, while the dominant foreground contains rich details of rural life, including a depiction of a farmhouse, barn, and bake oven.

In composing the view, Peachey followed the artistic conventions of the day, creating a panoramic vista from an elevated viewpoint and affording a distant prospect of the main subject. According to eighteenth-century aesthetic theory such views in nature and in art were worthy of contemplation and their sheer vastness was a characteristic of the sublime and the beautiful. In keeping with this philosophy, the grouping of rustic figures served to place man in perspective with nature and created an idyllic setting where the prosperity of the city and the fruits of rural labour symbolized the country's potential source of wealth. While ostensibly a view of the city, according to Peachey's title, the watercolour is imbued with meaning that would have been readily understood by a contemporary audience. Combining his training as a draughtsman with the practices of landscape painting, he provided a topographically accurate view tempered by the attitudes and values that shaped the way in which Europeans viewed the New World.

Peachey was among the first in a century-long succession of visiting British topographer-artists, many of them military officers, whose watercolour views of Canada are among the highlights of the National Archives' documentary art collection.

A View of the City of Quebec with the Citadel and
Outworks on Cape Diamond, taken from the Heights on
the Opposite side of the River, c. 1785
James Peachey (active 1773–97)
Watercolour and pen and black ink over pencil, 39.1 × 65.4 cm
Purchased in 1913
Neg. c 2029

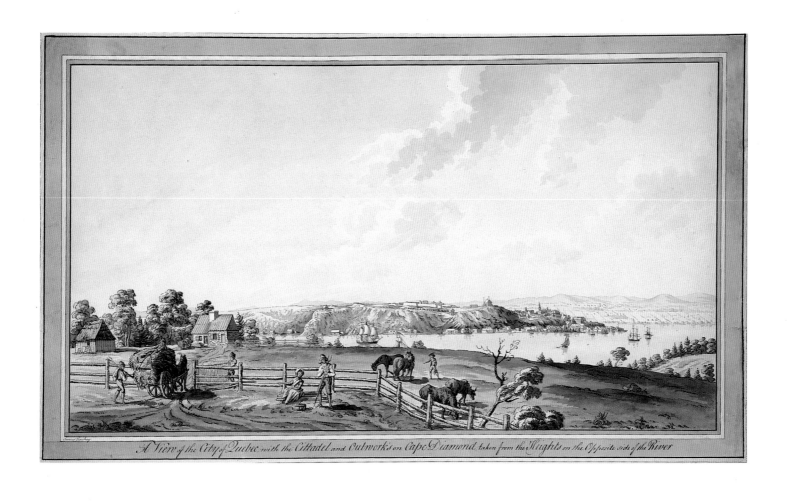

A View of the City of Quebec, with the Cittadel and Outworks on Cape Diamond, taken from the Heights on the Opposite side of the River

Miniature portrait of a surveyor general

This miniature was commissioned by Joseph Bouchette (1774–1841), surveyor general of Lower Canada from 1803 to 1840. His long career also included service in the Provincial Marine, in the militia during the War of 1812, and as a surveyor on the Maine-New Brunswick boundary dispute in 1817 and 1818.

Bouchette's duties as surveyor general involved surveying, mapmaking, granting land, and providing evidence to help settle land disputes. In addition, he made major contributions to the cartographic record of Canada with two publications. The first, *A Topographical Description of the Province of Lower Canada*, was published in both English and French in London in 1815. It included descriptions of the history, topography, industrial, and agricultural outputs of the seigneuries of the province, illustrated with maps and sketches. In keeping with an illustrative convention of the day, the frontispiece bore an engraving by Francis Engleheart of this miniature, which had been painted by John Cox Dillman Engleheart; both were members of a single family of London artists. The miniature was engraved again in 1831 for Bouchette's second topographical publication, *The British Dominions in North America*, also published in London. With maps and illustrations, it described all the British North American colonies.

This is the only known portrait of Bouchette; all subsequent engravings and even a sketch by his son, Robert-Shore-Milnes Bouchette, used either one of the two engravings or the original miniature as a model. The widow of his great-grandson, Alfred Henri Bouchette, donated the miniature along with other items to the Archives in 1976.

Joseph Bouchette, 1815
John Cox Dillman Engleheart (1782/4–1862)
Watercolour on ivory, 10.0 × 8.0 cm
Donated in 1976 by Meeta Myers Bouchette in loving memory of her husband Alfred Henri Bouchette
Neg. c 112049

Treasured memento of a people now extinct

Probably the greatest national treasure held in the documentary art collections is this miniature, the only known life portrait of any member of the extinct Beothuk of Newfoundland. Their infrequent but violent contact with Europeans and their demise early in the nineteenth century have deprived us of visual documentation of these native people. What little we know of their culture is derived mainly from the archaeological record.

The Beothuk inhabited the interior of the island, fishing and hunting along the Exploits River. Contact with Europeans, which began in the sixteenth century, was sporadic but hostile. When the Beothuk began stealing knives and fishing equipment, articles that were vital to the settlers' survival, the Europeans responded by shooting them on sight. For reasons unknown, the Beothuk never adopted the gun for either hunting or warfare. Starvation became an additional threat as white settlement increased and the Micmac from Nova Scotia expanded into southern Newfoundland, competing with the Beothuk for the caribou essential to their survival.

Newfoundland, first claimed by the British in 1583, was formally ceded in 1713 by other European powers. It was not until the 1760s, however, that a proclamation was issued forbidding the murder of Beothuk and encouraging friendly communication with them. Two expeditions to establish contact were sent out, in 1768 and in 1811, but both were unsuccessful. A map from one of those expeditions is found in the Cartographic section (page 39). In 1813, a reward of £100 was offered for the establishment of friendly contact with the Beothuk, but it was already too late.

In March 1818, some fishermen from Notre Dame Bay encountered a group of Beothuk at Red Indian Lake and captured Demasduit. She was named 'Mary March' and brought to St John's, where she was presented to the governor, Sir Charles Hamilton. This fine portrait of her was painted by the governor's wife, Henrietta Martha, Lady Hamilton. Sir Charles ordered that Demasduit be returned to the Beothuk, but she died of tuberculosis in Twillingate in 1820 before she could be reunited with her people. Through her niece, Shanawdithit, who was captured in a similar manner three years later, the tragic tale of the Beothuk people was revealed. Over the centuries, starvation, disease, and the settlers' guns had devastated the group. When Shanawdithit died in 1829, she was the last known survivor of her people.

Mary March, 1819
Henrietta Martha Hamilton (c. 1780–1857)
Watercolour on ivory, 7.5 × 6.5 cm
Purchased in 1977
Neg. c 87698

Cultures merge in a Red River tipi

Peter Rindisbacher's pictures of the Red River area are among the earliest depictions of the Canadian West. The Swiss artist was fifteen years old when he emigrated to the Red River colony in 1821 with his family. He created a large number of drawings and watercolours of the settlers' journey across the ocean and overland, and of the many aspects of life at the colony, including scenes of Indian life. Many are now held in the Archives.

A rare scene of a tipi interior, this watercolour demonstrates both the ethnic mixture particular to the Red River area and the cross-cultural exchange in which Europeans took up Indian habits while Indians adopted European technology. The occupants are smoking two distinct types of Indian pipes. The Indians are holding Woodlands pipes, carved from black stone and decorated with lead inlay, while the European, who may be the artist himself, is smoking a Plains Indian pipe, made from catlinite, a red clay from the upper Missouri region. The seated man with his back to us wears a breech-clout and leggings typical of the Saulteaux, but his knife and its sheath are Métis type. The exchange between the Indian and European cultures is shown by the European wearing moccasins and a Métis-type quilled shot-pouch, while the rifle and the silver trade jewellery, such as the brooch worn in his hair by one seated Indian, signify the Indians' pragmatic adoption of some European artifacts.

This watercolour was part of the collection of David I. Bushnell Jr, an American anthropologist who owned an extensive collection of pictures depicting North American native peoples. He was one of the first to study such pictures for their ethnographic content, realizing their inestimable value for the period before photography.

Inside of an Indian Tent, 1824
Peter Rindisbacher (1806–34)
Watercolour with pen and black ink, 25.8 × 21.3 cm
Purchased in 1981 with the assistance of a grant from the
minister of communications under the terms of the
Cultural Property Export and Import Act
Neg. c 114484

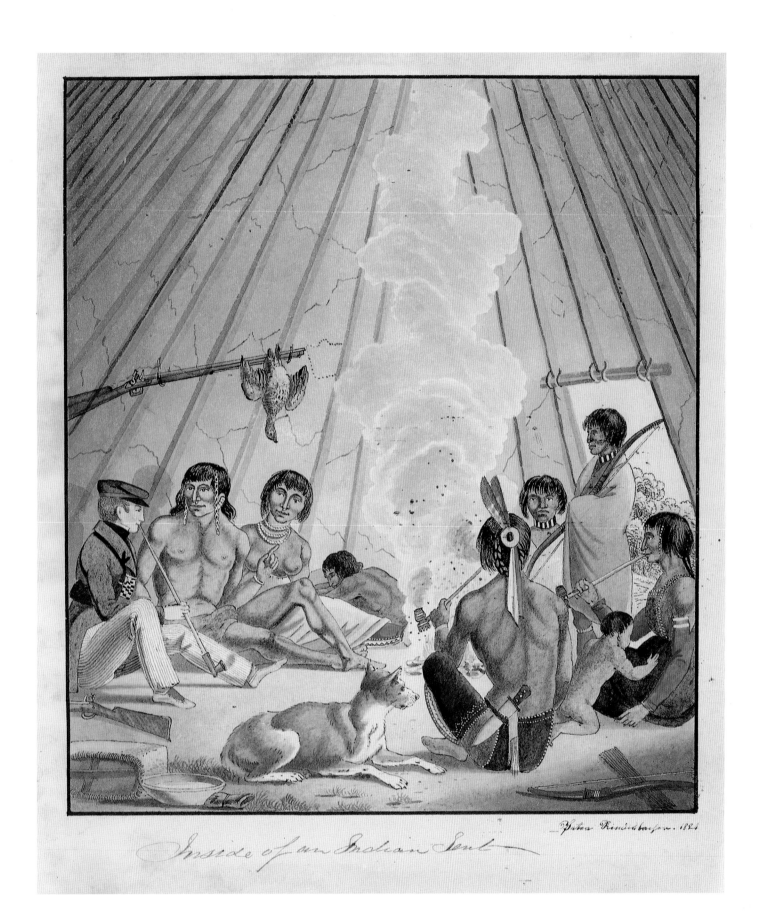

Inside of an Indian Tent

Inuit bartering with Hudson's Bay Company supply ships

This watercolour was painted by Robert Hood, a member of Sir John Franklin's first overland Arctic expedition of 1819–22. Hood had entered the British Navy while still a child, and was a veteran of the Napoleonic Wars. He was still a midshipman when he was appointed one of two artist-officers to the expedition, along with Midshipman George Back, whose own work appears on the next page. During the course of the expedition, Hood was promoted to lieutenant, but he was dead before news of the promotion reached the expedition.

Franklin's expedition set out from England on board a Hudson's Bay Company vessel and travelled via Hudson Strait and Bay to York Factory at the mouth of the Nelson River. From there they travelled by a series of inland rivers and lakes to the Arctic Ocean. During its three-year odyssey, the expedition charted more than 675 miles of previously unmapped arctic coastline, from the mouth of the Coppermine River east to Point Turnagain. But the expedition and its leaders could not cope with the harsh realities of the arctic environment. Although they survived three harsh winters, their failure to plan for adequate provisions during the summer and fall of 1820 cost them the lives of eleven men, including Robert Hood. Most died of starvation or exhaustion. Hood was apparently murdered because he had uncovered evidence of another member's cannibalism.

Hood's watercolour, one of the very few original works by him in a public collection, is both beautiful and evocative. As a portrayal of the contacts made between European civilization and the Inuit, it represents the startling contrast between Western and native technology and depicts with great vigour the barren and hostile environment in which the Inuit survived. It is ironic that European technology did not succeed in maintaining the lives of members of the first Franklin expedition, but the lessons learned during those three years would be put to good use during the second overland expedition to the Arctic led by Franklin in 1825–7.

The Hudson's Bay Company Ships Prince of Wales *and*
Eddystone *Bartering with the Eskimos off the Upper Savage*
Islands, Hudson Strait, Northwest Territories, 1819
Robert Hood (c. 1796/7–1821)
Watercolour, 25.7 × 38.7 cm
W. H. Coverdale collection of Canadiana
Purchased in 1970 with a special grant from the Canadian
government
Neg. C 40364

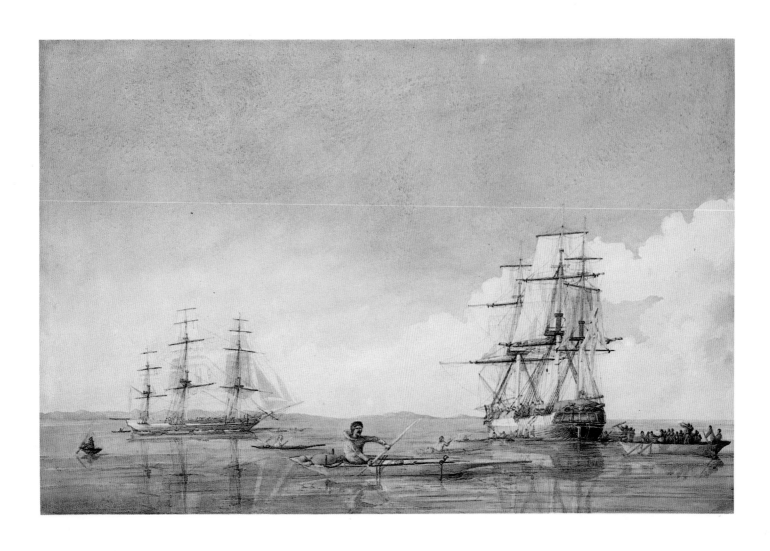

The second Franklin expedition at Great Bear Lake

The early nineteenth century quest by the British to explore the Canadian Arctic and to find the Northwest Passage is an event well documented in the collections of the National Archives. A wealth of visual material was produced in the form of drawings, watercolours, and maps by early explorers and seamen. Much of it was later reproduced as engravings and lithographs in contemporary published accounts by the explorers.

George Back joined the navy in 1808. After the conclusion of the Napoleonic Wars, he volunteered in 1818 for arctic service in the Spitsbergen Seas, where his skill as an artist was recognized by Lieutenant John Franklin. Along with Robert Hood, Back joined Franklin's first overland expedition (1819–22) to chart the north coast of America. They succeeded in reaching the mouth of the Coppermine River and charting much of the coastline eastwards, although half the party perished during the journey. Franklin used sixteen of Back's sketches from that journey in his published account.

This watercolour is from Franklin's second overland expedition to the Arctic, to explore the coast to the east and west of the Mackenzie River (1825–7). It comes from the first of two sketchbooks containing pencil drawings and watercolours that document the expedition as it moved from New York State through western Canada to Fort Franklin on Great Bear Lake. This watercolour, the most spectacular of several views of the fort, shows buildings and trees surrounded by deep snow, with snowshoers and a dogsled arriving on the right. Back finished some of his pencil sketches with watercolour during the long hours the party spent wintering there. The sketchbook was completed on 21 June 1826, three days before the party left on the second leg of its journey along the Mackenzie River to the Arctic Coast. Twenty-six of Back's sketches were later engraved for Franklin's narrative of the second expedition.

George Back was involved in two subsequent arctic explorations, in 1833–5 and 1836–7. He was knighted in 1839. This sketchbook, acquired in 1955 from a family descendant, is a fine example of the work of one of the most original and interesting British topographical artists to have worked in the Canadian Northwest.

Winter View of Fort Franklin from the Little Lake,
N.W.T., winter 1825–1826
Back Sketchbook No. 1: *Sketchbook – Views from Upper Canada*
along the McKenzies [sic] River to Great Bear Lake, 1825–26,
folio 54 recto, p. 104
George Back (1796–1878)
Watercolour over pencil, 13.0 × 21.0 cm
Purchased in 1955
Neg. C 3257

An exemplary citizen of Beloeil

The National Archives holds more than three hundred painted portraits. Most represent people who have played a role in the political, cultural, or economic life of Canada, but some depict persons of more obscure repute. After the conquest, economic prosperity and a population explosion led to the rise of a middle class, and simultaneously to the flourishing of the portrait. To meet the demand, artists travelled as their commissions dictated, and some even redirected their careers.

A painter of vehicles and signboards who was born in Quebec City, Jean-Baptiste Roy-Audy was forty years of age when he announced in the newspapers that he would henceforth be devoting his talents to religious and portrait painting. He was living in Montreal when Alphonse Dumont, a minor notable from the Beloeil region south of Montreal, called on his services. This portrait of Dumont, with its linear drawing, bright colours, and precise detail, is typical of the somewhat naïve style of Roy-Audy, who is an important figure in the history of Canadian art because he was one of the earliest full-time portrait painters active in the Canadas.

Through records preserved in the National Archives, it has been possible to reconstruct the life of Alphonse Dumont (1787–1858). Son of a merchant, he had a brilliant career in the militia, taking part in the Battle of Châteauguay in 1813. He was also justice of the peace, churchwarden, and bailiff to the seigneur of Saint-Hilaire, while at the same time developing his own property. He never married. His portrait and that of his father, painted by Louis Dulongpré, were donated to the National Archives in 1982 by the family of one of their descendants.

Alphonse Montaigu Dumont, 1834
Jean-Baptiste Roy-Audy (1778–c. 1848)
Oil on canvas, 57.4 × 46.7 cm
Gift of Alfred F. and Eileen Greenwood
in memory of Dumont and Frances Huot, 1982
Neg. c 136468

An imprisoned Patriote of the Rebellion in Lower Canada

In 1984, the National Archives acquired an exceptional series of portraits of Patriotes of the Rebellion of 1837–8 in Lower Canada. The subjects had been rounded up and held on suspicion of plotting the overthrow of the colonial government after the outbreak of armed rebellion in November 1837.

Imprisoned in Montreal between December 1837 and July 1838, the notary Jean-Joseph Girouard, a member of the Assembly and leading Patriote, portrayed sixty-seven of his companions in misfortune. He drew their profiles from shadows cast on paper hung on the prison wall; each person is identified by name, age, profession, and date of incarceration. Freed on bail in July 1838, Girouard was once more imprisoned in November 1838, at which time he added twelve more portraits to his collection.

The series also includes eleven portraits of Patriotes who were not imprisoned, or were imprisoned elsewhere than Montreal. One such was Joseph Légaré (1795–1855), painter, collector, and politician. Although his portrait is typical of those made during Girouard's first incarceration, it was in Quebec City that Légaré was imprisoned for five days in November 1837. Girouard visited that city in August 1838.

Légaré left an abundant and highly varied body of work: a few portraits, some landscapes, and many religious pictures inspired by European works. Furthermore, he painted subjects that attracted none of his contemporaries: historical pictures, political subjects, and natural disasters like cholera, rock falls, and fires. This portrait is an important addition to the National Archives' collection of portraits of artists, which includes several self-portraits. The fact that it is part of a series of great historical importance only adds to its value.

Joseph Légaré, 1838
Jean-Joseph Girouard (1794–1855)
Pencil and charcoal, 29.4 × 21.3 cm
Purchased in 1984
Neg. C 18492

The Great Seal of Canada in the reign of Victoria

In law, a seal is a device adhering to or attached to a document as evidence of authenticity or attestation. The National Archives acts as the official repository for all official government seals. These include the Great Seal of Canada, which is affixed to all formal documents issued in the name of the reigning monarch, and the Governor General's Privy Seals. The use of Great Seals to authenticate documents in the name of the monarch and the state dates back to the reign of Henry I (1031–60) of France; the use of seals generally is much older.

From 1 July 1867 until its official defacement in December 1869, a temporary Great Seal featuring the Royal Arms of England was used by Canada. The seal featured here is the first permanent official Great Seal, which came into use in mid-1869 and continued to be affixed to all official documents until its eventual replacement, after the death of Queen Victoria in 1901, by a new Great Seal introduced for the reign of Edward VII on 4 July 1905.

The first permanent Great Seal of Canada depicts Queen Victoria seated beneath a triple Gothic canopy, a sceptre with a cross in her right hand, and an orb with a cross in her left. In the right- and left-hand niches of the canopy are the four shields bearing the arms of the provinces that then made up all of Canada, granted by royal warrant in 1868. The date of Confederation also appears, while a scroll above the canopy bears the motto *Dieu et Mon Droit.* The Royal Arms of the Realm appear at the base of the seal. The inscriptions around the periphery, translated from the Latin, state 'Victoria, by the Grace of God Queen of Great Britain, Defender of the Faith' and 'The Seal of Canada.'

This matrix for the Great Seal was modelled in silver, a metal found to be too soft for the pressure needed to impress upon paper over wax. Subsequent seals were struck in tempered steel. No relief counterseal is known to have existed for this Great Seal, and it may be possible that a pad of some type was used instead.

The present Great Seal for Queen Elizabeth II is entrusted to the minister of consumer and corporate affairs, in the capacity of registrar-general of Canada.

The Great Seal of Canada, 1869
A.S. and J.B. Wyon
Silver, 12.4 cm (diameter)
Acquired before 1955
Neg. C 6792

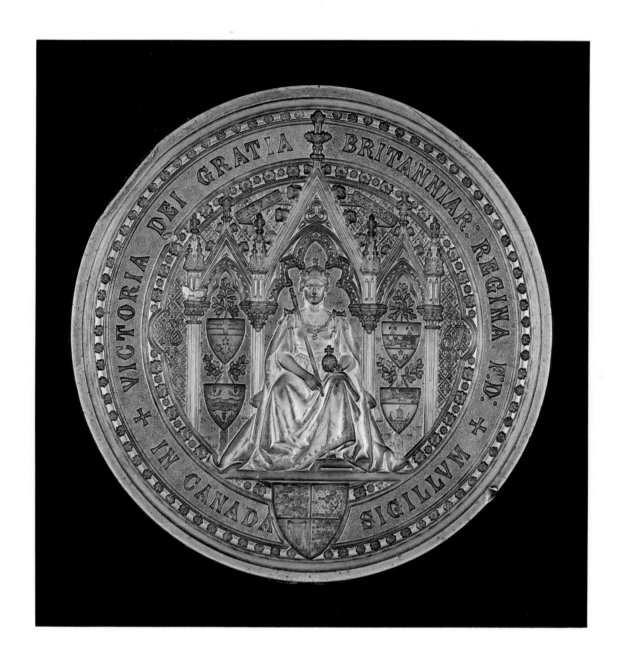

The wife of the chief factor follows the fur trade routes

Frances Anne Hopkins, granddaughter of Sir William Beechey, RA, court painter to Queen Charlotte, was born and raised in England. After her marriage to Edward Hopkins, chief factor of the Hudson's Bay Company, she moved to Montreal and lived there for twelve years, from 1858 to 1870. During these years she kept a record of incidents in her life in the form of sketches and watercolours, some of which are now in the National Archives. Adventurous in spirit, she accompanied her husband on at least two lengthy canoe voyages, an unusual experience for a European woman in this period.

Mrs Hopkins was greatly inspired by her Canadian experience, and based many of the paintings she subsequently exhibited on Canadian subject matter. Her paintings, nostalgic for a way of life and mode of travel that was rapidly disappearing, gave a romantic interpretation of Canada for audiences abroad. The National Archives holds five of her large-scale oil paintings depicting various aspects of canoe travel, acquired between 1917 and 1923. Dated 1869, this painting was finished in Canada, just before Mrs Hopkins returned to England. It is likely that this is the painting exhibited in the Royal Academy in 1870 as *Canoe Travelling in the Backwoods of Canada*, accompanied by a quotation from Longfellow's poem *Evangeline*.

The birch-bark canoe designed and used by Indians throughout eastern North America was adapted and became the backbone of the Canadian fur trade until the last quarter of the nineteenth century. In this painting Hopkins has portrayed a Hudson's Bay Company birch-bark *canot de maître*, decorated on the stern with the company's flag, and on the headboard with a *cassette* of rayed design, originating from French-Canadian folk-art. Since no fur-trading canoes have been preserved in museums, such a faithful depiction in full colour, which photographs of the time were unable to supply, is very precious indeed. The passengers are likely the artist herself, fashionably attired in a pork-pie hat, decorated with a stuffed bird, and her much older husband. A kettle perched on top of the baggage is easily available for the next campsite; the decorated skin blanket was perhaps a new addition to Edward Hopkins's extensive collection of Indian artifacts, now housed at Oxford University.

Canoe Manned by Voyageurs Passing a Waterfall, 1869
Frances Anne Hopkins (1838–1919)
Oil on canvas, 73.7 × 152.4 cm
Purchased in 1921
Neg. C 2771

101

Bringing in the harvest in New Brunswick

This beautiful harvest scene has only recently been identified as one of William G.R. Hind's finest oil paintings, done during his years working in New Brunswick. Initially attributed to another artist, and described as a harvesting scene from Saint John, the painting was purchased because of its scrupulous documentation of harvesting activity and of the Maritime countryside. The artist's fastidious depiction of the church enabled the National Archives staff to identify it as Trinity Anglican Church in Sussex, New Brunswick.

Based on technical and stylistic similarities, the painting has since been attributed to Hind, who rarely if ever signed his pictures. Within the small format typical of the artist can be seen the church, which still stands today, and other buildings all recorded with minute, almost microscopic brush strokes, an astonishing perspective of trees carefully differentiated by type, the hay fields and harvesting details. The streaming smoke in the far distance might depict a train, an appropriate touch, since the artist worked for the Intercolonial Railway in his later years.

Hind arrived from England in 1851 to join his geologist brother, Henry Youle Hind, in Toronto. He had already received art training in England and became drawing master at the Toronto Normal School. The older Hind led an expedition to explore the Moisie River in the summer of 1861, and the younger brother was invited to produce a pictorial record. His sketches were used to illustrate the two-volume account of the journey. In 1862 Hind set out to the British Columbia goldfields with a group of 'Overlanders,' gold-seekers travelling to the west coast by land. He did not strike gold in the Cariboo, but settled in Victoria until 1869. He then moved to the Maritimes, where he continued sketching, making a wonderful record of several small communities. He died in Sussex.

The Archives holds more than 130 of his drawings, watercolours, and oils, all executed with great precision and attention to detail.

Harvesting Hay, Sussex, New Brunswick, c. 1880
William George Richardson Hind (1833–89)
Oil on commercial board, 27.5 × 47.1 cm
Purchased in 1982
Neg. C 103003

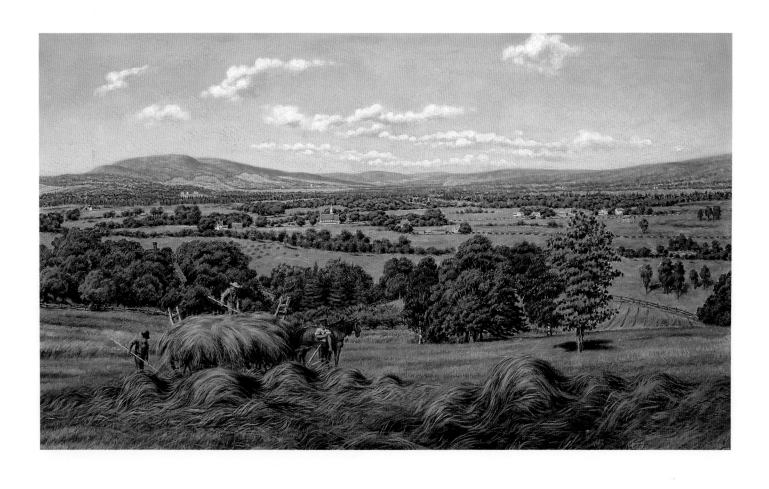

Looking for recruits in Quebec

In 1916, Prime Minister Robert Laird Borden pledged to increase Canada's contribution to the Expeditionary Force fighting in Europe to five hundred thousand soldiers. Recruitment of volunteers was intensified throughout the dominion through a variety of means, most visibly through widely distributed recruiting posters. In this one, men from Quebec's Eastern Townships were urged to do their patriotic duty for King, Country, and Humanity and to join the newly formed 178th French Canadian Battalion. Such recruiting propaganda was not uncommon during the First World War, and typically played upon Canadians' sense of patriotism and local pride. The artist of this particular poster is unknown. He or she was probably employed as a staff artist by Mortimer Company Limited, a long-time Ottawa printing company that often did government work. When such recruiting efforts failed to elicit the results required, the Canadian government was forced to introduce conscription in August 1917, a measure greatly resisted in Quebec.

This is one of more than two thousand First World War posters held by the National Archives, and forms part of one of the most significant and comprehensive war poster collections in the world. The entire poster collection consists of more than thirty thousand items and encompasses a variety of subjects ranging from war to political to cultural topics.

Le 178ième Bataillon Canadien-Français
des cantons de l'est, 'Les Purs Canayens,' 1916
Mortimer Co. Ltd., Ottawa
Colour offset lithograph, 105.2 × 68.3 cm
Acquired c. 1919
Neg. c 95266

The prime minister, weary from war

During the 1919 Paris Peace Conference at the end of the First World War, the Canadian prime minister, Sir Robert Laird Borden, sat to Sir William Orpen, a prominent British portrait artist. This oil sketch is the result of at least four sittings. It was used by Orpen as the model for Borden's portrait in a large group portrait of the conference delegates, commissioned by the British government, which now hangs in the Imperial War Museum, London.

As they faced each other, both artist and subject were emotionally and physically exhausted. Orpen had served as a war artist for the Canadian War Memorials under Lord Beaverbrook and had been greatly affected by his battlefield experiences. Borden had mobilized an entire nation and raised a large fighting force, of which sixty thousand perished. The toll of these efforts shows clearly in Borden's weary expression, portrayed by an artist who had seen the devastation of the war firsthand. The spontaneous brushwork and unfinished appearance give the portrait a great immediacy; rather than showing a leader in the flush of victory, it reveals the sense of loss and anticlimax at the end of an extraordinary effort and, in Borden's own words, 'the extent to which my physical and nervous energies had been exhausted.' The following year Borden retired from public life.

Orpen sold his peace-conference portraits in 1921 to Sir James Dunn, who in turn put them on the block at Christie's auction house in 1926. The National Archives acquired the Borden portrait indirectly after this sale. It is particularly prized because, among the Archives' large collection of portraits, and unlike many formal portraits, it reveals the vulnerable side of greatness.

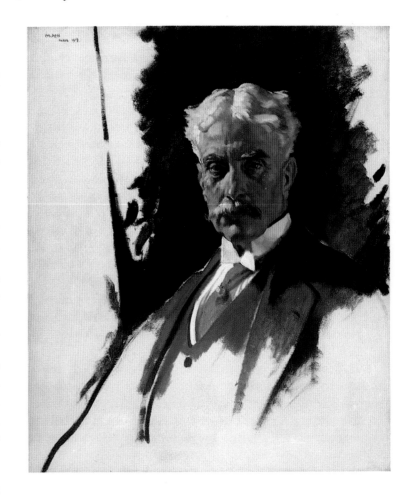

Sir Robert Laird Borden, 1919
Sir William Orpen (1878–1931)
Oil on canvas, 76.1 × 64.0 cm
Purchased c. 1926
Neg. c 11238

Private Lamb has a quiet afternoon in the canteen

Personal and private opinions about events and activities in Canadian life can be invaluable as historical records. Typically, such records take the form of written journals or letters. Occasionally visual documents in the form of scrapbooks or illustrated diaries provide insights into the past. A striking example is the illustrated diary kept by Molly Lamb Bobak during the Second World War. Bobak, then a twenty-year-old Vancouver artist, enlisted with the Canadian Women's Army Corps in 1942, and from the outset kept a diary in which she expressed the trials and tribulations of her life in the army in a delightful and humorous fashion. Bobak was eventually appointed an official Canadian war artist as part of the Canadian War Records Program in May 1945, enabling her to document the activities of Canada's armed services at home and abroad for official rather than personal purposes.

Women were first permitted entry into Canada's armed services during the Second World War; their participation, however, was restricted to such non-combatant roles as office and logistical support, clerical duties, transport, and food services. Bobak's caricature-like self-portrait shows her working behind the counter of a busy army barrack's canteen, one of the typical tasks to which women were assigned by the military. Her diary also recorded how men and women in the armed forces spent their off-duty hours. Here groups of off-duty army personnel socialize over coffee and pie amidst posters warning them not to repeat anything that the enemy might make use of. Bobak's diary was not created for propaganda purposes, unlike many of the official records that still survive about the Canadian Women's Army Corps. Containing more than 250 illustrations, it offers a refreshingly honest and accurate record of the CWACS by someone on the inside.

*Private Lamb has a Quiet Afternoon
in the Canteen,* 1 December 1942
'W110278' The Personal War Records of Private Lamb, p. 6
Molly Lamb Bobak (1922–)
Pen and black ink with watercolour over pencil,
45.6 × 30.4 cm
Donated in 1989
Neg. C 135722

Provincial Premiers At Work, 21 October 1964
Duncan Macpherson (1924–)
Brush, pen, and india ink,
34.7 × 26.6 cm
Donated in 1980
Neg. C 112829

Journalistic satire on constitutional change

Original editorial cartoons are significant for their incisive comment on public affairs as well as for often superb draughtsmanship. Nowhere are these characteristics more admirably combined than in the work of Duncan Macpherson, full-time editorial cartoonist for the *Toronto Star* from 1961 to 1982 and six-time winner of the National Newspaper Award.

This cartoon was drawn after a meeting in 1964 of Prime Minister Lester B. Pearson and the provincial premiers to discuss an amending formula for the document that forms the basis of Canada's constitution, the British North America Act. Although a draft recommendation had been unanimously accepted, public opinion was guarded. The *Toronto Star* editorial warned that provincial demands were dominating at the expense of federal powers, and that this would lead to the eventual breakup of Confederation. The tug-of-war of powers between the provinces and the federal government, the continued wrangling over formulae by which to amend the constitution, and the accompanying debate about the pros and cons of a strong central government have

been fundamental issues in Canadian politics since Confederation. Constitutional reform has provided a target for generations of Canadian cartoonists.

With his bland features and unassuming manner, Pearson was a notoriously difficult figure to caricature. Macpherson exaggerated these characteristics and capitalized on Pearson's public persona of the bungling idealist, oblivious to the political machinations going on around him. In doing so, he created the most successful caricature of Pearson – amusing and instantly recognizable.

In 1980, the *Toronto Star* donated 1216 original Macpherson cartoons to the National Archives. Another 1257 were acquired from the cartoonist himself in 1987, making the Archives the possessor of the largest and finest collection of work by this internationally renowned political satirist. The Macpherson collection is part of a larger holding of more than 25,000 original political cartoons in the Archives. They document political opinions in and about Canada from the eighteenth century onwards.

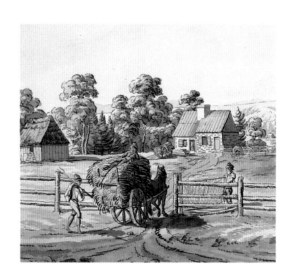

III

The Stages of a Postage Stamp

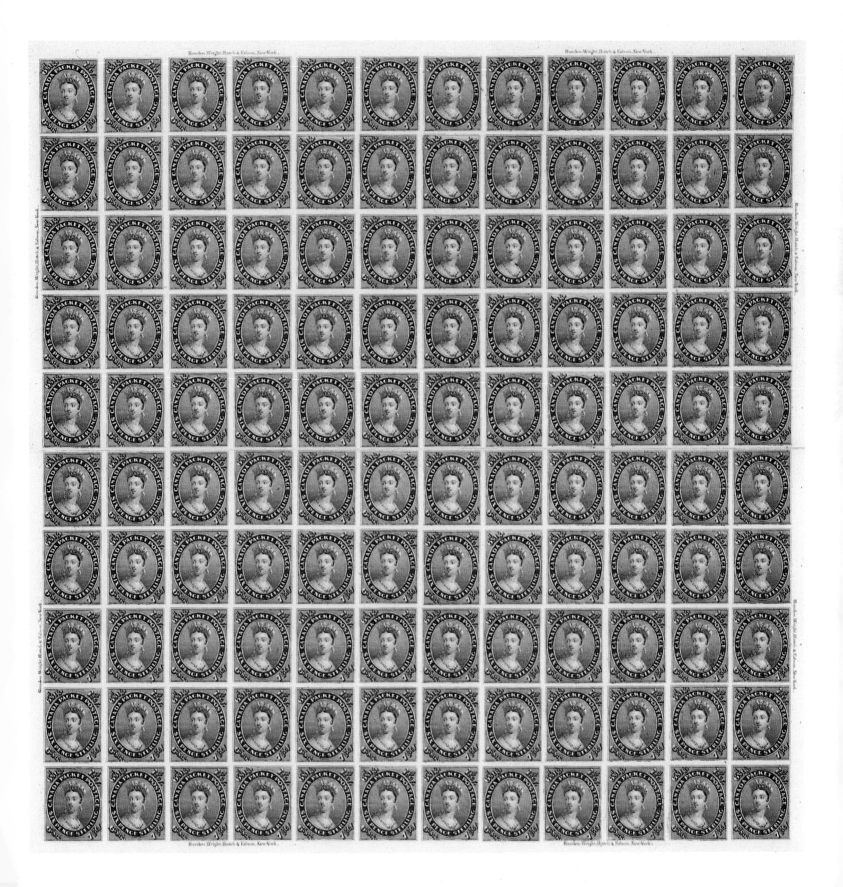

Philatelic Records

The Canadian Postal Archives was created in order to acquire and preserve Canada's philatelic heritage. The major collections were formerly held by the Canada Post Corporation in the National Postal Museum, but were transferred to the National Archives of Canada in 1988.

The collections comprise approximately 700,000 items that have been acquired from two main sources: the Canada Post Corporation (and formerly the Post Office Department) and the security printers responsible for printing the stamps. Additional material has come through donations and purchases from the private sector.

The philatelic collections cover all aspects of British North America/Canada postage stamp design and production. They include original artwork and designs, essays, progressive and approved die proofs, colour trials, press proof sheets and/or partial sheets or panes on either gummed or ungummed papers, and mint single stamps. The Archives also keeps material relating to meter and permit stamps, postal stationery, revenue stamps, and labels. Items representative of the different administrative periods of postal history include postal markings and covers carried by ocean, railway, and air.

A related component consists of photographs, documentary art, maps, broadsides, circulars, posters, manuscripts and papers, and a specialized library collection. The Archives also holds foreign-issued postage stamps acquired through the Canada Post Corporation exchange program with members of the Universal Postal Union.

The holdings reflect the evolution of postage stamp design, the art of engraving, and the variety of printing methods used in the production of British North America/Canada postage stamps from the mid-nineteenth century to the present. The examples selected for this section illustrate various steps involved in the design,

pre-production, and printing of postage stamps. They are representative of the wide range of accepted and unaccepted artwork, die and plate proofs, and issued postage stamps held in the collections. At the end, historical postal markings and a postally used cover are also included as examples of other significant collections held by the Archives.

Before the advent of adhesive postage stamps, recipients were required to pay a fee when a letter was delivered to them. The first stamps were issued in Great Britain on 6 May 1840, and were meant to ensure that postage was prepaid by the sender. This practice was adopted in British North America by the Province of Canada, Nova Scotia, and New Brunswick in 1851, Newfoundland in 1857, British Columbia and Vancouver Island in 1860, and Prince Edward Island in 1861. With Confederation, the federal government took over responsibility for the Post Office, and the various provinces ceased to issue their own postage stamps.

Initially, the majority of the designs for British North America/Canada postage stamps were developed by artists who were employed by the printers who also produced the stamps. During the 1950s the Canada Post Office Department began to solicit designs from other artists and designers, and in 1969, with the official creation of the Design (later Stamp) Advisory Committee, the process of selecting Canadian artists to prepare designs for postage stamps was formalized. Today the committee reviews the subjects and proposed designs, and makes its recommendations for the corporation's annual stamp program, which is then approved by the Board of Directors.

Because stamps have monetary value, they are printed using strict production and security controls. Before the late 1960s, the majority of the British North America/Canada postage stamps were printed by a steel-engraved/

intaglio process that made stamp forgery difficult. The process did not, however, allow for great flexibility in design, and the stamps were mainly limited to one- or two-colours. With the introduction of colour offset photolithography and photogravure in the 1960s, multicoloured Canadian stamps could be printed with more detail. Today most of Canada's stamps are produced by these two processes.

Design for an early British Columbia postage stamp

Although the postal establishments of the colonies of Vancouver Island and British Columbia were placed under separate administrative heads as of 31 July 1860, the colonies used the same 'Two Pence Half-Penny' postage stamp for the prepayment of colonial postage. However, on 4 May 1864 an ordinance for regulating the British Columbia Postal Service, which had been passed by the Legislative Council of British Columbia, was assented to by Frederick Seymour, the colony's governor. It stipulated that 'for every letter to and from British Columbia and Vancouver Island, and delivered at Victoria or New Westminster, and not exceeding 1/2 an ounce, there shall be paid a postage of 3d.'

The need for a new British Columbia postage stamp was apparent. On 23 September 1864 Seymour submitted the stamp design shown here to the Colonial Office, together with a formal written application that reached London, England, on 29 November 1864.

The proposed design, with minor modifications to the crown, letter 'V,' oval frame, and lettering, was adopted and the new 'Three Pence/British Columbia' postage stamps were issued on 1 November 1865. Although this original drawing cannot be attributed to a specific designer, it is of special significance because it is the earliest example of postage stamp artwork/design held by the Archives.

Three (3d.) Pence
Preliminary postage stamp artwork,
original pen and ink drawing
Colony of British Columbia, 1864
2.2 × 2.5 cm (original)
Acc. 1988-216 Neg. POS 3

An unfulfilled design of tri-national friendship

On 11 February 1941, William P. Mulock, postmaster general of Canada, forwarded this proposed postage stamp design to Prime Minister Mackenzie King for his consideration. In his accompanying letter, Mulock outlined the rationale for the creation of the new stamp, suggesting that the issue might commemorate the friendship that the people of the United States had shown towards Canada and Great Britain.

The design was to include portraits of the Right Honourable Winston Churchill as prime minister of Great Britain, the prime minister of Canada, and the president of the United States, Franklin D. Roosevelt, along with the slogan: 'That Democracy shall not perish from the earth.' Mulock suggested that an appropriate time to issue the stamp would be when the US Lend-Lease Bill was approved and became law. (Although the United States had not yet declared war, Roosevelt was anxious to help the Allies. The Lend-Lease Bill passed in March 1941, and provided for the transfer of American war materials to the Allies in return for deferred payments.)

The prime minister replied that he did not think it was advisable to use the suggested design, but unfortunately did not elaborate on his concerns. Perhaps he was thinking that in practice Canadian postage stamp designs do not honour living persons other than members of the royal family. He did feel, however, that there was merit in creating a special stamp to commemorate Canadian-American friendship.

The idea for the stamp never went beyond the proposal stage, and this hand-painted composite model, retained by King, remains as mute testimony to a wartime postage stamp that might have been.

Canada, United States, Great Britain Friendship
Proposed commemorative postage stamp design,
composite photographic/hand-painted model
Canada, 1941
2.2 × 3.5 cm (original)
Design: Canadian Bank Note Company, Limited, Ottawa
Acc. 1989-324 Neg. POS 2492

Depicting an endangered species

Robert Bateman, noted wildlife artist and conservationist, created this painting for the 12 cents 'Eastern Cougar'/(*Felis concolor cougar*) postage stamp issued on 30 March 1977, part of a series of Canadian stamps highlighting endangered wildlife.

Bateman was commissioned to do the work and originally submitted three possible designs for the proposed stamp. He displayed his professional concern for accuracy and detail by stating that 'since it is very difficult to distinguish between the endangered Eastern Cougar and the commoner one on Vancouver Island for example, I decided ... to put (the Cougar) in a tree which only occurs in the East ... the White Pine.' His other reason for choosing a tree for the setting was aesthetic; he liked the 'oriental' way that space could be divided by using the pine branches. In addition to vividly portraying the cougar in one of its natural environments – the remote forested areas of New Brunswick and the Gaspé – the artist has successfully created an image that can be reproduced satisfactorily as a stamp-sized miniature.

12 Cents 'Eastern Cougar'
Endangered Wildlife
Postage stamp artwork, acrylic
Canada, 1976
16.0 × 21.5 cm (original)
Design: Robert Bateman
Acc. 1989-565 Neg. POS 2481
Reproduced with the permission of
Canada Post Corporation

The world's first animal pictorial postage stamp:
a lithographic essay proof

In May 1849 the Legislative Assembly of United Canada resolved to allow 'postage stamps for prepayment': till then, the person receiving a letter was expected to pay for the service. The Assembly also decided that the stamps should be engraved. There followed several months of activity in 1851 by the postmaster general, James Morris. The result was the world's first animal pictorial postage stamp – the Province of Canada Three Pence 'Beaver.'

Morris involved Sandford Fleming, who later became known as Canada's foremost nineteenth-century construction engineer and railway surveyor and as a proponent of international standard time. Early in 1851 Fleming prepared the design of the stamp: this proof of it comes from his scrapbook and the handwritten note is his. Just why the beaver was chosen is uncertain: perhaps it was because of its industriousness, perhaps because of its importance as a source of colonial wealth through the fur trade.

The postmaster general tried to find a local printer to produce the stamp. He settled on J. Ellis, a British-born engraver and lithographer. But Ellis's work did not apparently meet the postmaster general's standards. An editorial in the *British Colonist* hints at the reasons why: it said that a rival printer in Montreal had assured Morris that he could produce a duplicate lithographic product in twenty-four hours. The stamps then would have been too easy to counterfeit. Ellis possibly needed more time than was available to produce stamps from a steel engraving.

At any rate, an order for steel-engraved/intaglio printed postage stamps was placed with Rawdon, Wright, Hatch & Edson in New York and the stamps were produced by them. The intact Three Pence 'Beaver' lithographic essay proof illustrated here remains highly significant, however; it represents the first efforts to have a postage stamp designed and printed in the 'Province of Canada.' It was not until after Confederation in 1867 that stamps were printed in Canada.

Three (3d.) Pence 'Beaver'
Lithographic essay proof
Province of Canada, 1851
Design: Sandford Fleming
Acc. 1989-565 Neg. POS 2214

publisher will meet with the warmest appreciation
theoretically and substantially.

Feby 1851

This is the first proof from the plate of
the first postage stamp issued in Canada
designed by Sandford Fleming for the Post
Master General The Hon'ble James Morris
Toronto Feby 1851

Steel engraved die proofs

The National Archives possesses a wide variety of postage stamp 'die proofs,' which singly and in their entirety provide a wealth of information for those who are interested in the techniques of steel engraving. Once the artwork for a postage stamp has been created and approved, highly skilled engravers, who are employed by the various security printers, are required to transfer accurately the artist's original design onto a soft steel die with the use of specialized engraving tools. Originally, many of the designs were created stamp-size, but current practice is usually to have the artwork done at five times the issued stamp size. The resulting engraved 'mirror images' are often reduced in size from the much larger original artwork – an act which requires the engraver to have patience and the ability to translate designs precisely from one medium to another.

Progressive proofs, such as the 50 cents 'Bluenose'

shown here, are pulled at various stages throughout the process in order to ensure that the engraving is proceeding satisfactorily. Proofs are also forwarded to the postage stamp issuing authority for commentary, approval, and retention.

The 'approved' die proofs generally bear various manuscript notations, official signatures or initials, and dates and become authorization documents that allow the printers to proceed to the next phases in the pre-production process – the creation of the transfer rolls, and the printing bases. These phases are explained in the following section.

Although the majority of the British North America/ Canada postage stamp steel dies no longer exist, the selected die proofs illustrated here are a lasting testimony to the intricate process involved and the exacting skills of the engravers who created them.

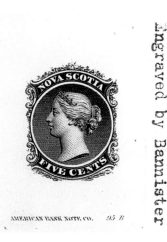
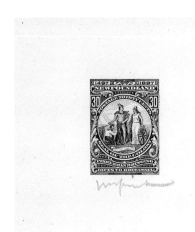
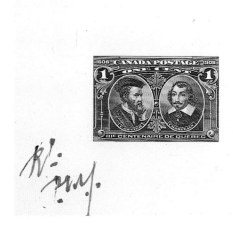

5 Cents 'Queen Victoria'
'Index Copy' die proof,
steel-engraved (one colour)
Nova Scotia, 1860
American Bank Note Company,
New York
Acc. 1990-241

30 Cents 'Seal of the Colony...'/
Newfoundland 1497–1897
Anniversary
'Approved' die proof, steel-engraved
(one colour)
Newfoundland, 1897
American Bank Note Company,
New York
Acc. 1990-241

1 Cent 'Jacques Cartier/Samuel
de Champlain'/Quebec
Tercentenary
'Approved' die proof, steel-engraved
(one colour)
Canada, 1908
American Bank Note Company,
Ottawa
Acc. 1989-565

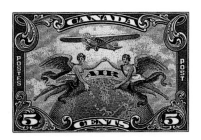

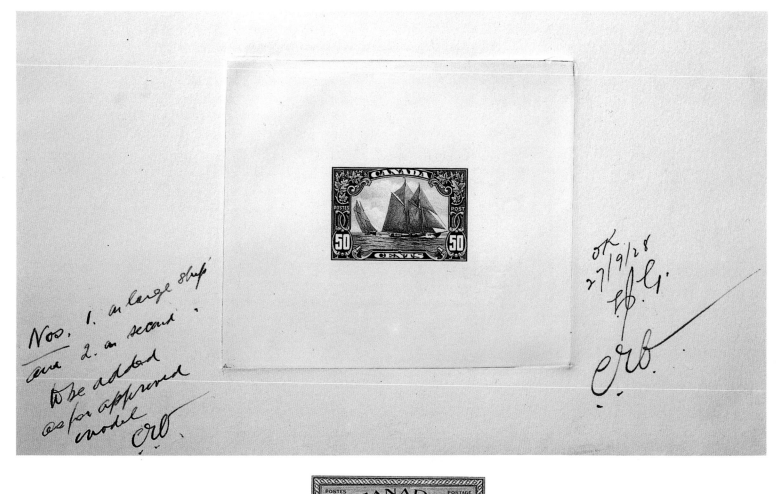

5 Cents 'Airmail'
'Approved' die proof, steel-engraved
(one colour)
Canada, 1928
Canadian Bank Note Company,
Limited, Ottawa
Acc. 1989-565

50 Cents 'Bluenose'/Pictorial
Regular Issue
'Progressive' die proof, steel-engraved
(one colour)
Canada, 1928
Canadian Bank Note Company,
Limited, Ottawa
Acc. 1989-565

20 Cents 'Combined Reaper
and Harvester'/
Pictorial Regular Issue
'Approved' die proof, steel-engraved
(one colour) Canada, 1946
Canadian Bank Note Company,
Limited, Ottawa Acc. 1989-40
Reproduced with the permission
of Canada Post Corporation

Plate proof: final check before printing

Once the steel die for a postage stamp has been officially approved and hardened, a small soft steel roller (or wheel) is rolled onto the die and the image is transferred onto the roll in relief. The resultant image is the exact reverse of that incised on the steel die. In turn, the roller is hardened and is used to create the multiple-image metal printing base from which the postage stamps are printed. Each of the images on the printing plate must be an exact duplicate of the master die. When the skilled craftsmen who make the plate are satisfied, the plate is hardened in turn and is readied for printing. This phase of the work of producing a stamp is referred to as siderography.

As with the preparation of the steel dies, proofs are pulled at various stages in order to determine if modifi-

cations are required to any part of the printing base. Once the base is approved, final plate proofs in the colour of issue of the postage stamp are prepared. Normally they are retained by the printer and/or the stamp-issuing authority as permanent records. These documents allow the printer to proceed with the actual printing of the postage stamps.

The mid-nineteenth-century 'Province of Canada' Pence/Cents Issues plate proofs pictured here (the Three Pence in full, the others as details from similar plates) were retained as part of the archives of the American Bank Note Company. Patriated to Canada in 1990, they are a permanent testimony to the abilities of the specialists who created the intricate multiple-image printing bases.

 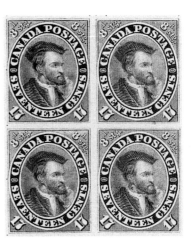

Six (b.d.) Pence 'Prince Albert'
Intaglio
Province of Canada, 1851
Acc. 1990-241 Neg. pos 2486

Three (3d.) Pence 'Beaver'
Intaglio
Province of Canada, post-1851 printing
Acc. 1990-241 Neg. pos 2529

One Half Penny 'Queen Victoria'
Intaglio
Province of Canada, 1857
Acc. 1990-241 Neg. pos 2488

Six (b.d.) Pence Sterling 'Queen Victoria'
Intaglio
Province of Canada, 1857
Acc. 1990-241 Neg. pos 2490
Printer: Rawdon, Wright, Hatch &
Edson, New York

17 Cents 'Jacques Cartier'
Intaglio
Province of Canada, 1859
Acc. 1990-241 Neg. pos 2487
Printer: American Bank Note
Company, New York

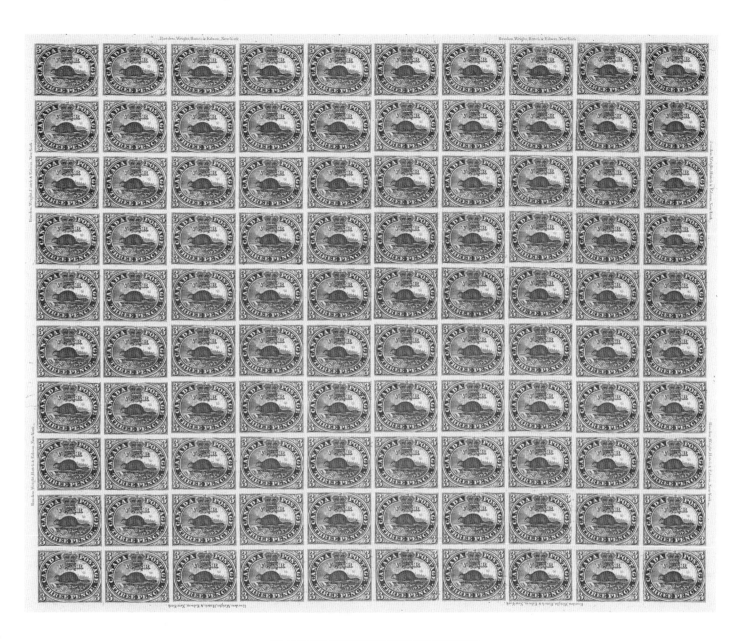

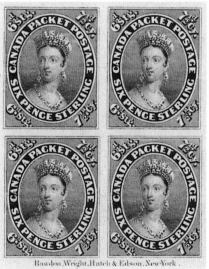

An early Canadian classic

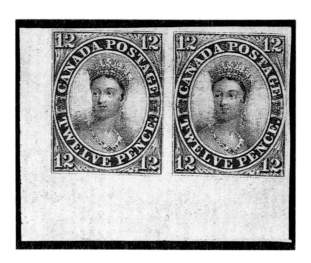

On 6 April 1851, the Imperial Post Office authorities in Great Britain transferred the control of the Post Office Department to the government of the Province of Canada, and postage stamps for the pre-payment of letters of the respective values of three pence, six pence, and one shilling were ordered.

The proposed one-shilling stamp underwent various design changes before it was finally released. Sandford Fleming, in addition to preparing the Three Pence 'Beaver,' introduced a similar design for the one shilling stamp. But for reasons not fully confirmed, the beaver was not incorporated. The vignette for the issued stamp was based on the portrait of Queen Victoria which was painted by Alfred E. Chalon. The denomination was changed to twelve pence, the equivalent of one shilling.

Fifty-one thousand twelve-pence steel-engraved/intaglio postage stamps were printed by the firm Rawdon, Wright, Hatch & Edson in New York. It now is considered one of the world's classic postage stamps. Very few have survived in their original state, and even fewer in multiple format. The National Archives holds this unique unused corner margin pair of the issued postage stamps.

Twelve (12d.) Pence 'Queen Victoria'
Postage Stamp
Steel engraved/intaglio
Province of Canada, 1851
Printer: Rawdon, Wright, Hatch & Edson,
New York
Acc. 1989-565 Neg. POS 31

Inversion on the Seaway

When released on 26 June 1959, the Canada and United States postage stamps commemorating the opening of the St Lawrence Seaway marked the first occasion that the two countries had issued a stamp jointly. Except for the necessary differences in captions and denominations, the stamps were identical in design and were the result of cooperative efforts of Canadian and American artists.

It was not until 8 October 1959, however, that the issue became notable for another reason. On that date, the Canada Post Office Department issued a news release stating that some three hundred misprinted copies of the stamp had reached the public. On all of them the central blue area that depicted the international seaway link was upside down in relation to the red printing at the top and bottom. William Hamilton, the postmaster general, explained that such an error could occur only when two or more plates were used to print a stamp. He assured all concerned that he did not expect such a misprint to occur again in Canada, as the printer had implemented a technique that would guard against such imperfections in the future.

In fact no similar major Canadian postage stamp inversion has surfaced in the public domain since 1959 – evidence of the exacting on-site inspections of the various printers. Now known unofficially as Canada's 'Seaway Invert,' the postage stamp has continued to generate speculation, intrigue, and where applicable – pride of ownership. No one knows precisely how many of them remain in existence.

5 Cents 'St. Lawrence Seaway'
Misprinted Postage Stamp,
Steel engraved/intaglio
Canada, 26 June 1959
Printer: Canadian Bank Note Company, Ottawa
Acc. 1989-565 Neg. POS 55
Reproduced with the permission of
Canada Post Corporation

Proof of cancellation

In order to meet its operational and administrative needs over the years, the Canada Post Office Department has ordered an extensive variety of postal markings devices from a number of suppliers across Canada.

Cancellation hammers and rollers were used to cancel postage stamps so that they could not be reused. Other handstamps were used to apply instructional markings to mailed items to ensure that they were delivered properly. Impressions of such postal marking devices were struck in order to verify the accuracy of the wording and/or the graphic designs. These impressions, which in most cases bear a proof date and related reference number, were mounted in impression books as permanent records and were retained by the Post Office. This sample page includes various proof impressions for devices that were proofed in July 1909 and issued to community and railway post offices across Canada.

No longer required as current records, the unique set of impression books, covering the period c. 1908–86, continues to have practical reference value. It is used extensively by individuals who are interested in the evolution of the postal system in Canada, for the books contain valuable historical details which relate to Canada's early post offices, many of which no longer exist.

Canada Post Office – Proof Impressions
July 1909 (vol. 1, p. 86)
Acc. 1989-565 Neg. POS 35

BANK OF HAMILTON,
ABERDEEN, SASK.
PAY TO THE BEARER

POSTMASTER

962·B

ENGLEHART
AM
JUL 23
09
ONT.

974 B

O.L.&S.R.P.O.
S
JUL 19
09
B.C.

WILKESPORT
JUL 19
09
ONT.

945·B

ALBERTON
JUL 19
09
P.E.I.

MACOUN
AM
JUL 17
09
SASK.

WHITTINGTON
JUL 19
09
ONT.

951·B

ST LAMBERT DE LEVIS
JUL 19
09
QUE.

945·B

SHIPPIGAN ISLAND
JUL 19
09
N.B.

946·B

FIELD
AM
JUL 21
09
B.C.

968 B

P.M. General 991 B

OPENED AND ASSORTED
AT OTTAWA, ONT.

NO SUCH FIRM IN EDMONTON

NOT IN DIRECTORY

959·B

957·B

HALIFAX & SYDNEY R.P.O.
W
JUL 23
09
NIGHT

HALIFAX & SYDNEY R.P.O.
W
JUL 23
09
NIGHT

HALIFAX & SYDNEY R.P.O.
W
JUL 23
09
NIGHT

HALIFAX & SYDNEY R.P.O.
W
JUL 23
09
NIGHT

LA BANQUE D'HOCHELAGA,
WEST END BRANCH
MONTREAL. QUE.
PAY TO THE BEARER

POSTMASTER, SUB. OFFICE No. 34

956·B

REGISTERED
JUL 17 1909
ELK LAKE, ONT.

971·B

COBOURG
JUL 23
09
ONT.

973 B

BANK OF HAMILTON,
ABERDEEN, SASK.
PAY TO THE BEARER

POSTMASTER

962·B

00086

MERCHANTS BANK OF CANADA
TOFIELD, ALTA.
PAY TO THE BEARER

POSTMASTER

BANK OF HAMILTON,
BRANT, ALTA.
PAY TO THE BEARER

POSTMASTER

975·B

ENGLEHART - ONT.

ENGLEHART - ONT.

ENGLEHART - ONT.

974·B

Canada's first official air mail

Over the years, various methods have been used to transport mail to distant communities across Canada – boats and ships, trains, motor vehicles, and aircraft. The postal service has adapted new technologies to ensure the rapid and efficient conveyance of mail from sender to receiver.

Captain Brian A. Peck, Royal Air Force (Canada), successfully completed the first officially sanctioned air-mail flight in Canada on 24 June 1918. Flying a Curtiss JN 4 biplane from the Bois Franc Polo Grounds in Montreal, Quebec, to Leaside, Ontario (an eastern suburb of Toronto), with stops near Kingston and at Deseronto, he completed the flight in under seven hours.

The flight was conceived by the Montreal Branch, particularly the treasurer, Edmund Greenwood, of the Canadian Division of the Aerial League of the British Empire as a means to arouse public interest in aviation. Permission to carry mail by air was accorded by the deputy postmaster general, R.M. Coulter, who also appointed Greenwood as acting aerial postmaster (Monreal) on this occasion. An estimated 124 items, consisting of mail randomly chosen from the ordinary Montreal mail together with official correspondence and civic greetings, were secured in the mail bag.

This first flight cover was forwarded from L.J. Gaboury, chief post office superintendent, Eastern Division, Canada Post Office, to Greenwood, and bears the distinctive inverted triangular-shaped aerial mail cachet that was applied to the mail carried on this flight. The accompanying official warrant authorized the department messenger to turn the special mail bag over to Greenwood. The bag was delivered to William E. Lemon, postmaster at Toronto, at the end of the flight.

Although Peck had demonstrated the feasibility of intercity aerial mail service, regularly scheduled flights were not established by the Post Office Department till later. This postal cover and warrant remain as evidence of Canada's first officially sanctioned air mail.

Flown Cover, Official Warrant
Canada's first officially sanctioned aerial mail flight
23/24 June 1918
Acc. 1989-565

IV

The Official Record of Canada's Past

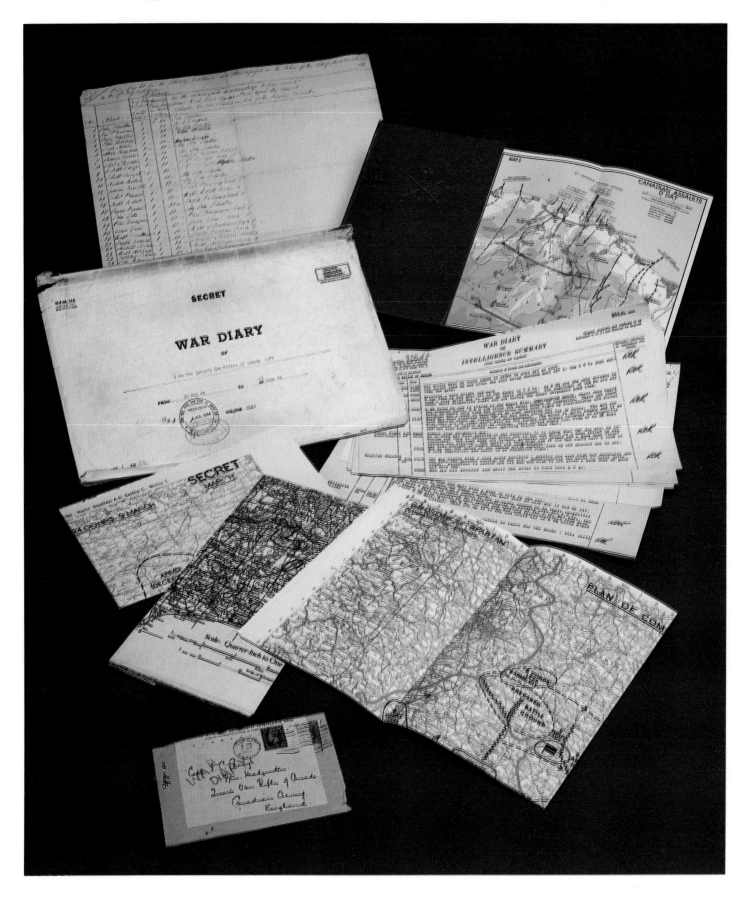

Government Records

In 1867, the British North America Act gave the new federal government of Canada certain specified responsibilities, including taxation, defence, transportation, postal services, fisheries, immigration, and natural resources. In directing the growth and development of the country, the various government departments created records to document their own administration, operations, decisions, and accomplishments. Since Confederation, the nature and format of records have evolved from dockets, registers, and letterbooks to modern file-management techniques and automated computer systems. Regardless of changes in the medium, however, the federal government continuously creates and collects information on virtually every aspect of the Canadian experience and has done so since 1872.

Government records document the evolution of Canada from a federal perspective, its trials and triumphs in times of peace and in times of war. Collectively, they constitute the memory of the nation and offer a window on the past, thus providing us with the means to know ourselves better as Canadians. If records-keeping is an ongoing and integral function of the federal government, the nature of that information and its uses have changed over time. In the 1990s, government touches the lives of individual Canadians in many ways – taxes, family allowances, postal services, social insurance numbers, and regulations that bear on a host of personal and business activities. In our daily lives, the federal government swirls around us through government-funded broadcasting, transportation facilities, and a myriad of seen and unseen activities. This has not always been the case. Government involvement in the daily lives of individuals has evolved over the past 125 years from little contact in the nineteenth century to more comprehensive intervention today. In the process, activities by and on behalf of Canadians have been thoroughly documented in records maintained by the federal government and now preserved in the National Archives.

In the years between Confederation and the First World War, the day-to-day lives of Canadians were hardly touched or noticed by the government in Ottawa, and most Canadians preferred it that way. Aside from efforts to 'count' Canadians once every ten years (the decennial census actually began in 1851), detailed personal information about individuals was rarely collected by the federal government. With few exceptions, average Canadians seldom encountered any representative of the government in the four decades from Confederation to 1914.

The period between 1914 and 1945, defined by the beginning of one war and the conclusion of a second, witnessed a dramatic and fundamental change in the role of government in the lives of individual Canadians. The First World War, for example, saw the introduction of a temporary measure called income tax, while the vicissitudes of war eventually forced the government into a wide range of regulations and prohibitions: conscription, wheat sales, liquor, and consumer prices, to mention only a few. The exigencies of war also forced the government to become more aware of the health and welfare of individual Canadians, from pensions for veterans to old-age allowances in the 1920s. The Depression of the 1930s only underlined the need for increased state action, as hundreds of thousands of Canadians turned to the government for assistance in the struggle to survive. The outbreak of the Second World War in 1939 accelerated the process and led to the incursion of the federal government into the financial and industrial workings of the country, while individuals too were subjected to unprecedented regulations and controls.

At the coming of peace in 1945, Canada was a different nation from the one it had been thirty years before. The intervening decades from then to the present have witnessed further government intervention in the lives of ordinary Canadians. This evolutionary process has been documented by the acquisition and preservation of government records having historical and archival value.

Within a few years of Confederation, the federal gov-

ernment recognized the need for a national archives. During the first four decades of its existence, the Archives concentrated on records created by other governments – Great Britain and France – that had a direct bearing on the history of Canada. In 1903, the Archives was given responsibility for the care and custody of public records, a responsibility that was clearly spelled out in Canada's first archives act in 1912. Initiatives were taken to acquire records created by federal government departments and agencies, but efforts in this direction met with only limited success in the 1920s and 1930s. The rapid expansion of government activity during the years of the Second World War was a major factor in focusing attention on the voluminous records created during those years. The establishment of the Public Records Committee in 1944 and a new emphasis on records management policies and techniques in government in the 1950s set the stage for the more centralized control of records creation and disposition in the past thirty years.

The Archives played a central role in this evolutionary process and now occupies a pivotal position within government in trying to control the information revolution and to ensure that records of historical and archival value are preserved. In its daily business, the federal government creates a massive amount of information, but of all records generated by the government, only a small percentage, less than 10 per cent, is identified, selected, and eventually added to the Archives' permanent holdings. Today, the National Archives is responsible for the textual and machine-readable records of the federal government, over 60 kilometres of textual records, 19,000 reels of microfilm, and 2000 data files that document the evolution of the government and, by the same token, the evolution and development of Canada from a pioneer society to the challenges of the twenty-first century. Collectively, these records constitute a great national treasure of value not only to the government, but also to each and every Canadian who seeks to learn of our nation's past, its people, its institutions, and the essence of the national experience.

This chapter illustrates this evolution by looking at a small selection of documents found in government archives. Some documents have intrinsic value, such as the 1822 Indian Treaty and the 1982 Constitution Proclamation; others are representative of the vast storehouse of government records in the National Archives.

The Chippewa Nation surrenders its land

On 8 July 1822, the Chippewa Nation formally surrendered to the British Crown, through William Claus, deputy superintendent of Indian affairs for Upper Canada, approximately 580,000 acres of land north of the River Thames in the London and Western Districts of present-day Ontario. The treaty extinguished for all time any native claim to the land for a payment of £2 10 shillings 'in goods and merchandise' to every man, woman, and child then inhabiting this vast tract of land. With its twelve totems, it is a striking example of the many treaties that are found in government archives. Each totem signifies the hereditary symbol associated with a clan or tribe.

For better or for worse, native North Americans and European settlers have coexisted on the continent for hundreds of years. The federal government and its predecessors have been intimately involved with the native peoples from the time of first settlement. The nature of that coexistence is debated still and, while past history cannot be rewritten, the relationship between native and non-native can be renewed or restyled in a context more equitable to the former. With the increasing development of native self-awareness in the past decade, virtually all aspects of the relationship between native and non-native, particularly the question of lands claims, have come under intense scrutiny.

Government archives include historical records, some dating from the seventeenth century, on all aspects of state administration of aboriginal peoples, from the provision of health care to schools. These records are critical to the current debate and have been widely used by historians, social scientists, and government researchers. More importantly, they have been used by native people themselves to struggle through the tangle of current land claims and to discover their own heritage.

Treaty with Chippawa Nation, 1822
Records relating to Indian Affairs
RG10, vol. 1842

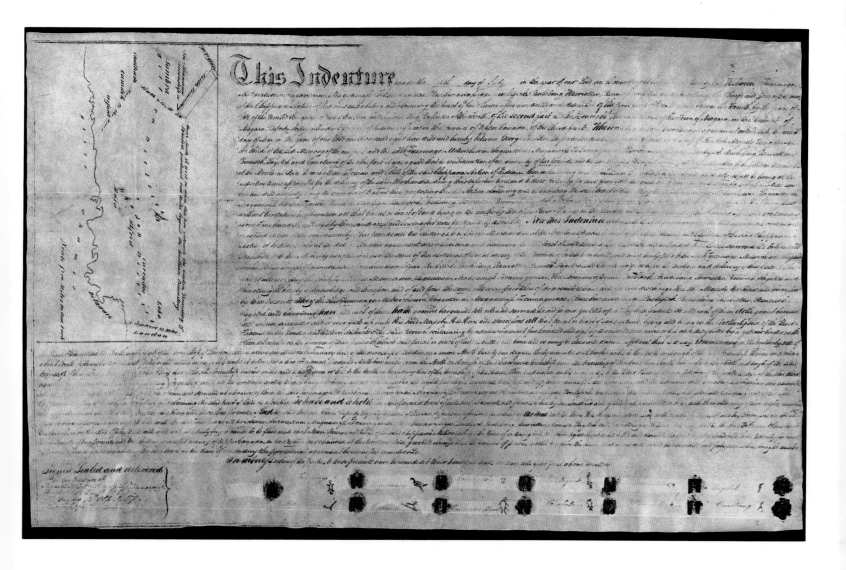

A nation's birth is entered in a ledger, 1867

It is a simple ledger entry in the careful handwriting that is the hallmark of so much nineteenth-century documentation, yet it is an entry that conveys the beginnings of a nation. This entry records the expenses incurred by the Canadian delegation and the delegates from Nova Scotia and New Brunswick who travelled to London, England, in the fall of 1866 to oversee the passage of the British North America Act and the creation of the Dominion of Canada. The delegates met in conference at the Westminster Palace Hotel from 4 December until Christmas. Some minor revisions were made to the terms agreed upon earlier at the Quebec Conference in 1864 and incorporated in the draft legislation. The British North America Act became law on 1 July 1867. Did the clerk who entered these numbers into the Finance Department ledger experience any special excitement at doing so, or was it simply another entry among many?

In themselves, financial records may not appear to be very interesting, nor have they been used extensively in historical research. Ledgers, journals, vouchers, and related documentation, however, represent the day-to-day financial transactions of the government. These records document the financial life-blood of the nation, its works, operations, and activities on behalf of all Canadians from Confederation to the present day. In this simple entry, one can see the promise of a nation that was envisioned by British North Americans and their desire to create a new nation in 1867.

Records of the Finance Department, some of which date from the eighteenth century, and of related agencies such as the Treasury Board, Customs and Excise, and Auditor General's Office, to mention only a few, document the internal workings of government administration, the policies and programs that have been developed and modified over time to give substance to the promise first made by the Fathers of Confederation in 1867.

Government of Canada ledger, 1866–7
Records of the Department of Finance
RG19, vol. 1480, folio 185

Expenses connected with Confederation & Imperial Legislation.

Copyright Duty.

Towards cost of Confederation Medal.

Bank Imposts.

Parliament Hill: The deed to a national symbol

One of the most enduring symbols of our nationhood is Parliament Hill, with its grand Gothic-style buildings and a majestic view of the surrounding city and countryside. The Parliament Buildings grace our currency and our postage and are instantly associated throughout Canada with the federal government. Beyond its purely symbolic value, it is the home of our national political institutions, the place where decisions are taken and policies enunciated that have an impact on Canadians in every corner of the land.

The Parliament Hill lands were conveyed from Hugh Fraser to the crown on 18 June 1823 for public use. Lands transferred to the crown are described in the deed and consisted of about 415 acres; in modern terms, the deeded parcel consisted of all lands north of Wellington and Rideau streets extending from Bronson Avenue in the west to the Rideau River in the east.

From wild bush land and partially cleared farm land in the 1820s, the central portion of these lands was transformed into a magnificent set of Gothic-style buildings after Ottawa was chosen as the national capital of the new dominion created in 1867. Parliment Hill consists of three impressive buildings: the Centre Block, which includes the House of Commons, the Senate, and the Library of Parliament; the East Block; and the West Block. Construction began in 1859 and was completed by 1865. The Centre Block was officially opened in June 1866. Fifty years later, in February 1916, a spectacular fire completely razed the Centre Block. Rumours abounded that enemy agents had torched the building, but the real culprit was careless smoking in the Library. While members of the House of Commons and the Senate carried on their deliberations in a local museum, the Parliament Buildings were rebuilt to their former grandeur, reopening in 1921.

Parliament Hill has been a silent witness to many of the great personalities and events of Canadian history since the time of Confederation. It is a unique symbol of Canadian nationhood, a focal point for national identity and consciousness.

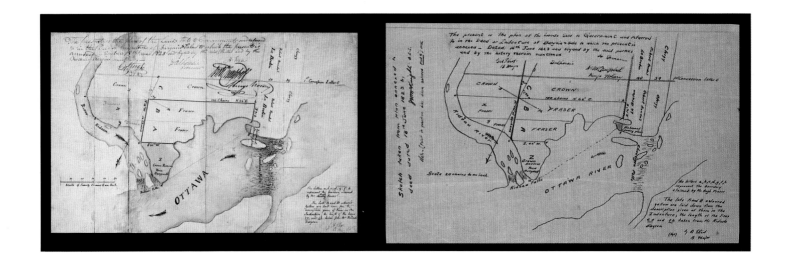

Deed, 18 June 1823
Records of the Canadian Parks Service
RG84, acc. 1990–91/239

This Indenture

made the Eighteenth day of June in the year of Our Lord One thousand eight hundred and Twenty three at the City of Quebec in the Province of Lower Canada By and between [...] one of the Prothonotaries of the Court of King's Bench of the District of Three Rivers **Of the one Part** and [...] Excellency George Earl of Dalhousie Knight Grand Cross of the Most Honourable Military Order of Bath Captain General and Governor in Chief in and over the province of Lower Canada Vice Admiral of the same &c &c &c acting for and in behalf of His Majesty George the fourth King [...] of the United Kingdom of Great Britain and Ireland [...] King Defender of the faith His Heirs and Successors **Of the other Part** [...] said parties in the presence of the undersigned Witnesses who were present at the Signing Sealing and delivery hereof have agreed acknowledged [...] stipulated and covenanted and by these presents Do acknowledge declare stipulate covenant and agree to and with each other in manner following **Whereas** His Majesty's government with consent for purposes of public utility of certain lots of land situate in the [...] Township of Nepean in the District of [...] in the Province of Upper Canada hereinafter described **And Whereas** the said Hugh Fraser did declare that he is now the true lawful and rightful owner of all and singular the said lots of land and premises mentioned in the Plan hereunto annexed and signed by the said Hugh Fraser and by His said Excellency the Earl of Dalhousie and now is lawfully and rightfully seized in his own right of a good sure perfect absolute and indefeasible estate of Inheritance in fee simple of and in the premises hereby intended to be granted bargained and sold without any condition or limitation of Use or Uses or any other matter of thing to alter change charge incumber or defeat the same and did as such true lawful and rightful Owner Offer to grant sell convey [...] of convey and confirm unto His said Majesty George the fourth His Heirs and Successors the said lots [...]

Counting the people and the land

Beginning in 1851, the government of the United Canadas ordered a census of the population of all those living in what is now Quebec and Ontario. It was the first decennial census undertaken to determine the size and nature of the Canadian population. Agricultural and industrial information was also collected, providing the government with a wealth of statistical information that could be used in the formulation of national policies.

The 1871 census return for Montreal East is a typical example of a nineteenth-century nominal return for urban dwellers, showing name, age, nationality, occupation, ability to read and write, and other data. Census records, however, are more than nominal returns. In 1871, for instance, enumerators were obliged to complete a total of nine schedules. In addition to the nominal return of the living, returns were also compiled for the following information: those who had died in the twelve-month period preceding the census; public institutions, real estate, vehicles and implements; cultivated land, field products, plants, and fruits; livestock, animal products, homemade fabrics, and furs; industrial establishments; forest products; shipping and fisheries; and mineral products. These records offer a comprehensive snapshot of Canadians and their way of life in 1871.

Since the creation of the Dominion Bureau of Statistics in 1918 (now Statistics Canada), the federal government has collected, compiled, analysed, and published statistical data on virtually every aspect of our daily lives and continues to do so. Monthly labour-force statistics and the consumer price index are only two of the most widely known reports issued on a regular basis by the government on matters affecting the general population and national economic activity.

Nineteenth-century census returns are among the most widely used government records in the custody of the National Archives. These records are used primarily, but not exclusively, by family historians. In recent years, social scientists and historians have discovered the riches to be found in census records and in other statistical information collected by the federal government. Statistical documentation now in the custody of the Archives (much of it stored on modern computer tape) will assist future investigators when they delve into the habits and lifestyles of twentieth-century Canadians.

Census return, schedule 1, Nominal Return of the
Living District 105, Montreal East, 1871
Records of Statistics Canada
RG31, vol. 956

No	Num.					Noms	Sexe	Age	Nés dans les douze derniers mois	Pays ou Provinces de naissance	Religion	Origine	Profession, occupation ou métier	Marié en cours de voyage	Marié dans les douze derniers mois	Allant à l'école	Au dessus de 20 ans ne sachant lire	Au dessus de 20 ans ne sachant écrire	Sourds muets	Aveugles	Aliénés	Dates de l'Enregistrement et Remarques
1						McCormick Mary	f	4	–	Q	Catholique	Irlandaise	–	–	–	–	–	–	–	–	–	
2						" Joseph	M	2	–	"	"	"	–	–	–	–	–	–	–	–	–	
3						Crilly Margary	f	19	–	"	Catholique	"	servante	V	–	–	–	–	–	–	–	Rue Lagauchetière 405
4	202	235				Breen Mary	f	62	–	Irlande	Catholique	Irlandaise	–	V	–	–	–	–	–	–	–	
5						" Cecelia	f	32	–	"	"	"	–	–	–	–	1	–	–	–	–	(Loue)
6	203	236				Lacroix Charles	M	50	–	Q	"	Française	Commerçant	M	M	–	–	–	–	–	–	
7						" Mathilde	f	50	–	"	"	"	–	M	–	–	–	–	–	–	–	
8						" Adolphe	M	20	–	"	"	"	Menuisier	–	–	–	–	–	–	–	–	
9						" Olibrius	M	18	–	"	"	"	Machiniste	–	–	–	1	–	–	–	–	
10						" Charles	M	10	–	"	"	"	–	–	–	–	–	–	–	–	–	
11	204	237				Campbell John	M	27	–	Irlande	"	Irlandaise	Forgeron	M	M	–	–	–	–	–	–	
12						" Mary	f	23	–	Q	"	"	–	M	M	–	–	–	–	–	–	
13						" John	M	3/12	Août	"	"	"	–	V	–	–	–	–	–	–	–	
14						" Mary	f	53	–	Irlande	"	"	–	–	–	–	–	–	–	–	"	
15	205	238				Carroll James	M	45	–	"	"	"	Cordonnier	M	–	–	–	–	–	–	"	
16						" Bridget	f	22	–	"	"	"	–	M	–	–	–	–	–	–	"	
17	206	239				St Jean Moïse	M	25	–	Q	"	Française	Cordonnier	M	Sept	1	1	–	–	–	"	
18						" Caroline	f	24	–	"	"	"	–	M	Sept	1	1	–	–	–	"	
19						St Jean Maxime	M	23	–	"	"	"	Journalier	M	–	1	1	–	–	–	"	
20						" Cordelia	f	16	–	"	"	"	–	M	–	–	–	–	–	–	"	

No	Num.					Noms	Sexe	Age	Nés dans les douze derniers mois	Pays ou Provinces de naissance	Religion	Origine	Profession, occupation ou métier	Marié en cours de voyage	Marié dans les douze derniers mois	Allant à l'école	Au dessus de 20 ans ne sachant lire	Au dessus de 20 ans ne sachant écrire	Sourds muets	Aveugles	Aliénés	Dates de l'Enregistrement et Remarques
1	207	240				Bingham John	M	48	–	Irlande	E. d'Angleterre	Irlandaise	Plâtrier	M	–	–	–	–	–	–	–	Rue Lagauchetière (Loue)
2						" Marguerite	f	55	–	"	"	"	–	M	–	–	–	–	–	–	–	
3	208	241				McDougall D. Alexr	M	35	–	Ecosse	Prot. Presbyt.	Ecossaise	Marchand	M	–	–	–	–	–	–	–	No 403
4						" Emily	f	25	–	Angleterre	"	Anglaise	–	M	–	–	–	–	–	–	–	
5						Un enfant pas encore nommé	M	1/12	Mars	Q	"	Ecossaise	–	–	–	–	–	–	–	–	–	
6						Hyde Jane	f	23	–	"	E. d'Angleterre	Anglaise	Servante	–	–	–	–	–	–	–	–	
7	209	241				Labelle Sévère	M	50	–	"	Catholique	Française	Marchand	M	–	–	–	–	–	–	"	377
8						" M. Louise	f	38	–	"	"	"	–	M	–	–	–	–	–	–	"	
9						" Romuald	M	17	–	"	"	"	Commis	–	–	–	–	–	–	–	"	
10						" Leonidas	M	14	–	"	"	"	–	–	1	–	–	–	–	–	"	
11						" Joseph	M	12	–	"	"	"	–	–	1	–	–	–	–	–	"	
12						" Philippe	M	3	–	"	"	"	–	–	–	–	–	–	–	–	"	
13						" Emilie	f	6/12	Oct	"	"	"	–	–	–	–	–	–	–	–	"	
14						Globenski Steven	M	22	–	"	"	"	Dentiste	M	–	–	–	–	–	–	"	
15						" Caroline	f	19	–	"	"	"	–	M	–	–	–	–	–	–	"	
16	210	242				Bourgeau Hector	M	62	–	"	"	"	Architecte	M	–	–	–	–	–	–	"	Rue Dorchester No 370
17						" Eduige	f	58	–	"	"	"	–	M	–	–	–	–	–	–	"	
18						" Louis	M	40	–	"	"	"	Agent	–	–	–	–	–	–	–	"	
19						Thérien Christine	f	24	–	"	"	"	Servante	–	–	1	–	–	–	–	"	
20	211	243				Trigg William	M	50	–	Angleterre	E. d'Angleterre	Anglaise	Marchand	M	–	–	–	–	–	–	"	392

The judges of Canada's highest court

The Supreme Court of Canada is the pinnacle of our judicial system. Although the court was established in 1875, it acted only as a general court of appeal in Canada. Judgments could be and were referred to the Judicial Committee of the Privy Council in Great Britain. In 1949 such appeals were abolished, however, and the Supreme Court asserted its role as the highest court in the land for all legal matters affecting both federal and provincial jurisdictions; the court is also the final court of appeal in both civil and criminal cases. The court is presided over by a chief justice and eight puisne or associate judges; the first chief justice was the Honourable Sir William Buell Richards (1815–89), appointed in 1875. Illustrated here is the first folio of the Judges' Roll, which contains the oaths of office and signatures of all the men and women who have been appointed to the Supreme Court since its inception.

With the repatriation of the Constitution in 1982 and the institution of a Canadian Charter of Rights and Freedoms, the Supreme Court has assumed greater responsibility for interpreting different points of law, many of which are rooted in a broad spectrum of political, economic, and social issues. It serves as the final court of appeal for criminal, civil, and constitutional cases. For this reason, more than ever before in its long history, the court's decisions have had and will continue to have an important impact on relations between the federal and provincial governments and, indeed, on the lives of individual Canadians.

Archival documentation bearing on judicial and legal matters is extensive. It includes the historical records and case files of the Supreme Court dating from 1875, Department of Justice records (some of which pre-date Confederation), and records of the Solicitor General.

Supreme Court Judges' Roll, first folio, 1875
Records of the Supreme Court of Canada
RG125, vol. 483

Roll of the Judges of the Supreme Court of Canada.

I _____ Do sincerely Promise and Swear that I will be faithful and bear true allegiance to Her Majesty Queen Victoria as lawful Sovereign of the United Kingdom of Great Britain and Ireland, and of this Dominion of Canada dependent on and belonging to the said Kingdom And that I will defend Her to the utmost of my power against all traiterous conspiracies or attempts whatever which shall be made against Her Person, Crown and Dignity And that I will do my utmost endeavour to disclose and make known to Her Majesty Her Heirs or Successors, all Treasons or traiterous Conspiracies and attempts which I shall know to be against Her or any of them And all this I do swear without any equivocation, mental evasion or secret reservation, and renouncing all pardons and dispensations from any person or power whatever to the contrary _____ So help me God.

I _____ Do Solemnly and sincerely Promise and Swear that I will duly and faithfully and to the best of my skill and knowledge execute the Powers and Trusts reposed in me as (Chief Justice or as one of the Judges) of the Supreme Court and of the Exchequer Court of Canada. _____ So help me God

Name.	Chief Justice or Puisne Judge.	How sworn	When sworn
Wm. B. Richards	Chief Justice	Sworn before Sir William O'Grady Haly, K.C.B. administrator of the Government in Council at Ottawa	Friday 8 October 1875
W. J. Ritchie	Judge	Sworn before the Chief Justice after Oath taken Ottawa	Monday 8 November 1875
S. H. Strong	Judge	Sworn before the Chief Justice at Ottawa	Monday 8 November 1875
J. T. Taschereau	Judge	Sworn before the Chief Justice	Monday 8th November 1875
T. Fournier	Judge	As above	Monday 8th November 1875
W. A. Henry	Judge	as above	Monday 8th November 1875

Registration in a maritime tradition

It is often forgotten that Canada is a maritime nation, with oceans on three sides and a network of inland seas. The first European settlements were close to the ocean or on inland waterways with access to the sea. For generations many Canadians have depended on maritime trade for both life and sustenance. Shipping is clearly representative of this dependence, particularly in the Atlantic provinces and Newfoundland and slightly less so on the West Coast and the Great Lakes. The registration record for the *Ethel Blanche* tells a story in itself. The *Ethel Blanche* (official number 74151), a three-masted barkentine of nearly four hundred tons, was built in 1875–6 at Mount Stewart, Prince Edward Island, by Edwin Coffin, and registered at Charlottetown on 27 May 1876. Owned by James, George, and Ralph Peake, prominent Charlottetown entrepreneurs, and Thomas Handrahan, a business associate, she was launched with pride, but eight years later met an ignoble end when she collided with an iceberg in the North Atlantic east of Newfoundland on 5 June 1884. She was abandoned the next day.

The National Archives has custody of registration records from virtually every port of registry in Canada. Collectively, they document Maritime Canada as no other record in our custody, allowing us to reconstruct the history of Canadian shipping, trade, local shipbuilding, and underwater heritage. These records provide rich source materials that can be used by genealogists searching for information about a sea-faring ancestor and by historians delving into the social and economic history of Maritime Canada.

Related records created by Transport Canada, the Department of Railways and Canals, the St Lawrence Seaway Authority, the National Transportation Agency, the Canada Ports Corporation, and their predecessor agencies document ports and harbours, canals, and marine transportation. Individuals who made the sea their lives, masters, mates, and merchant seamen, are also documented in the historical records of the government of Canada. Our maritime heritage is well served by the holdings of the National Archives.

Registration record for the *Ethel Blanche,* 1876
Records of the Marine Branch
RG42, vol. 1604, folio 69, reel C-3182

OFFICIAL NUMBER OF SHIP _74151_

NAME OF SHIP _Ethel Blanche_

Port Number _Eighteen_ /81	Port of Registry _Charlottetown Prince Edward Island_
	British or Foreign built _British_

Number of Decks _One_	Build _Carvel_
Number of Masts _Three_	Galley _Sweet_
Rigging _Barkentine_	Head _Scroll_
Stern _Elliptic_	Framework _Wood_

Gross Tonnage	In Imperial Tons	In Cubic Metres
Tonnage under Tonnage Deck	_355.35_	
Closed-in Spaces above the Tonnage Deck, if any, viz:—		
Space or Spaces between Decks	_11.03_	
Poop		
Forecastle	_42.98_	
Roundhouse of	_42.50_	
Other enclosed Spaces, if any, naming them _Roundhouse forward_		
Gross Tonnage	_436.76_	
Deductions as per contra	_38.80_	
Register Tonnage	_398.94_	

559 Tons

Names, Residence, and Description of the Owners, and Number of Shipwright Shares held by each Owner

James Peake	_Sixteen 16/ Shares_	
George Peake	_Sixteen 16/ Shares_	
Ralph Peake	_Sixteen 16/ Shares_	
Thomas Hendrahan	_Sixteen 16/ Shares_	
all of _Charlottetown, Prince Edward Island, Merchants_		

Dated _27th May 1876_ MASTER _William A. Learmond_

Whether a Sailing or Steam Ship; if Steam, how propelled	_Sailing_	Where built	_Mount Stewart Prince Edward Island_	When built	_15th May_ 1876

Measurements ...

PARTICULARS OF ENGINES (IF ANY)

Builder's Name and Address _Owen Coffin, Mount Stewart P.E. Island_

Col. 1	Col. 2	Col. 3	Col. 4	Col. 5	Col. 6
Number of Transaction	Date Number and Description of the Instrument, if any	Name of Person from whom Title is derived	Nature of Transaction and State of Transaction	Name, Residence, and Occupation of Grantors, Mortgagees, or other Persons acquiring Title to Ship	
1	_Ralph Peake Peake_	16	_14th March 1880 at 4.30 a.m._	_Capt. Peake Peake..._	_Edward James Hodgson, Cornelius George Martin DeBlois..._
2	_Edward James Hodgson George Martin DeBlois Thomas Henderson_	16	_16th March 1880 at 9.30 a.m._	_Bill of Sale dated 25th March 1880_	_James Peake (Northam) and George Peake (Northam) both of Charlottetown..._
3	_George Peake_	5	_29th March 1880 at 4 p.m._	_Bill of Sale dated 25th March 1880_	_Thomas Henderson of Charlottetown in Prince Edward Island, Merchant_
4	_James Peake_	2	_29th March 1880 at 4 p.m._	_Bill of Sale dated 29th March 1880_	_Thomas Henderson of Charlottetown in Prince Edward Island, Merchant_
5	_James Peake_	22	_13th January 1882 at 4 p.m._	_Bill of Sale dated 13th January 1882_	_George Peake and Thomas Henderson both of Charlottetown in Prince Edward Island, Merchant_

Collided with iceberg, Lat 46.48 N Long 49.25 W on the 5th June 1880, was abandoned following day.

Col. 8	Col. 9	Col. 10	Col. 11	Col. 12	Col. 13	Col. 14
	Name of Owner	Mortgagee		Number of Shares	Remarks	
	James Peake			16		
	George Peake			16		
No. 1	_Owen James Hodgson, George Martin DeBlois, Thomas Henderson_	_Joint owners_		16		
	Thomas Henderson			16		
		Total 16th March 1880		64		
No. 2	_James Peake_			24		
	George Peake			24		
	Thomas Henderson			16		
		Total 16th March 1880		64		
No. 3	_James Peake_			24		
No. 3 or 4	_George Peake_			21		
	Thomas Henderson			19		
		Total 29th March 1880		64		
No. 3	_James Peake_			22		
	George Peake			21		
No. 3 or 4	_Thomas Henderson_			21		
		Total 29th March 1880		64		
No. 2 or 5	_George Peake_			32		
No. 3 or 5	_Thomas Henderson_			32		
		Total 13th January 1882		64		

Certificate of Registry returned & cancelled. Registry closed on the 19th June 1880.

Founding the experimental farms

In November 1885, the federal Department of Agriculture asked William Saunders (1836–1914), a noted authority on agriculture and horticulture, to investigate and report upon the organization and operation of the experimental farm system in the United States and in certain European countries. Agriculture was the foundation of Canada's trade and commerce and a major factor in attracting immigrants to the western prairies, but the country was in a depression in the 1880s and some means had to be found to encourage and to develop its agricultural potential.

Saunders reported to the government in February 1886 and, by the end of the year, legislation was in place creating an experimental farm system in Canada. Saunders was appointed first director of the Central Experimental Farm, a 460-acre site near Ottawa that became the hub of the country's agricultural research. By 1890, four additional farms had been created at Agassiz, British Columbia, Indian Head, North West Territories, Brandon, Manitoba, and Nappan, Nova Scotia.

Canada remained a predominantly agricultural nation until the 1920s, although agriculture and farm products maintain a significant place in the Canadian economy. The creation of an experimental farm system was essential to the scientific development of agriculture in Canada and has allowed Canada to remain at the forefront in research and development. Experimental farms conducted investigative research in all areas related to agriculture, including livestock breeding, field husbandry, horticulture, and entomology. The development of new varieties or breeds suited to Canadian agricultural conditions was, and remains, a priority. The successful creation in 1907 of the early-ripening Marquis wheat, which had a tremendous impact on the country's economy, is one example of the work carried on under the auspices of Agriculture's experimental farms.

Letter, John Lowe, Secretary, Department of
Agriculture to William Saunders,
2 November 1885
Records of the Department of Agriculture
RG17, vol. 1552, folio 104
Plan of the experimental farm
RG17M, 78903/75, NMC 0024066

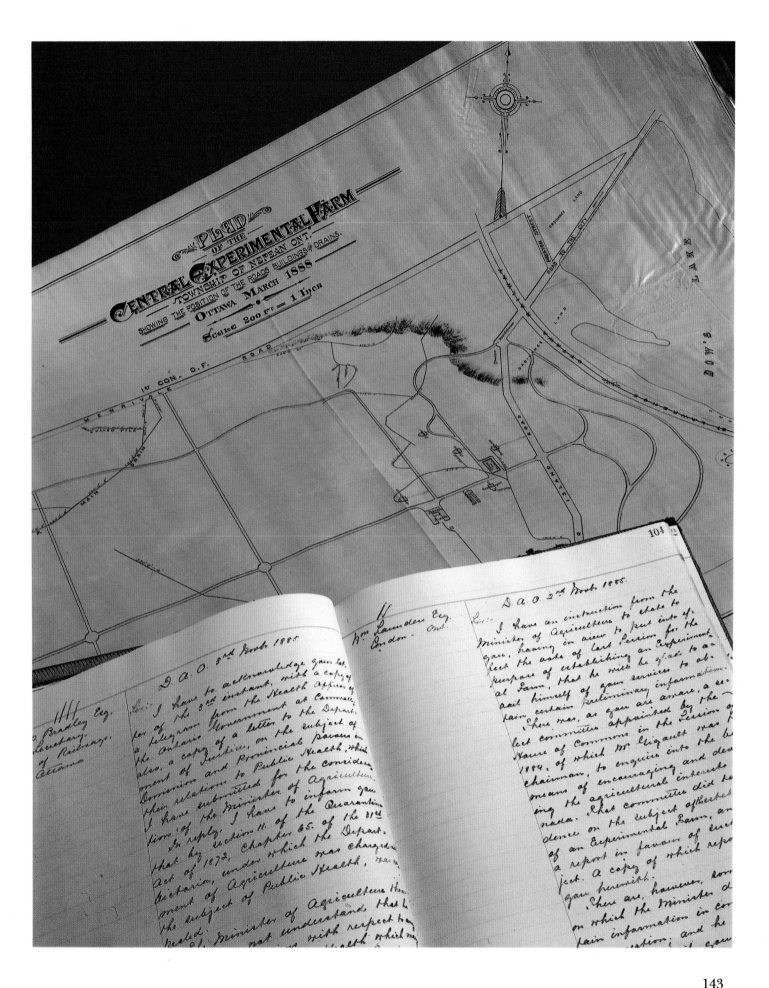

Joining the track – and the nation

Railways have been essential agents of Canadian development since the 1850s and were a significant factor in completing Confederation. British Columbia, a colony of Great Britain, agreed to enter Confederation in 1871 only on the understanding that a transcontinental railway would be constructed linking the West Coast with central and eastern Canada. It was a massive undertaking. To be built entirely in Canada, construction would take the line through the rugged Canadian Shield, across the barren prairies, and through little-explored mountain ranges to the Pacific Coast.

While the Canadian Pacific Railway Company built extensive portions of the line, the federal government itself undertook construction through some of the most difficult and hazardous terrain in all of Canada. 'The track was joined in Eagle Pass on Saturday morning the 7th' – this is the matter-of-fact way in which Marcus Smith, a government engineer, described the driving of the last spike to Collingwood Schrieber, his superior in Ottawa. What has become one of the most memorable scenes in Canadian history was significant for two reasons: first, the rail link to British Columbia was finally established and the land was now bound together from east to west; and, second, it emphasized the commitment of the federal government to nation-building, to ensuring that structures were in place that would allow the country to develop along an east-west axis.

Rapid and efficient transportation was an important consideration in the nineteenth century, all the more so in a country so vast and geographically diverse as Canada. Records created by the Department of Railways and Canals, Transport Canada, and a host of government agencies document the development and construction of railways in Canada, and the role played by the federal government in fostering other means of transportation so essential to nationhood.

Letter, Marcus Smith to Collingwood Schrieber,
12 November 1885
Records of Transport Canada
RG12, vol. 1993, file 3556-33, part 4

Kamloops. B.C.
Nov 12 - 1885 -

Collingwood. Schreiber Esq?
 Chief Eng? Gov't Railways.

 Dear Sir -

 The Track was joined in
Eagle pass on Saturday morning the 7th instant
and the train with Mr Van Horne + party came
through the same day , arriving at Port Moody
about noon next-day. I went so far
with them on the invitation of Mr Van Horne
and in conversation he contended that - with
the exception of Station Buildings and Water
supply the line is finished between Savonas
and the West crossing of the Columbia River
in accordance with the agreement between the
Government and the Company that is : to the
Standard of the Union Pacific Railway as it
was in 1873. I did not give any opinion
on the matter as I had no authority to do so.
I may however state to you that I travelled
twice over the Union Pacific Railway in 1873
and then it was far from finished . On a
great part of the Platte Valley and other flats
 the

National parks are born at Banff

Canada is a country uniquely blessed with an abundance of natural resources, geographic diversity, and natural beauty. Much of our history can be seen in terms of our relationship to the land: taming the land, conquering its vast distances, living amidst its great diversity, and using it to sustain an ever-growing population with all its needs. The intrinsic value of this natural and national resource was recognized by the federal government shortly after Confederation, and led to the establishment of a national parks system, first in the mountainous regions of western Canada and eventually throughout the country, from coast to coast.

In November 1883 two railway workers, Frank McCabe and William McCardell, discovered the hot springs and basin at Sulphur Mountain. In spite of controversy over conflicting claims, the federal Department of the Interior acted swiftly and set aside the area for the benefit and enjoyment of all Canadians. It was a momentous decision. The Banff Hot Springs was established as Canada's first national park in November 1885 and remains to this day one of Canada's best-known natural preserves and tourist attractions. Over two dozen national parks can be found across the country. The parks system has been developed and extended to preserve areas of natural beauty and national interest as a trusted legacy for all Canadians and visitors to Canada to enjoy.

The development of the parks system is thoroughly documented in the historical records in the custody of the National Archives. Records of the Canadian Parks Service, the Department of the Interior, Environment Canada, and related federal agencies tell the story of our relationship with the environment around us, and serve to remind us of our stewardship of this patrimony that we share as Canadians.

Poster, plan, and correspondence, Banff, 1880s
Records of the Canadian Parks Service
RG84, vol. 626, file 86776

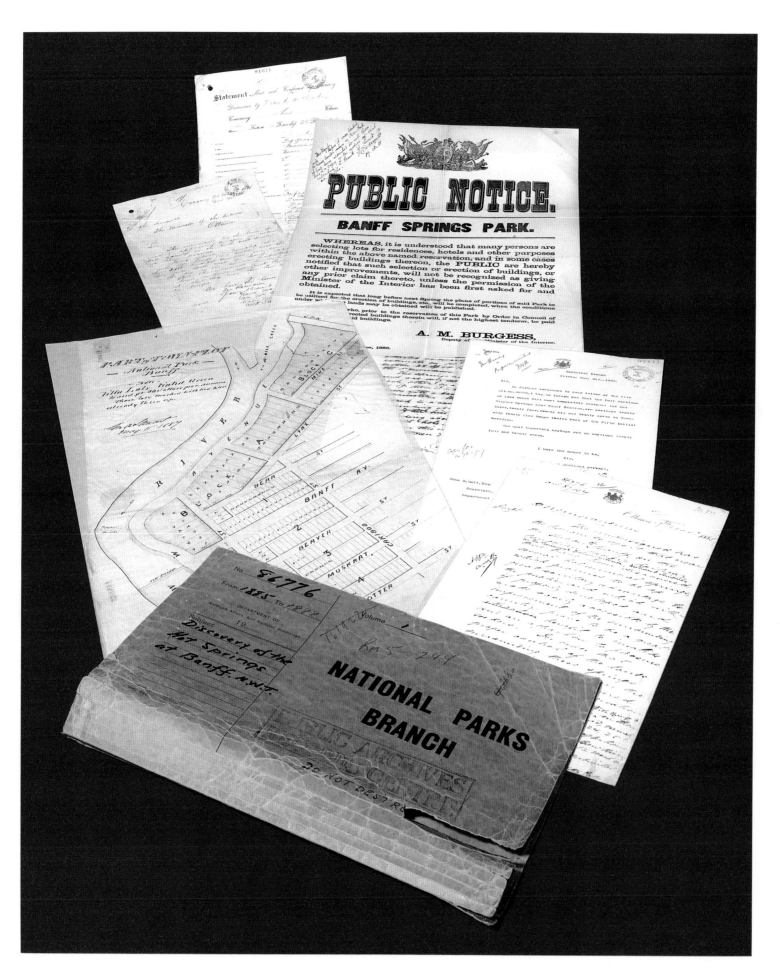

Brandon benefits from the government as builder

Federal government activity takes many forms and affects the day-to-day lives of Canadians in a variety of ways. Federal presence can be found in a number of cities, towns, and villages throughout the country. Since Confederation, in fact since the 1840s, the Department of Public Works has played a significant role in the planning and construction of government buildings and structures. Custom houses, post offices, canals, lighthouses, harbour facilities, telecommunications towers, armouries, federal office buildings, and the official residences of the prime minister and the leader of the opposition are all the responsibility of Public Works.

By the late 1880s, Brandon, Manitoba, was a boom city. Brandon is approximately 220 kilometres west of Winnipeg. In June 1888, a federal contract was awarded to local builder James Hanbury for a three-storey stone and brick edifice on Rosser Avenue. At a cost of approximately $50,000, the building was completed, and in September 1891 it was occupied by the Post Office Department, Customs, and Inland Revenue officials. This magnificent addition to the city landscape served Brandon for four decades, after which it was abandoned and subsequently torn down.

For those interested in architectural history, local history, urban development, and heritage matters in general, Public Works' records include plans, specifications, estimates, correspondence, photographs, and other materials.

Estimates for public buildings, Manitoba, 1891–2
Records of the Department of Public Works
RG11, vol. 3051, folios 137–8

Estimates of Canada for the Fiscal Year ending 30th June, 1892.

Public Works. **MANITOBA.** Chargeable to Income.

PUBLIC BUILDINGS.

BRANDON. Post Office etc. To complete.
T. M. Daly, M.P. (Selkirk)

(See Printed Estimate Book Vote _154_ Page _50_)

Revote $ _Nil_ Total Vote for 1891-92, $ _16,500_

Financial Year.	TOTAL APPROPRIATION.	EXPENDITURES.				Total Construction and Repairs.		REMARKS.
		Construction.		Repairs.				
	$	$	cts.	$	cts.	$	cts.	
1888	4,000	21	50			21	50	Site - Lots Nos 21,22,23 &
1889	15,000	6,722	"			6,722	"	24 purchased for $5460 from P.
1890	20,000	18,943	55			18,943	55	Holt & W. Beaufort & the Scottish
1891	21,000	11,364	90			11,364	90	Ont. Land Co: fronting 96 ft.
								Up to Dec 31/90 on Rosers Avenue depth 75 ft.
1892	16,500							together with a strip in the rear
								25 ft. wide on the lane & 132
						37,051	95	ft. deep through Eleventh St.

This Vote of $16,500 is to provide as per subjoined
estimate of the Chief Architect for completing in 1891-92
the public building which is being erected at Brandon for
Post Office, Custom House and Inland Revenue purposes.

Total expenditure up to 16 March 1891 $44,581.95
Balance due 16 March 1891 on Contract
and additional works — — 4,446.00
Furniture & fittings including lock boxes . 8,000.00
Fencing and foot paths 1,500.00
Architect — — 1,750.00
Clerk of Works 750.00
Incidentals 2,000.00
 Total probable cost of building $ 63,027.95
Deduct —
Total expenditure up to 16 March/91. $44,581.95
Balance on hand 16 March 1891 - 2,105.10 46,687.05

Grant required to complete in 1891-92 $ 16,340.90
 or say — 16,500.00
 Contract

Posters promote Canada's West

Canada is a land of immigrants and, ever since the 1870s, peopling this vast land has been the responsibility of the federal government. In the nineteenth century, advertising became the chief means of attracting settlers from the United States, Great Britain, and Europe. This advertising was done in many forms, and there are other examples elsewhere in this book. The posters illustrated here serve as a graphic reminder that hundreds of thousands of people from all over the world viewed Canada as a land of opportunity, a place to renew their lives and the lives of their families. The real immigration boom began in the 1890s and, with the exception of wartime and depression, has continued to the present.

Through a network of offices in Great Britain and Europe, immigration agents extolled the virtues of settlement in the Canadian West with posters, pamphlets, and lectures. Clifford Sifton, federal minister of the interior from 1896 to 1905, launched an ambitious campaign for immigrants, attracting them to Canada with promises of free land and assisted passage. Since the Second World War and especially in the past twenty years, Canada has earned a reputation as a safe haven for the displaced, the refugees, and all those who leave their homelands with hope in their hearts for a new start.

This central fact of Canadian history is thoroughly documented in the immigration records in the National Archives. Historical records of the Immigration Branch include an extensive collection of passenger lists dating from 1865 to 1918, and policy and subject files on a wide range of immigration matters, from advertising schemes and group settlement to juvenile immigrants. Canada's multicultural character has been determined by the ebb and flow of immigration since Confederation; government records document the creation of that mosaic.

Immigration posters
Records of the Immigration Branch
RG76, vol. 418, file 608414
Records of the Department of Agriculture
RG17, vol. 1668, file 1886–90, Ah-Al
Records of the Department of the Interior
RG15, vol. 336, file 6300

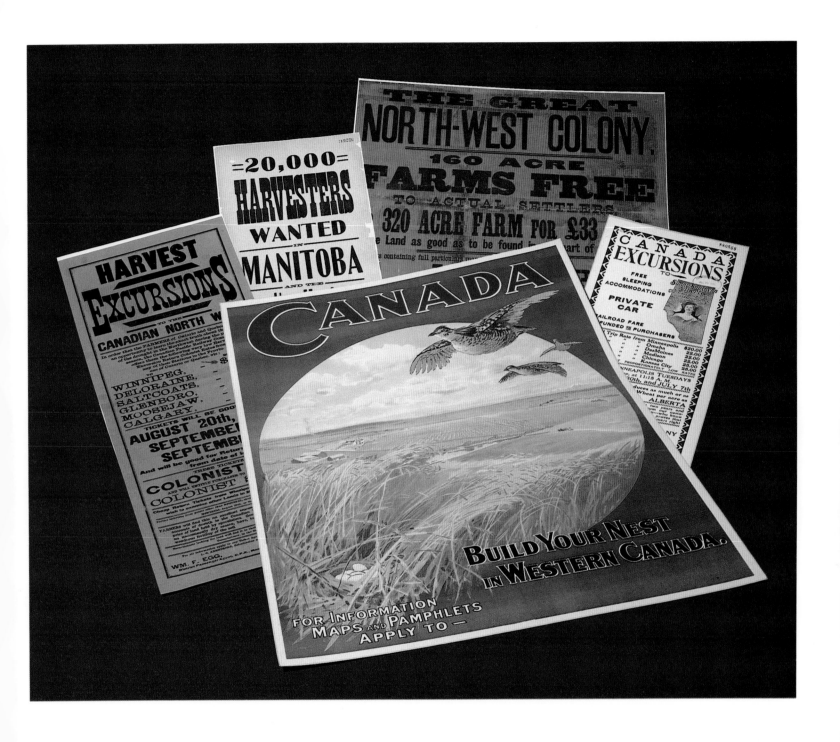

The Mounties get their man – finally

The North-West Mounted Police force was organized in the spring of 1873 in response to the administrative organization of the North-West Territories, now Alberta and Saskatchewan. The force played a crucial role in overseeing the orderly settlement of the prairies from the 1870s until the First World War and was instrumental in establishing trust between native peoples and settlers, ensuring the peaceful development of the Canadian West. Renamed the Royal Canadian Mounted Police in 1919, it now is a sophisticated national police force.

One of the most enduring symbols of Canada has been that of the red-coated Mountie. The saying that the Mounties 'always get their man' is of course a myth, but for convicted murderer and escapee Ernest Cashel, nothing could be closer to the truth. Cashel was a young American, reputedly a member of the infamous Hole-in-the-Wall Gang and accomplice of Butch Cassidy and the Sundance Kid, who ventured into Canada in the fall of 1902. First arrested in Calgary for forgery in October of the same year, he escaped from police and remained at large until the following spring, when he was arrested and jailed for horse stealing. When it was subsequently discovered that he had also murdered a rancher, murder charges were brought against him and Cashel was sentenced to hang on 15 December 1903. Just days before meeting his fate, Cashel escaped custody with help from his brother, robbed several ranchers, and again eluded police. One of the largest manhunts in RCMP history was undertaken before Cashel was finally recaptured by the Mounties in January 1904. He walked to the gallows at Calgary on 2 February.

Historical records of the RCMP document many aspects of the opening of western and northern Canada. Patrol reports from northern detachments, for example, are among the most important records in the Archives for an understanding of the transformation of the North in this century. While Mounted Police records document aspects of the underside of Canadian society, they also tell the stories from which myths are made and symbols emerge.

Poster and correspondence about Ernest Cashel, 1903-4
Records of the Royal Canadian Mounted Police
RG18, vol. 310, file 124, parts 1–4
Records of the Department of Justice
RG13, vol. 1444

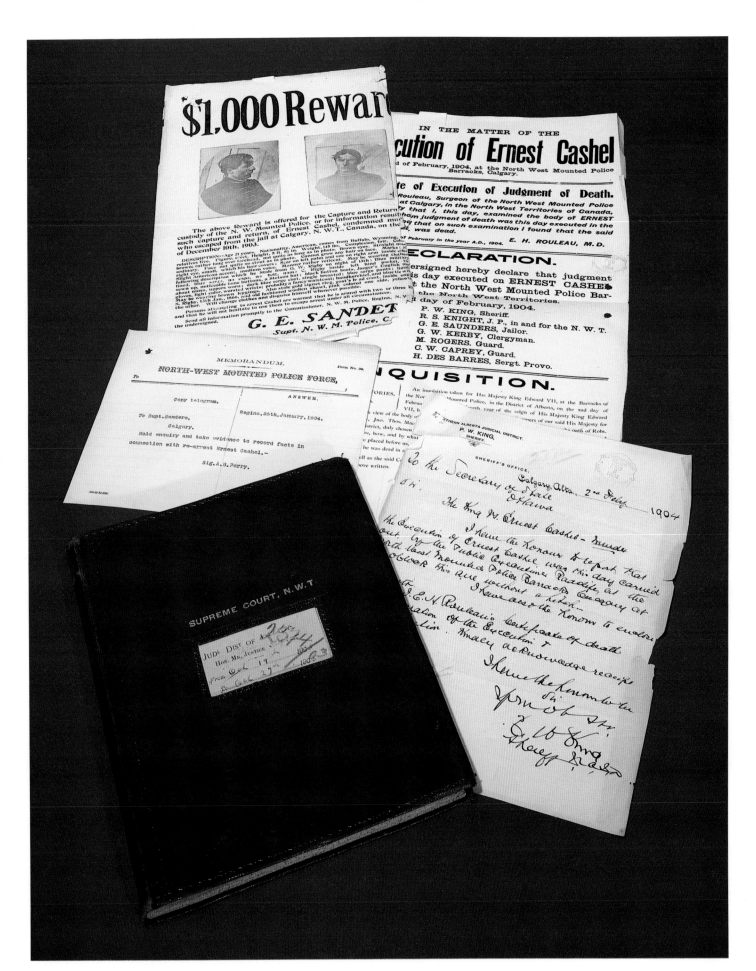

Migratory birds receive protection

The ratification of the Migratory Birds Convention in 1917 was a significant development in halting the careless destruction of our avifauna. Before the convention, some species of birds were decimated. The passenger pigeon was hunted to extinction while the magnificent whooping crane was reduced to a token number. To halt this process of wanton destruction, action was required by the governments of both Canada and the United States. It was a long and complicated process involving the Canadian, American, and British governments of the day. International agreement was required in the struggle to overcome prevailing attitudes to North American birdlife.

Gordon Hewitt (1885–1920), appointed dominion entomologist in 1909, almost singlehandedly brought these concerns to the attention of the federal government. Beginning in 1913, Hewitt proposed that a treaty be negotiated with the United States to protect migratory birds common to both the United States and Canada. He assisted in these negotiations and in the subsequent drafting of the regulations, which were designed to prevent the indiscriminate hunting of migratory birds and establish specific times during the year when certain species could be hunted. Regulation was the first step towards preservation, and Hewitt was above all a dedicated conservationist. He recognized that birdlife was symptomatic of larger issues affecting the natural environment in Canada, a country that abounds in bird and animal wildlife.

Records in the National Archives of Canada document the discovery and development of Canada's natural resources, from minerals and oil to fish, birds, and wildlife and their preservation for the use and enjoyment of all Canadians now and in the future. Concerns about environmental damage and pollution and the depletion of our natural resources in the past decade are reminders that the environment around us is to be protected and preserved.

Letter, Gordon Hewitt to J.B. Harkin,
20 February 1918;
Regulations under the Migratory Birds Convention Act
Records of the Canadian Wildlife Service
RG109, vol. 114, file WLU 10, parts 1 and 2

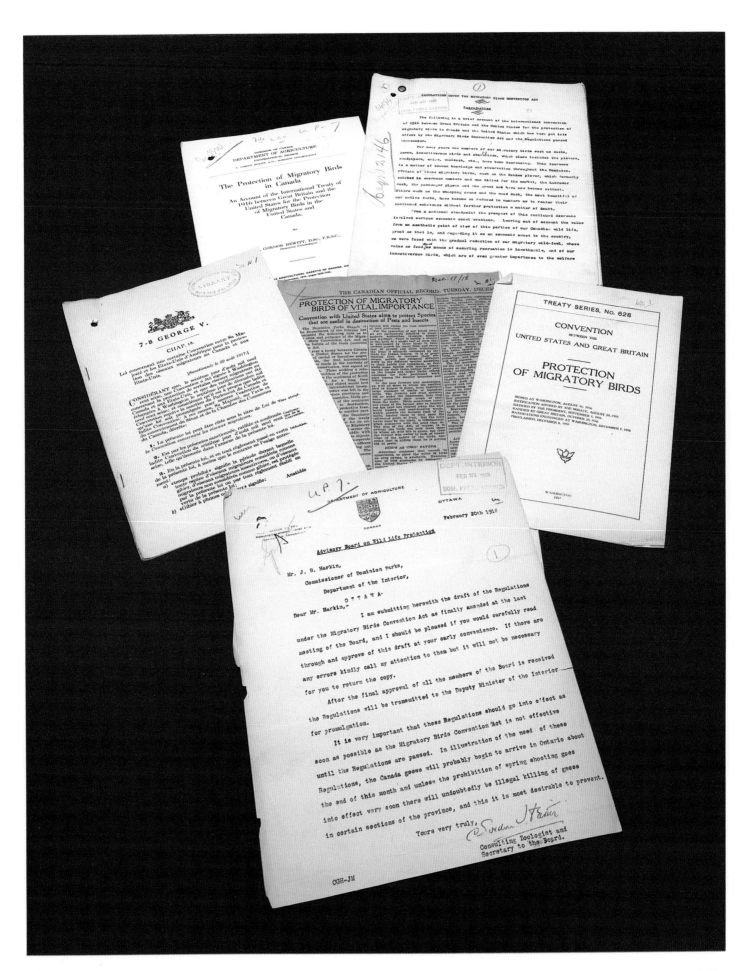

Trans-Canada Air Lines becomes a national carrier

Crown corporations are a unique federal contribution to the corporate landscape in Canada, especially in areas where private enterprise has been unwilling or unable to provide a particular service or product. Nevertheless, crown corporations have long been the object of controversy in political and financial circles, and in recent years many government-owned or controlled companies have been privatized. Trans-Canada Air Lines, known as Air Canada since 1965, was established in April 1937 as a government-owned corporation to provide an air passenger and mail service in Canada. Just as the transcontinental railway was seen as a ribbon of steel linking the regions of the country, a national airline was envisaged as a means of overcoming Canada's vast distances. In fact, TCA was closely linked with another government-controlled corporation, Canadian National Railways.

TCA commenced operations on 1 September 1937 with passenger service between Vancouver and Seattle, and extended the service on 1 April 1939 with flights from Montreal and Toronto in the east to Vancouver on the West Coast. It was long regarded as Canada's national air carrier.

In addition to being the national repository for the records of the government of Canada, the National Archives has also acquired the historical records of many crown corporations. In addition to Air Canada, records have been acquired from Canadian National Railways, Canada Post Corporation, Canada Ports Corporation, Eldorado Nuclear, Canadian Commercial Corporation, and others. These records reveal the nature and extent of government involvement in the corporate boardrooms of the nation and, ultimately, in the lives of all Canadians.

Airline schedules,
Trans-Canada Air Lines Board of Directors'
minutes, and ephemera
Records of Air Canada
RG70, vol. 45 (schedules); 378 (Board minutes);
other items from vol. 113 and 124

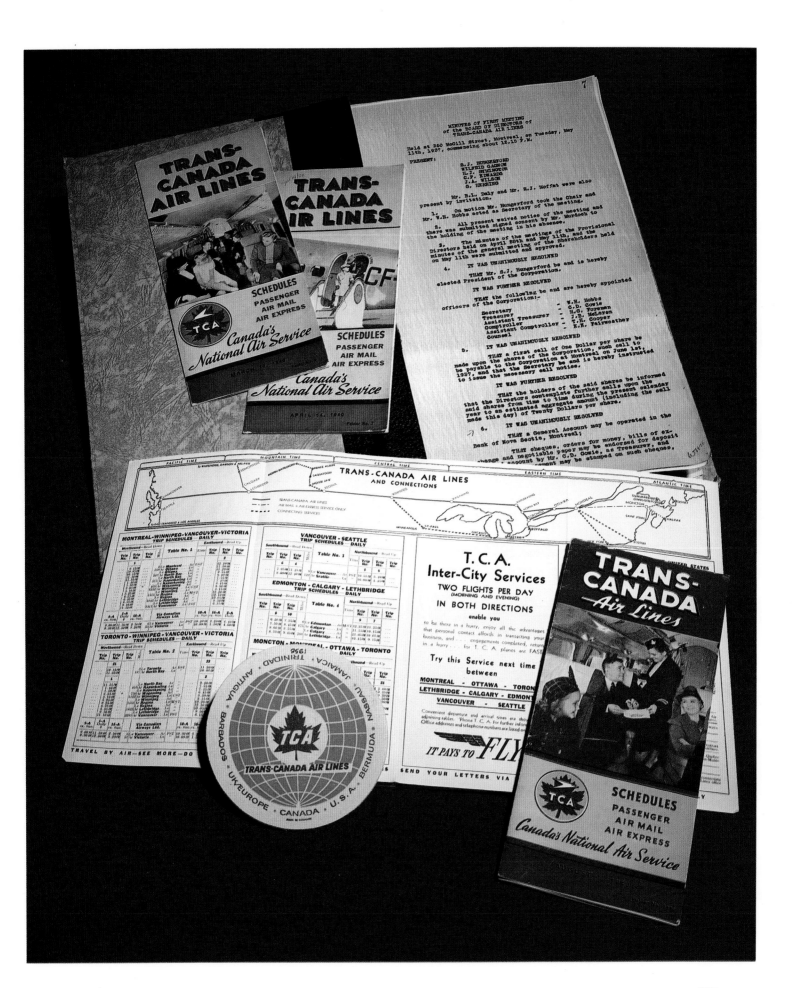

The country embarks on social welfare, 1944

On 13 June 1944, the federal cabinet discussed the introduction of a family allowance, or 'baby bonus' program, to take effect from 1 January 1945. This was the first universal welfare initiative undertaken in Canada, and served as a precursor to a wide range of social programs sponsored by the federal government for the young, the elderly, and the disabled. The concept of a family allowance for all children under the age of sixteen emerged from a broader examination of social security needs in Canada, specifically those described by Leonard Marsh in his *Report on Social Security in Canada*, which appeared in 1943. The allowance (initially six dollars per child per month) was designed to provide children with the basics: food, clothes, and shoes. Although hotly debated in some social work circles, this legislation, embodying a bold new initiative in social policy, passed through the House of Commons unanimously.

The structure of government bureaucracy in Canada is hierarchical in nature and at the pinnacle rests the Privy Council Office, secretariat to the Prime Minister's Office and the cabinet. Records created at this level of decision-making are among the most valuable for an understanding of Canadian government and of the role that government plays in the lives of individual Canadians. Cabinet, however, did not maintain a formal record of decisions, or 'conclusions,' until 1944; the cabinet discussion on the family allowance is an example of this type.

Historical records created by cabinet and the Privy Council Office consisting of conclusions, orders in council, cabinet committee records (including the Cabinet War Committee, 1939–45), correspondence, and central registry subject files are crucial to the documentation of the central decision-making process of the government of Canada.

Cabinet conclusions, 13 June 1944
Records of the Privy Council Office
RG2, vol. 2636

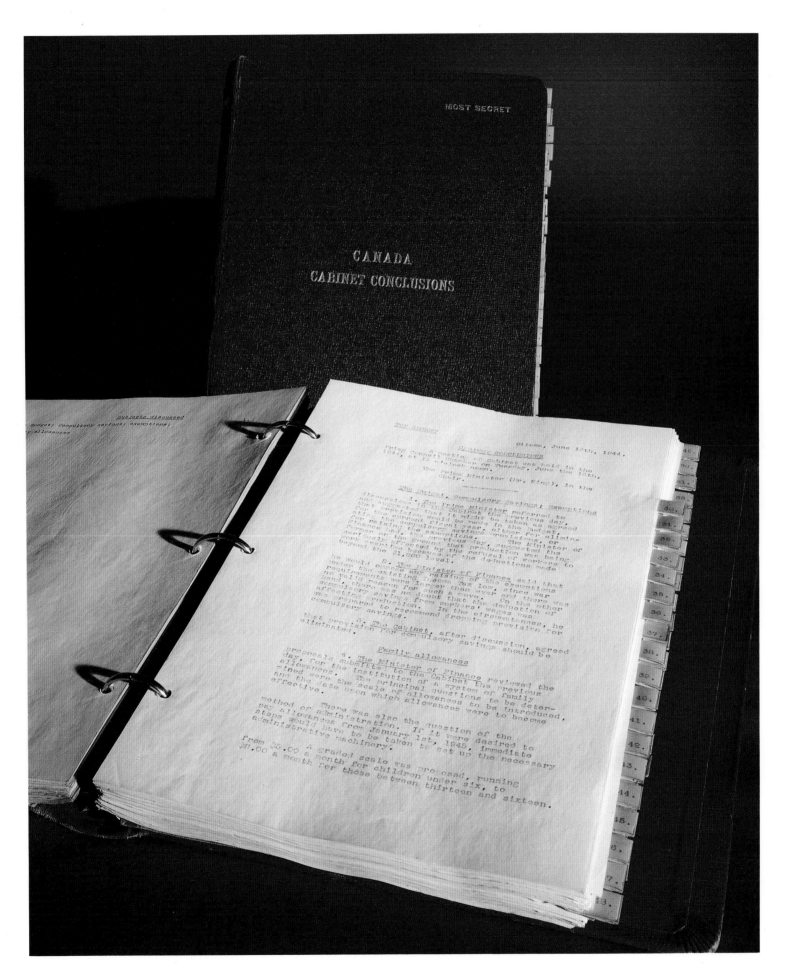

The Queen's Own writes a diary of D-Day

Canada has had a rich and diverse military experience, one closely tied to many of the central events of our collective past. Canada's military experiences have been both domestic and international. From internal rebellions in 1837–8, Fenian raids in 1866 and in 1870, the Red River uprising, also in 1870, and its terrible sequel in 1885, to adventures in South Africa, 1899–1902, and cataclysmic global wars in the twentieth century, our national history has been forged by war.

The outcome of the War of 1812 may have been inconclusive, but there is no doubt about its symbolic significance for defining how the northern half of the North American continent would evolve towards nationhood. In July 1812, a group of thirty-two men under the command of John Johnston formed part of a larger force under Captain Charles Roberts that took Fort Michilimackinac from American forces; five years later they received a handsome award of prize money for their actions. Canada won its national spurs in the First World War and participation in the Second World War won for the country a place among the great nations of the world. But such sentiments were far from the minds of members of the Queen's Own Rifles as they prepared for the invasion of Europe on D-Day, 6 June 1944; the extract from the unit war diary, also reproduced on the first page of this section, captures the prevailing sense of bravado as one of the greatest events in modern military history was about to unfold along the beaches of northern France. Film of the same event is shown in the Moving Image and Sound section, page 289; these two different perspectives of the same event illustrate the rich connections among different parts of the Archives.

Government records in the custody of the National Archives, from the War of 1812 to peacekeeping operations in the Middle East, South East Asia, and Africa, document this military heritage and the men and women who created it. In addition to war diaries, operational records, correspondence, and subject files, the Archives also maintains more than 110 kilometres of service files of those who have served in Canada's armed forces since 1914.

Prize pay list, 1817, and war diary,
Queen's Own Rifles of Canada, June 1944
The War of 1812 document is from the records
of the Department of Militia and Defence
RG9, series IB4, vol. 21, file H44, folios 702–3
Documents relating to the Queen's Own Rifles of Canada
are from the records of the Department of National
Defence RG24, vol. 15168

Petition, Mackenzie King, Secretary of State
for External Affairs, to King George VI
Records of the Department of External Affairs
RG25, vol. 3681, file 5475-40C, part 4

Canada joins the United Nations

On 25 October 1945, King George VI approved Canada's accession to the United Nations Charter. For Canada, the creation of the United Nations was one of the most significant developments to emerge from the Second World War. From the earliest proposal in 1941, Canada supported the concept of an international organization to replace and improve upon the League of Nations, which had been created in 1919 in the aftermath of the First World War. For two decades, the League had struggled to promote the principle of collective security and arbitration as a means of settling international disputes. Ultimately, the League had failed and the world found itself at war in 1939.

Canadian representatives played a prominent role at the San Francisco Conference in September 1945 that led to the establishment of the United Nations. Since then, Canada has made a significant and ongoing contribution to the administration of the UN and its organizations and activities throughout the world, including the International Civil Aviation Organization (ICAO), the Food and Agriculture Organization (FAO), the United Nations Educational, Scientific and Cultural Organization (UNESCO), and the United Nations Children's Fund (UNICEF).

On an individual level, Lester B. Pearson, while serving as Canada's minister of external affairs, won the Nobel Peace Prize in 1957 for his suggestion that a UN peacekeeping force be dispatched to the Middle East to defuse international tensions during the Suez crisis of 1956. Pearson later became Canada's fourteenth prime minister (1963–8).

The evolution of Canada's role in international affairs is thoroughly documented in the historical records of the Department of External Affairs now in the custody of the National Archives. From the inception of the department in 1909 to Canada's participation in peacekeeping operations in the 1970s, archival records tell the story of Canada's contribution to international diplomacy, to the formation of the United Nations in the wake of the Second World War, and to subsequent efforts to maintain peace and security in the world.

Canadian contributions to international aid and development and our relationship with other countries of the world are further documented in the archival records of the Department of Trade and Commerce, the Canadian International Development Agency, the International Joint Commission, and the Office of the Governor General.

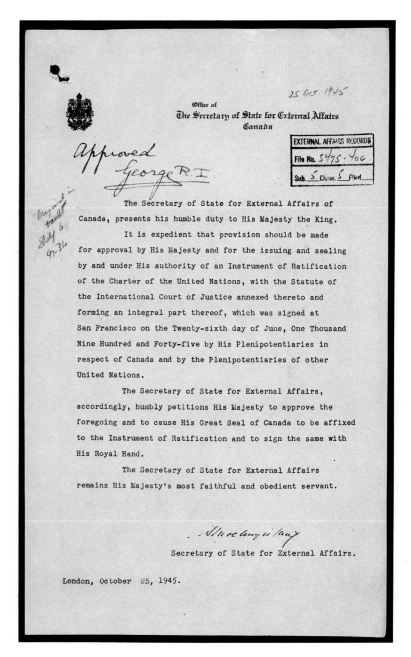

The Massey Commission surveys Canada's culture

Royal commissions are used by the federal government to investigate matters of public concern. Derived from British monarchical tradition dating from the sixteenth century, they have become a common phenomenon in Canada; more than 450 such commissions have been appointed since Confederation.

On 8 April 1949, the federal government appointed Vincent Massey, formerly the first Canadian minister to the United States, wartime high commissioner to Great Britain, and a well-known patron of the arts, to head a Royal Commission on the National Development of the Arts, Letters, and Sciences in Canada. He was ably assisted by Arthur Surveyer, a Montreal civil engineer, Norman Mackenzie, president of the University of British Columbia, the Most Rev. Georges-Henri Lévesque, dean of the Faculty of Social Sciences, Laval University, and Hilda Neatby, professor of history, University of Saskatchewan. Meetings began in Ottawa in August 1949 and were held throughout Canada during the ensuing months. The commissioners travelled more than 10,000 miles, held more than 220 meetings, and heard 1200 witnesses in an effort to assess the state of Canadian culture at mid-century. A cross-section of the Canadian cultural community appeared before them: representatives of art galleries, drama groups, radio stations, libraries and archives, musical groups, universities, ethnic associations, and others delivered briefs and answered questions, all in an effort to define Canadian culture, its nature, and its future needs.

A long tradition of cultural activity already existed in Canada by the 1940s, but the deliberations of the Massey Commission led to a greater awareness of cultural issues within the country. It initiated movement towards state involvement in and financial support for a wide range of cultural activities in the country, most clearly seen in the creation of the Canada Council and the blooming of culture in Canada in the past forty years. For these reasons, the Massey Commission is a landmark.

The Massey Commission records in the National Archives consist of minutes of meetings, briefs, correspondence, and research studies. The Archives is preserving and documenting Canadian culture by acquiring the historical records created by government cultural agencies including the Canada Council, the Canadian Broadcasting Corporation, the National Library, the National Museums, the Social Sciences and Humanities Research Council, and the Department of Communications.

Minutes of proceedings, August 1949, and report of
the Massey Commission, 1951
Records of the Royal Commission on National Development
in the Arts, Letters and Sciences
RG33/28, vol. 33

The Constitution is proclaimed

Canada was created by the British North America Act, an act of the British Parliament, in 1867. Our national identity and, more importantly, our autonomy as a separate and independent nation evolved slowly over time. Events during the First World War thrust Canada onto the world stage and her contribution to postwar attempts to ensure international peace guaranteed that Canada would no longer be regarded as a mere colony of Great Britain.

If we gradually acquired a sense of identity as Canadians and a degree of independence, the existing constitutional arrangements embodied in the BNA Act left little room for flexibility. Amending the Constitution required the sanction of the British Parliament, an awkward situation that undermined Canada's claims as an independent, sovereign nation.

Repatriation of the Constitution was a long and complicated process, one that precipitated intense political manoeuvring and often bitter political debate throughout the land. The decision to bring the Constitution home was not a unanimous one, but on a cloudy April day in 1982, repatriation was accomplished when Queen Elizabeth II signed two copies of the Constitution Proclamation in a ceremony on Parliament Hill. The copy illustrated here bears marks left by raindrops. The Constitution provides all Canadians for the first time with a Charter of Rights and Freedoms and, in spite of the fact that the debate continues today, represents a significant step forward in the evolution of Canada's national being.

Government archives consist of kilometres of correspondence files, ledgers, microfilm, and now computer tapes, but archives also include prestigious items such as this, documents that are the very soul of the nation, important components of our memory as a nation.

Constitution Proclamation, 1982
Records of the Registrar General of Canada
RG68, vol. 886

ELIZABETH THE SECOND

BY THE GRACE OF GOD OF THE UNITED KINGDOM, CANADA AND HER OTHER REALMS AND TERRITORIES QUEEN, HEAD OF THE COMMONWEALTH, DEFENDER OF THE FAITH.

TO ALL TO WHOM THESE PRESENTS SHALL COME OR WHOM THE SAME MAY IN ANYWAY CONCERN —

GREETING:

Elizabeth R

Jean Chrétien
Attorney General of Canada

A PROCLAMATION

WHEREAS in the past certain amendments to the Constitution of Canada have been made by the Parliament of the United Kingdom at the request and with the consent of Canada;

AND WHEREAS it is in accord with the status of Canada as an independent state that Canadians be able to amend their Constitution in Canada in all respects;

AND WHEREAS it is desirable to provide in the Constitution of Canada for the recognition of certain fundamental rights and freedoms and to make other amendments to the Constitution;

AND WHEREAS the Parliament of the United Kingdom has therefore, at the request and with the consent of Canada, enacted the Canada Act, which provides for the patriation and amendment of the Constitution of Canada;

AND WHEREAS Section 58 of the Constitution Act, 1982, set out in Schedule B to the Canada Act, provides that the Constitution Act, 1982 shall, subject to section 59 thereof come into force on a day to be fixed by proclamation issued under the Great Seal of Canada;

NOW KNOW YOU that We, by and with the advice of Our Privy Council for Canada, do by this Our Proclamation, declare that the Constitution Act, 1982 shall, subject to section 59 thereof, come into force on the Seventeenth day of April, in the year of Our Lord One Thousand Nine Hundred and Eighty-two.

OF ALL WHICH Our Loving Subjects and all others whom these Presents may concern are hereby required to take notice and to govern themselves accordingly.

IN TESTIMONY WHEREOF We have caused these Our Letters to be made Patent and the Great Seal of Canada to be hereunto affixed. At Our City of Ottawa, this Seventeenth day of April in the Year of Our Lord One Thousand Nine Hundred and Eighty-two and in the Thirty-first Year of Our Reign.

By Her Majesty's Command

André Ouellet
Registrar General of Canada

P.E. Trudeau
Prime Minister of Canada

GOD SAVE THE QUEEN

ELIZABETH DEUX

PAR LA GRÂCE DE DIEU REINE DU ROYAUME-UNI, DU CANADA ET DE SES AUTRES ROYAUMES ET TERRITOIRES, CHEF DU COMMONWEALTH, DÉFENSEUR DE LA FOI.

À TOUS CEUX QUE LES PRÉSENTES PEUVENT DE QUELQUE MANIÈRE CONCERNER,

SALUT:

Le procureur général du Canada

PROCLAMATION

CONSIDÉRANT qu'à la demande et avec le consentement du Canada, le Parlement du Royaume-Uni a déjà modifié à plusieurs reprises la Constitution du Canada;

qu'en vertu de leur appartenance à un État souverain, les Canadiens se doivent de détenir tout pouvoir de modifier leur Constitution au Canada;

qu'il est souhaitable d'inscrire dans la Constitution du Canada la reconnaissance d'un certain nombre de libertés et de droits fondamentaux et d'y apporter d'autres modifications;

que le Parlement du Royaume-Uni, à la demande et avec le consentement du Canada, a adopté en conséquence la Loi sur le Canada, qui prévoit le rapatriement de la Constitution canadienne et sa modification;

que l'article 58, figurant à l'annexe B de la Loi sur le Canada, stipule que, sous réserve de l'article 59, la Loi constitutionnelle de 1982 entrera en vigueur à une date fixée par proclamation sous le grand sceau du Canada;

NOUS PROCLAMONS, sur l'avis de Notre Conseil privé pour le Canada, que la Loi constitutionnelle de 1982 entrera en vigueur, sous réserve de l'article 59, le dix-septième jour du mois d'avril en l'an de grâce mil neuf cent quatre-vingt-deux.

NOUS DEMANDONS À Nos loyaux sujets et à toute autre personne concernée de prendre acte de la présente proclamation.

EN FOI DE QUOI, Nous avons rendu les présentes lettres patentes et y avons fait apposer le grand sceau du Canada.

Fait en Notre ville d'Ottawa, ce dix-septième jour du mois d'avril en l'an de grâce mil neuf cent quatre-vingt-deux, le trente et unième de Notre règne.

Par ordre de Sa Majesté

Le registraire général du Canada

Le premier ministre du Canada

DIEU PROTÈGE LA REINE

Using our national treasures

Since the 1870s, records deposited in the Archives have been available for research purposes to interested users. While most visitors have scholarly interests, archives, particularly government records, have long been used by a variety of people for historical research, genealogy, legal research, journalistic writing, native land claims, and the like.

The Archives has a particularly strong and traditional relationship with professional historians, who have turned to our documentary heritage time and time again to better understand our collective past. Professional interest in Canadian historical studies took root after the First World War and, by the mid-1920s, was flourishing in many universities. For the first time, Canadian academics turned their attention to the archival riches available in Ottawa. This register page captures a group of young scholars who, in the summer of 1932, turned to the Archives to pursue research. Historians such as Donald Creighton, C.P. Stacey, Hilda Neatby, A.L. Burt, and George Brown would soon dominate the field of Canadian historical studies. Through their writing and teaching they laid the basis for the expansion, growth, and sophistication of the profession in the decades following the Second World War.

Without the Archives and, more importantly, without the records collected by the Archives, none of this would have been possible. Ironically, the Archives is not only the repository for our documentary heritage; it also documents the users of that heritage. The growth of government in the past five decades and the ever-increasing accumulation of government historical records have provided succeeding generations of scholars with the necessary raw materials to fashion fresh interpretations of our national history.

Register of students, 1932
Records of the National Archives
RG37, acc. 1991–1992/202

$1,000 Reward

The above Reward is offered for the Capture and Return to custody of the N. W. Mounted Police, or for information resulting in such capture and return, of Ernest Cashel, condemned murderer, who escaped from the jail at Calgary, N. W. T., Canada, on the ____ of December 10th, 1903.

DESCRIPTION—Age 21 years. Nationality, American, comes from Buffalo, Wyoming, or relatives live. Figure, erect. Height, 5 ft. 8½ in. Weight, 145 lbs. Complexion, fair. Color brown; rather long over forehead, not quite as long as in photo. Brown eyes. Straight nose, ordinary. Face not quite so stout as in photo. Cannot grow any hair on face. Marks: Scar right eye, small, which his hair covers; Scar on left palm and one on right arm inside elbow. Slight American accent; medium voice. Manner rather reticent. May be wearing clothes following description which he stole from O. W. Rigby on night of 13th: Blue military lined, blue serge, no cape, no belt, name C. Rigby inside left hind pocket, also sewn up, noticeable bone buttons, a Stetson hat; black button boots, Jaeger's English made, about nines, uppers worn; dark blue serge coat, single breasted; blue serge pants; lined gloves, light color, worsted wrists; probably a fancy waistcoat; handkerchief, and blue tie with May be wearing brown leggings. Also stole gold signet ring, goat's head crest, inside engraved S. Rigby, 13th Jan., 1866, and old fashioned woollen shawl, pink colored one side, yellow the other. Will change clothes and disguise himself whenever possible.

Persons attempting to arrest Cashel are warned that he is armed with two or three and that he will not hesitate to use them to escape arrest under all circumstances.

Send all information promptly to the Commissioner, N. W. M. Police, Regina, N. W the undersigned,

G. E. SANDEF
Supt. N. W. M. Police, C.

V

The Private Record of Canada's Past

July. 1867.

Friday 5th. My beautiful new Diary Book!
I am ever so pleased with it and have been examining & admiring it for full two minutes! The Lock too __ My Diaries as Miss Bernard did not need such precautions but then I was an insignificant young Spinster & what I might write did'nt matter, now I am a Great 'Premier's Wife, & Lady Macdonald & "Cabinet Secrets & mysteries" might drop or slip off unwittingly from the nib of my Pen.

That is - they might do so - if my Pen had any Nib or if I knew any Cabinet Secrets, which I certainly d'ont - but then a Locked Diary looks consequential, & just now, I am rather in that line myself. - I mean the consequential Line - of course - My Husbands new title, is just five days old. So - for a short time longer I may be excused for some little bumptious-ness

It has been a hot fussy day - but these are fussy times. - This new Dominion of ours came noisily into existence on the 1st & the very Newspapers look hot & tired with the 'weight' of announcements & Cabinet-lists.

Here - in this house - the atmosphere is so awfully political - that sometimes I think the very flies hold Parliaments on the Kitchen TableCloths! In theory I regard my Husband with much awe, - in practice I tease the life out of him, by talking of dress & compliments - then he comes home to rest - ! Today he rebelled - poor man, & ordered me out of the room, I went at once

Manuscripts
and
Private Records

From its inception, the National Archives has recognized the importance of acquiring textual documents from sources other than federal government institutions. These documents, known as manuscripts and private records, touch on all aspects of Canadian life from the earliest voyages of discovery to the many-faceted activities of Canadians in today's complex, multicultural society. The breadth of the private record is also evident in the variety of documentation that it embraces – everything from letters and diaries to legal papers and literary manuscripts, from native documents on birch-bark to the latest form of electronic data storage.

The selection of documents that follows illustrates the diversity of manuscripts and private records held by the National Archives, both in their form and in the multitude of subjects and concerns they reflect. Among the major areas of national activity documented in manuscripts and private records are the federal political process, the affairs of state during the pre- and post-Confederation periods, and the social, cultural, economic, and scientific achievements of Canadians in the context of our broader society.

In the political realm, the manuscript record represents an indispensable source and includes the papers of prime ministers, federal cabinet ministers, members of Parliament, senators, and political parties. Much of the value of these records derives from the fact that they shed light not only on the official side of politics but also the more personal aspects of our political culture – see, for instance, the entry from the diary of Agnes Macdonald, the wife of Canada's first prime minister. Here we are afforded a behind-the-scenes glimpse of life at the heart of the Canadian political system.

Other manuscripts and records touch on the role of the state in Canada during the French and British regimes and the years since Confederation. This portion of the record, which includes thousands of copies of French and British documents, reveals much about the nature of colonial administration as well as the evolution after 1867 of the Canadian judiciary, military, public service, and diplomatic corps. It includes the act establishing the Company of New France in 1627 and a memo of 1857 from Windsor Castle documenting the selection of Ottawa as the Canadian capital. Without archival documents of this kind, our understanding of our past would be diminished.

The political and public aspects of Canadian life, however, form only part of the private record. Manuscripts and other private records also represent a major source for the study of the larger Canadian society. Here are documented the lives of the men and women from various cultural communities who have built Canada, contributing to the country in virtually every field of endeavour from religion and education to science and commerce, from health and technology to sport and culture. It is a manuscript area that provides essential information both on renowned Canadians like L.M. Montgomery – whose reaction to the success of *Anne of Green Gables* is documented in her letter to Ephraim Weber – and on generally unknown Canadians like the settlers identified in a document concerning the Jewish Colonization Association's settlement at Hirsch, Saskatchewan.

Taken together, the representative treasures in this section, selected from the Archives' extensive holdings of manuscripts and private records, tell a story about the development of Canada in all regions and within many different communities. They also illuminate the archival process and the efforts archivists have made over the years to preserve manuscripts and other private records as a major source for the understanding of the Canadian identity. Beginning with a sixteenth-century agreement pertaining to the settlement of Newfoundland and ending with the speculative musings of the media specialist Marshall McLuhan, the selection underscores the impact of the manuscript record.

Manuscripts and private records not only contain information, they are themselves information. Each document is a unique and discrete piece of history. Its provenance, form, medium, and condition can all provide important historical evidence. McLuhan's rough draft of the first page of an essay from his groundbreaking work *The Mechanical Bride* captures a great mind at work and permits one to see what the printed page cannot reveal – the creative process of writing. Similarly, a mere transcript of the petition of the native Canadians of Wabigon Lake to the governor general could not adequately convey the power and significance of the document's presentation. The form of the document is an integral part of its message, representing a kind of subtext that must be taken into account if the meaning of the manuscript is to be fully grasped.

These manuscript treasures, then, should be seen as more than receptacles of significant information. They are, in fact, direct links with our past and represent in themselves a crucial dimension of our history. Each manuscript is an encounter with some of the people and events that have shaped Canada.

A contract for the land
'Betwene the Cape of Florida and Cape Britton'

In the last quarter of the sixteenth century, English attitudes towards the New World of the Americas began to change. No longer did they view the American continents merely as sites in which to plunder the Spanish or exploit the fisheries. North America in particular became a place to colonize.

The Brudenell collection, which documents this changing perception of the New World, totals twenty-seven pages and consists of two draft agreements: one involving Sir Humphrey Gilbert, Sir George Peckham, and Sir Thomas Gerrard (9 June 1582), and the other Peckham, Gerrard, Sir Edmund Brudenell, Sir William Catesby, William Shelly, Philip Basset, Sir William Stanley, Richard Bingham, and Martin Frobisher (June 1582). Gilbert was an Elizabethan soldier with imperial dreams, and his financial backers were mostly Roman Catholic gentry. It was a strange marriage of the ambitious and the persecuted, whose partnership required detailed nego-tiations. The drafts lay out the rights and obligations of each party to an agreement whereby each would receive vast tracts of land in a New World colony 'Betwene the Cape of Florida and Cape Britton' (Cape Breton) in return for funds to support Gilbert's 1583 expedition to North America. This expedition saw Gilbert take possession of Newfoundland for England, and then lose his life on the return voyage.

These texts are the most valuable early manuscripts in English held by the National Archives. The documents had been kept by the Brudenell family for most of the intervening four hundred years before being acquired by the Archives in 1979. The significance of these almost medieval financial documents is enhanced when it is understood that they are more than Sir Humphrey Gilbert's mortgage on his last expedition. More importantly for us, they reflect the ideas that led to permanent English settlement in North America.

Agreement between Sir Humphrey Gilbert,
Sir George Peckham, and Sir Thomas Gerrard for
a settlement in North America, 9 June 1582
Brudenell collection MG18, B18

Articles of agreement tripertite indented concluded and agreed uppon
betwene Sr Humfrey Gilbert of Compton in the countie of
Devon knight ... Thomas Edwards of ... in the
countie of Lancaster knight and Sr George Peckham
of ... in the countie of Buck knight ... the ...
of ... in the ... yere of the reigne of our Soveraigne
Ladye Elizabeth by the grace of god Quene of
England Fraunce and Ireland defendor of the faith &c

First that wheras our Soveraigne Ladye the Quene made by her graces

Lres patentes under the great Seale of England bearinge date at Westm

the ... daie of ... in the ... yere of her maties reigne hathe geven

and graunted unto the said Sr Humfrey Gilbert his heires and assignes

for ... free libertie from tyme to tyme and at all tymes hereafter

to discover searche finde oute and viewe suche remote heathen and barbarous

landes countries and territories not actuallie possessed of any Christian

Prince or people as to him his heires or assignes and to every or anie

of them shall seme good And the same to have holde occupie and

H Gylberte

G.P. 13

The roots of Scottish settlement in Nova Scotia

Sir Duncan Campbell (c. 1551–1631), the seventh Laird of Glenorchy, was knighted in 1590 and by his efforts substantially increased the lands and status of his family (his thirteen children providing substantial incentive). One of his acquisitions came in the form of a charter issued 29 May 1625 by Charles I granting to Sir Duncan a hereditary baronetcy of Nova Scotia with the right to occupy, settle, and exploit a tract of land (described as 16,000 acres) on Anticosti Island.

The first baronetcies of Nova Scotia had been created by James I (of England, VI of Scotland) in his capacity as king of Scotland. Charles I continued the practice, creating some 107 such estates, of which 31 were on Anticosti Island. Charles I, however, ceased to claim Anticosti Island as part of Nova Scotia in 1632, on concluding the Treaty of St Germain-en-Laye with France. The baronets of Nova Scotia, reluctant to give up the dignities of their titles, nevertheless preserved the charters for lands they had never occupied.

According to custom, the charter was engrossed in Latin on parchment and the King's Great Seal was affixed. But contrary to custom for documents relating to colonies, the Great Seal affixed was that for Scotland. This document is remarkable not only for the description of the lands as being in 'Cannada' but also for surviving with its Great Seal attached and virtually intact. Vellum and parchment are at particular risk from rodents, who find animal skins an attractive foodstuff. Pendant seals are at risk not only from gnawing rodents but also from breakage as the sealing wax (a combination of beeswax and resin) becomes brittle with age.

The obverse or face of the seal depicts the king mounted and waving a sword. The reverse or underside exhibits the Royal Arms of Charles I for Scotland (the lion rampant in the first and fourth quarters, the leopards and lilies of England in the second quarter, and the harp of Ireland in the third quarter). His name and titles are inscribed in a band around the rim. Damage to the seal has been limited to the lower edge and has not significantly affected the image or the inscription.

Charter granting a hereditary baronetcy in Nova Scotia to Sir Duncan Campbell, on parchment, with pendant Great Seal (minor endorsement on the back); in Latin,
29 May 1625
1 leaf
Sir Duncan Campbell papers MG18, F36

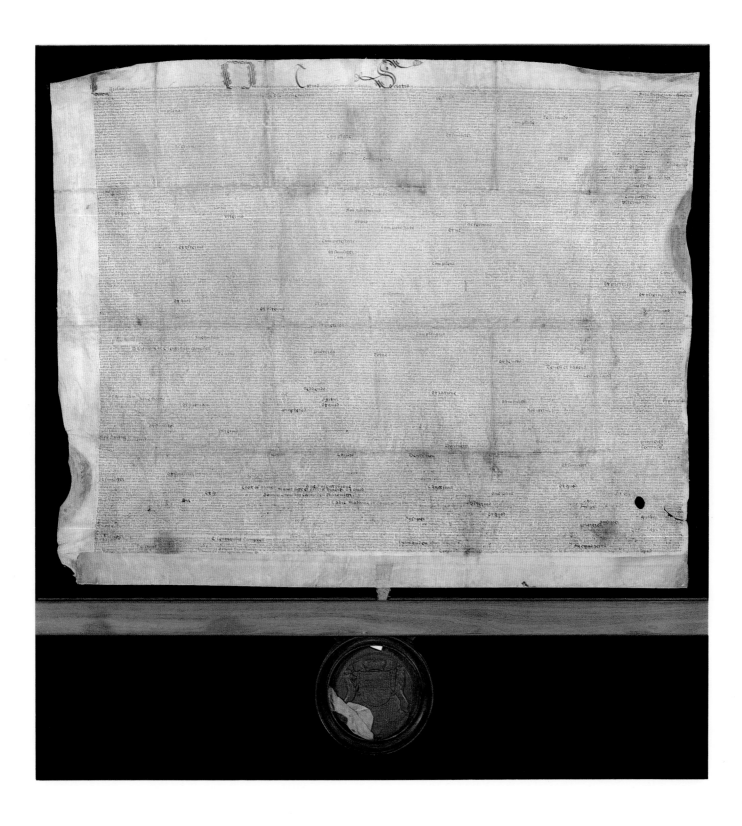

The Company of New France, known as the Hundred Associates, 1627–63

Twenty years after the founding of Quebec in 1608, the English and Dutch colonies in North America already had close to three thousand inhabitants, while New France had only about a hundred. To correct this imbalance, Cardinal de Richelieu, 'grand master, head, and superintendent of the commerce and navigation of France,' founded a powerful company of one hundred members in 1627, including many high officials and a smaller number of merchants.

This deed established the Company of New France, or Company of the Hundred Associates, and granted it full legal ownership of the 'seigniory' of New France, along with a monopoly in perpetuity on the fur trade and, for fifteen years, on all other commerce, fisheries excepted. In return, the company was required to assume the costs of the colonial administration and to bring four thousand immigrants into North America within fifteen years, all of them French Catholics.

In 1628, the Hundred Associates sent four ships bearing four hundred colonists to Canada, but this fleet was captured by the English. A new fleet was outfitted the next year, but the English seized Quebec City, holding it until 1632. These misfortunes and others that followed soon after broke the momentum of the Hundred Associates. True, they sent colonists over, but New France was populated mainly thanks not to their efforts but to recruitment by religious communities, owners of seigniories, groups of mystics, and associations of colonists and merchants. When the company resigned its commission to the king in 1663, New France had a population of about four thousand, more than three-quarters of them in the St Lawrence valley.

Deed establishing the Company of New France,
commonly known as the Hundred Associates,
Paris, 29 April 1627
Company of New France papers MG18, C1, p. 1

Le Roy continuant le mesme desir que le deffunct Roy
Henry le grand Roy, père de glorieuse mémoire auroit de fe rechercher et
reconnoistre par le travail et couleur de la Nouvelle France dicte Canada quelque
habitans capable pour y establir colonie affin d'essayer auec l'assistance
diuine d'amener les peuples qui y habitent les horas a la cognoissance
de Dieu Pare de policer a Instruire a la foy et religion catholique
apostolicque et romaine.

Monseigneur Le Card. de Richelieu grand m.tre chef et
surintendant gnéral de la navigation a commerce de France obligé par
le debuoir de sa charge de fe reussolies s. Intencion et desseings de sd
seigneur Roy ayant considéré que le seul moyen de disposer les peuples
a la cognoissance du vray dieu est ou de peupler led pais de natuvelz
françois catholicques Et pour par leur exemple disposer les
nations a la religion chrestienne a la vie civille et moure, y establissant
l'authorité Royalle tient des horas nouvellement deccouvertes qu'il
auantageux commerce pour l'vtilité des subiects du Roy.

Neaumoingds qu'en ceulx ausquelz on auoit confié ce soing auoient
esté si peu d'effect qu'iceux apres Huidy en fault
que d'habitation en laquelle bien qu'il pour lord.re, on y rencontre quarante
ou cinq b. françois plustot pour seruice des marchans que pour
le bien et l'advancement du seruice du Roy aud pais s'y ils quelzons
ils ont esté mal assisté Jusques a ce Jour Que le Roy en a rendu avisé
elesurvent en son conseil a la culture du pais y a esté si peu advancé
qu'ils y auoit manque a y pourveur aimer les saisons a aumer
choser neccessaire pour ce nombre d'hommes Ils se sont conveau
y plus de faim n'ayant pas de quoy se nourrir tymour apres le
temps auquel les vaisseaux ont accoustume d'arriuer toua Leuana.

177

Hired labourers for New France

Since New France lacked a labour force, the state encouraged soldiers to settle there, sent over specialized workers, and 'required merchant vessels to transport hired labourers or soldiers.' But the state was not alone in taking action: private individuals and groups also recruited workers in France.

Depending on the period, the chief recruiters were colonization companies, ship captains, colonial administrators, religious communities, merchant associations, landowners, and even simple colonists. Notarial contracts were normally signed with those engaged to come and work in Canada, regulating the conditions of their voyage, work, and upkeep.

These contracts might mention the worker's place of origin, trade, and wages. The workers received board and lodging for the duration of their service. Generally, they signed contracts for three years, but sometimes the period of service was longer. In this ordinance Canadians were permitted to enter into four- or five-year contracts with the workers from France. The document was signed by de Meulles, intendant of New France, and as such second in rank only to the governor of the colony. As intendant he had responsibility for settlement and economic development.

The men included skilled workers (carpenters, masons, millers, edge-tool makers, and so on), but also common labourers such as farm hands and handymen. Many of those who claimed some trade were 'without actual experience of a trade or too young to have done much else than an apprenticeship.' The great majority of the hired labourers were unmarried. Many became colonists once their contracts ended.

Ordinance of Intendant Jacques de Meulles
permitting Canadians to enter into four- or five-year
contracts with labourers from France
Quebec City, 25 September 1684
Jacques de Meulles papers MG18, G5

Jacques De Meulles Seigneur de la source
Chevalier Cons.er du Roy en ses Conseils Intendant de la
Justice Police et finances en Canada et pais de la france
Septentrionalle.

[25 septembre 1684]

Sur Les Ordres que Nous Auons receu de la sour de
distribüer aux habitans de ce pais plusieurs Engagez qui sont
venus cette anneé de france, Et ayant sceu que plusieurs
desd. habitans feßoient difficulté de les prendre, pour les trois anneés de leur
Engagement, attendu leur bas âage, Et qu'jls auroient de la
peine par le peu de trauail qu'jls retirent d'eux a se
rembourser de ce qu'jl leurs ont cousté, Nous Suplians Asd.
habitans de vouloir leur permettre de les engager de leur
Consentement pour quatre ou Cinq anneés, Et Enjoindre
a tous Notaires de ce pais de passer tous actes a ce
Necessaires; NOUS Ordonnons a tous les nottaires de
ce pais de passer tous actes d'Engagemens dont jls seront
requis par lesd. habitans de ce pais qui auront pris des
engagez de sa Maj.té Soit pour quatre, soit pour Cinq
anneés tout ainsy qu'jls en conuiendront par deuant eux
Mandons &c. fait a Quebec A 25.e 7bre 1684

Demeulles

Par Monseigneur
Peuuret

A new colony in 'French Acadia'

Between 1604 and the mid-eighteenth century, Acadia changed hands many times. The English, who had shown little interest in making the territory British in character, altered their policy after the return of Louisbourg to the French by the Treaty of Aix-la-Chapelle in 1748. In 1749, the English set out to establish themselves firmly in Nova Scotia by moving the capital from Annapolis Royal to Halifax and by recruiting immigrants. They even planned to settle in present-day New Brunswick, claiming that this territory, as part of Acadia (Nova Scotia), had been ceded to them in 1713 by the Treaty of Utrecht. Such expansion would allow the English to block land communication between Quebec City and the French colony on Île Royale (Cape Breton Island).

To prevent this, the French decided to occupy the extreme south of present-day New Brunswick. They re-established Fort Menagouèche and built Fort Saint John at the mouth of the river of the same name, constructed Forts Beauséjour and Gaspereau at the Nova Scotia border, and urged the Acadians to leave that British colony and settle in 'French Acadia.' While some Acadian families made their way to the Saint John River, many more of them settled around Beauséjour, which quickly became a centre of French colonization. Its plan is reproduced on the opposite page. Facing it less than three kilometres away on the other side of the Missaguash River was Fort Lawrence, erected by the British in 1750.

In 1755, the British seized Forts Beauséjour and Gaspereau and forced the French to blow up a fort on the Saint John River. On the pretext of a refusal by the Acadians to swear an oath of unconditional loyalty, they rounded up the Acadians in these areas who had not managed to escape into the woods. Those who did not escape to Quebec were deported to the American colonies and to England in a process that lasted until 1762. 'French Acadia' had collapsed.

Plan of Fort Beauséjour on the Isthmus of Chignecto,
Louis Franquet, 1751
1 plan, manuscript, colour
Louis Franquet papers MG18, K5

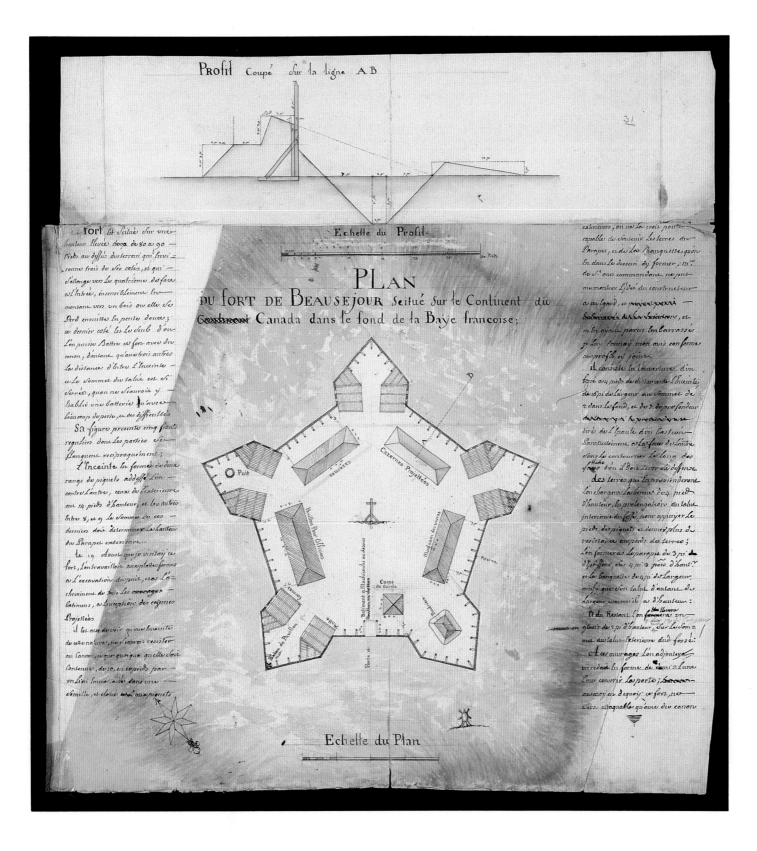

A decisive month in the Seven Years' War

In the early years of the Seven Years' War, a world-wide conflict among European powers, the French won a number of significant victories in North America: at the Monongahela in Ohio in 1755, at Fort Oswego on Lake Ontario in 1756, and at Fort William Henry on Lake George in 1757. But in 1758 the English gained the upper hand, seizing Louisbourg on Cape Breton Island and Fort Frontenac on Lake Ontario, destroying fishing establishments in the Gulf of St Lawrence, and forcing the French to blow up Fort Duquesne in the Ohio region.

The English retained the advantage in 1759. In July they took Fort Niagara on Lake Ontario and obliged the French to evacuate Forts Carillon and Saint-Frédéric in the Lake Champlain region. While these operations went on, a powerful British fleet was laying siege to Quebec City. Major-General James Wolfe, the commander of the expedition, bombarded the city day and night and ravaged the surrounding countryside. However, all these efforts came to naught and the British army was held in check through July and August.

As Lieutenant-General the Marquis de Montcalm, the commander-in-chief of the French forces, wrote in this letter to François-Charles de Bourlamaque, the month of September was to be 'decisive.' For if the British did not succeed in quickly taking Quebec, they would have to lift the siege and set sail: they could not run the risk of being icebound on the river with the sudden arrival of winter.

Knowing this, the assailants launched a final effort on 13 September and, taking advantage of their adversary's blunders, won the day on the Plains of Abraham. Both Montcalm and Wolfe were fatally wounded in the battle. Quebec surrendered on 18 September but it was not until the capture of Montreal by the British in 1760 that New France fell.

Letter from Louis-Joseph de Montcalm to
François-Charles de Bourlamaque,
[Sault Montmorency], 1 September 1759
François-Charles de Bourlamaque papers
MG18, K9, vol. 1, p. 589

Au Camp du Sault le S.^{bre} 7.^{bre} 1759

Je souhaite, Mon Cher Monsieur, que vous
soiés très tranquille dans votre partie, ce Moïen
il sera bien décisif pour cette colonie. les
ennemis paroissent très occupés d'inquiéter notre
Communication au dessus de Quebec. Si Monsieur
de Levis je pense à votre Marine. Cette partie
ci est toujours la plus Critique, sur tous les
pointes.

J'ay l'honneur d'être avec toute l'amitié
possible, Monsieur, votre très humble &
très obéissant serviteur

Montcalm

M. de Bourlamaque

Early observations of the Pacific Northwest Coast

James Cook discovered a market in China for sea otter and other furs, and thus stimulated the exploration of the Pacific Northwest coast. British and Spanish naval expeditions shared the sea with French and Russian commanders, as well as with British and American merchant vessels. To bolster Spanish claims to sovereignty north of California, Esteban José Martínez Fernández y Martínez de la Sierra (1742–98) was sent out in command of the frigate *Princesa* and the packet-boat *San Carlos*. His encounter at Nootka Sound with the Englishman John Meares and his seizure of the *Argonaut* and the *Princess Royal* precipitated a diplomatic crisis. The Nootka Convention of 1790 resolved the crisis, recognizing the fisheries and navigation of the Pacific Ocean as open to British subjects except within ten leagues of coasts occupied by Spain.

Martínez was an experienced captain. He was on an expedition in 1774 which went as far as the Queen Charlotte Islands and sailed in 1788 to the 61st parallel north latitude while investigating Russian activity on the coast. Thus his log – 'Diario de la Navegación que hizo al Puerto de Sn. Lorenzo de Nutca en 1789 D. Estevan José Martínez' – is more than the usual official record of a voyage to be reported to his superiors in Mexico City and Madrid. Drawing on his own observations and on others, notably those of Joseph Ingraham, pilot of the American vessel *Columbia*, he incorporated extensive commentary on Nootka Sound, its environment and inhabitants, its trade in furs, as well as a Nootka-Castillian vocabulary. He listed the visitors to that coast from the Russian Behring onward. Elsewhere, he recorded a brief Hawaiian-Castillian vocabulary.

This small volume, which was preserved by his family, offers a remarkable picture of the Pacific Northwest coast in general and Nootka Sound in particular during the first decade of substantial European contact.

Log book kept by Esteban José Martínez,
commander of the frigate *Princesa*, 1789
Restored binding
Esteban José Martínez Fernández y Martínez de
la Sierra papers MG23, J12, p. 258

Vocabulario de la Lengua de S.ⁿ Lorenzo de Nuca traducido al sentido Castellano.

Nuca	Castellano.
Upitsaska	Caveza
Apsiap	Cavello
Appapiah	Frente
Casi	Ojos
Ahicchi	Cejas
Ateksimacsime	Pestañas
Nitsah	Naris
Papi	Orejas
Ah-ah-mas	Carrillo
Yhtacsul	Boca
Chup	Lengua
Chi-chi-chi	Dientes
Jequap	La Barva
Apuasamuh	Las Barvas
Ynmut	El Pescueso
Ah-up-etso	Los Brasos
Cuk-cui-nex-a	La Mano
Upatsul	La Palma de la Mano
Enapulth	El Reves de la Mano
Eharomsts	El Dedo Pulgar
Cupyac	El Primer Dedo
Tayi	El Dedo de enmedio
Oatso	El Dedo del Anillo

A fur trader describes the West and its peoples

Alexander Henry the younger joined the fur-trading North West Company about 1792 and joined his uncle Alexander Henry the elder (1739–1824) as a partner in 1801. Henry the younger travelled extensively between Lake Superior and the mouth of the Columbia River, crossing the Rocky Mountains several times and making detailed observations en route. His journals offer an exceptional record of the country, the native people, and the rivalries amongst the Montreal-based North West Company and the London-based Hudson's Bay Company and other fur traders. Juxtaposed with lists of furs and trade goods exchanged are meteorological observations and extensive commentary on the customs and beliefs of the aboriginal peoples whom he met. Of particular note is an extensive vocabulary of Ojibwa, Cree, Assiniboine, and Slavey with their English equivalents, introduced with the note that 'A person thoroughly acquainted with which is seldom at a loss to make himself understood.'

Alexander Henry the younger drowned off Fort George (previously known as Astoria) in May 1814, while working to establish the North West Company's trade at the mouth of the Columbia River. The remarkable anthropological and ethnological record he created in his journals survived thanks to his literary executor, his brother Robert Henry, and to George Coventry (1793–1870). While employed between 1859 and 1863 by the House of Assembly of the Province of Canada to collect and copy historical records relating to Upper Canada and the West, Coventry made a full transcription of the Henry journals, which had been prepared for publication in 1824, apparently by Robert Henry. The structure of the journals, notably the breaks between entries and the gaps of 1806–8 when he was at Pembina and of 1811–13 when he was travelling west of Rocky Mountain House, indicate that the originals were in several volumes. There is reason to believe that the record of those missing years was unavailable to George Coventry as well as to us.

The microfilming of Henry's journals and their publication in book form have ensured that their information has been made available to linguists as well as historians of the fur trade and native people.

Journal of Alexander Henry the younger
[transcript copy, c. 1859],
entry of September 1808
Alexander Henry the younger papers
MG19, A13, vol. 1, p. 783

1808 | the arrows, they reckon the Game. | They have a
They also play at a kind of Game. By | game some
holding some articles in the hand | thing similar
or into two shoes, one of which has | to Odd and
the article, the other is empty. The | Even
Platter is also now very common
among them, and another Game
which requires 40 to 50 small stick
about the size of a Goose Quill and
about a foot long. they are shuff
led together and then divided into
two parts, and according as you
choose, equal or odd numbers, you
either loose or gain. they have several | The number
different ways of playing with these | of these people
sticks. Of their number I have been | I have been
particular to enquire into. But I find | particular
them so much divided, and subde | to find out
vided again into different classes | and the
or tribes, as to make it a difficult | following
task, to ascertain their exact num= | is as near
bers, however the following is as | the truth as
near the truth as I can obtain | I can come
information. Viz. | at

200 Tents of the Little Girl Asiniboine who inhabit
 the Rivere to Souris and Moose Hills & Isle a la Biche
200 do Paddling and Foot do. Lakes of Rivere
 qui Appelle &c. to the Banks of the Missouri
160 Canoe or as some call them Canoe and
 Paddling asiniboine. who dwell to the
 West of the Paddling and Foot asinibone
24 Tents of the Red River asiniboine who dwell
 to the West and near the latter
30 Tents of the Rabbit-asiniboine who dwell
 to the West and near the latter

An early manual for Canadian freemasons

Freemasonry is a curious phenomenon that cuts across the more usual categories in society's cultural organization. It appears to have begun in the Middle Ages during the period when the great Gothic cathedrals and abbeys were being built all over Europe. The freemasons were skilled itinerant masons who were free to move from one building project to another without restraint by the local guilds. Since their nomadic way of life denied them the usual protection and aid provided by the great guilds in settled town communities, this scattered international brotherhood had to develop its own mutual-aid arrangements. Similarly, because freemasons had to be highly competent architects and engineers but were not subject to the usual town mechanisms of apprenticeship and regulation, they had to devise their own systems of training and control. Accordingly, they used 'mason's word' (a password revealed only to freemasons) and various secret signs for the purpose of recognizing those who truly belonged to their society and of identifying the degree of competence that each had achieved. The symbolic interpretation and understanding of their craft, which are notable features of modern 'speculative' freemasonry, probably resulted from their long and close association with monastic communities in their huge ecclesiastical building projects. How and why non-prac-tising 'speculative' masons began to be 'accepted' into the fellowship is obscure, but by the eighteenth century in Britain the accepted speculatives had taken over completely. The society had become a brotherhood of 'accepted' masons, working with purely symbolic interpretations of the original operative freemason's craft. It was no longer confined to the artisan classes, but also included many members of the British middle class, gentry, nobility, and royalty, as well as the soldiers who planted the society in Quebec in 1759. In the two centuries since British regimental masonic lodges introduced it into Canada, freemasonry has spread widely through society in virtually all regions of the country.

This *Mason's Manual* is an early Canadian book of which few copies are known to be extant. It comes from the unique and remarkable masonic bequest made by Alfred John Bidder Milborne (1888–1976) to the National Archives, which maintains his library as a special collection. Milborne was the only Canadian member of the prestigious Quatuor Coronati Lodge, No. 2076 ER, of London, a research lodge whose membership is restricted to forty freemasons distinguished for their contributions to masonic studies, art, literature, or the sciences. The Archives also holds Milborne's collection of masonic research papers.

The Mason's Manual Comprising rules and regulations
for the Government of the Most Ancient and Honorable
Society of Free and Accepted Masons in Lower-Canada
Quebec: Printed at the New Printing-Office by
T. Cary, Junr. & Co., 1818, 126 pp.
Milborne collection No. 116109

*His Royal Highness
Prince Edward Duke of Kent &c. &c. &c.
Past Grand Master of Masons in
Lower Canada*

THE
MASON's MANUAL,

COMPRISING

Rules and Regulations

FOR THE GOVERNMENT

OF THE

Most Ancient and Honorable Society

OF

FREE AND ACCEPTED
MASONS,

IN

LOWER-CANADA:

To which is added

AN APPENDIX,

Containing various useful Charges, etc.

Published by order of the Provincial Grand Lodge.

QUEBEC:

PRINTED AT THE NEW PRINTING-OFFICE, BY T. CARY, Junr. & Co.
No. 21, Buade Street.

1818.

The Hunters' Lodges continue the 1837 rebellion

In contrast to the bloodier Lower Canadian uprisings of 1837 and 1838, the Upper Canadian rebellion of 1837 is usually portrayed as comic opera: after brief skirmishes north of Toronto killed three men, the rebels fled, many to the United States. However, this clash was a beginning, not an end. With their American and a few European sympathizers, the rebels organized 'Hunters' Lodges' and, during 1838, raided from the United States into Upper Canada. At least sixty-five men died, including twenty-one who were later hanged.

Most rebels were farmers, labourers, or tradesmen; many were American immigrants or their children, part of the vast westward movement of Americans. They, and the moderate reformers who did not rebel, had advocated civil and religious liberty. Like Lower Canada, Upper Canada was dominated by a colonial oligarchy that, with imperial backing, managed politics to its own benefit. The reformers dismissed the oligarchy as a Family Compact; the elite denounced reformers as democrats, republicans, and pro-American traitors.

This commission, issued in 1839 by the North-Western Army on Patriotic Service in Upper Canada, betrays the Hunters' exaggeration and pretension. By the time it was issued, rebel armies were only wishful thinking. The woodcut illustration of the American eagle seizing the British lion and knocking off his crown, and the slogan 'Liberty or Death,' clearly link the Hunters to the American revolutionary tradition and to the American belief in 'Manifest Destiny.' It can be argued that this imagery reveals that these persistent rebels offered an independent Upper Canada no fate but absorption into the United States.

Commission issued by the Commander in Chief
of the North-Western Army on Patriotic Service
in Upper Canada, 1839
Printed form with manuscript additions
William Lyon Mackenzie papers
MG24, B18, vol. 4, p. 216

LIBERTY OR DEATH.

Head Quarters, Windsor, U. C.

SIR—By authority of the Grand Council, the Western Canadian Association, the Great Grand Eagle Chapter, and the Grand Eagle Chapter of Upper Canada, on Patriot Executive duty—You are hereby Commissioned to the rank in line of a of the Regiment of the Brigade of the Division on Patriot Service in Upper Canada.

Yours with respect,

Commander in Chief of the North-Western Army on Patriot Service in Upper Canada.

Adj. Genl. N. W. A. P.

Ottawa is recommended to Queen Victoria

Attributed to Prince Albert, this note was actually prepared by his secretary, Sir Charles Grey. Queen Victoria's initials at the end indicate that the sovereign read it.

Grey was writing in the last days of October 1857, as a decision approached on the choice of a permanent capital for Canada. He made a vigorous argument in favour of Ottawa, while acknowledging that the city required substantial fortification; finally, he suggested that a large park be laid out as grounds for the future government buildings.

For nearly two decades after the union of Upper and Lower Canada in 1841 MPs could not agree on a choice for a capital. From 1841 to 1849 Kingston and then Montreal hosted the Parliament; the honour was subsequently shared, at various times, by Toronto and Quebec City. A permanent site was a leading topic of legislative and public debate. Meanwhile, travel between cities became increasingly expensive. Each move required that everything be packed up (furniture, library, archives) and accommodation sought for the two chambers and their members, as well as for the public service. In 1856, the Legislative Assembly failed in another attempt to decide on the capital when the Legislative Council rejected its choice of Quebec. The Macdonald-Taché government resolved to leave the matter in the queen's hands.

The contending cities submitted briefs. In the fall of 1857, the governor, Sir Edmund Head, arrived in London. Using his full influence in favour of Ottawa, he won over the Colonial Office. Sir Charles Grey's note repeats some of the arguments Head had formulated. This text is one of a number that were submitted to the queen's attention. Military and strategic considerations were still pre-eminent: in 1857 defence was still the responsibility of the Imperial Parliament.

Memo, Windsor Castle, initialled by Queen Victoria,
selecting Ottawa as the capital of Canada,
27 October 1857
Henry Labouchere, First Baron Taunton papers
MG24, A58

ported by no means deficient in natural strength. It ought to have a Citadel placed upon the best military dis[trict] commanding the Town, but detached from it, so as not to impede the natural growth of a Metropolis, destined to assume the largest dimensions. Great care ought to be taken to leave sufficient space round the fortress, so that the town should not act as a covered way for its attack; plans of the locality ought at once to be submitted to the Home Gov[ernmen]t, & the necessary ground reserved before its value has been increased by the Gov[ernmen]t decision. —

In order to secure future beauty & healthfulness, space ought at once to be acquired for laying out a large Park which American Towns do not in general possess, & would form the best site for the future public offices. The military strength of the position would be much increased by two fortified posts in advance on the St Lawrence — say at Prescott or Brockville or Cornwall which an American force crossing the St Lawrence to attack the new Capital could not with safety leave in their rear. —

The diary of Lady Macdonald

When she started her diary, Lady Susan Agnes Macdonald had been married to Canada's leading politician, Sir John A. Macdonald, for less than five months. Agnes, the sister of Macdonald's private secretary, Hewitt Bernard, had grown up in Jamaica. She first met John A. in 1860 in Quebec City. She was his second wife, and at the time of their marriage, in February 1867, Macdonald was fifty-two and Agnes, thirty-one. Some 160 pages in length, her diary chiefly covers the period 1867–9, with a few entries for later years.

The first page, reproduced here, is written in a lively style just four days after Confederation, when her husband became Canada's first prime minister. She calls it 'My beautiful new Diary Book!' and writes: 'It has been a hot, fusty day, but these are fusty times. This new dominion of ours came noisily into existence on the 1st & the very Newspapers look hot & tired with the weight of announcements & Cabinet Lists.'

Much of the diary is very personal. Lady Macdonald writes of her relationship with her husband, her strong religious beliefs, and some of the frustrations of political life. She describes dinner parties and receptions, travelling about Ottawa in a sleigh in winter, attending church, and meetings of the Ottawa Orphans' Home. In spite of her resolution on the first page of the diary not to discuss anything of a political nature, she does record some comments on her husband's colleagues and on the issues of the day.

Although it covers a relatively brief time period, the diary provides a fascinating view of the personalities of Sir John A. Macdonald and Lady Macdonald and of their life together. No other diary of a prime minister's wife has become public property. The page is reproduced closer to life size on the opening page of this section.

Diary of Lady Macdonald, entry of 5 July 1867
Rt. Hon. Sir John A. Macdonald papers
MG26, A, vol. 559A, p. 1

An author's unfinished manuscript

Philippe-Joseph Aubert de Gaspé (1786–1871), descendant of an illustrious family that had settled in New France in 1655, practised law from 1811 until 1816, when he was appointed sheriff of the District of Quebec. A poor administrator, he was relieved of this office in November 1822. He then took refuge with his large family at his mother's manor house in Saint-Jean-Port-Joli, down the St Lawrence from Quebec City, for about fifteen years. From 1838 to 1841 he was imprisoned for debt, being finally released by an act of Parliament. He then gave up all professional activity, but still took part in the cultural life of Quebec. In 1863, at an advanced age, he published *Les Anciens Canadiens [The Canadians of Old]*, a historical novel of manners that was later translated into English and Spanish. It described the life of a Canadian and a Scot before and after the Conquest. This was followed by *Mémoires* in 1866, which was a picture of Canadian society, urban and rural at the beginning of the nineteenth century.

In spite of the unprecedented success enjoyed by these two works, in 1869 Philippe Aubert de Gaspé, at the venerable age of eighty-three, began preparation of a third volume. The excerpt reproduced here is taken from a document of about ten pages. Unknown to the public for over a century, the text contains a prologue in which the author, in dialogue with a friend, explains the reasons why he started writing, and an initial chapter dealing with the aboriginal peoples of Canada. It seems that the passages on the Indians that were published in Aubert de Gaspé's *Divers*, which appeared posthumously in 1893, were created in order to continue this first chapter.

Draft of a third work by
Philippe-Joseph Aubert de Gaspé, [1869]
Aubert de Gaspé Family papers
MG18, H44, vol. 6, p. 1

An honest day's pay

The last decades of the nineteenth century were a period of stable prices and uneven economic development in Canada. Yet it is hard to imagine how a family of five or six could have survived on an income of one or two dollars a day. Documents such as this wage book bring home the reality of a nineteenth-century worker's place in society.

This book records the wages paid weekly to each employee at the John H.R. Molson & Bros brewery in Montreal between 1879 and 1889: a dollar a day, perhaps a bit more for some skilled workers, and much less for the women employed as bottlers. The information includes the worker's name, number of days worked per week, rate per day, and amount paid per week. Lists of bonuses paid to some workers at the end of each brewing season are also included (typically ten cents a day for each day worked).

The significance of this volume, which forms part of a series dating from 1878 to 1909, lies in the fact that it provides detailed wage information for a comparatively large group of nineteenth-century workers over a long period of time. As a whole, the series provides social historians with an important source of data that can be used, along with other archival sources, to help establish the standard of living of the working class in Montreal during the last quarter of the nineteenth century.

Wage book, John H.R. Molson & Bros,
Brewers, 1878–89
Molson Archives MG28, III57, vol. 299

Brewery Wages

Names				Names			

Brewery Floor — J. Hyde, E. Hooton, J. Hutchins, C. Curran, A. Grogan, J. Hickens, J. Logan, R. Hearn, J. Tanguay, T. Lourana, Jos. Cook, Jos. Hyland, E. Gille, Jno. Gravitt, Jos. Gillie, G. McLean, A. Donald, Jno. Aspel, M. Walsh, M. Theriau

Malt House — L. Couvineau, J. Thomas, J. McCarthy, J. Hodgson, P. Foley, J. McDonald, J. Thomas

Coopers — A. Renaud, A. Prevost, H. Bastie

Blacksmith & Cart — L. Temple, Jn. Kenneva

Johnston's Cart — Wm Roberts

Refinery Watchman — E. Coxall

Malt House — J. Read, D. McDonald

Bottling Dept — Wm Lonsdon, A. Cunningham, H. Murray, H. Murray, H. McGillis, J. Cinr, E. Bouthillier, Jane Murray, C. Cotnam, V. Mayer, E. Casavant, Mary Murray, Wm Cinr, A. Ouellet, J. Bartlett, W. Smith, J. Piquette, M. Gaignon, D. Cotnam

Gratuity List for 1866 - 67

Names	Occupation	Date From	Date To	No. of Days	Amount $ c
Alfred Gingras	Drawing Room	1st Sept 66	1st May 67	236½	23.66
Jno. Hyde	Brewery	do	do	200⅓	30.08
Hugh Hyland	Malt Floor	do	do	261½	26.15
Jno. Nesbitt	do	do	do	265	26.50

Paid 10 June 1867 — $100.39

Brewery Floor — J. Hyde, E. Hooton, J. Hawkins, C. Currie, A. Gingras, J. Hickens, J. Logan, A. Grogan, J. Tanguay, M. Lourana, J. Cook, J. Hyland, E. Gille, Jno. Gravitt, Jno. Aspel, M. Walsh, M. Theriau, S. Bell

Malt House — J. McDonald, L. Couvineau, J. Thomas, J. McCarthy, P. Foley, J. McDonald, J. Read

Coopers — A. Renaud, M. Bastien

Blacksmith &c — L. Temple, Jno. Kenneva

Johnston's Cart — Wm Roberts

Refinery Watchman — E. Coxall

Laborer — Jno. Rodgers

Bottling Dept — Wm Lonsdon, A. Cunningham, H. Murray, H. Murray, H. McGillis, J. Cinr

Mr Galons — E. Bouthillier, Jane Murray, C. Cotnam, V. Mayer, E. Casavant, Mary Murray, Wm Cinr

E. Labrance — J. Bartlett
M. Gauthier — W. Smith, J. Piquette, H. Cotnam, H. Clark, G. Labelle

E. Griffin — M. Gagnon, C. Lepinasse, J. Vallee, S. Westward

Men — M. McArthur, Geo. Cox, J. Webster, G. Bell, J. Aspel, C. Bain

$315.02 $356.12 $334.76

A native address to the governor general

Written on birch-bark and bordered by two strings of white wampum beads, this extraordinary address was delivered on 25 July 1881 by Chief Kawakaiosh of the Chippewa, who had come to Wabigon Lake to meet the governor general, the Marquis of Lorne, who was then on his way to the Canadian West.

Lorne became governor general in 1878 at the age of thirty-three. Like Lord Dufferin, his immediate predecessor, he was a man who loved projects. Between them, they transformed the office of governor general and gave it a firm direction. They strove to develop a feeling of patriotism by supporting the arts and letters, founding new institutions, and undertaking imaginative initiatives. They travelled extensively, and were the first governors general to travel throughout the Canadian West.

To ensure good press coverage of the great journey he was making to the prairies in July 1881, Lorne took along some British journalists, hoping to entice future immigrants through their articles. The group included Charles Austin of *The Times* and a talented illustrator employed by the London *Graphic*, Sydney Prior Hall. During the venture, Hall executed more than 250 sketches, which now belong to the National Archives.

The episode involving this birch-bark address occurred at the outset of the expedition. The travellers had crossed Lake Superior on a small steamboat that deposited them at Prince Arthur's Landing (now Thunder Bay). From there, the train took them 220 miles to Wabigon Lake (the name means lake of flowers, or lake of white and yellow lilies), where the railroad ended in mid-construction. The group halted there and raised tents. It was seven o'clock in the evening.

Having been notified of the governor general's arrival, a throng of Chippewa Indians assembled on the shore of the lake. Their faces were painted in bright colours. Chief Kawakaiosh then read his address. It presented in clear terms the changes brought about by the arrival of the railway: the burgeoning logging operations and the eclipse of the old fur-based economy. The Chippewa claimed felling rights on their reserves and expressed their satisfaction at the coming of the railway, which would free them, they said, from the oppression they felt themselves to be suffering at the hands of the merchants.

Amerindian documents of this period are relatively rare, and, where they exist, must be used carefully. One of the *Globe* correspondents travelling with the party made a thought-provoking comment when he observed, with some amazement, that the address 'was neatly written in English.' Nevertheless, documents like these give interesting insights into native-newcomer relations.

Petition from the Chippewa Indians of Wabigon Lake to Governor General Lord Lorne, written on birch-bark and bound with wampum, 25 July 1881
Sir John Douglas Sutherland Campbell, Marquess of Lorne papers MG27, I B4, file 5

Wabigon Lake July 25th 1881

To the Governor General
of Canada.

My Lord,

I speak to you through this writing as the Chief of the Wabigon Chippewa tribe. We have come here to-day from different parts of the country, with our canoes and families to do ourselves the honour of meeting our great Mother's Son in law and her speaker for this country. We all shake hands with you through me as their chief. I wish to represent to you that our reserves are no benefit to us as they stand, and we crave the right to cut and use timber upon them in any way we like for our general good. We are glad to see the iron road come through this wild country, as it will relieve us from the oppression of Hudson Bay traders.

We thank the Queen for her honest treatment of us and all Canadian Indians, as we have not been cheated by her agents as the Indians have been in the United States.

I wear this silver medal which you see upon my breast given to me by the Queen with the greatest love, and respect, and we hope she thinks as much of us as we do of her.

Yours in Sincerity.

Signed
Caugh-a-wi-osh

The driving of the last spike

When British Columbia entered Confederation in 1871 it was assured that a transcontinental railway would be constructed within ten years. However, before the nation-building project could begin, the Conservative government of Sir John A. Macdonald was defeated as a result of the Pacific Scandal. That scandal, which broke in April 1873, centred on revelations concerning the campaign funding that the Conservatives had received during the 1872 election from Sir Hugh Allan and other railway promoters.

Macdonald returned to power in 1878 and eventually awarded the railway contract to the Canadian Pacific Railway headed by George Stephen, Donald A. Smith, and J.J. Hill. Bolstered by considerable government largesse, the CPR embarked in 1881 on one of the great engineering feats of the nineteenth century. Although the success of the enterprise owed much to Macdonald, Smith, and Stephen – not to mention thousands of anonymous workers – the driving force behind the project was CPR general manager William Cornelius Van Horne. Under his supervision, the railway was completed on 7 November 1885. To mark the occasion, Smith, Van Horne, and other dignitaries travelled to Craigellachie station in Eagle Pass, BC, to witness the laying of the final rail. Smith was given the honour of driving the last spike.

In this telegram from Craigellachie to Ottawa, Van Horne informed Macdonald that the railway was finally completed, and attributed the realization of the project to Macdonald's farsightedness and determination. The text of even this short message is longer than the remarks Van Horne delivered that same morning in Eagle Pass. Asked to make a speech commemorating the occasion, Van Horne replied, 'All I can say is that the work has been well done in every way.'

Telegram, W.C. Van Horne to Sir John A. Macdonald,
Craigelleaichie (sic), Eagle Pass, British Columbia,
7 November 1885
Rt. Hon. Sir John A. Macdonald papers
MG26, A, vol. 129, p. 53567

FORM 1. Cox's Patent INFOLD. Canada, Nov. 10th, 1883; U.S., May 27th, 1884.

To open, tear off the colored label at the perforated mark.

THE GREAT NORTH WESTERN TELEGRAPH COMPANY OF CANADA.

OPERATING THE LINES OF THE MONTREAL, DOMINION AND MANITOBA TELEGRAPH COMPANIES.

53567

110

Money orders by telegraph between principal telegraph offices in Canada and the United States.

TELEGRAM.

Use this space for Continuation of Lengthy Addresses, OR INSTRUCTIONS TO MESSENGER.

To Rt Hon Sir
J. A. MacDonald
KCB

No. 3 Check 27

Sumas

Rec'd No.	From	Sent by	Rec'd by	Time
2	N	CD	ME	3h

Ottawa, _____ 188

From _Craigellachie Eagle pass BC 7_

Thanks to your far seeing policy and
unwavering support the Canadian
Pacific Railway is completed the
last rail was laid this (Saturday)
morning at 9.22

W. C. Van Horne

Louis Riel's last letter to his wife and children

Louis Riel (1844–85), the head of the provisional government set up by the Métis in 1869, failed in his first attempt at an agreement with the government of Canada on his people's future and on autonomy in the Red River region; thereupon he sought refuge in the United States for some months in the summer of 1870. In 1873, he was elected a member of the federal Parliament, but could not sit because of a warrant of arrest issued against him. Although re-elected in 1874, he was expelled from the House and once again had to seek refuge, this time in Quebec, where he spent some time in a mental asylum, and then in the United States. Over the years his religious feelings deepened and he became convinced that he was entrusted with a religious mission.

He resumed leadership of the Métis rights movement and played an active part in the uprising of 1884–5, but was forced to surrender to Canadian troops on 15 May 1885. He was officially charged with high treason and prosecuted. At his trial, which took place from 20 to 31 July, Riel's lawyer counselled him to plead guilty by reason of insanity. He refused. Nevertheless, he was examined by three doctors, only one of whom found him to be insane. Pronounced guilty, he was sentenced to death. Louis Riel died on the scaffold in Regina on 16 November 1885.

Although its date is difficult to determine absolutely, its contents suggest that this is the last letter in Louis Riel's hand, written to his wife Marguerite Monet, *dit* Bellehumeur, and his two children, Jean and Marie-Angélique, on the day of his hanging: 'Today is the sixteenth: a very remarkable day.' This moving letter testifies to his great religious fervour, the predominant trait of his character; to his love for his people; and to the calm and courage with which he faced death: 'Your children belong even more to God than to you. Strive to care for them just as your faith dictates. Make them pray for me ... Be strong.'

Letter from Louis Riel to his wife Marguerite
and his children, Jean and Marie-Angélique,
[Regina, Northwest Territories], 16 [November 1885]
Lawrence M. Lande collection MG53, B29

Ma bien chère Marguerite,

Je t'écris de bon matin. Il est à peupres une heure. C'est aujourd'hui le 16: un jour bien remarquable.

Je t'envoie mon bon souvenir. Je te conseille aujourd'hui selon la charité que tu m'as comme à ton égard. Aie bien soin de tes petits enfants. Tes enfants sont encore plus à Dieu qu'à toi. Efforce toi bien de leur donner les soins les plus conformes à la religion. Fais les prier pour moi.

Écris souvent à ton Bon Papa. Dis lui que je ne l'oublie pas un seul jour. Qu'il prenne courage. La vie paraît triste parfois: mais dans le temps où elle nous semble plus triste c'est quelquefois la même qu'elle est plus agréable à Dieu.

Louis "David" Riel. Ton Mari qui t'aime en Notre Seigneur

J'écris un mot de charité selon le Bon Dieu, à mon petit, petit Jean;
un mot de charité, de tendresse aussi à ma petite, petite Marie-Angélique.

Prenez courage. Je vous bénis.

Votre Père
Louis "David" Riel

Steam-age power for industries and municipalities

By the late nineteenth century the stationary steam engine was the prime source of power for Canadian industry and municipal services. After a century of development, steam engines were powerful yet compact. The horizontal Wheelock engine, as built by Goldie & McCulloch of Galt, Ontario, was used to power factories, pump water, and generate electricity. Its variable steam cut-off valve made it an economical engine to run, which contributed to its popularity.

The manufacture of steam engines was an important Canadian industry. Goldie & McCulloch, established in 1859, started by building grist and sawmill equipment, mill gearing, and boilers. Soon the company began to build stationary steam engines. Arrangements with the Wheelock Company allowed them to manufacture numerous examples of this engine. Goldie & McCulloch still exists in Galt (now Cambridge), Ontario, under the name of Babcock and Wilcox, who took the company over in 1964.

Trade catalogues issued by companies are a valuable source of information, providing illustrations and descriptions of products, including size, variety, and price. Trade catalogues also often contain information about the company itself, such as the date of establishment, company officers, facilities, and sometimes a list of customers. Often a trade catalogue is all the direct evidence there is for a company's activities. The illustrations in this c. 1890 catalogue from the John Davis Barnett papers give a clear idea of what stationary steam engines looked like in the late nineteenth century. A list of more than 180 users of Wheelock engines, mostly in Ontario, but some in the Maritimes, gives a good idea of their impact.

John Davis Barnett (1849–1926) was an engineer, and a notable collector of books as well as of technical and cultural information at the turn of the century. His rich and extremely varied collection, now held by the National Archives, includes approximately 10,000 pieces of trade literature, 1600 drawings and plans, and numerous photographs, broadsides, press clippings, and advertising ephemera.

Goldie & McCulloch, Galt, Ont.,
Steam Engines, Boilers, Mill Gearing &
Furnishings of Every Description ...
Wheelock Automatic Engine
Toronto: Bingham & Webber,
[c. 1890], 12 pp., illus.
John Davis Barnett papers
MG30, B86, vol. 68, catalogue 14

The ❧ Wheelock ❧ Engine

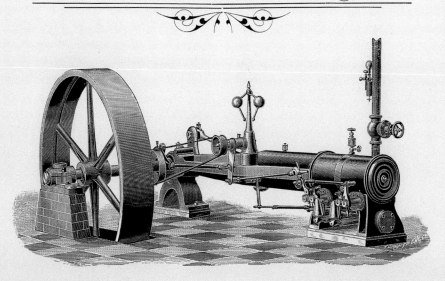

Having made arrangements with the Patentee for the manufacture of the above celebrated **VARIABLE CUT-OFF ENGINE,** and also put into our Shops a number of special tools for the purpose, we are now prepared to supply these Engines, got up in the best style.

GOLDIE & McCULLOCH,

Canadian Manufacturers of the Wheelock Engine. GALT, ONTARIO.

Sandford Fleming's great time crusade

Until a century and a half ago, timekeeping was largely of local concern. By the 1850s, with long-distance railway lines and telegraph systems, serious discrepancies in local timekeeping could no longer be tolerated. For railways to provide safe and efficient service, they had to impose 'railway time' on the towns and villages along their lines. However, this did not overcome the problem of time differences among major cities. There was also a need to standardize time internationally.

Canada's greatest proponent of standardized time was Sir Sandford Fleming (1827–1915), the chief engineer of the Intercolonial and the Canadian Pacific railways and a strong advocate of undersea telegraph cables linking the British Empire. From his experience, Fleming realized the problems that varying local times were causing.

Starting in 1878, he became a tireless advocate of a scheme of universal time based on the meridian passing through Greenwich, England. With support from railway companies, and intellectual and professional associations, an International Time Convention was held in Washington, DC, in 1882. There Fleming's international time standard was adopted. Individual countries, though, still had to be convinced to conform to the international standard, and Fleming spent many more years writing about the virtues of standard time. Both Canada and the United States adopted international standard time on 18 November 1883. Fleming's 'Reforms in Time Reckoning' was a draft of a talk given to the Canadian Institute in Toronto on 21 March 1891 and published in its *Transactions* of 1890–1.

Draft article 'Reforms in Time Reckoning'
by Sandford Fleming, [c. 1891]
Sandford Fleming papers
MG29, B1, vol. 102, file 33

~~Time and Reforms in~~

Reforms in Time Reckoning
by Sandford Fleming

It is, only, within the last ~~twelve~~ fifteen years
that special attention has been directed
to the false principles and untenable theories and ~~to~~
the curious old usages which still in
many quarters
prevail ~~in our social economy~~ with
respect to Time, its measurement and
notation. In spite of the advance
in science in other directions, which
makes the incongruities in question the
more remarkable we have remained until now rooted
observances
in ~~customs~~ which cannot be defended
on any rational or scientific grounds.
while
We do not ~~even~~ suppress our ridicule at
many ancient customs which at the
to us
present day appear absurd ~~nevertheless~~
we remain blind to the fact that some
in the reckoning of time
of our every day practices are not less
irrational, being based on theories
which cannot be sustained

The birth of the women's movement in Canada

In May 1893, women from about twenty countries gathered at the World's Fair in Chicago to open the first World Congress of Women, where they agreed to establish a national federation of women's organizations in their respective countries. Lady Ishbel Aberdeen, wife of the recently appointed governor general of Canada, was elected president of the International Council of Women. That council, founded in 1888, united women's groups in a non-sectarian, non-partisan organization dedicated to social reform.

On 22 May 1893, as these minutes recorded by Mrs Emily Cummings reveal, Canadian women attending the World Congress issued 'an appeal to the leaders of the various woman's societies in the seven provinces, asking them ... to organize on Dominion lines and to federate into our Canadian council.' Mary McDonnell, president of the Woman's Christian Temperance Union, was elected provisional president of the proposed National Council of Women, which included members from the Women's Enfranchisement Association of Canada, the Canadian branch of the International Order of King's Daughters and Sons, the Young Women's Christian Association, the Methodist Missionary Association, journalists, and teachers.

The first public meeting of the Dominion Council of Women of Canada (DCWC) was held at Toronto's Horticultural Pavillion on 27 October 1893. Lady Aberdeen, who was also acclaimed as the first president of the organization, presided over the meeting, which formally adopted a constitution and general policy. The preamble of the constitution read as follows: 'We, Women of Canada, sincerely believing that the best good of our homes and nation will be advanced by our own greater unity of thought, sympathy and purpose, and that an organized movement of women will best conserve the highest good of the family and state, do hereby band ourselves to further the application of the Golden Rules to Society, Custom and Law.'

The founding of the DCWC was a historic event in the development of the women's movement in Canada. The council developed into a non-sectarian national umbrella organization affiliated with local councils of women and other women's groups across the dominion.

With a membership composed of mainly upper-middle-class Protestant women, the Dominion Council was less radical than feminist organizations such as the Dominion Woman's Christian Temperance Union. Nevertheless, the Dominion Council supported the women's reform movement and was concerned with issues such as the preservation of the sanctity of the family, the raising of children, and the debate over women's suffrage. During the twentieth century, the DCWC (later renamed the National Council of Women of Canada) maintained close ties with the Victorian Order of Nurses, the Imperial Order Daughters of the Empire, children's aid societies, and the Canadian Association of Consumers.

Minutes, Dominion Council of Women for Canada
meeting in Chicago, Illinois, 22 May 1893
National Council of Women papers
MG28, 125, vol. 1, file 1 'Minutes of Meetings'

Dominion Council of Woman
for Canada

Chicago May 22nd 1893.

At 10.30 a.m

On Monday May 22nd a Meeting
of the Representative Women
from Canada, who had attended
the Woman's Congress, was held in
Patteson C. Palmer House, Chicago
for the purpose of Electing Provisional
Officers, for a proposed National
Council of Women which should
consist of all organizations of women
organized on Dominion lines.

In the absence of the Countess
of Aberdeen the chair was taken
by Mrs Florence Fenwick Miller of
England, as her Representative.

Jewish settlers in Saskatchewan

To secure Canada's frontier from its American neighbour to the south, successive Canadian governments initiated and developed ambitious plans to colonize vast tracts of sparse and undeveloped land in the Canadian North-West Territories. The provinces of Saskatchewan and Alberta were eventually created out of this area in 1905. Beginning in the early 1880s, vast numbers of immigrants from Eastern Europe, especially from what is now Western Ukraine, settled on the land. Canada was seen by these impoverished immigrants as a land of freedom and limitless opportunity.

By 1900, thousands of Eastern European Jewish immigrants had entered Canada. The centuries-old Canadian Jewish community cared for the new arrivals through the Young Men's Hebrew Benevolent Society of Montreal (est. 1863). The YMHBS, together with the Jewish Coloni-zation Association of Paris, saw the government's efforts as an opportunity to settle large numbers of immigrant Jews on the land. The colony, established in April 1892 at Hirsch (named after the founder of the JCA, Baron de Hirsch, and now in Saskatchewan), was one of the first such attempts. The colony grew in numbers and prospered until the advent of the Great Depression in the 1930s. Found in the Louis Rosenberg papers in the National Archives, this document lists the original settlers and gives a descriptive account of their economic status from their arrival up to 1900. Canadian Jewry's leading demographer, Louis Rosenberg (1893–1987), taught at one of the colonies. He later served as the western Canadian director of the JCA. The Archives contains hundreds of similar collections pertaining to the great wave of immigration and colonization of this period.

Report on the colony established by
the Jewish Colonization Association at Hirsch,
North-West Territories, [c. 1900]
Louis Rosenberg papers MG30, C119, vol. 14,
file 'Hirsch Colony Correspondence, 1900–1'

Hirsch Colony Assiniboia North West Territories CANADA

West of 2nd Meridian

Original Settlers still upon the Colony. April 189? date of settlement.

	Name	Qr Section	Township	Range	Amt Advance	Date	Amt Mtge at 5%	Mortgage	Date	Other securities Promissory note	Date	Remarks
7	Felickson Calman	NW 28	3	5	876.	53	July /9?	$600	Oct 28/95	53. 98 74 200. -	July /94 199	Has not cultivated this land since Jan't 1900 but procured a transfer to his wife name S.W. 228.5 where he resides.
23	Fishstrum Moses	SE 30	3	5	1252	12	"	$600	June/95	57. 85	July /94	
24	Sair Abraham	NW 30	3	5	1237	26	"	$600	Oct 11/95	15-8. 53	" /94	Resides at Oxbow.
4?	Hirschberg John	NE 16	3	4	725	36	"	$600	Dec /95	30 .	July /96	From Winnipeg (or Regina)
4	Levitt Isaac	SE 36	3	6	781	74	"	$600	June/95	129 53	July /94	Resides at Oxbow for some time From Winnipeg (or ?)

Original Settlers who have LEFT the Colony since Jan't 1st 1902

	Name	Qr Section	Township	Range	Amt Advance	Date		Mortgage	Date	Other securities	Date	Remarks
12	Moses Schatzsky	SW 32	3	5	853	90	From about /92	$600	Oct /95	48 53	July /94	Removed to Winnipeg
63	Schatzsky Samuel	NE 32	6	5	686	68	"	$600	Oct /95	5 53	"	Removed to Winnipeg
32	Barenblat Israel	NE 30	3	5	1203	57	July /94	$100	June/95	168 21	"	Residing at Oxbow occasionally cultivate ?
*	Levitt Michael	SW 36	3	6	787	76	/94	$600	Oct /95	56 93	"	Deceased —

No application was made for patents on any of the above lands by the Society.

* These settlers did not go to the Colony sent by the Society either to Winnipeg direct from Montreal, having been previously or Regina

Lucy Maud Montgomery and the price of fame

Lucy Maud Montgomery was born in Clifton, Prince Edward Island, in 1874. As a young student and school-teacher she had a modest literary career, publishing poetry and short stories in Canadian and American magazines, but in 1908 she achieved sudden international fame with the publication of *Anne of Green Gables*, the story of the wilful red-haired orphan Anne Shirley.

Montgomery had begun corresponding with Ephraim Weber, an Alberta homesteader with literary interests and aspirations, in 1902, and on 10 September 1908 she wrote to him bemusedly about the unexpected popularity of *Anne of Green Gables* and her publisher's insistence that she write a sequel. Although, as the letter shows, Montgomery had ambivalent feelings about her heroine, she went on to finish *Anne of Avonlea* and another six Anne novels, as well as almost a score of other juvenile books – all but one with Prince Edward Island settings – before her death in 1942. Her books have since been translated into over fifteen languages and have sold millions of copies around the world, making her possibly Canada's best-known author.

Montgomery and Weber corresponded for almost forty years. Although the letters from Weber to Montgomery have disappeared, the Montgomery letters survive in the National Archives. Dating from 1905 to 1941, they cover a wide range of subjects, from education, religion, current events, and travels to her domestic affairs, and from her own work to writing in general. They are thus a rich source of information on Montgomery's life and career. The Montgomery-Weber correspondence illustrates the importance of literary correspondence for an understanding of a writer's relationship with her work.

Letter from L.M. Montgomery to Ephraim Weber,
Cavendish, Prince Edward Island, 10 September 1908
Ephraim Weber papers MG30, D53, vol. 1, file 1908

Cavendish, P.E.I.

Thursday evening:.
 Sept 10, 1908.

My dear Mr. Weber:.

I know my
correspondents all think I'm dead.
I'm not – but I'm so tired and
worn out, after a summer of steady
grind, that I might almost as
well be, as far as real living is
concerned. To tell the truth, I feel
horribly "played out."

You see, "Anne" seems to have
hit the public taste. She has gone
through four editions in three
months. As a result, the publishers
have been urging me to have the

praise her. You did not make
second volume ready for them by
October – in fact insisting upon it.
I have been writing "like mad"
all through the hottest summer
we have ever had. I finished
the book last week and am
now typewriting it, which means
from three to four hours pounding
every day – excessively wearisome
work; I expect it will take me
a month to get it done – if I
last so long.

Thank you for your kind
remarks on "Anne". I suppose she's
all right but I'm so horribly
tired of her that I can't see a
single merit in her or the book
and can't really convince myself
that people are sincere when they

After six months, Stefansson meets companions who thought him dead

Canadian-born Vilhjalmur Stefansson's (1879–1962) personal mission was to change the Arctic's reputation. His Arctic was less cold than Minnesota, less barren than U.S. deserts, and its inhabitants friendlier than most southerners. Living with Eskimos of the Mackenzie Delta during the years 1906–8, he learned their language, ate their food, and adopted their dress and hunting methods. On later expeditions, these skills would be vital to survival.

After a second expedition, which lasted from 1908 to 1912, Stefansson planned a major scientific expedition. To bolster its claims to arctic sovereignty, the Canadian government sponsored this expedition, which cost $519,370.97 and lasted for five years, from 1913 to 1918. Stefansson had complete control of the expedition, including selecting his staff, but from the start his command, conduct, and subsequent reports were controversial. Lack of respect from, and support by, some of his team (some ignored his direct orders) contributed to his difficulties, including the loss of his flagship *Karluk*, and eleven lives, north of Siberia. In the excerpt shown here from Stefansson's log, he describes finding his camp after a six-month journey across polar ice. His team had given him up for dead:

Friday, Sept. 11 [1913]:

I came upon a *footprint of a heeled boot.* This was one of the gladdest sights of my life. – it showed white men had been there not many days before, for the tracks were nearly fresh and the probabilities were in favor of their being our men ... Half a mile further I saw the tracks again ... At the cape itself I found no traces, but a mile or more E along the coast I got to the top of a hill from which I saw the tips of two masts. I could hardly believe my eyes ... I ran a half mile for fear they might start off at any moment, but then I came in sight of a cluster of tents and the walls of a sod house that was building ... Bernard was working at the house in full sight from the time I was 200 yds. off till I was 50 and then he turned his back on me and walked to the ship, never seeing me. Crawford now came out and was puttering away, and finally saw me when I was 15 yds. or so off. Then his eyes stuck out like pegs.

Despite such difficulties the expedition accomplished a great deal. Stefansson proved that it is possible to survive on food gathered while travelling on the ice-cap. He charted the northern waters and islands and discovered the last major islands of the Canadian Arctic: Borden, Brock, Meighen, and Lougheed. In 1951 Lougheed Island was discovered to consist of two islands, one of which was named after Stefansson.

Stefansson subsequently became a lecturer and consultant on the Arctic, and promoted aerial and submarine exploration to exploit its strategic, tourist, and commercial potential. In the course of thirty years he collected the world's largest library on the Arctic/North, which he moved to Dartmouth College in Hanover, New Hampshire, in 1951. Dartmouth was his base of operations during the last decade of his life.

Stefansson's private diaries of the expedition, which are held partly by the National Archives and partly by the Dartmouth College Library, provide a wealth of geographical, atmospheric, and ethnographic information.

Diary of Vilhjalmur Stefansson,
entry of 11 September [1913]
MG30, B81, vol. 1, p. 128

the men are at fault again. Tomorrow we shall see if
any ship has been to Killett. Matt promised to leave something for me
at Killett if — as he feared and I did not — my men failed to try to
carry out my orders. Party. Cloudy forenoon, nearly clear afternoon; a few clouds on
horizon at sunset — had not seen sun set yet. N22E⁵ at 9 A.M. N22E¹⁰ at noon,
N35E¹⁵ at 3: P.M. N E¹⁵ at 6: — Ground frozen in forest glades and some
ice on small ponds; freezing most of forenoon and after 5: P.M. 128

Friday. Sept. 11: At Banksland Wint. Camp of Canadian Arctic Expedition.

Started at 7:30 A. and reached foot of Killett sandspit about 11:30 —
dist. about 7 miles S. Crossed river, I about a mile S of camp and
half a mile S of it I came upon a footprint of a heeled boot.
This was one of the gladdest sights of
my life — it showed white men had been there not many days
before, for the tracks were nearly fresh, and the probabilities were in
favor of their being our men. I built a monument by
the tracks for the others and scribbled them a note; then I hurried
on. Half a mile further I saw the tracks again; they were therefor
headed about for the foot of Killett, and there was cross-hatching to show they
were rubber boots. This made it almost certain that the one
man — it was only one — would be one of the scientific staff of the expedition,
for some of them had rubber boots of their own along. At the cape itself
I found no tracks, but a mile or more E. along the coast I got
to the top of a hill from which I saw the tops of two masts.
I could literally believe my eyes — somehow it seemed so natural
to find a ship in Banks Island, where it ought to be. I ran
a half mile for fear they might start off at any moment, but then I
came in sight of a cluster of tents and the walls of a sod
house building. The ship was the Mary Sachs and was hauled
up on the beach partly. Bernard was working at the house in
full sight from the time I was 300 yds. off till I was 50, and then
he turned his back on me and walked to the ship, never seeing me.
Crawford now came out and was puttering away, and finally saw
me when I was 15 yds. or so off. Then his eyes stuck out like
legs. Bernard now saw me too, and came running. Thompson
was there too and his wife and Stokeson's Levy is with them
cooking, but was off in a boat out of sight after a wounded or
dead duck. Wilkins and Billy make up the rest — they
are off in the country hunting with a sled on wheels. Thompson
and Crawford went off at once with tobacco for Ole and a bag
of doughnuts for each — & I had told them to camp at the foot of the
Killett sandspit. I got home about 3: P.M. and others tw2 about
two hours later.

News: The Karluk was crushed in January near Wrangell
Island — about 60 miles off. Before
she was crushed Mackay, Mamen (?) and a sailor had left to
land on Wrangell. Bartlett and all others got safely ashore

During the Winnipeg General Strike, a permit to deliver milk

The Winnipeg General Strike of 1919 was one of the most complete withdrawals of labour ever to occur in North America. The strike began in the metals and building trades over issues of union recognition and collective bargaining. In support, a general sympathetic strike was called for Thursday, 15 May 1919, and more than 22,000 workers responded. On 17 June many of the strike leaders were arrested and charged with seditious conspiracy. Four days later, on 'Bloody Saturday,' a charge by Royal North-West Mounted Police into a group of strikers resulted in many injuries and one death. With their leaders arrested, the Mounties, military, and special police forces patrolling the streets of Winnipeg, and many individuals suffering after six weeks with no income, the strike was called off by the Central Strike Committee on 26 June.

To protect vital services during the strike, the Strike Committee, in cooperation with the Winnipeg City Council, provided printed placards to demonstrate that workers still engaged in essential services were not betraying their fellows. Of special concern to the strikers and councillors alike was the delivery of milk to children. This document is one used by drivers for the Crescent Creamery Company. Following the strike, it was used in court as evidence against Robert Boyd Russell, secretary of the Metal Trades Council and one of the leaders of the strike. Russell was found guilty of seditious conspiracy and sentenced to the maximum term of two years. The crown claimed that the placard proved that the leaders of the strike were attempting to govern Winnipeg.

On the back of the document is the signature of J.M. Carruthers, manager of the Crescent Creamery Company, as well as other court stamps indicating that the placard was also used as evidence in the trial for seditious conspiracy against F.J. Dixon, member of the Legislative Assembly for Winnipeg Centre, and other strike leaders.

Permission card issued by the Strike Committee
during the Winnipeg General Strike, 1919
Printed document with manuscript additions
Charles F. Gray papers MG30, A83, vol. 1

216

PERMITTED BY

AUTHORITY OF

STRIKE COMMITTEE

This is one of the Permission Cards which was issued to milk drivers during the Strike and which was removed from one of the Crescent Creamery waggons by myself

16-4-19

The king empowers a Canadian to sign a treaty

In 1923, Canada's external relations were still the responsibility of Great Britain. However, the Canadian government, led by William Lyon Mackenzie King since 1921, wanted to secure its autonomy. It planned to further its cause by establishing precedents, the first of which was the negotiation and signing of the Halibut Treaty with the United States by a Canadian minister without consultation with Great Britain. This treaty, which concerned fishing rights in the North Pacific, marked an important legal milestone in Canada's progress towards independence.

To carry out this undertaking, Canada had to ask the king to issue a commission empowering the Canadian minister of marine and fisheries, Ernest Lapointe, to sign the treaty with the United States. This is the document that the minister had in his possession when he went to Washington in February 1923. To ensure that he would be the only one to sign the treaty, he refused the British ambassador's offer to accompany him. The next day, Lapointe and the Liberal government received numerous congratulations. Lapointe and his family preserved the commission signed by George V as a treasure.

Ernest Lapointe (1876–1941) was a member of Parliament from 1904 to 1941 and a minister in Liberal governments from 1921. He was considered the Liberal leader's francophone lieutenant, and took part in many international meetings, such as imperial conferences and sessions of the League of Nations.

Commission signed by King George V investing
the Minister of Marine and Fisheries with full power
to conclude a treaty on the Pacific Halibut Fishery
with the United States, 1 February 1923
Ernest Lapointe papers MG27 III, B10

George R.I.

George by the Grace of God, of the United Kingdom of Great Britain and Ireland and of the British Dominions beyond the Seas King, Defender of the Faith, Emperor of India, &c. &c. &c. To all and Singular to whom these Presents shall come, Greeting: Whereas for the better treating of and arranging certain matters which are now in discussion, or which may come into discussion, between Us and Our Good Friends the United States of America, relating to the regulation of the Pacific Halibut Fishery We have judged it expedient to invest a fit person with Full Power to conduct the said discussion on Our Part. Know Ye therefore that We, reposing especial trust and confidence in the wisdom, loyalty, diligence and circumspection of Our Trusty and Well-beloved the Honourable Ernest Lapointe, one of Our Counsel learned in the Law, Member of the Parliament of Canada, Member of Our Privy Council for Canada, Minister of Marine and Fisheries of Our Dominion of Canada, have named, made, constituted and appointed, as We do by these Presents name, make, constitute, and appoint him Our undoubted Commissioner, Procurator and Plenipotentiary: Giving to him all manner of power and authority to treat, adjust, and conclude, with such Minister or Ministers as may be vested with similar power and authority on the part of Our Good Friends the United States of America, any Treaty, Convention, or Agreement that may tend to the attainment of the above-mentioned end, and to sign for Us, and in Our Name, everything so agreed upon and concluded, and to do and transact all such other matters as may appertain thereto, in as ample manner and form, and with equal force and efficacy, as We Ourselves could do if personally present: Engaging and Promising upon Our Royal Word that whatever things shall be so transacted and concluded by Our said Commissioner, Procurator and Plenipotentiary shall, subject if necessary to Our Ratification, be agreed to, acknowledged and accepted by Us in the fullest manner, and that We will never suffer, either in the whole or in part, any person whatsoever to infringe the same, or act contrary thereto, as far as it lies in Our power. In witness whereof We have caused the Great Seal of Our United Kingdom of Great Britain and Ireland to be affixed to these Presents which We have signed with Our Royal Hand.

Given at Our Court of Saint James the First day of February in the year of Our Lord one thousand nine hundred and Twenty-three and in the Thirteenth year of Our Reign.

The diary of William Lyon Mackenzie King

On 24 September 1939 William Lyon Mackenzie King had been prime minister of Canada for thirteen of the previous eighteen years. He held the office for twenty-two years in total, longer than any other prime minister in British Commonwealth history. Despite this political success, Canadians never held him in great affection. Since his death, many have not forgiven his public banality and smug cautiousness, although they have been fascinated by his private spiritualism and by his affection for his dogs and for his dead mother. Perhaps because he never married, King found intimacy in correspondence, particularly with women. But his closest companion and confidant was his extraordinary diary.

The diary begins in 1893 when King was an eighteen-year-old student and ends at his death fifty-seven years later. Starting in the late 1930s, the diary, which had originally been recorded in King's own hand, was largely dictated to his private secretary. In the early years it was frequently abandoned for months. But when he was prime minister, King rarely allowed a day to pass without recording personal and political events, usually in remarkable detail. He often recounted not only what was said at meetings, but also the appearance of others, his own mood, and minor details such as flower arrangements.

Rarely have the daily opinions, prejudices, and expectations of any head of government anywhere been recorded so thoroughly. Arguably his diaries are the crown jewel of Canadian political archives. The first portion of the diaries was opened to researchers in 1971. Now all are available to the public. This Sunday entry, made at his summer house at Kingsmere just north of Ottawa in Quebec, begins and ends with war worries. During the day, he walked with his dog Pat, wrote letters, worked, lunched with his friend Joan Patteson and her husband, Godfroy, and read.

Diary of Mackenzie King,
entry of Sunday 24 September 1939
Rt. Hon. W.L. Mackenzie King papers
MG26, J13, p. 1080

KINGSMERE,

Sunday, September 24, 1939

Slept well through the night though dreamed a good deal about the European situation. My mind is haunted with the thought of masses of men being slaughtered on the Western front.

Was up at 8.30 (Daylight saving changed at midnight). Out for a walk with Pat before breakfast. A beautiful morning.

Spent the forenoon writing Lady Minto, Lady Gladstone, and Gregory Clark, going over office papers particularly on organization of War Effort. Cleared up most material I had taken with me over the week-end.

Worked steadily till 1.30 when J. and G. arrived. J. and I walked with the little dogs across the open field. After lunch, we went for quite a long walk in the sun, first to the little cottages by the lake, then by Moorside across the Abbey Ruin to the far end of the field. Back across the fields and over the moor. Then went to bed for a good rest. Slept soundly from 4.30 till 6. We then went for another walk around by the side of the lake, and back by the road.

After dinner, spent the evening in the sitting room reading some war material. Also a few of the verses from the "Open Road".

Received today a despatch about British war plans, very serious outlook as it views possibilities of Italy and other countries entering against Britain. It is almost equivalent to Britain and France taking on most of the world except the U.S. which is out of things. Never has such an appalling situation faced mankind. I believe, however, that Britain and France will win. Two years has been the period that I have thought the war would take - those words having stood out underlined in my Bible on the morning that Britain entered the war.

After listening to the broadcast, read a little poetry before going to sleep.

Marshall McLuhan writes The Mechanical Bride

He was described as a 'media guru' and 'Canada's intellectual comet,' and his phrases such as 'the medium is the message,' 'hot' and 'cool' media, and 'the global village' have entered the vocabulary of North American intellectual circles.

Born in Edmonton in 1911, Herbert Marshall McLuhan studied English literature at the University of Manitoba and at Cambridge University. He later joined the faculty of English at St Michael's College, University of Toronto, where he taught courses in literary criticism and held seminars on culture and communications. In 1963 he became director of the university's Centre for Culture and Technology, which studied questions of communications and sensory perception, the media and popular culture, and the impact of technology on society. His innovative theories on the media made him an international celebrity during the 1960s.

McLuhan's pioneering ideas on mass media (print, radio, and television) and popular culture were presented in *The Mechanical Bride: The Folklore of Industrial Man* (1951), *The Gutenberg Galaxy: The Making of Typographic Man* (1962), *Understanding Media: The Extensions of Man* (1964), *The Medium Is the Massage: An Inventory of Effects* (1967), and *War and Peace in the Global Village* (1968).

This handwritten text, from the first draft of his manuscript 'The Mechanical Bride,' is one of several short essays in which McLuhan examined the ways in which newspaper and magazine advertisers used images and symbols to shape contemporary opinions during the late 1940s. The essay was published in the book of the same title. Like the letters of Lucy Maud Montgomery, draft manuscripts such as this give valuable insights into the process of a literary mind at work.

Manuscript of 'The Mechanical Bride'
by Marshall McLuhan, [c. 1950]
Marshall McLuhan papers
MG31, D156, vol. 66, file 66-15

The Mechanical Bride

It was ~~several years ago~~ while preparing a study of ~~It was while studying~~ the patterns of <u>Life</u> ~~magazine~~ that the ~~preceding~~ repeated ~~consummation~~ of the marriage of sex and technology ~~emerged~~ as archetypal, ^not just for Life but^ ^unexpectedly^ for our industrial world. ^Hovering^ over and ~~around~~ this archetype in protean disguises is death. Wherever sex and ~~technology~~ meet and ~~fuse~~ there will be found in association ^pictorial^ ~~and reportorial~~ ~~world~~ ^presentation^ a ~~world~~ of hectic violence, of breathless ~~speed and sudden~~ death. ^very much of it^ I do not pretend to understand, this ~~pattern~~, but it is there for all to ^study^ ~~see~~. And it is certainly linked to the patterns noted in "Love Goddess Assembly Line". ~~And~~ ~~many~~ a time these same legs have stood (over)

[Begin here]

[Lone] Thus, for example, the legs "on a Pedestal" presented by the Gotham Hosiery company ~~knew~~ are one facet of our ~~a neat an illustration~~ of ~~the~~ "replaceable parts" cultural dynamics. In a specialist world it is natural that we should select some single part of the human body for attention. ~~And the~~ ^many^ ~~ordinary men~~ today ~~are~~ unconscious specialists ~~for whom the present attempt to see things relatedly is a meaningless effort.~~ ^Al Capp's^ ~~Li'il Abner~~ ^had Li'il Abner^ expressed this ~~popularly~~ ^ironically^ when he ^fell^ desperately in love with the pictorial scrap of a woman's knee, saying ~~from~~ (Jan. 21, 1950) "Why <u>not</u>? Some boys falls in love with the expression on a gals face. Ah is a knee man!" Four ~~five~~ months and many lethal ^and romantic^ adventures later Li'il Abner ~~is~~ was closing in on the ~~murderous vampire~~ ^owner^ of the knee who proved to be a male.

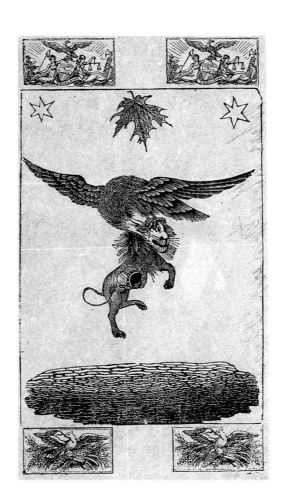

VI
Tracing Ancestors

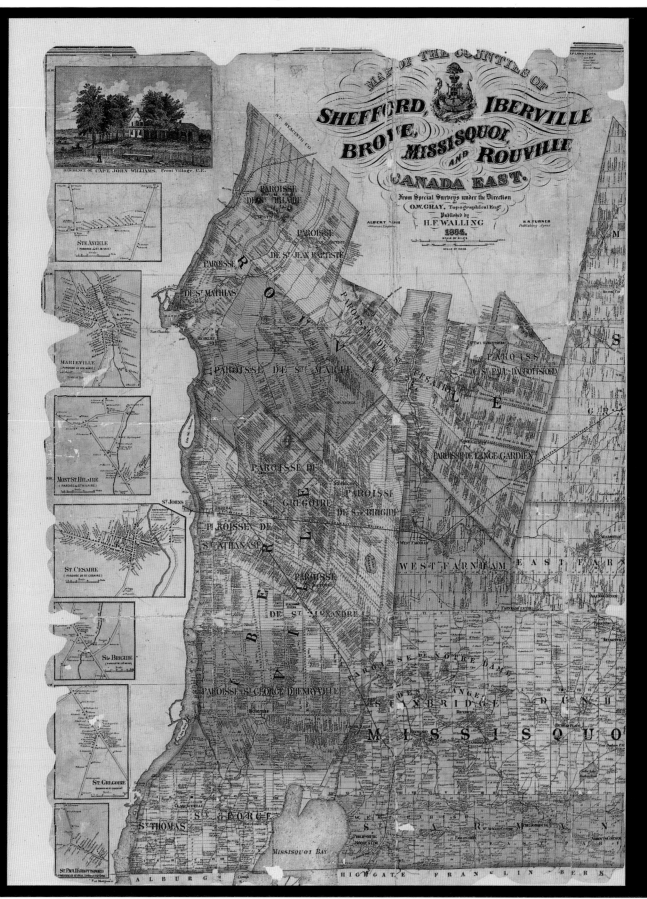

Genealogical Records

The history of our families is an essential thread in the fabric of Canadian society. As a fifteen-year-old once told a member of the National Archives' genealogical staff, 'history may be written by historians, but it is made by people.' Whether our ancestors were legislators or labourers, native Canadians or recent immigrants, they each contributed to the shaping of our nation. History, moreover, is often written by people who are not historians. The writing of family history, based in large part on genealogical research in archives, is an example of the history of everyday Canadians written by everyday Canadians.

Countless documents held by the National Archives of Canada are genealogically significant. Despite this, the concept of 'genealogical treasures' is perhaps somewhat of a contradiction, in that an ordinary scrap of paper, a poorly shot photograph, or a seemingly uninteresting military file often provide important information to the family researcher using the archival record. These documents are not so much valuable intrinsically as for the information they contain. Census returns may have a lasting historical value, for example, because of their broad portrayal of Canadian society in a given era. A genealogist, however, will likely be more interested in the specific details relating to no more than a few individuals. Similarly, government documents relating to the settlement of the West may provide valuable insight to an academic historian; to the family historian, the same documents may chronicle the arrival of grandparents or great-grandparents in Canada. The vast wealth of archival collections in our custody and the endless possibilities of research in them make it difficult to identify a select few. It is just these possibilities, however, that may lead to a greater understanding of a particular family's history and of the social circumstances in which that family lived.

By necessity, then, this chapter is more concerned with the ultimate use to which archives are put than with the particular documents themselves. What follows represents only a cursory sampling of the holdings that are regularly exploited in the search for genealogical information. Nonetheless, within the impressive variety there is a common thread, something with which every experienced researcher is familiar – archival documents have many uses, which more often than not have little to do with the original reason for which they were created. Documents created at the turn of the century by the Immigration Branch of the Department of the Interior, for example, have long outlived their original purpose and utility; their continuing value to genealogists is, however, obvious.

It also must be remembered that documents used for genealogical research provide singular clues to, or pieces of, a much larger picture. No one document in the holdings of the National Archives will provide the complete answer; on the contrary, the document may often pose a new mystery or research problem to be solved. The painstaking nature of archival research, whatever the topic or purpose, requires careful planning and patient investigation.

Genealogical research, in seeking to uncover information about Canadians and the way they lived, is more than a solitary journey into one's past. It provides its dedicated and persevering practitioners with a sense of belonging to a greater collectivity. It also contributes in a lasting way to a wider understanding of our heritage and what it is that makes Canada and Canadians unique.

Tracing families in early vital records

Every genealogist dreams of finding a record of his ancestor's birth. If the place and denomination are known, the search for surviving parish and civil registers can begin. Responsibility for the preservation of these records falls within the jurisdiction of various institutions, from individual parishes to denominational and provincial archives.

In Acadia, as in most French colonies in the seventeenth century, clergymen were responsible for keeping the records of births, marriage, and deaths. Many of those early records have survived for important Acadian centres such as Beaubassin, known today as Amherst, Nova Scotia.

This entry, extracted from transcripts of the registers of Beaubassin, concerns Agnès and Marie, twin daughters of Thomas Cormier and Magdeleine Girouard. They were born on 12 May 1686 and baptised on the 20th. The priest who performed the baptismal rites added the words 'sous condition' in the registration to denote that the infants' survival was uncertain. However, several Acadian genealogists produced evidence that Marie and Agnès survived to marry the brothers Jean-Baptiste and Pierre Poirier and to have children of their own.

Registres de l'état civil,
Acadie et Gaspésie,
Beaubassin, 1686
MG9, B8, vol. 1, p. 32

Tracing families at a fur-trading post

Investigating the lives and careers of ancestors involves searching for records of schools, apprenticeship, employment, and property transactions, among many other things. Documents such as these detail the social and economic circumstances in which individuals lived. Unfortunately, they rarely identify more than names; yet sometimes unanticipated information can be gleaned from improbable sources. The predictable benefit of consulting an account book, for example, would be to find details confirming when a particular person was active in a place or clarifying the nature of a business relationship.

This volume records the transactions of natives at Fort Matawgamingue, on Lake Mattagami in northern Ontario. Established by the North West Company around 1794, the post later became part of the Hudson's Bay Company after the two companies merged in 1821. Richard Hardisty, who reportedly spoke Cree, was the chief trader and post manager from 1837 to 1848. In the last years before it closed in 1924, Fort Matawgamingue was used only as a winter outpost.

This ledger records the sale of furs and the purchase of goods such as blankets, cloth, knives and kettles, giving information about how these people lived. But the entries offer an additional and unexpected bonus: they identify many family relationships among clients of this Hudson's Bay Company trading post.

Credit records of Fort Matawgaminque, 1838–9
MG19, D16, vol. 3, p. 29

Economic conditions in Quebec City, 1771

Fire was an ever-present danger to our ancestors who lived in wooden houses without running water. For the safety of the community, regulations were passed that required the regular sweeping of chimneys and the proper storage of combustible materials. To ensure compliance, an inspector of chimneys was appointed in 1768 for the town of Quebec.

Jonathan Franks reported the fees he collected for chimney sweeping in a set of remarkably detailed accounts. Several of his surviving reports can serve as a substitute for a census of the town and suburbs of Quebec. This selection comes from Franks's statement for the period 1 November 1770 to 31 October 1771. Opposite the name of each resident householder of a specified street or suburb, an entry appears in one of the five columns that indicates economic circumstances: prompt and full payment, no payment but trustworthy, partial payment, absolutely too poor to pay, and unwilling to pay for various reasons. An additional column was reserved for those who had vacated their dwelling and the town.

Unlike a true census, however, these records say nothing of the age or occupation of the householders, and identifying the only women listed would be impossible were it not for the abbreviation (Vve) of the word 'widow' (*veuve*) that precedes the name of her deceased spouse. No other members of the households are identified in any fashion. Nonetheless, incomplete as it is, information gleaned from these records can be used to build pictures of families living in Quebec during this period.

Returns of chimneys swept in
the Town of Quebec, 1771
RG1, E15A, vol. 10, no. 247

A midwife seeks a licence

Residents of the provinces of Upper and Lower Canada petitioned their government for land grants – and for many other purposes besides. Records of the civil and provincial secretaries include applications for various licences – for culling of timber, tavern and inn-keeping, and the practice of medicine; for commissions to practise as notaries and advocates and for public appointments.

Increasingly, genealogists seek information beyond basic vital records – those of birth, marriage, and death – to add colour to family histories. The descendants of Jane Drew Orchard, the applicant in this case, would indeed be gratified that she chose the vocation of midwifery in an age when society expected nothing more of her than to spend her life being the wife of Mr Orchard.

From her petition, one can learn that Jane Drew Orchard had practised previously in London, but unfortunately she does not mention where she was living in Lower Canada when she made her application in 1800. According to a note on the back of the document, the application was referred to the board appointed by the governor of Quebec for an examination and report concerning the applicant's character, fitness, and capacity under the requirements of the law.

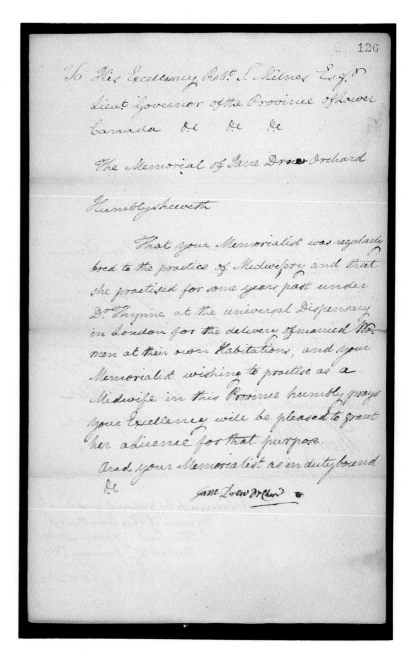

Application for medical licence, 1800
RG4, B28, vol. 47, p. 126

Muster roll: a black settlement in Nova Scotia

There are no census returns for the early period of British settlement, but muster rolls – the official lists of officers and men in a military unit – and provision lists can serve to place ancestors. Unlike most records of its type, which list only the heads of families and the total number of people in each household, this muster includes the names of the wives and children, thus facilitating the identification of whole families.

Most muster rolls of the Loyalist era were compiled by military officials; this is the return of Colonel Stephen Blucke's Company at Birchtown, Shelburne County. Although the list was originally created to document receipt of provisions, genealogists can use it to confirm their ancestors' age, place of residence, and occupation. Many of the men had trades, such as rope maker, boat builder, sawyer, in contrast to most settlers in this period who were farmers and labourers.

The settlement at Birchtown was one of several black communities established in Nova Scotia between 1782 and 1784 by freed American slaves and disbanded soldiers from black Loyalist regiments. Despite government promises, most blacks did not receive grants of land, and only Colonel Blucke received 200 acres, for which he waited four years. Conditions eventually proved so severe that nearly half the inhabitants of Birchtown left in 1792 for new colonies in Sierra Leone in West Africa.

Muster book of free black settlement
of Birchtown, NS, 1784
MG9, B9–14, pp. 108–9

Colonel Blucke's Company
who have drawn Provisions at Birch Town near
Shelburne from the 3d September 1783 to the 24 July
1784 —

Heads of Families	Women & Children	Age	Men	Women	Children above 10	Children under 10	Occupations	Remarks
Colonel Blucke		31	1					Bristol ✓ M
	Margaret Blucke	40		1				✓ M
	Isabella Gibbons	18			1			✓ M
	Richard Wilkinson	14			1			✓ M
	William Monday	26	1				Ropemaker	
Captain Hutchins		29	1					
	Elizabeth Hutchins	24		1				
Fall		27	1				Boat Builder	
	Dolly Fall	22		1				
	Jerry Fall	2				1		
Bush		20						
Isaac Bush		40	1					
	Lucy Bush	24		1				
Luke Smith		16	1				Farmer	
	Sukey Smith &	40		1				
Sandy Smith		22	1				Farmer	
	Lewis Smith	13			1			
	Nancy Smith	7				1		
	Rose Smith	18			1			
Joseph Newell		26	1				Sailor	
	Silvia Smith	23		1				
	Jude Smith	6 wks				1		
James Jones		40	1				Sailor	
	Sarah Jones	36		1				
James Connor		25	1				Sawyer	
	Christian Connor	24		1				
	Patience Connor	9 mo				1		
Luke Wilson		29	1				Sailor	
	Dolly Wilson	36		1				

A Loyalist's claim is registered

Although the first settlers in Upper Canada received government authorization to occupy lands, they could not obtain title deeds until a formal system to issue them was set up in 1795. Before that date, a wide variety of informal documents were used to record the transfer of land titles by sale, gift, or inheritance. In 1797, the Heir and Devisee Commission was established to investigate and adjudicate the validity of land claims based on such documentation.

This example comes from the 1803 register compiled by the commission for the Johnstown District, now Leeds and Grenville counties in Ontario. Claimants are listed with the description of the land allowed and the name of the original nominee. A genealogist's attention would be drawn to any number of details: the names of the heirs of the late Cirus Hand, the identification of Joel Parish, a settler from Vermont, of Solomon Jones as a surgeon with Jessup's Rangers, and of George Alley as a soldier with the 44th Regiment.

Most of the original nominees are described as veterans of Loyalist regiments and are likely to be included in other contemporary Loyalist sources, such as land petitions that often give information on the petitioner's family, antecedents, and country of origin, and sometimes striking accounts of experiences during the American Revolutionary War. Claimants' names may also appear in Loyalist lists, muster rolls, and land board records. For example, one could search for Oliver Sweet's land petition for his original grant of lot 36, concession 5, Augusta Township, and also for any petitions submitted by Isaiah Carpenter, to whom the land was allocated in 1803.

Register of claims allowed,
Johnstown District, 1803
RG1, L5, vol. 90, p. 94

Claim No.	Year	To Whom Allowed	Lot	Concess.	Acres	Township	Original Nominee	Description	
43	1803	William LaRue	12	front		Yonge	Ephraim Eyres	soldier in Jessups	
44		Samuel Smades	6	8		Augusta	Abraham Smades		
45		Joseph White	35	4		Do	Joseph White Seni. (to conformable convent)	son of Joseph Seni.	see White's claim No. 42.
46		Ichiel Hurd	6½ 29	2		Do	James Chambers	soldier Loyal Rangers	see J. Hurds claim No. 45.
47		Isaac Hurd	30	3		Do	John Jones Capt.	Captain in Jessups	
48		Asahel Hurd	21	1	200	Marlborough	Joel Parish	a settler from Vermont 8th July 1790	
49		David Nettleton	East 6	4	100	Augusta	Ezekiel Spicer Senr.	soldier in Jessups	
50		Rhody Hand, Arty Hand & Ann Hand, heirs of the late Cyrus Hand	16	4		Elizabeth Town			
51		Samuel Lee	25	9	200	Do	Jerred Sealy	a settler 1786 S.Stk.	
52		William Kelsey	29	2		Do	James Mead & William Kelsey		
53		James Butler	6½ 10	8	100	Do	William McCue	soldier Army	
54		John Baldwin	4½ 3	1	100	Do	Paul Carrigan	soldier Loyal Rangers	
55		Isaiah Carpenter	36	5	200	Augusta	Oliver Sweet	soldier Do	
56		Zalmon Mitchel	4½ 33 6½ 34	3		Do	heirs of George Mitchel	soldier Army	
57		Sophia Bowen	15	7	200	Do	John Bunker	soldier Army	
58		Jacob Stech	5 8	8 6		Do	Paul Neck	Corporal with Burgoyne	
59		Samuel Stech	17 5½ 7	14 2		Do	Solomon Jones Esqr.	Surgeon in Jessups	
60		Do Do	6½ 14	3	100	Do	Henry Rash	German soldier	
61		Samuel Roos	24	9	200	Elizabeth Town	Henry Mott	soldier Loyal Rangers	
62		Benjamin Andrews	front½ 17½ 18	3		Do	Roger Stevens	Ensign Kings Rangers	
63		Jonah Brown	6¾ 23	2	150	Do	John Whitley	soldier in Jessups	
							Jacob Wormley	soldier Army	
64		George Alley	4½ 20	3	100	Augusta	George Alley	soldier 44 Regiment	

The daughter of a Loyalist petitions for land

Early settlers, in order to obtain crown lands, were required to submit petitions to the governor stating their claims to free grants. Many of them were Loyalists who had served the British cause during the American Revolution, or were descendants of Loyalists.

As the daughter of Loyalist Alexander Grant of Charlottenburg, Jane Ross was entitled to 200 acres of land from the crown. In the application she submitted at Elizabethtown in 1806, she declared herself the wife of William Ross of Augusta. In addition to clearly establishing Jane's Loyalist descent by naming her father, the petition opens a gate that will allow a modern researcher to extend the Loyalist connection through at least one more generation. It identifies her husband and his place of residence, and with that information, it is possible to trace their children through church and census records.

Land petitioners rarely specified the region or locality from where they had come, or indicated a location for the grant they requested. However, the endorsement of the petition indicates whether it was recommended or rejected by the Executive Council. The researcher thus is prompted to pursue or abandon the quest for the location of the grant in records held by the relevant provincial archives.

Upper Canada land petition, 1806
RG1, L3, vol. 426, R8/26

To his Excellency Francis Gore Esquire
Lieutenant Governor of the province of Upper
Canada &c. &c. &c. In Council —

 The petition of Jane Ross
Daughter of Alexander Grant of Charlottten
burg in the Eastern District a U.E. loyal
ist and married to William Ross of
Augusta Yeoman,
 Humbly Sheweth —

 That your petitioner has
never drawn any land or order for
lands from the Crown — Therefore prays
your Excellency in Council will think
proper to grant her 200 acres of the
waste lands of the Crown, And permit
Reuben Sherwood Surveyor, to be my agent
to locate the same and to take out the
Deed when completed — And your petit
ioner as in duty bound will ever pray

Elizabeth Town
Nov.r 12.th 1806

turn over

Oaths of Allegiance

Theobald Lorentz's name appears in the 1848 naturalization register along with the names of other settlers of Waterloo County who took the Oath of Allegiance after living in the province for at least seven years. From this data, one can infer that Lorentz arrived in Ontario in 1840 at the latest. As well, knowing the township of residence is a starting point for land and census searches.

Individual signatures are seldom seen in records of this period. Most unusually, all the people in this particular list appear to have been literate, as evidenced by the fact that none signed with an x. This register is also unusual in that oaths of allegiance in this period were taken orally and thus rarely recorded. Later records of naturalization provide more information about the applicant, but few have survived from the period before 1917.

Before the Canadian Citizenship Act of 1947, people born in Canada were considered British subjects. Because they held equal status, immigrants coming directly from Great Britain and the Commonwealth did not need to be naturalized.

Naturalization register,
Waterloo County, 1848
RG5, B47, vol. 8

Oath (and Affirmation) of Allegiance — under Act 4th & 5th Vict. Cap. 7.

I do swear, (or solemnly affirm, as the case may be) that I was actually resident within the Province of Canada, on the tenth day of February, in the year of Our Lord, one thousand eight hundred and forty one, at the place named in the declaration to which I have set my name in this Register; that I was continually resident in the said Province, for a term of Seven years, in which the said day was included; that all the other particulars in the said declaration, are true, to the best of my knowledge and belief, and that I truly believe myself entitled to be admitted to all the priviliges of British birth, within the said Province, under the provisions of an Act of the Legislature thereof, passed in the fifth year of the Reign of Her Majesty Queen Victoria entitled "An act to secure to and confer upon certain inhabitants of this Province, the civil and political rights of natural born British subjects", and I do further swear (or solemnly affirm, as the case may be) that I will be faithful, and bear true allegiance to the Sovereign of the United Kingdom of Great Britain & Ireland; and of this Province as dependant thereon. So Help Me God.

Declaration.

Name in full.	Residence on the 10th day of February, 1841.	Present Residence.	Date of the Expiration of the Seven Years' Residence.	Whether the party was, or was not under 16 years of age, at the date named in the next preceding column; and if he was, then the date at which he attained that age.	Signature.	Date of Registry.	No. of Registry.
Charles Frederick German	Waterloo,	Wilmot,	November 1, 1847.	Not under 16 years.	Charles Frederick German	January 5, 1848.	366
John Tinkann	Wilmot,	Wilmot,	September, 1840.	Not under 16 years.	John Tinkann	January 5, 1848.	367
Theobald Seiler	Wilmot,	Wilmot,	July, 1840.	Not under 16 years.	Theobald Seyler	January 5, 1848.	368
Sylvester Frank	Wilmot,	Wilmot,	November, 1838.	Not under 16 years.	Sylvester Frank	January 5, 1848.	369
Theobald Lorentz	Wilmot,	Wilmot.	15 September, 1847.	Not under 16 years.	Theobald Lorentz	January 5, 1848.	370
Joseph Martini	Wilmot,	Wilmot,	May — 1839.	Not under 16 years.	Joseph Martini	January 5, 1848.	371
Peter Wilker —	Wilmot,	Wilmot	August, 1839.	Not under 16 years.	Peter Wilker	January 5, 1848.	372
John Andres,	Wilmot,	Wilmot	15 September, 1840.	Not under 16 years.	Johann Andres,	January 5, 1848.	373
Frederick Hüther,	Wilmot,	Wilmot	— December, 1839.	Not under 16 years.	Friedrich Hüther	January 5, 1848.	374
John Haist,	Wilmot,	Wilmot,	1st December, 1838.	Not under 16 years.	John Haist.	January 5, 1848.	375
John Myers,	Woolwich,	Woolwich,	15th April, 1839,	Not under 16 years.	John Myers	January 5, 1848.	376
Jacob Blum,	Wellesley,	Wellesley,	July, 1840.	Not under 16 years.	Jacob Blum	January 5, 1848,	377
Conrad Smitt,	Waterloo,	Waterloo,	1 October, 1842.	Not under 16 years.	Conrad Schmitt	January 5, 1848,	378
Christian Naffzieger	North East Hope	Woolwich	October, 1835.	October, 1835.	Christian Naffzieger	January 5, 1848,	379
Nicholas Seyler,	Wilmot,	Wilmot,	July, 1840.	Not under 16 years.	Nicholas Seyler	January 5, 1848,	380

Compensation for losses in the War of 1812

Some civilians and veterans sought compensation for financial losses sustained as a result of American incursions into Upper Canada during the War of 1812, whether caused by the Americans or by the British Army and its Indian allies. Claims were usually accompanied by supporting documents, such as this affidavit by James Richmond, an employee of claimant John Harford. Richmond piloted Harford's boat to transport army families from Burlington Heights. In the affidavit he described how the vessel was wrecked in bad weather on the shore near Forty-Mile Creek, where she was subsequently destroyed by the Americans.

The rest of the claim file includes various statements by civil and military officials to the effect that John Harford had served with the First Regiment of Northumberland militia and had frequently been employed by the government to provide boating service between Kingston and York during the War of 1812. Most claims include a financial statement of the losses incurred, but Harford's claim only bears a notation that £25 was allowed.

While details in this file do not indicate clearly whether Harford lived in Haldimand or in Cramahé, the nature of the services he provided would lead the researcher to conclude that he occupied waterfront land on Lake Ontario in either one of these neighbouring townships in Northumberland County.

Claim for losses, War of 1812
RG19, E5a, vol. 3746, file 2, claim 435

Occupants and townships

One of the basic steps in a genealogical investigation is to determine an ancestor's place of residence and to familiarize oneself with that area. Maps are an indispensable tool for this purpose, as many records used in the course of research are organized geographically. This is particularly true of census returns.

This partial map of the Eastern Townships is a forerunner of the popular illustrated historical atlases published by private map makers in the late 1800s. The names of the occupants appear on most lots, a helpful tool for locating an ancestor's property. Subscribers paid to have their names shown, and for a higher fee could also include biographical notes and illustrations of their residences.

Another useful feature of this map is the delineation of townships within each county, providing a visual aid to research in census returns and local records. Along with other geographical tools such as gazetteers and toponymic dictionaries, contemporary maps can also help to locate villages that no longer exist and to identify place-name changes.

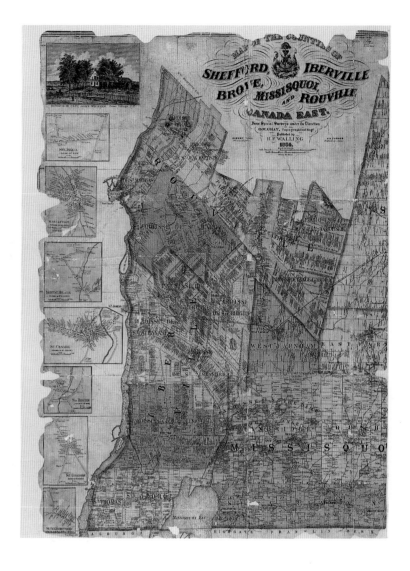

Map of the counties of Shefford,
Iberville, Brome, Missisquoi,
and Rouville, Canada East, 1864
NMC 14735

Census returns: the ideal primary source

Few genealogists can bypass census returns in the compilation of their family histories. Census returns constitute the only official and the most complete enumeration of Canada's population. Although compiled by the government for statistical purposes, they provide rich details about the lives of ordinary Canadians.

Before 1851, returns showed the name of the head of household only, with other family members indicated by numbers – for example, three females under age twelve. Full nominal returns began in 1851 and provide a picture of each family group at ten-year intervals. Names and ages, country or province of birth, ethnic origin, religious denomination, and occupation are only some of the details included.

Most returns were compiled by enumerators who visited each household and recorded the answers to the census questions. This often led to errors in the spelling of names, especially in cases where the enumerator did not speak the language of the resident. Errors in age could be a result of several factors, such as enumerations conducted later than the official census year. The 1851 enumeration, for example, was not started until January 1852. If the question was posed as 'age at next birthday,' one could find an ancestor born in 1831 shown as aged twenty-two in the 1851 returns.

Ages of children can serve as clues to a family's period of residence in the country. For example, if the eldest child was born in Ireland and the second in Ontario, their ages should suggest the approximate year the family arrived in Canada.

In most enumerations before 1881 the agricultural returns have also survived. These indicate the location of the land, acreage, types and amounts of crops planted, numbers of animals, implements, and buildings, along with other similar details. Some enumerators even specified the financial value of the farm. Discovering the exact land description assists the genealogist in pursuing relevant land records such as purchases and transfers.

The microfilm is of the 1891 census returns. Like many other government documents, these were microfilmed for preservation, and the originals were subsequently destroyed.

Canada Census: Northumberland County, NB;
Saguenay County, QUE, 1851
RG31, vol. 264, District 51, Northumberland County,
Newcastle Parish, p. 19
RG31, vol. 202, District 353, Saguenay County,
Isle-aux-Coudres, pp. 1, 33
RG31, reel T-6384

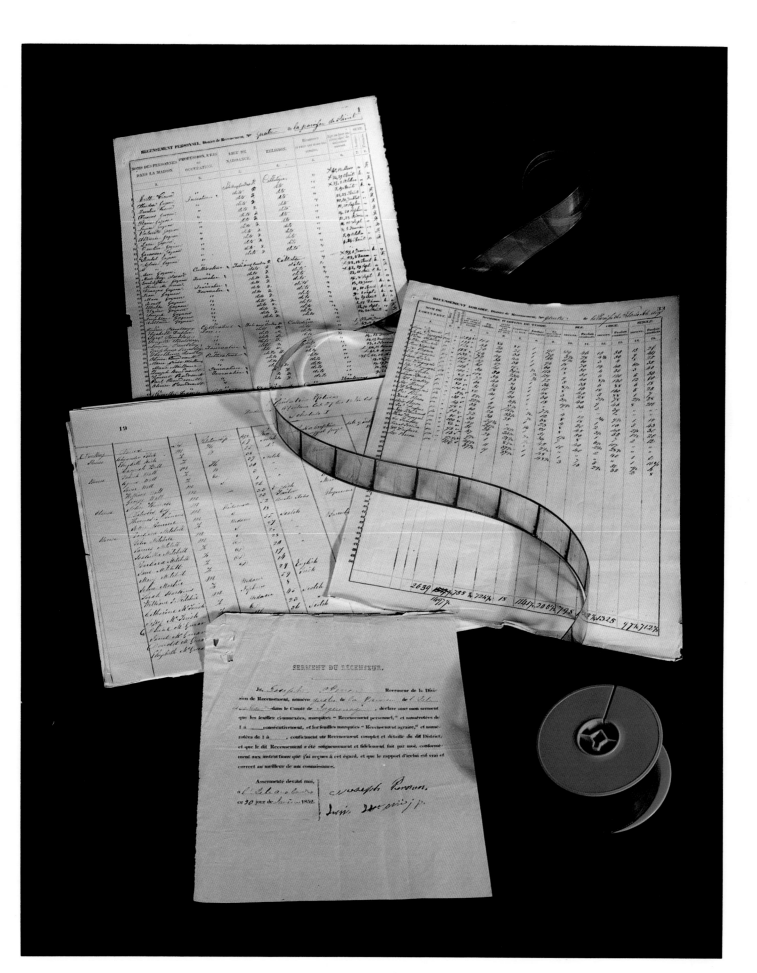

Rewards of census searching

Tracing French-Canadian ancestry in the province of Quebec may be the most rewarding of genealogical searches. Not only is the documentation more extensive, it is often more informative. Marriage records, for instance, always indicate the wife's maiden name and those of her parents. In this extract from the 1851 census returns of Baie-Saint-Paul, Saguenay County, Eulalie Fortin is listed as the wife of Florant Dufour, both born in that parish. Every individual living in a particular household was enumerated, regardless of relationship to the family. This household, for example, includes a servant, Marguerite Verrault, born in Petite-Rivière.

The information in census returns varies with each enumeration year and geographical area. Most returns list only the country or province of birth rather than the exact place, and few include the wife's maiden name. Some New Brunswick returns show the year of entering the colony. A death schedule for 1871 lists those who died in the preceding twelve months as well as the cause of death. In the case of infants, age is shown in number of months, providing a more precise indication of birth date.

In other returns one can learn that an ancestor could read and write, that she lived in a wooden two-storey house with five rooms, that she was a widow, and, in the 1891 returns, her parents' country of birth. These kinds of details flesh out a researcher's picture of his or her ancestor.

Canada Census, Baie-St-Paul,
Saguenay County, 1851
RG31, vol. 202, District 350, Saguenay County,
Baie-St-Paul, p. 127

RECENSEMENT PERSONNEL, District de Recensement, Nº *premier* de *la Paroisse de la Baie St Paul*

	NOMS DES PERSONNES DANS LA MAISON.	PROFESSION, ETAT ou OCCUPATION.	LIEU DE NAISSANCE.	RELIGION.	RÉSIDENCE SI ELLE EST HORS DES LIMITES.	Age au jour anniversaire de naissance suivant.	SEXE. Hommes.	SEXE. Femmes.
	1.	2.	3.	4.	5.	6.	7.	8.
1	Bernabé Tremblay	Cultivateur	Baie St Paul	Catholique	~ X	25	1	
2	Luane Dufour	Sa femme	Do	Do	X	36		1
3	Justinien Tremblay	journalier	Do	Do		5 mois	1	
4	François Martel	cultivateur	Eboulemens	Do		46 ans	1	
5	Israil Martel	journalier	Baie St Paul	Do		16	1	
6	Josephine Martel	Do	Do	Do		15		1
7	Guillaume Martel	Do	Do	Do		13	1	
8	Sara Martel	Do	Do	Do		12		1
9	Zoé Martel	Do	Do	Do		7		1
10	Jean Baptiste Dufour	Cultivateur	Ptite Rivière	Do		76	1	
11	Florant Dufour	Cultivateur	Baie St Paul	Do	X	34	1	
12	Eulalie Martin	Sa femme	Do	Do	X	37		1
13	Philomine Dufour	journalier	Do	Do		11		1
14	Delina Dufour	Do	Do	Do		10		1
15	Marie Dufour	Do	Do	Do		9		1
16	Delphine Dufour	Do	Do	Do		7		1
17	Angel Dufour	Do	Do	Do		5		1
18	Marguerite Renault	Servante	Petite Rivière	Do		17		1
19	Joseph Dufour	Cultivateur	Ditto	Do	X	61	1	
20	Marie Anna quay	Sa femme	Baie St Paul	Do	X	67		1
21	Lucien Dufour	journalier	Do	Do	X	29	1	
22	Zoé Bouchard	Sa femme	Do	Do	X	23		1
23	Ferdinand Dufour	journalier	Do	Do		8	1	
24	Théophile Dufour	Do	Do	Do		5	1	
25	Alphonsine Dufour	Do	Do	Do		3		1
26	Pamphile Dufour	Do	Do	Do		1	1	
27	Telnesime Martel	Do	Do	Do		17		1

Scottish immigrants on the *Dorothy*

Before official immigrant records began in 1865, few passenger manifests were compiled and even fewer have survived. Among the rare exceptions is this list from the *Dorothy*, which arrived at Quebec City from England on 4 September 1815.

Although only the names of family heads are included, one can learn the number of members in each family, the man's occupation, and a rare detail – his town and county of residence in Scotland or England. Unfortunately, until later records, the ultimate destination in Canada is not shown.

Few early lists give details that can positively identify a family, especially those with more common surnames. For example, if this list did not include the column showing number of children, it would be difficult to differentiate the two John McDonalds from Perthshire.

Most genealogists dream of discovering when and where their ancestors entered Canada, but few will ever find an answer. If one considers that in 1833 alone more than 65,000 immigrants arrived here, the odds of locating an ancestor's name on any of the handful of surviving lists from before 1865 are remote indeed.

Passenger manifest of the *Dorothy*, 1815
RG4, A1, vol. 147

Return of Settlers, arrived from England in Ship Dorothy, n. 383. Quebec 4th September 1815.

No.	Ship	Date of arrival	Names	Trade	County	Town	No. of Women	No. of Children	Sums Deposited Sterling	Remarks
1			Malcolm McBean	Sheppard	Perth	Callander	1	6	18. 2.	
2			Peter McPherson	Ploughman	do	do	1	0	34. 2.	
3			James McLuirn	Weaver	do	do	1	6	16. 2.	
4			John Ferguson	Farmer	do	do	1	7	20. 4.	
5			John McDonald	Labourer	do	do	1	6	30. 6.	
6			John McLaring	Mason	do	do	1	3	20. 4.	
7			Peter McDougal	Shoemaker	do	do	1	3	18. 2.	
8			Peter Stewart	Farmer	do	do	1	4	18. 2.	
9			Duncan Campbell	Weaver	do	do	1	4	18. 2.	
10			Wm McDougall	Farmer	do	do	1	2	18. 2.	
11			Richd McLaring	Weaver	do	do	1	4	18. 2.	
12			Archd McLaring	Mason	do	do	1	2	18. 2.	
13			John McLeod	Labourer	Inverness	Isle of Sky	1	0	18. 2.	
14			James Miller	Farmer	Ayrshire	do	1	3	18. 2.	
15			John McLaring	Wheelwright	Perth	Callander	1	8	18. 2.	
16	Ship Dorothy	4th September	Donald McLaring	Labourer	do	do	1	6	18. 2.	
17			John McDonald	Mason	do	do	1	2	18. 2.	
18			Alexr McDonald	"	do	do	1	0	18. 2.	
19			Alexr McDiarmid	Weaver	do	do	1	3	18. 2.	
20			Alexr McLaring	Wheelwright	do	do	1	0	18. 2.	
21			Hugh Fraser	"	do	do	1	5	18. 2.	
22			Wm Rutherford	. "	Annshire	Leith	0	0	16. ". "	
23			Wm Spalding	Mason	do	do	0	1	16. ". "	
24			Duncan McGregor	Labourer	Perth	Callander	1	2	18. 2.	
25			James Drysdale	Farmer	Fife	.	0	0	16. "	Left a Wife and 5 children at home.
26			Duncan McArthur	Labourer	Perth		1	1	18. 2.	
27			Alexr McDonald	"	Inverness	Ft Augustus	1	3	18. 2.	
28			Wm McGilery	Farmer	do	do	1	6	18. 2.	
29			Farquhar Smith	Labourer	do	do	1	2	18. 2.	
30			Donald McGilvry	Taylor	do	do	1	3	34. 2.	a Son 19 years, paid £16.
31			Donald McDonald	House Carpenter	Perth	Callander	1	2	18. 2.	
32			Duncan McLaring	Weaver	do	do	1	6	18. 2.	
33			Donald McPrie	House Carpenter	Ayrshire	Ft William	1	5	18. 2.	
34			Duncan McDonald	Labourer	Inverness	Ft Augustus	1	3	18. 2.	
35			Dugall McPherson	"	Lanrick	Glasgow	1	2	18. 2.	Pensioner from 45 Regiment.
36			John McDonald	"	Inverness	Ft Augustus	1	2	18. 2.	a Son about 20 years, paid £16.
37			Thomas Duncan	"	Lanrick	Glasgow	1	4	18. 2.	
38			Thomas Smith	"	Inverness	do	0	0	16. ". "	

Chinese immigrants arrive on the *Empress*

Passenger lists constitute the official records of immigration from 1865 to the mid-1920s. Only ships arriving at the port of Quebec, however, are covered before 1881, the year in which Halifax also became an official port of entry. Records for other ports began in subsequent years, Saint John in 1900 and Vancouver/Victoria in 1905. Passenger lists are available only on microfilm.

Chinese immigrants were required to pay a fifty dollar head tax in order to enter Canada. These and other restrictions resulted in the creation of additional documentation for this ethnic group. Several volumes of nominal registers include information such as village of origin and family relationships.

The information contained in passenger manifests varies over the years, but generally includes details about an immigrant's country of birth, occupation, age, and marital status. Sometimes one finds specific comments about an immigrant, such as a marginal remark that a woman was going to join her husband. This notation would lead to a search of earlier lists for the man's arrival. The destination is probably the most important and consistent detail provided in passenger lists, making it possible to trace an immigrant through local and provincial records. Some manifests list special groups of immigrants: farm labourers, domestics, returning soldiers and their dependants, specific ethnic groups such as the Mennonites, and children from juvenile homes.

There is no nominal index to passenger manifests: before a search can be attempted, the researcher must have some idea of both the date and port of arrival. Another difficulty encountered with these records is variation in the spelling of names, particularly for immigrants from Eastern Europe and Scandinavia.

Many researchers seek out photographs of the ships that brought their ancestors to their new country. They may also seek general photographs of immigrant groups that illustrate other aspects of the newcomers' lives, from clothing to dwellings. Photographs such as these give us a visual aid in imaging how our ancestors lived.

The steamship *Empress of China*, built in 1891 for the Canadian Pacific shipping line, plied the Pacific between Vancouver, Japan, and China until she was wrecked on a reef in Tokyo Bay in 1911. Like her sister ships, the *Empress of Japan* and the *Empress of India*, she could carry 160 first-class and 40 second-class passengers. Most immigrants on these ships, up to 700 per voyage, travelled steerage and originated from China, Japan, and India, while others were tourists or returning Canadians.

Passenger manifest of the ss *Empress of China*,
June 1906
RG76, reel T-515

ss *Empress of China*, Vancouver, 1904
Notman collection, C 03943

527539

SCHEDULE A.

PARTICULARS RELATIVE TO THE VESSEL.

INSTRUCTIONS TO PURSERS

Each passenger should be given a card indicating the number of sheet and line on sheet his name is to be found on.

VESSEL'S NAME	MASTER'S NAME	TONNAGE	FROM WHAT PORT OR PLACE	Total number of superficial feet in the several compartments set apart for passengers, other than Cabin Passengers.	Total number of Adult Passengers, exclusive of Master, Crew and Cabin Passengers which the vessel can legally carry.	WHERE BOUND
EMPRESS OF CHINA.	R. ARCHIBALD, R.N.R.	3,048	HONG KONG. SHANGHAI. NAGASAKI. KOBE. YOKOHAMA.	6000	745	VANCOUVER, B.C.

Port of Embarkation HONG KONG. SHANGHAI. NAGASAKI. KOBE. YOKOHAMA.

Date of Sailing May 20 & June 7th & 16th & 18th 1906

IMMIGRATION JUL 1.4 RECEIVED.

NAMES AND DESCRIPTION OF PASSENGERS.

N.B.—Cabin Passengers must also be included in this Schedule after the other Passengers. "The Immigration Act," Chapter 65, R.S.C.

Chinese Steerage for Victoria

No. of Passengers	S.S. TICKET	Amount of Cash To be filled in by Immigration Agent at Port of Landing.	NAME OF PASSENGER	Age of Adults (M)	(F)	Children under (number)	Able to Read	Write	Married or Single	Profession, Occupation or Calling of Passengers.	Nation or Country of Birth.	Do you intend to become a settler in Canada?			Place of Ultimate destination of Passengers occupying "Tourists and returned Canadians," who are to be described.
1	24057	50	Toi Po	43			yes	yes	M	Grocer	China	Yes		yes	Victoria
2	24058	50	Toi Ping	24			"	"	"	"	"	"		"	"
3	24059	50	Toi Chow Fung	31			"	"	"	"	"	"		"	"
4	24060	50	Tam Kut Hing	39			"	"	"	with Cousin No 4	"	"		"	"
5	24061	50	Tam Wing Heung	17			"	"	S.	"	"	"		"	"
6	24062	50	Wong Yee Nui	24			"	"	M	Grocer	"	"		"	"
7	24063	50	Ma Hin	33			"	"	"	"	"	"		"	"
8	24064	50	Wong Sai Sick	39			"	"	"	"	"	"		"	"
9	24065	50	Wong Chuen Kwong	31			"	"	"	"	"	"		"	"
10	24066	50	Wong Tin	32			"	"	"	"	"	"		"	"
11	24067	50	Ip Hing Heun	34			"	"	"	"	"	"		"	"
12	24068	50	Wong Kwong Choy	19			"	"	S.	"	"	"		"	"
13	24069	50	Wong Sum San	29			"	"	M.	"	"	"		"	"
14	24070	50	Wong Tak Chan	32			"	"	"	"	"	"		"	"
15	24071	50	Lee Yim	24			"	"	"	"	"	"		"	"
16	24072	50	Lee Kong Nam	32			"	"	"	"	"	"		"	"
17	24073	50	Lee Sow	28			"	"	"	"	"	"		"	"
18	24074	50	Lum Tak Kow	26			"	"	"	"	"	"		"	"
19	24075	50	Lum Tuk Hing	32			"	"	"	"	"	"		"	"
20	24076	50	Sing Cheong	32			"	"	"	"	"	"		"	"
21	24077	50	Mon Young Shing	35			"	"	"	"	"	"		"	"
22	24078	50	Leung Nay	41			"	"	"	with Cousin No 243	"	"		"	"
23	24086	50	Ng Ming Sam	17			"	"	S.	"	"	"		"	"
24	24187	50	Wong Sing	28			"	"	M	Grocer	"	"		"	"
25	24188	50	Wong Sau	39			"	"	"	"	"	"		"	"
26	24189	60	Chan Po	33			"	"	"	"	"	"		"	"
27	24190	60	Ma Choy	23			"	"	"	"	"	"		"	"
28	24191	50	Ma Yew	30			"	"	"	"	"	"		"	"

LIST OF RACES WILL BE FOUND ON THE BACK OF THIS SHEET.

An American crosses the border

Before 1908, people were able to move freely across the International Boundary between Canada and the United States. Beginning in that year, however, border ports were established along the boundary.

On 19 June 1909, Frank Alger, a dairyman from Montana, crossed into Canada to seek work in New Westminster, British Columbia. Although his movements in Canada cannot be traced in census records until the 1911 enumeration is released (in 2003, under current policy), listing might be found in city directories. If he subsequently left Canada, no record would exist of his departure, as the Canadian government recorded only people entering the country. For earlier records, descendants could pursue their search in American sources, as these border records generally provide the last place of residence in the United States in addition to the country of birth.

If Frank Alger had passed through Huntingdon after the port had closed that day, or if he had crossed the border where no official port existed, his name would not have been recorded. Ironically, while not all those entering legally were documented, the names of those who were turned away at the border usually appear in daily reports interspersed with the entry records.

Border entry records, Huntingdon, BC, 1909
RG76, reel T-5472

REPORT OF IMMIGRATION INSPECTOR.

1062617

To the Superintendent of Immigration, Ottawa,

MONTH OF _____ June, _____ 19 09

TOTAL NUMBER OF IMMIGRANTS _____ NUMBER OBJECTED TO _____

PARTICULARS OF OBJECTIONS AND ACTION TAKEN IN EACH CASE:

(IMMIGRATION RECEIVED stamp: JU... 1909)

Name	Age M. F.	Occupation	Country whence come	Travelled by	From	To	Form and No. of Railway Ticket	Why Objected to	Action Taken	
...io ...onsona,	33	Laborer	Norway	Road	Bellingham, Wash.	Abbotsford, B.C.	✓		Reported to Ottawa as unsettled case'	
...on ...gla,	35	"	"	"	"	"	"	✓		" " "
Stephen Mikes,	33	"	"	"	"	"	"	✓		" " " " " "
Frank Alger,	27	Dairyman	U.S.	Rail	Warm Springs, Montana.	New Westminster, B.C.	✓		Passed. Looking for work.	
Lavena Halbusteed,	18	Domestic	"	"	P.L.Wash.	Agassiz, B.C.	✓		" Going to sister.	
James Ross,	47	Miner	Canada	"	Nome, Alaska.	Ashcroft, "	✓		" Mining.	
R.Newton,	61	Farmer	U.S.	"	Everett, Wash.	Calgary, Alta.	✓		" Settle. Family to follow.	
Vitteria Pereiro,	4	Laborer	Spain	Road	Bellingham, Wash.	Abbotsford, B.C.			Reported to Ottawa as unsettled case.	
...lian Fairbanks,	23		U.S.	Rail	Seattle, "	Wetaskiwin, Alta.	✓		Passed.Going to father.	
...J.Marshall,		Farmer	Scotland	"	Montesano, "	Regina, Sask.			Reported to Ottawa as unsettled case.	
...s Sarah Becard,	30	Street Foreman	U.Br...		San Francisco, Cal.	Revelstoke, B.C.	✓		Passed.Going to live with her mother there.	
...n Batson,	47	Former	"	"	Sedro Wolley, Wash.	Maniteu, Man.	✓		" Intend to settle.	

Signature of Officer

H.E. Skinner

PORT OF _____ Huntingdon, B.C. _____

Note.—All immigrants are required to be inspected, whether arriving by train or boat, or by any other means.

School records in the North

Genealogical research usually requires that the place of residence be known in order to consult relevant sources. This is particularly true of Indian records as it is the way to identify the specific district or territorial authorities responsible for creating the records.

Knowing a family lived in Ross River, Yukon Territory, in 1925 could lead a researcher to these day-school returns, which record the pupils' names, ages, and academic records. Those who attended less than ten days out of sixty-six might be expected to have a nomadic lifestyle. To the native genealogist, however, the identification of each child by band is the most important detail, as it allows a search of specific band records.

A growing number of people are interested in confirming family stories about Indian ancestry. In order to attempt a search in the many extensive records of the relevant government departments, however, one must first undertake a basic genealogical search to identify each generation in the family line. Although census returns before 1891 list ethnic origin, such as Indian, French, or English, this information is not sufficient to determine the band.

Day school returns, 1925
RG10, vol. 6478, file 931–2

QUARTERLY SCHOOL RETURN

Yukon Agency

REP___ of the _Carmacks and Ross River_ School ___ on ___ Reserve for Quarter ended _September 30_ 19_25_

Teacher's Salary, $ ___

	NAMES OF PUPILS	AGE	BOY	GIRL	BAND	CLASS OF STUDY Standard 1						STANDING IN CLASS Very good	Good	Fair	Bad	Conduct	ATTENDANCE Days Present	Days Absent	Average Attendance for Quarter	REMARKS AS TO PROGRESS, ETC. HOLIDAYS DURING QUARTER AND REASONS THEREFOR
1	Chapman Atkinson	12	1		Pelly	1						1				B	15	51		Summer school taught
2	Joe Etzel	6	1		"	1								1		A	16	50		as opportunity offered.
3	Mary Etzel	5		1	"	1						1	1			A	1	65		
4	Jake Pelly John	13	1		"	1								1		B	5	61		The three last pupils are over
5	Joe Pelly David	8	1		"	1							1			A	5	61		age but they were anxious
6	Joe Skookum Charlie	15	1		"	1						1				A	10	56		to learn and it seemed right
7	George Skookum Charlie	12	1		"	1							1			C	3	63		to encourage them.
8	Paul Skookum Charlie	11	1		"	1							1			C	6	60		
9	Jacks Skookum Charlie	15	1		"	1							1			B	2	64		This is a true copy of the record
10	Fred Tom	14	1		"	1						1				A	10	56		sent in by the teacher Mrs J.H.
11	Jessie Isaac	15		1	Carmacks	1						1				A	5	61		Bryce on which some mistakes
12	Selina Isaac	12		1	"	1							1			A	5	61		were made in computing
13	Jackson Hutchi Bill	11	1		"	1						1				B	4	62		the attendance.
14	Solomon Hutchi Charlie	14	1		"	1						1				A	1	65		S.O. Stringer
15	Shorty Hutchi Charlie	12	1		"	1							1			C	4	62		Bishop of Yukon
16	Anna Magundy	11		1	"	1						1				A	4	62		
17	Doulal Magundy	9		1	"	1							1			A	4	62		
18	Sam Little Sam	6	1		"	1							1			B	3	63		
19	Chap Little Sam	5	1		"	1							1			B	4	62		
20	Ruth Little Sam	11		1	"	1							1			A	4	62		
21	John Drury Magundy	6	1		"	1							1			B	4	62		
22	Taylor Magundy	14	1		"	1							1			A	1	65		
23	Fred Mackenzie John	20	1		Pelly	1							1			A	9	57		
24	David Whiskers	28	1		"	1								1		A	3	63		
25	Pete Skookum Charlie	20	1		"	1							1			A	7	59		
26																				
27			19	6								9	8	5		25	135	1515	6.43	

No. of pupils on Register	22	
Aggregate attendance during Quarter	135	
No. of school days in Quarter	66	✓
No. of days in Quarter school was open	21	✓
No. of holidays in Quarter	44	✓
Average attendance during Quarter	6.43	

Note.—Marks for conduct: A, good; B, fair; C, bad. Insert name of School, Reserve and Agency.
All the columns of the Return must be added and the totals placed at the foot thereof.

EXAMINED found correct

Support for a Métis claim

A complex series of legislation, beginning with the Manitoba Act of 1870 and ending in 1924, provided for the settlement of claims arising from aboriginal rights to land in western Canada. All Métis heads of families resident in Manitoba on 15 July 1870 were eligible for 160 acres, or for $160 in scrip redeemable for dominion lands at $1 per acre. Later amendments allowed for claims by offspring born between 1870 and 1885, and raised the acreage to 240, or $240 in scrip.

Applications for land or scrip provide considerable information about the claimant: date and place of birth, names of parents and whether they were halfbreed or Indian. For nomadic or semi-nomadic groups, it is possible to trace at least partially their progress from place to place. Often, claims were accompanied by supporting documents, in this case Jane Elizabeth Saunders's baptismal certificate. In her answer to question six, Jane has indicated her mother's full maiden name, Caroline Nelson, while the certificate simply refers to her parents as John and Caroline Saunders.

Jane's declaration shows that she was born in Prince Albert and was still there when she filed her claim on 26 May 1900. The researcher might consult the 1881 and 1891 census returns of the area, which might then reveal Jane's parents' ages, their province(s) of birth, John Saunders's occupation, and similar information about other members of the Saunders's household. Church and local records might show that Jane married in the early 1900s, and the search for her descendants could be pursued in subsequent records.

Application for scrip, 1900
RG15, DII 8C, vol. 1366

Baptismal Certificate

When baptized.	Child's Christian Name.	Parents' name Christian	Parents' name Surname.	Abode.	Quality, Trade, or Profession	By whom the Ceremony was performed.
1880. March 1st. Nᵒ 139.	Jane Elizabeth	John & Caroline	Saunders	Prince Albert.	Farmer	James Settee Missionary.

I certify that the above is a true and correct copy of an entry recorded in the Baptismal Register for the parishes of St. Mary's and St. Catherines —

James Taylor.

Emmanuel College
May 12th 1900.

274 Form C. Certificate nᵒ 435 394

Approved 5th May 1900
Prince Albert

Form A.

NORTH-WEST HALFBREED CLAIMS COMMISSION.
1900.

Before NARCISSE OMER CÔTÉ, of the City of Ottawa, in the Province of Ontario, Esquire, and

SAMUEL McLEOD, of the Town of Prince Albert, in the North-West Territories, Esquire, COMMISSIONERS.

duly appointed and sitting as a Royal Commission at **Prince Albert** in the North-West Territories, to investigate claims of Halfbreeds who were born in the Territories between the 15th July, 1870, and the 31st December, 1885, personally came and appeared **Jane Elizabeth Saunders**

————— Claimant, who being duly sworn, deposes as follows :—

Question 1. What is your name ?
Answer Jane Elizabeth Saunders

Question 2. Where do you reside ?
Answer Prince Albert. Sask.

Question 3. Where were you born ?
Answer Prince Albert. Sask. N.W.

Question 4. When were you born ?
Answer Jan. 18, 1880. Baptismal Certificate Attached

Question 5. What is your father's name ?
Answer John Saunders

Question 6. What was the name of your mother before her marriage ?
Answer Caroline Nelson

Question 7. Is your father a Halfbreed or an Indian ?
Answer Half Breed

Question 8. Is your mother a Halfbreed or an Indian ?
Answer Half Breed

Question 9. Have you ever received land or scrip in Manitoba or the North-West Territories in commutation of your Halfbreed rights ?
Answer No

Doukhobors settle at Yorkton

Doukhobors, a sect of Russian dissenters, frequently faced persecution in their homeland for their heretical and pacifist beliefs. For this reason, many fled to Canada, a country willing to grant concessions in education and military service in order to encourage the settlement of the West with experienced farmers.

In 1898–9, more than 7400 Doukhobors arrived in Saskatchewan to establish their own communities. Some men had been banished to Siberia by the Russian government and were unable to accompany their families. This list shows names and relationships of families from the Yorkton Colony who left husbands and fathers behind. Eventually, most of the men joined their relatives in Canada, including the group's leader, Peter Verigin.

Verigin and many of his followers later resettled in southern British Columbia, partially as a result of stricter government regulations concerning homesteads. Like other religious and ethnic groups that immigrated to Canada with hopes of maintaining their culture and language, Doukhobors often encountered strong pressures to assimilate. Today there are approximately 30,000 descendants of this group living in Canada.

List of Doukhobors, 1900
RG76, vol. 184, file 65101, part 5

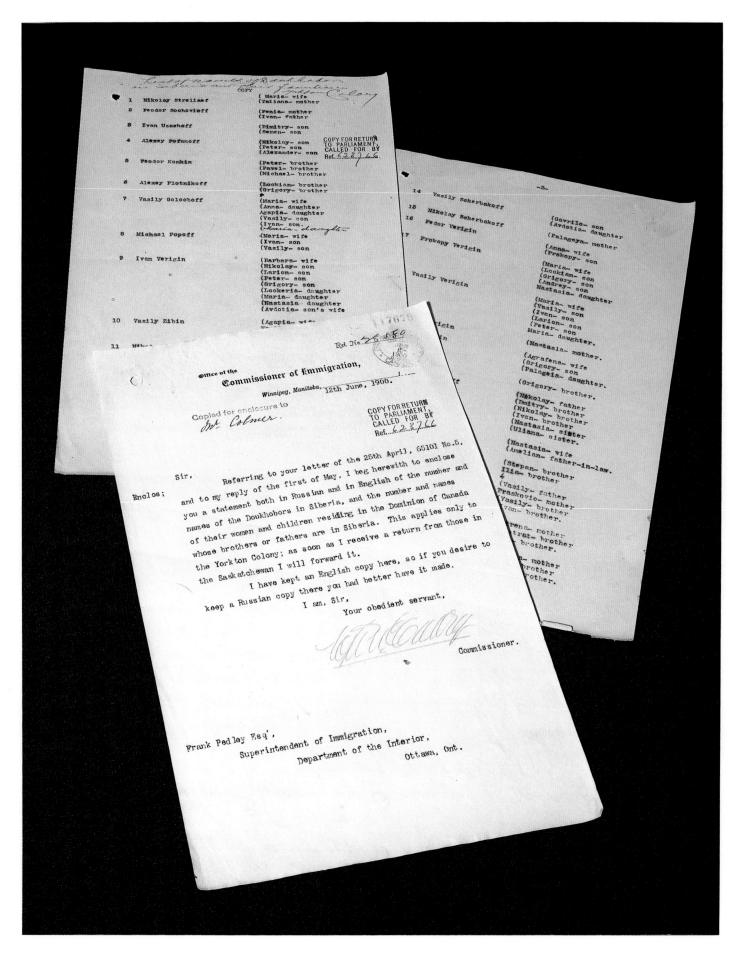

Last names of Doukhobors in Siberia and their families colony

COPY

1	Nikolay Streliaef	(Maria- wife (Tatiana- mother
2	Feodor Sochovioff	(Fenia- mother (Ivan- father
3	Ivan Usacheff	(Dimitry- son (Semen- son
4	Alexey Fofanoff	(Nikolay- son (Peter- son (Alexander- son
5	Feodor Konkin	(Peter- brother (Pavel- brother (Michael- brother
6	Alexey Plotnikoff	(Lookian- brother (Grigory- brother
7	Vasily Golooboff	(Maria- wife (Anna- daughter (Agapia- daughter (Vasily- son (Ivan- son (Maria- daughter
8	Michael Popoff	(Maria- wife (Ivan- son (Vasily- son
9	Ivan Verigin	(Barbara- wife (Nikolay- son (Larion- son (Peter- son (Grigory- son (Lookeria- daughter (Maria- daughter (Nastasia- daughter (Avdotia- son's wife
10	Vasily Zibin	(Agapia- wi
11	Mik	

COPY FOR RETURN
TO PARLIAMENT,
CALLED FOR BY
Ref...622.166

-2-

14	Vasily Scherbakoff	
15	Nikolay Scherbakoff	(Gavrilo- son (Avdotia- daughter
16	Fedor Verigin	(Palageya- mother
17	Prokopy Verigin	(Anna- wife (Prokopy- son
	Vasily Verigin	(Maria- wife (Lookian- son (Grigory- son (Andrey- son Nastasia- daughter
		(Maria- wife (Vasily- son (Ivan- son (Larion- son (Peter- son Maria- daughter.
		(Nastasia- mother.
		(Agrafena- wife (Grigory- son (Palageia- daughter.
		(Grigory- brother.
		(Nikolay- father (Dmitry- brother (Nikolay- brother (Ivan- brother (Nastasia- sister (Uliana- sister.
		(Nastasia- wife (Amelian- father-in-law.
		(Stepan- brother Ilia- brother f
		(Vasily- father Praskovie- mother Vasily- brother van- brother.
		rena- mother trat- brother brother.
		a- mother brother rother.

117679

Ref. No. 35550

Office of the

Commissioner of Immigration,

Winnipeg, Manitoba, 12th June, 1900.

Copied for enclosure to
Mr. Colmer.

Sir,

Enclos;

Referring to your letter of the 25th April, 65101 No.6, and to my reply of the first of May, I beg herewith to enclose you a statement both in Russian and in English of the number and names of the Doukhobors in Siberia, and the number and names of their women and children residing in the Dominion of Canada whose brothers or fathers are in Siberia. This applies only to the Yorkton Colony; as soon as I receive a return from those in the Saskatchewan I will forward it.

I have kept an English copy here, so if you desire to keep a Russian copy there you had better have it made.

I am, Sir,

Your obedient servant,

Commissioner.

Frank Pedley Esq',
Superintendent of Immigration,
Department of the Interior,
Ottawa, Ont.

Selling Canada

For centuries, the desire for land has served as a catalyst for migration. Anxious to fill the West with farmers, the Canadian government promoted settlement with offers of 160 acres of free land. This 1901 poster announced a meeting in Brown City, Michigan, where prospective immigrants would hear land agent M.V. MacInnes extol the advantages of farming on the Canadian prairies.

Agent MacInnes did a booming business, distributing hundreds of letters, pamphlets, and maps each month through his Detroit office. He was delighted to receive a glowing thank-you letter from Peter Muirhead in 1902. In it the settler explained how he had been so taken with the land in southern Alberta that he had purchased a 3000-acre ranch for $51,000 cash.

Other inducements offered to prospective settlers included the promise of no taxes, except those for school purposes, and the offer of inexpensive train excursions by Canadian Pacific Railway to see the country for themselves. Posters aimed at Americans reflect the Canadian government's policy of recruiting 'desirable' settlers. This poster is typical of appeals made to people in Great Britain, Scandinavia, and Western Europe.

Although posters do not refer to specific immigrants, they can benefit the genealogist by illustrating the circumstances in which some migration decisions may have been made. Posters from different eras in Canadian history often reveal the social, political, and economic context of the times in which our ancestors lived.

Western settlement poster, 1901
RG76, vol. 140, file 33674, part 1

An Exceptional....

..OPPORTUNITY

FOR AMBITIOUS MEN.

The Canadian Government has thrown the gates of

WESTERN CANADA

wide open and offers

160 ACRES FREE

to every man of 18 years and over.

The Best Land on Earth! 🌿 🌿

Close to Schools, Churches, Markets and Railways. Over 8000 settlers from the Central and Western States embraced the opportunity last year and secured a home for themselves and their boys in fertile WESTERN CANADA.

M. V. MacINNES, Gen. Can. Gov. Agent,
will be at the

NEW OXFORD HOTEL,
OXFORD.

All Day THURSDAY, January 17th, 1901.

HARRINGTON HOUSE,
BROWN CITY,

FRIDAY, January 18th, 1901

and will be pleased to meet all those who are thinking of bettering their condition.

SEE THE FINEST GRAIN ON EARTH.

Samples of the Grains and Grasses of Western Canada will be on exhibition.

Maps, Pamphlets, etc., given away.

CHEAP RATES

To go and see the Country.

If you cannot be present on the above dates, write for all information to

M.V. MacINNES, 2 MERRILL BLOCK, Detroit, Mich.
Gen. Can. Gov't Agent,
Cor. Woodward & Jefferson Aves.

A newcomer's hospital record in Edmonton

Among the many hardships faced by new immigrants, illness or injury could be the most frightening, especially if they had no relatives in the country. Thomas Craven arrived in May 1904 from Yorkshire, England. In August he suffered a head injury that placed him in the Edmonton General Hospital. Unfortunately, the account does not indicate whether Craven was released or died after his one-day stay.

These accounts for the care of immigrant patients who had been in Canada less than a year were submitted by the hospital to the Immigration Branch of the Department of the Interior. Although some patients or relatives were able to pay part or all of their bills most could not. Any amount they were able to pay, calculated by the length of their stay, was deducted from the total that the hospital charged the government.

Names of immigrants arriving in the western provinces in the late 1890s and early 1900s appear in few records other than passenger lists and homestead applications. This uncommon type of documentation provides the researcher with precious details, such as past and present residences and date of arrival in Canada. The latter information offers the essential clue to a successful passenger list search.

Edmonton General Hospital accounts,
1904
RG76, vol. 166, file 47481, reel C-7323

Edmonton General Hospital, *(Title of Hospital.)*

No. of Claim.	NAME.	Age.	Race.	Country of last residence.	Address in Canada.	Name and Address of next of kin in Canada.	Date of arrival in Canada.	Disease.	Entered Hospital.	Left Hospital.	No. of Days.	Paid by patient or friends.	Remarks by Inspector.
											302	27	
9	John McCready	23	Irish	Cork, Ireland.	Strath-cona,	No relations	1904. April 24	Contu-sions,	July 14	July 16	2		
10	Mrs.A.Backett	24	Scotch	London, England.	Strath-cona,	No relations	1904. April,	Endeme-tritis,	July 16	July 27	11	8	
11	Mrs.T.R.Over-ton,	21	Ameri-can,	Nebraska	Edmonton	No relations	1904. June,	Lapara-tomy,	July 20	Aug.15	26	19	
12	Wm.Henschel	19	German	Germany	Edmonton	Father-Edmon-ton,	1904. June,	Pneumon-ia,	Aug. 1	Aug. 5	4		
13	Thos. Craven	22	English	York-shire, England.	Edmonton	No relations	1904. May,	Injury to head,	Aug.6	Aug. 7	1		
14	Andrew Hadduck	30	Polish	Washing-ton	Strath-cona,	No relations	1904. May 31,	Rheuma-tism,	Aug. 25	Sept.5	11		
15	Mrs.T.Wolmar	21	German	Germany	St.Albert	Husband-St.Albert,	1904. April,	Fievre puer perale	Aug.31	Oct.15	45		
											402	54	

Children from Barnardo's Homes

Spurred by social conscience and a conviction that rural life offered a better future than urban poverty, philanthropic organizations in Great Britain shipped thousands of poor children and teenagers to Canada in the late nineteenth and early twentieth centuries.

One of the best-known of these organizations, Barnardo's, operated homes in England for orphans and children forced into care by poverty or illness in the family. Barnardo's sent parties of children aboard regular passenger liners, such as the ss *Tunisian*, to its distribution homes in Canada. From there, the children would be forwarded to private homes, generally to fill farmers' needs for domestic and farm labour.

In addition to the passenger manifests, separate lists often were compiled by the Immigration Branch of the Department of the Interior. This example shows the names and birth dates of children who passed a government medical inspection before leaving Liverpool on 10 March 1910. These types of documents usually indicate the home or workhouse where the children last resided. Elizabeth Mitchell, for example, came from the Gatehead Union. Unfortunately, few records have survived that document the children's fate after their arrival in Canada or the circumstances in which they were initially placed in group care.

List of immigrant children,
Barnardo's Homes, 1910
RG76, vol. 51, file 2209, part 1

Service records from the South African War

The South African or Boer War (1899–1902) was fought between Britain and the republics of South Africa and the Orange Free State. English Canadians rallied to the imperial cause, and some 7000 men volunteered to fight in South Africa. Another 1000 were raised to relieve the British regular troops in Halifax.

Service files were not kept for the Canadian militia before the First World War. The only exceptions are the attestation papers that have survived for 70 per cent of the enlisted men who served with the Canadian Contingent in South Africa. These papers usually include a background questionnaire, physical description, and medical certificate, with details such as age and place of birth, name and address of next of kin, religion, and occupation before enlistment.

Records such as these show how documents created for non-genealogical purposes can be used by genealogists to learn more about an individual's personal background. Knowing that William Drader was born in London, Ontario, for example, one could confirm through city directories that his father Joseph still lived there in 1891, and conduct a search in the relevant census returns of that year for more details about the family.

To further the search for information about an ancestor's service in the South African War, one could consult the Queen's South Africa medal register, which records the medals and clasps issued to participants in that conflict. Entries give the recipient's regimental number, rank and corps, theatre of action, and address at the time the medal was delivered.

Medal registers also exist for earlier campaigns: the Fenian Raids of 1866 and 1870, the Red River Rebellion of 1870, and the Northwest Rebellion of 1885. In the absence of personnel files these registers can help confirm an ancestor's military service. Although some pay lists and muster rolls have survived for the Canadian militia as early as 1812, they contain little beyond names, and the regiment must be identified before a search can be undertaken.

South African War service records, 1902
RG38, vol. 28

Military documents from the First World War

In addition to service files, other military documents can be useful in genealogical research. Pertinent information must be pieced together from several sources, and details on specific individuals often are impossible to locate; yet war diaries, log books, private correspondence from the war front, and similar material on occasion may furnish personal information about family members.

Several types of archival documents created during the First World War are illustrated; all can have genealogical value. Moving clockwise from the top: a photograph of the 13th Brigade, Canadian Field Artillery passing the saluting base on the Bonn Bridge in December 1918; a corps commander's logbook dated November 1918 from the Arthur William Currie collection describing the events of Armistice Day; an example of personal correspondence from the war front, from the L.E. Breault papers; coloured YMCA stationery, provided free of charge to all Canadian servicemen overseas; a personnel book for 'B' Company of the 13th Battalion (Royal Highlanders of Canada), giving information on casualties; two 'whiz bangs' – pre-printed postcards sent from the trenches, used when a letter could not be written, also from the L.E. Breault collection; a composite oblique aerial photograph and map taken from the unit war diary of the 4th Battalion (Canadian Mounted Rifles). The typewritten diary extract in the centre comes from the 4th Battalion as well. War diaries provide detailed information about battles, physical surroundings, and day-to-day activities at the front, and may also include some personal information.

Collage of military documents
from the First World War
PA3772; MG30, E100, vol. 43;
MG30, E532;
MG30, E102; MG30, E532; RG9, III,
vol. 4947, file 467, part 2; RG9, III,
vol. 4947, file 465, part 2

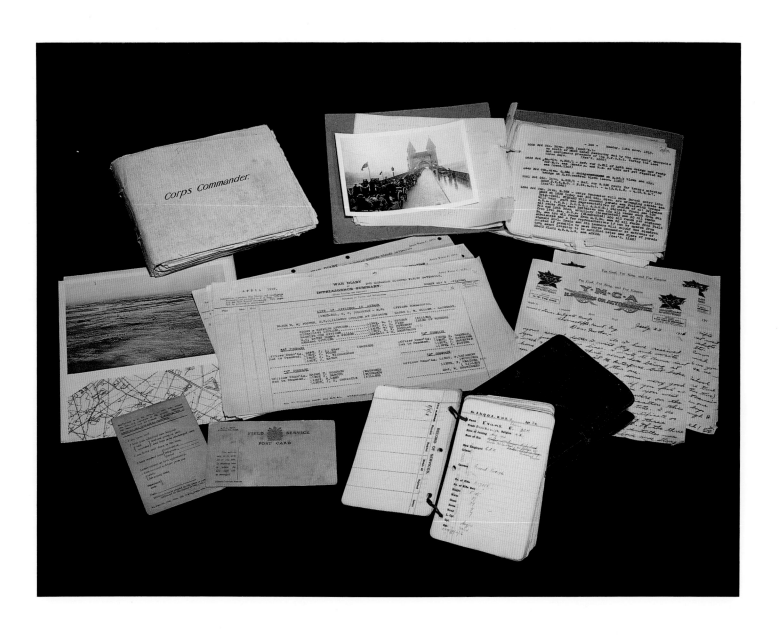

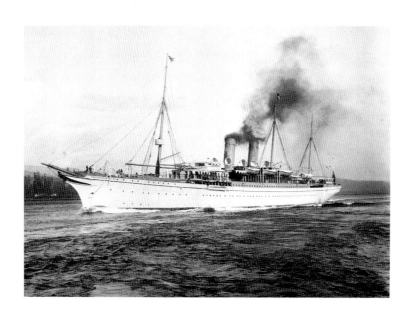

VII

Technologies of the Twentieth Century

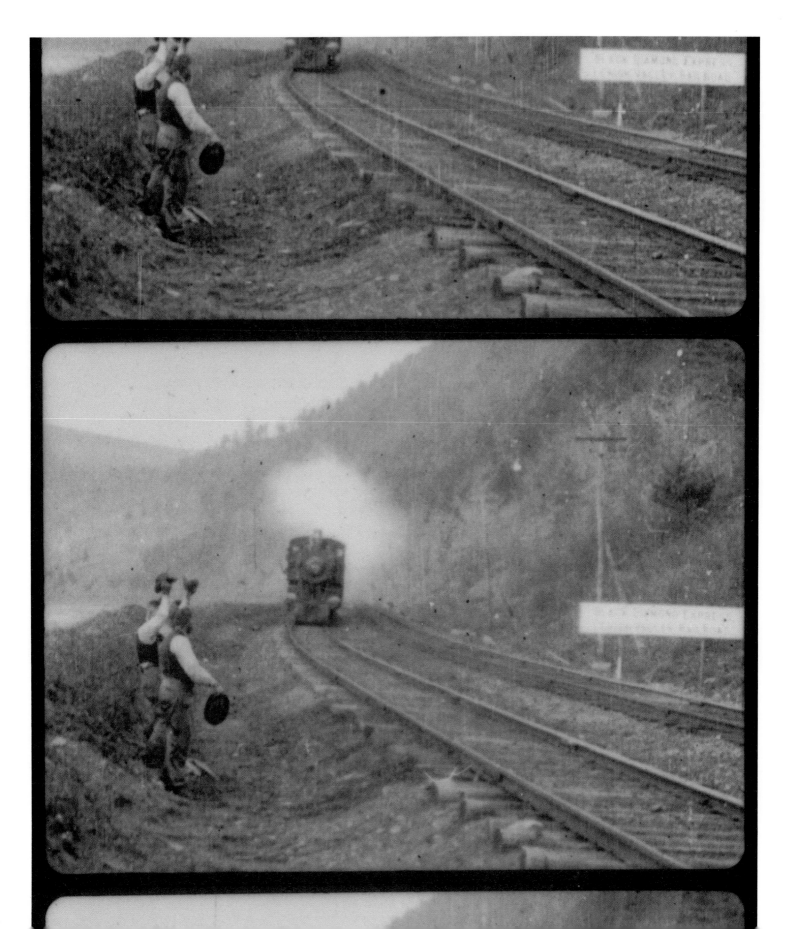

Moving Image
and
Sound Records

Canada's film heritage began to evolve almost from the dawn of motion pictures. Not only did Edison and Lumière productions find their way here as entertainment for the public; as early as the 1890s, Canada's snowy scenery became a favourite subject of the moving image novelty. Between 1902 and 1910, the Canadian Pacific Railway commissioned the Charles Urban Trading Company to make films aimed at encouraging new British immigrants to the West. The crews were instructed to avoid scenes of ice and snow, but needless to say, they were not totally successful.

One might expect that over the years a vast treasure of cinematic gems, polished or unpolished, edited or unedited, has accumulated in the national vaults, waiting for an enterprising producer or researcher to exploit it. Alas, that great vault is not as full as it might be. Perhaps, with the approach of cinematography's centenary, the impact of film both as an art form and as a recorder of humankind's activities will be better appreciated. At the outset, film was regarded as a unique short-term 'product,' to be exploited and then discarded.

The loss of early movies can be attributed to various factors, including accidents, fires, theft, and even deliberate destruction. Many early films that have been lost were made on cellulose nitrate stock, which could provide exceptional picture quality but was highly flammable even in its best condition and, depending on age and storage conditions, could become chemically unstable. Kodak did not discontinue the manufacture of 35 mm professional nitrate film until 1951, although a cellulose-acetate, slow-burning, safety stock had been developed around 1923. Today, the copying of nitrate collections is a top priority for most world-class archives. Sadly, acetate-base stocks are also beginning to show properties of decomposition, much sooner than had been anticipated. Polyester is the film base used for contemporary archival preservation.

The National Film Board of Canada lost much precious film in a nitrate fire in Beaconsfield, Quebec, in 1967 – an event so thorough and all-encompassing that it is referred to as a major, albeit negative, milestone in Canadian film history. Up to that time, the NFB had been the de facto archival depository not only for its own rich collection, including the films of the Canadian Government Motion Picture Bureau and vast amounts of military footage gathered from around the world, but also for the prized holdings of other institutions which lacked their own storage facilities. Unfortunately, both nitrate and safety film were stored at the same location. So devastating was the conflagration that the total extent of losses will never be known, although it is estimated that up to 50 per cent of Canada's early productions went up in flames. The end result was the establishment of a film archives division within the National Archives, that has sought to recover and restore the nation's surviving film heritage wherever possible.

These materials turn up in a variety of locations – attics of private individuals, basements of film buffs, even projection booths of old cinemas slated for demolition. The Dawson City Museum collection consists of a cache of nitrate-print newsreels and fiction shorts from before and after the First World War, which, having reached the end of their distribution circuit and subsequently having been discarded, were literally dug up from a land-fill site in the Yukon permafrost. A genuine buried treasure!

Deliberate destruction has also contributed to the dearth of early footage. During the 1950s, in particular, productions which had been screened were regarded as having served their purpose and were consequently declared surplus. The savings in storage space, and the income from silver recovered from the film, were a greater priority.

The National Archives' sound holdings include oral history interviews of notable politicians living and dead, radio broadcasts from private stations across the country, proceedings of government commissions, and historical speeches. However, the bulk of the collection consists of radio programming produced by the Canadian Broad-

casting Corporation and Société Radio-Canada. It is appropriately an indication of this crown corporation's predominant role in the development of radio broadcasting in Canada. Even before the CBC's creation in 1936 under the government of Mackenzie King, Canada was witnessing noteworthy pioneering achievements in the history of radio. Among them were Marconi's first transatlantic transmission in 1901, the transmission of human voices in 1906 by Canadian Reginald Fessenden, and the claim of 'first' radio station in North America by XWA (better known as CFCF) of Montreal.

Though early experiments with television took place in the 1920s, it is a young medium in terms of commercial broadcast. In Canada, the first Société Radio-Canada and Canadian Broadcasting Corporation stations went on air in 1952. As with radio, early television broadcasts went out live, an ideal recording medium not yet having been developed. Radio eventually settled on discs as the common recording format, while television programs that we are still able to view today owe their survival to the kinescope, which essentially recorded the screen image on film. 'Kines' were poor in quality compared with the broadcast image. Broadcast videotape became operational in Canada only around 1960.

With the proliferation of videotape systems and the sheer volume of programming, there will be a greater than ever challenge to decide what to acquire in the future. It would be a shame to repeat the errors of the past in taking contemporary production for granted. Producers are now seeking footage for use in popular archival retrospectives, without realizing that it was once common practice for program managers to erase and reuse broadcast-quality videotapes to economize on production budgets and shelf space. Other programs were hastily erased before they were even aired.

The archivist of the future is in danger of being overwhelmed by the volume the global village has to offer. Archives are recognizing a responsibility to assure competent archival control of their audio-visual acquisitions, rather than just numbering, shelving, and restricting access because of lack of protection. All too often the public is heard to ask, 'What is the point of saving material if we cannot use it?' There is no convincing argument. Motion pictures, television, radio, and oral history were created to be seen and heard. Access has to be considered a prime requirement, if not a right, in the long-term preservation of our audio-visual heritage. Towards such a future, technology must be harnessed to assist in achieving this goal within existing financial and human resources.

Justice is not necessarily rendered to film, television, and sound treasures when they are trapped between the pages of a book. Certainly, the technological achievements cannot be brought home to a reader in quite the same way as they would with large loudspeakers or in a wide-screen theatre. Grainy frame enlargements from precious 16 mm and 35 mm prints or studio location shots, no matter how well done, can never replace the excitement of the moving image and sound experience itself. Perhaps the treasures here will tantalize and promote more interest in further research and access to the ever-increasing archival holdings of these media.

Turn-of-the-century entertainment

The Butterfly Dance, Black Diamond Express, and *Police on Parade* are three of twenty titles in the Flaherty Brothers collection, restored from Canada's oldest surviving collection of motion pictures. Originally shot in the United States between 1896 and 1897, and distributed by the Thomas Edison Company, the nitrate prints, which have been restored on modern safety stock, were part of a touring Edison package destined for screening in Canada.

The year 1895 is considered the birth date of cinema. This collection provides a fine example of the type of cinematographic entertainment available to Canadians around the turn of the century. Films of this time were commonly short, and dealt with usual occurrences such as a passing train or a policemen's parade. The main excitement for the audience was the fascination of the moving image itself. Today, these films are of particular interest to film historians and students of cinema who are seeking insights into the techniques and the novelties of the era.

The programming of films shown in Canada in 1897 comprised many of the titles found in this collection. These particular nitrate copies were purchased for distribution from the Chicago Talking Machine Company in 1897 by William White and G. Warden and, with the use of an Edison No. 2 projector, they were shown to an appreciative audience at Alexandria Hall, Beaverton, Ontario, in April of that year. The *Beaverton Express* of 21 March 1897 wrote, 'The kineoptiscope, Edison's latest marvel in the way of electric inventions ... reproduces pictures on a screen in the most marvellous and life-like manner, every movement of actual life being depicted.'

At the time, cameras were hand-cranked and the speed of the film would vary, averaging sixteen to twenty frames per second, depending on the cameraman. Considering the number of frames per second, *The Butterfly Dance* is all the more remarkable since the colour version was produced by the painstaking process of hand-tinting. Each single frame was individually coloured – with phenomenal success.

The Butterfly Dance
Flaherty Brothers collection Acc. 1982-0026

Black Diamond Express
Flaherty Brothers collection MISA 5099

Police on Parade
Flaherty Brothers collection MISA 5123

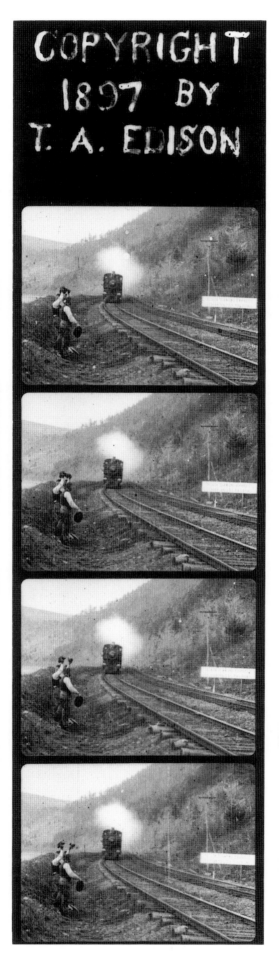

COPYRIGHT 1897 BY T. A. EDISON

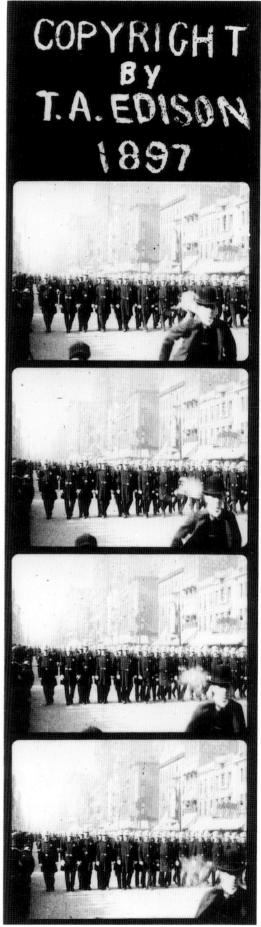

COPYRIGHT BY T. A. EDISON 1897

The CPR films Canadian life

Between the end of the nineteenth century and 1914, more than three million emigrants were lured to Canada by combined efforts of the federal government and Canadian railway companies. In this process of persuasion, film played a key role.

First in the motion picture field was the Canadian Pacific Railway, whose commercial viability depended on the rapid settlement of the Canadian West. In 1902 the CPR hired a British group to travel across Canada and film scenes of Canadian life. The British partner in this venture, Charles Urban Trading Company, guaranteed release of the films in Britain and supplied the personnel of the production group – the Bioscope Company of Canada. The group produced about thirty-five 'interest' films, scenes of Canadian life, which were released as the Living Canada series and later re-released as the Wonders of Canada, Winter Sports, and Winter Sports in Canada series. Examples of these films are held by the National Archives of Canada and several other film archives elsewhere in the world.

Eight years later, in 1910, the CPR turned to American filmmakers to present Americans with the beauty and the advantages of life in Canada. Keeping up with the changing taste of film audiences, the company requested short, dramatic, comic, and scenic films that would show the 'actual conditions' of life in western Canada rather than routine travelogues. The work was given by contract to the Edison Company in New York, and in the summer of 1910 a group of nine company members (among them director J. Searle Dawley and cameraman Henry Cronjager, pictured to the right) spent two months filming across Canada, from Montreal to Victoria. During this trip they produced thirteen short films that were seen in theatres throughout the United States, Canada, and Great Britain, and proved popular with audiences and critics alike.

Unfortunately, all that is known to have survived of this venture is some twenty photographs taken during the travel across Canada, a few frames from each film that were deposited in the Copyright Office of the Library of Congress in Washington, and copies of three films: *The Song That Reached His Heart, An Unselfish Love,* and *The Life of a Salmon.* Copies of the photographs and of the surviving films are held by the Archives.

An Unselfish Love
Canadian Film Institute/
Library of Congress collection
MISA 3531

The Song That Reached His Heart
Canadian Film Institute/
Library of Congress collection
MISA 3530

The Life of a Salmon
Canadian Film Institute/
Library of Congress collection
MISA 3529

J. Searle Dawley (seated),
Henry Cronjager (at camera)
Canadian Film Institute collection
MISA 4954

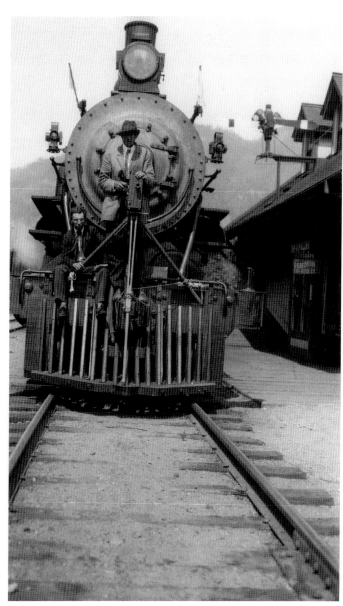

Back to God's Country

Back to God's Country, shot early in 1919, is the oldest surviving Canadian feature film. It was produced for a Calgary company, Canadian Photoplays Ltd, by Canadian-born entrepreneur Ernest Shipman. Filming began at Faust on Lesser Slave Lake where the last part of the film was shot, a chase across the barrens. Daytime temperatures did not rise above −40 °C and the cast and crew suffered greatly in the name of authenticity. Much credit must go to cameraman Joseph Walker, then a young man at the beginning of what was to be an outstanding career.

Stories set in the 'Northwoods' were popular at the time, both in literature and in film. *Back to God's Country* is a simple tale of a determined and self-reliant heroine, aided in her hour of need by a faithful dog, and it still has the power to thrill and excite an audience. The finished film, which starred Nell Shipman, Ernest's wife, was released in the fall of 1919. It went on to become a huge success at the box office, and was seen all around the world. In New York it played at the newly opened Capitol, a picture palace with a seating capacity of 5300, the largest in the world.

Back to God's Country was restored by the National Archives at its technical facilities in Ottawa. The restored version was made from two incomplete prints, one found in the United States, the other in the United Kingdom. Both were deteriorating nitrate prints which had been given colour effects by the old process of tinting and toning. These tints and tones were carefully reproduced on modern colour negative and the film can now be seen much as it looked to audiences in 1919.

Nell Shipman and Wheeler Oakman
in *Back to God's Country*
Canadian Film Institute collection
MISA 4736

From the left: Wellington Playter, the villain;
Nell Shipman, the heroine; Wheeler Oakman,
her husband in *Back to God's Country*
Canadian Film Institute collection
MISA 4734

Alexander Graham Bell and the hydrofoil

This interesting newsreel was discovered amongst a cache of film unearthed in 1978 at Dawson City in the Yukon. The find was the focus of worldwide interest when it was located during digging at a Parks Canada Klondike-era site restoration project. The films had been buried in a neglected swimming pool during the late 1920s in an attempt to solve two local problems. The burial disposed of the flammable films, which had become a storage problem at a Dawson bank; and it also provided fill to convert an idle facility into a desirable winter hockey rink. When they were uncovered fifty years later, the films were rushed to the National Archives for conservation treatment and copying. Approximately half the 550 reels found at the site were American feature films, which were repatriated to the Library of Congress in Washington for restoration. The films were in terrible condition. At both institutions they were treated and eventually were copied successfully. Today these unique documents are available to film historians and researchers.

One newsreel showed the Hydrodrome 4 or HD-4, the fourth in a series of experimental hydrofoils developed by Alexander Graham Bell and F.W. 'Casey' Baldwin. On 9 September 1919, the HD-4 achieved a water speed of 114.04 kilometres per hour, a world record that was not surpassed for nearly a decade. In addition to remarkable scenes of the HD-4 in action, the newsreel shows Bell posing for the camera at the controls of the swift watercraft. In fact, Bell never actually piloted the hydrofoil, a duty that was left to his colleague Baldwin. The HD-4 itself is preserved at the National Historic Site at Baddeck, NS.

International News, Vol. 1, Issue no. 52

Dawson City Museum and Historical Society collection

Acc. 1979-0191, courtesy of Leonard A. Green

INTERNATIONAL

VOL. No. 1 ISSUE No. 52

— On —
A FLYING FISH
— at —
71 MILES AN HOUR

Baddeck, Cape Breton

INTERNATIONAL

Dr. Alexander Graham Bell, the famous inventor, at the wheel of the fastest water craft in the world.

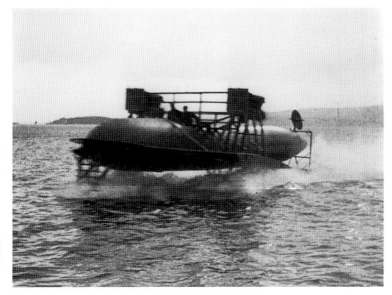

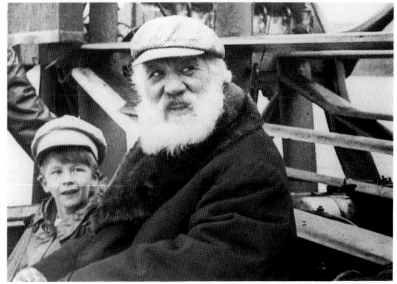

Grey Owl and the beavers

A series of films about the so-called Indian naturalist Grey Owl and his beavers, produced by the National Parks Service Department of Northern Affairs and National Resources, was filmed by William J. Oliver with a view to promoting the national parks and their conservation work. Titles in the series included *Beaver Family, Beaver People, Strange Doings in Beaverland, Pilgrims of the Wild,* and *Grey Owl's Neighbours.* Shown throughout North America and the British Empire, the series greatly helped to increase the public image of Grey Owl.

The *Beaver Family,* filmed in 1929 at the Riding Mountain National Park, records the behaviour of two beavers, Jelly Roll and Rawhide, and their friendship with Grey Owl. It shows them in their natural habitat, constructing a beaver lodge, while also interacting with Grey Owl, who is able to summon and even feed the baby from a bottle. The film was Oliver's own creation: he was script writer, director, and cameraman.

Born in England in 1887, Oliver emigrated to Canada in 1910. His productions were popular with audiences for their cinematographic qualities as well as for their presentation of wildlife and nature conservation. Because of his own sensitivity to the importance of preserving the wilderness, Oliver was well suited to this project.

Grey Owl, best known as a North American Indian, was originally a trapper who turned from killing animals to protecting them. He had been influenced by two little beavers he and his wife Anahareo had adopted. He became a naturalist, writer, and conservationist. In 1931, he was appointed by Parks Canada to Riding Mountain and later to Prince Albert National Park as a specialist in the conservation of beavers, with a mandate to establish a beaver sanctuary. After his death in 1938, the press finally discovered his true identity. He was in fact an Englishman named Archibald Stansfeld Belaney, born at Hastings in 1888. He died in Prince Albert, Saskatchewan.

Grey Owl feeding beaver,
Prince Albert National Park,
Saskatchewan
Lovat Dickson collection
PA 147582

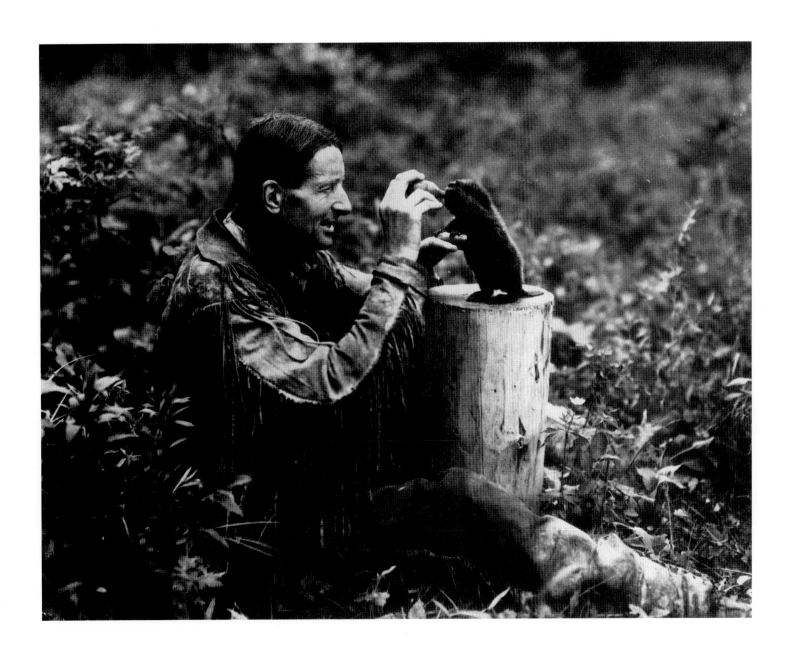

The Moose River Mine disaster

The three-day live radio coverage of the dramatic rescue attempt of three men trapped in an abandoned gold mine near Moose River, Nova Scotia, made broadcasting history and won Canadian radio international fame. As regional representative for the Canadian Radio Broadcasting Commission (CRBC) in Halifax, J. Frank Willis persuaded his employers in Ottawa to send him to Moose River to broadcast live from the disaster site. Already the North American press had swept all other news from its headlines, and public interest had spread to Europe. This 'eyewitness' account of the event demonstrated the immediacy and power of radio as a news medium and launched Willis's broadcasting career. Over his thirty-year career, Willis made an immense contribution to CBC radio and television as a performer, producer, and broadcaster.

The rivalry that existed between radio and the print media is evident in an excerpt from one of his broadcasts: 'We're standing here; we can spit into this pit and yet from thousands of miles away people are contradicting what we have to say.' More than ninety Willis broadcasts were relayed via a primitive telephone circuit across the continent.

Frank Willis talks to miners at Moose River,
Nova Scotia, 1936
Canadian Broadcasting Corporation collection
MISA/CBC 15284

Gordon Sparling, Doris Elizabeth Hyde, and Roy Tash filming *Back in '23*
Canadian Cameo Series
Bellevue-Pathé/Associated Screen News Limited collection
MISA 2521

The Canadian Cameo Series

When Gordon Sparling, the renowned pioneer of the Canadian cinema, joined Associated Screen News in Montreal in 1931, he undertook to create a series of short theatrical films about different aspects of Canadian life, which he baptized the Canadian Cameo Series. From 1932 to 1954, in what he called the Associated Screen Studios of ASN, he produced eighty-five Cameos, many memorable. The most famous are probably *Grey Owl's Little Brother* from footage photographed by Bill Oliver;

Rhapsody in Two Languages in 1934; *Music from the Stars* and *Ballet of the Mermaids* in 1938; and *Sitzmarks the Spot* in 1948.

The Cameos were each about ten minutes in length, inventive, imaginative, and lively. When they appeared little else was being produced independently in Canada. Most important perhaps, they all enjoyed wide exhibition on Canadian screens and many were shown abroad. The Archives has recovered almost all of them.

Lest We Forget

Produced in 1934 under the supervision of the Great War Motion Picture Committee of the Department of National Defence, by Photo-Sound Corporation in association with the Canadian Government Motion Picture Bureau, *Lest We Forget* was the bureau's first sound feature film. This 101-minute compilation – directed, written, and edited by Frank C. Badgley and W.W. Murray, using material from newsreels, graphics, and staged sequences – recounts Canada's role in the First World War. It was well received at home and abroad on its release in 1935.

Lest We Forget stands as a landmark in the history of Canadian cinema and as a model of its kind, the only film that solely described Canadian participation in the Great War.

It has been preserved by the National Film Board, which replaced the Canadian Government Motion Picture Bureau, and has acted as an archive for many important films that would otherwise have been lost.

Lest We Forget
Canada Veterans Affairs collection
MISA 15953, MISA 15955

The Royal Visit of 1939

In May and June 1939, King George VI and Queen Elizabeth visited Canada, arriving in Quebec and leaving from Halifax thirty days later. They travelled across the country, visiting Trois-Rivières, Montreal, Ottawa, Toronto, Winnipeg, Regina, Calgary, Banff, Vancouver, Victoria, Mount Robson, Jasper, Edmonton, Biggar, Saskatoon, Sudbury, Kitchener, Stratford, Windsor, London, Woodstock, Brantford, Hamilton, St Catharines, and Niagara Falls, making a side trip to Washington, DC, and the New York World's Fair, then continuing through Fredericton, Charlottetown, and Truro to Halifax. During their stay in Ottawa one of their duties was the dedication of Canada's National War Memorial, where the king laid a wreath.

The Canadian Government Motion Picture Bureau covered the visit and released a black and white eighty-six minute theatrical film called *The Royal Visit*. The Archives restored the film from a mint fine-grain print found in London. There was also a French-language version, *La visite de nos souverains*, with a commentary by Jacques des Baillets. That version was so long forgotten that many even denied it had ever existed; again, the Archives managed to make a new print using the sound from an old print found in the National Archives of Quebec and the image from the English-language version.

The existence of a third, colour version was known only to very few. All through the visit, Bureau 16 mm cameras were shooting Kodachrome footage. The result was a silent film running three-and-a-quarter hours. The camera film has been stored at the National Archives and the colours are as good today as when they were shot. This long film, interspersed with English titles, was given a commensurately long title: *The Royal Visit to Canada and the United States of America May 17–June 15, 1939.*

Miss Gertrude Halpenny, representing the Nursing Sisters, is presented to Her Majesty, from *The Royal Visit to Canada and the United States of America May 17–June 15, 1939* National Film Board of Canada collection Acc. 1984-0531

The service dedicating Canada's National War Memorial, from *The Royal Visit to Canada and the United States of America May 17–June 15, 1939* National Film Board of Canada collection Acc. 1984-0531

The king lays a wreath at Canada's National War Memorial on behalf of the queen and himself, from *The Royal Visit to Canada and the United States of America May 17–June 15, 1939* National Film Board of Canada collection Acc. 1984-0531

Outstanding drama serials from French radio's golden age

In the golden age of radio, three radio serials stood out from many others because of their author, their content, or the circumstances surrounding their creation and broadcasting.

One was 'La pension Velder,' by writer and director Robert Choquette (1905–91). Consisting of 1023 episodes broadcast between 3 October 1938 and 4 September 1942, this serial painted a picture of Montreal society from the twenties to the forties. Initially a novel, 'La pension Velder' was later transferred to the small screen where, between 1957 and 1961, it treated the same set of themes. The radio serials 'Métropole' and 'Quinze ans après,' by the same writer, formed sequels to 'La pension Velder,' for they depicted the Montreal of the 1950s and 1960s. 'La pension Velder' was produced for Radio-Canada by Lucien Thériault; its television producers were Jean-Pierre Sénécal and Louis Bédard. It was sponsored by Proctor & Gamble, and Canadian Pacific.

The second radio serial, 'Jeunesse dorée,' was written by Jean Desprez. Born Laurette Larocque in Hull, Quebec, in 1906, she had acquired solid experience in education, theatre, and radio adaptation before becoming a script writer for radio in 1939. 'Jeunesse dorée' was broadcast from 1942 to 1965, the year of her death. It was simultaneously published in *Radiomonde*. A militant feminist and nationalist, Jean Desprez was also a moderator and commentator, and the writer of 'Yvan l'intrépide' and 'Docteur Claudine' on the radio and of the television serial 'Joie de vivre.' Her radio and literary work is grounded in social criticism and a comic humanism.

Finally, 'La fiancée du commando' by Loïc Le Gouriadec, who wrote under the name of Paul Gury, represents the best of the radio propaganda serials during the Second World War. Based on real and fictional events, the serial, broadcast between 27 July 1942 and 17 January 1947, like 'Notre Canada' by the same writer, is stamped with an ultra-nationalism and anti-Nazism that recall wartime propaganda posters. It was translated into English and aired on the Canadian Broadcasting Corporation under the title 'Crusaders in Brittany'; it was also adapted for the stage and published in New York under the title 'La fiancée du commando, ou le mariage païen.' Of Breton origin, Paul Gury was born in 1888, and came to Canada as a refugee after the German invasion of France. He made his career primarily in the theatre, and died in 1974.

Sound effects technicians at work in the Canadian National CNRM studio in Montreal, 1934
PA 803753

Recording session in a CKAC studio in Montreal
MISA 15817, courtesy of the Canadian Association of Broadcasters

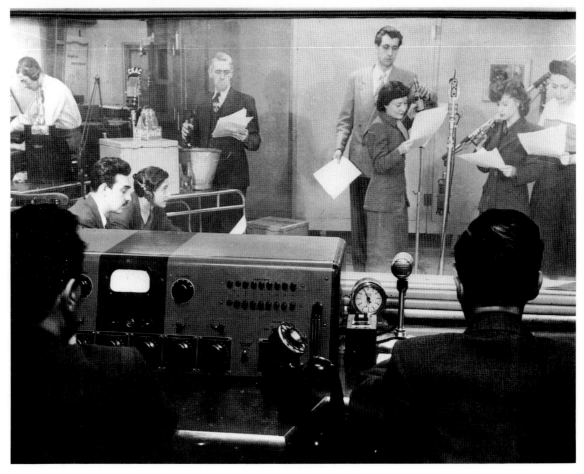

Assault on the beaches of Normandy

The Canadian Army Film and Photo Unit (CFPU) was formed in the fall of 1941 and assigned to cover the daily life of soldiers in training, their work and activities in Britain, and their participation in battlefield campaigns. During these years, the newsreel operation employed some 55 still photographers and cameramen; another 95 took part in recording combat operations. The unit also had 125 men and women carrying out production and distribution tasks. Since the Allied military footage was pooled for further use, their work appeared as well in many American and British newsreels.

The first Canadian Army Newsreel was produced in November 1942. Initially, newsreels were issued monthly. In the last year of the war, production became weekly and lasted through to the last newsreel, Number 106, produced in February 1946.

In April 1944, a CFPU section was organized for the invasion of Normandy. Canadian Army Newsreel Number 33, *Crusade for Liberation,* was filmed by Sergeant Bill Grant of Vancouver. He landed on the beach at Bernières-sur-Mer with the Queen's Own Rifles and his footage became the first to reach the British and American newsreel companies. That historic film, seen worldwide, showed soldiers in a landing craft, its ramp falling down, German obstacles in the water, and destroyed Norman houses in the distance. Under intense enemy fire, the Canadian troops struggled into the water and made their way towards the beach.

The newsreels of the Canadian Army Film and Photo Unit were the link between the troops at the front and the Canadian public back home. This one depicts the same events recorded in the official war diary on page 160.

The eve of D-Day, CFPU personnel assigned for the first wave of invasion. From the left: E.R. Bonter, Colin McDougall, L.E. Weekes, F.L. Dubervill, C.E. Roos (front), Sergeant Grant, D.A. Reynolds
MISA 15895, courtesy of Gordon Sparling

Troops landing on the beach at Bernières-sur-Mer, from the Canadian Army Newsreel no. 33
J.P. Rigby collection MISA 15934

A scarcely seen tale of liberation

The Antwerp Story, a documentary twenty minutes long, reports the liberation of the Belgian port of Antwerp and of the Netherlands by the Allied troops, which were mostly Canadians. This was an extremely difficult operation because the Germans had opened the dykes to flood the countryside, and had entrenched themselves behind canal banks.

Produced by the Canadian Army Film and Photo Unit during the Second World War, *The Antwerp Story* was directed by Gordon Sparling, commanding officer of the London headquarters of CAFPU. Because the film was made at the very end of the war and completed after the cessation of hostilities, it was not widely distributed. The negatives were stored in the vaults of the National Film Board until the Archives discovered them. The film now has been restored and is a vibrant homage to our soldiers and to the courage of cameramen who accompanied them on the scenes of battles.

Landing barge and party, from *The Antwerp Story*
National Film Board of Canada collection MISA 15940

Indian file towards the enemy,
from *The Antwerp Story*
National Film Board of Canada collection MISA 15935

A Red Cross truck on a pontoon,
from *The Antwerp Story*
National Film Board of Canada collection MISA 15939

A record of Latvian postwar revival in exile

Kas Mēs Esam ... Who Are We describes who and what the Latvians were at a crucial point in their history. Made in 1946 by the Latvian Displaced Persons Film Unit, Riga Film, the documentary depicts the predicament in which Latvian refugees found themselves at the end of the Second World War. Forced to flee their homeland after one Nazi and two Soviet occupations, they hoped to return to a free and independent Latvia. In the meantime, however, it was a question of basic survival. Some 250,000 people had made the hazardous journey to the West, but only half that number would actually reach the relative safety of the Allied occupation zones in Germany. Among the war-torn ruins of Europe, the survivors began to rebuild their shattered lives.

Essentially, the film is a record of the gradual revival, in exile, of Latvian society. A large proportion of these refugees were professionals, artists, and young people, full of energy and desire to demonstrate their abilities to the outside world. Housed in wooden barracks and existing on meagre rations, they nevertheless worked hard to set up hospitals, schools, theatres, and all the necessities of a vital cultural life. Life was arduous but stimulating. Many of the people shown in this production would go on to make significant contributions to their adopted lands, among them Canada, the United States, Europe, South America, and Australia.

The Riga Film camera crew, shown at work in the production studio, were themselves refugees with professional training and expertise. They worked under the protection and encouragement of the United Nations relief program. The film itself is of significance to Latvians in Canada as a record of a period leading to substantial emigration to this country. A marvel in that it has survived at all, the film also acts as a physical link between postwar Latvian exile film production and the activities of those who would go on to practise their art in Canada.

Although it had already begun to suffer decomposition, a 35 mm nitrate sound print, deposited by the producer Alberts Jekste, was used to restore and copy this film onto safety stock. Jekste had a long and colourful career in film production. Before the Second World War, he worked in Latvian film and broadcasting. After the war, he was invited by Premier Smallwood to set up a commercial production house in Newfoundland. The company, Atlantic Films, played an important role in the Newfoundland film industry of the 1950s.

Wooden barracks typical of Latvian DP camps, from *Kas Mēs Esam ... Who Are We*
Atlantic Films collection MISA 15944

Camera crew of the Latvian DP Film Unit, Riga Film, at work in the studio, from *Kas Mēs Esam ... Who Are We*
Atlantic Films collection MISA 15946

Newfoundland joins the Confederation

Crawley Films, founded by the late Frank Radford 'Budge' Crawley in 1939, produced more than 4000 films over a 50-year span and won 260 film awards around the world, including an Academy Award. In 1952 *Newfoundland Scene* was named best film at the Canadian Film Awards. The documentary, filmed by Crawley Films in 1949 and 1950 and released in 1951, was sponsored by Imperial Oil to introduce the province of Newfoundland – recently entered into Confederation – to the rest of Canada. It depicts the life-style, labour, and island character of the people. One memorable sequence of now historic footage, shot from the deck of a whaler, shows the stalking and eventual harpooning of a fin-back whale. Other exceptional scenes include a local doctor, travelling by dog team over rough terrain to make house calls; women laying fish on the beach for drying; three generations of fishermen from the same family embarking on a day's work; and the regular preparations of a lighthouse keeper.

Controversial seal-hunting footage, including the clubbing of baby seals, was removed from a 1972 revision that featured Gordon Pinsent in a new introduction. This reissue of the film some twenty years after it was originally produced is testimony to the popularity and quality of the production.

Men scanning the sea for the first signs
of 'white coats,' from *Newfoundland Scene*
Crawley Films Limited collection MISA 15714

Whaling sequence shot from the deck of
a whaler, from *Newfoundland Scene*
Crawley Films Limited collection MISA 10368

Radio-Canada's first teleplay

The first teleplay aired by Radio-Canada, 'Le seigneur de Brinqueville,' was broadcast on 3 August 1952, one month before the official inauguration of television in Montreal. Produced live at a time when videotape did not yet exist, it was preserved on 16 mm kinescope recording that was essentially a filmed copy of a television image.

It is a comedy by Pierre Petel, who directed the play himself. The cast includes Charlotte Boisjoli, Jeanne Demons, Jean Duceppe, Camille Ducharme, and Guy Hoffmann. In the years that followed, these actors were to become mainstays of Quebec theatre, movies, and television.

Guy Hoffmann as Le seigneur de Brinqueville
Société Radio-Canada collection MISA 15948

La famille Plouffe

An immensely popular television series, 'La famille Plouffe,' based on the novel of the same title, was the work of the well-known author Roger Lemelin. A study of manners initially directed by Jean-Paul Fugère and then by Jean Dumas, it was so successful that Radio-Canada and its counterpart, the Canadian Broadcasting Corporation, agreed to produce a version, 'The Plouffe Family,' with the same actors speaking their lines in English. Amanda Alarie and Paul Guèvremont played the mother and father of the family, and Denise Pelletier, Émile Genest, Jean-Louis Roux, and Pierre Valcour, the children. The series ran on the French network from 1953 to 1959. Of the 197 episodes produced, Radio-Canada preserved seven, and four episodes of 'The Plouffe Family' remain.

Fondly remembered by Quebecers, the story was picked up again in 1980 by filmmaker Gilles Carle in his movie *Les Plouffe*, and in a four-hour television mini-series in which Émile Genest this time played the role of the father of the celebrated family.

Cast of the TV series 'The Plouffe Family'
First row, from the left: Amanda Alarie, Paul
Guèvremont
Second row: Pierre Valcour, Jean-Louis Roux,
Denise Pelletier, Émile Genest
Société Radio-Canada collection MISA 6949

First flight of the Avro Arrow

The development of the Avro Arrow was to be Canada's contribution to the supersonic era. As early as 1946, the Royal Canadian Air Force had begun planning to equip its fighter squadrons with aircraft specifically designed for rigorous Canadian requirements. The criteria would include long-range, all-weather, supersonic capabilities. The specifications presented by the RCAF surpassed those of any other air force in the world.

In 1950, the advanced project group of A.V. Roe, Canada, presented submissions to the Canadian government on the possibility of replacements for the existing CF-100 all-weather fighter, which also had been designed and built by A.V. Roe. The preliminary design of an aircraft, with a project number designated as CF-105, was authorized by the Department of Defence in July 1953, and by September of the same year, wind-tunnel models were being tested in Ottawa. The average time from drawing board to production line was then about six years. To save time and cost, A.V. Roe decided not to build a prototype, but opted for advanced techniques based on production tooling.

Supersonic Sentinel: The Story of the Avro Arrow, produced by the Avro Aircraft Limited Photographic Department is a corporate documentary depicting the plane's devel-opment program and first flight. With test pilot Jan Zurakowski at the controls, the Arrow took off from Toronto's Malton Airport on 25 March 1958. Two chase planes tracked its progress. One carried Hugh MacKechnie, an Avro photographer with two 16 mm motion picture cameras and two still cameras. In the other, the RCAF pilot Ft-Lt J. Woodman had a 16 mm movie camera mounted on his helmet. In total, the event was covered by fourteen cameras in different locations.

It is more by luck and circumstance that footage of this project has survived. On Friday, 20 February 1959 Prime Minister Diefenbaker, citing cost as a major factor, announced the sudden cancellation of the entire Avro Arrow program. So complete was the shut-down that not long thereafter the company was ordered to scrap absolutely everything related to the project. The order was in itself controversial and led to suspicion and recrimination, not to mention much speculation as to what the Canadian aviation industry might have been had this project not been so abruptly cancelled.

A few surviving pieces of the Arrow, including wing tips, landing gear, and a nose cone, are held by the National Aviation Museum in Ottawa. This film is a further graphic reminder.

The Avro Arrow in flight and first roll-out
Avro collection Acc. 1978-0204

This Hour Has Seven Days

Almost three decades after its cancellation by the CBC, 'This Hour Has Seven Days' still has the reputation of being the most controversial television series ever broadcast in Canada. Inspired by the irreverent British current affairs series 'That Was the Week That Was,' 'This Hour Has Seven Days' used a similar mix of muckraking exposés of issues of vital interest to Canadians, presented in a slick and sometimes shocking manner.

Although many Canadian television viewers protested the series' cancellation in 1966, a number of other viewers, politicians, and even CBC television journalists were offended by its brash style and lack of regard for journalistic conventions of the time. Among the things that got the program into trouble were interviews with controversial figures such as the American Nazi leader George Lincoln Rockwell, a skit about the Pope, the engineering of a confrontation between two members of the Ku Klux Klan and a follower of Dr Martin Luther King, and hard-hitting, often embarrassing interviews with politicians.

CBC management felt that the series often sacrificed journalistic objectivity to be sensational. The CBC disapproved of the program showing film of an irate politician hitting reporter Larry Zolf, because it felt that the 'Seven Days' crew invaded the privacy of the politician, Pierre Sévigny, and made Sévigny look as if he had something to hide.

The CBC broadcast the weekly hour-long program from October 1964 to May 1966. There are close to three hundred hours of film of the series in the National Archives, including most of the programs as they went to air. The CBC collection at the National Archives also includes recordings of CBC current-affairs series that preceded and followed 'This Hour Has Seven Days,' making it possible for researchers to judge for themselves whether the series was key to the development of Canadian television journalism.

Laurier Lapierre (left) and Patrick Watson (right) hosting 'This Hour Has Seven Days'
Canadian Broadcasting Corporation collection
MISA 14078

A classic confrontation in a time of crisis

Tim Ralfe's verbal encounter with Prime Minister Pierre Elliott Trudeau on the steps of Parliament at the height of the October Crisis has become one of Canada's most famous television interviews. The 1970 crisis was precipitated when members of a Quebec revolutionary independence group kidnapped a British diplomat and issued a list of demands in return for his release.

More than just a classic confrontation between a journalist and a politician, the interview provides a fascinating insight into Trudeau's thinking just before his decision to invoke the War Measures Act. Although only the edited version was broadcast on the national network, the interview became a major news story and Trudeau's 'just watch me' quote came to epitomize his tough but then very popular stand on the issue.

But the clip is archivally significant more for what the public did not view than what was actually aired. The complete interview was more than seven minutes in length, but a nervous CBC management decided to edit it to two-and-a-half minutes. A comparison of the edited and unedited versions not only allows the viewer to reflect on the atmosphere that led CBC management to edit the interview; it also allows the viewer to realize in startling degree the power of the editing process and the importance of the broadcast 'out' as part of Canada's historical record.

After the crisis had subsided, the clip took on added significance when its complete version became available for research. Played in its entirety, it represents a chilling view into the fragile line between liberal democracy and authoritarianism and the role of the media in interpreting these values for society. It also demonstrates the power of television: its visual images compel the viewer to follow and weigh every parry and thrust of the debate.

A photograph from a TV screen of the impromptu but
dramatic encounter between Prime Minister Trudeau
and CBC TV journalist Tim Ralfe on the steps
of Parliament Hill, from 'The FLQ Crisis Special'
Canadian Broadcasting Corporation collection
Acc. 1985-0179

The Inuit Broadcasting Corporation

In 1989, the Archives began to acquire programs produced by the Inuit Broadcasting Corporation, which began operations in 1982. These programs, in the Inuktitut language, originate in various stations of the Canadian Arctic and are produced locally by aboriginal crews.

IBC television is linked not to Canadian news but to information from the world over, particularly that provided by the nations of the circumpolar conference that have met every three years since 1977. The IBC has been covering those meetings since 1983. The Archives borrows video records from the IBC, copies them in Ottawa, and sends the originals back to the owner. These records are accompanied by a description and credit titles in English to facilitate consultation.

Under an agreement that is renewed each year, the Archives will continue to acquire and preserve the best of the IBC's productions, in order to add them to our national heritage and allow researchers to become acquainted with a little-known culture that is an integral part of the Canadian mosaic.

Broadcast crew on location
MISA 15896, courtesy of Inuit Broadcasting Corporation

Montreal Canadiens and the Stanley Cup

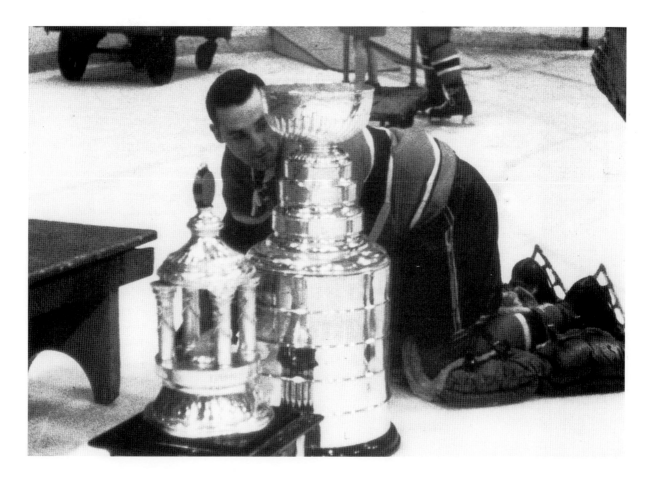

It has been many decades since hockey superseded lacrosse in the hearts and souls of most Canadians as the national sporting passion. Since the inception of radio and television in Canada, hockey has traditionally ranked among the most popular of broadcasts. In the early 1970s a large number of film kinescope recordings from the first twenty years of television were acquired by the National Archives. Slowly, additional film and television holdings were added to the unprocessed collection. In 1989, the producers of 'Hockey Night in Canada,' Molstar Communications, arranged to fund the archival triage, cataloguing, and conservation of this material, with support from Molson's Breweries.

In 1958 a documentary film highlighted the annual Stanley Cup playoffs for the championship of the National Hockey League. Several scenes were discovered in a discarded roll of out-takes not used in the final production. In one, the victorious Montreal Canadiens posed inside the Montreal Forum for their portrait with the Stanley Cup. Their victory over the Boston Bruins that year was the third consecutive Cup win for the 'Habs' in a record string of five glorious seasons. Another, shown here, is indicative of the emotional bond Canadians have with Lord Stanley's mug. Goalie Jacques Plante, wondrously unaware of the camera, is captured searching for his engraved name on the trophy.

Jacques Plante, from 'The Stanley Cup Finals, 1958'
Molstar Communications collection MISA 15950

VIII

Canada through the Camera

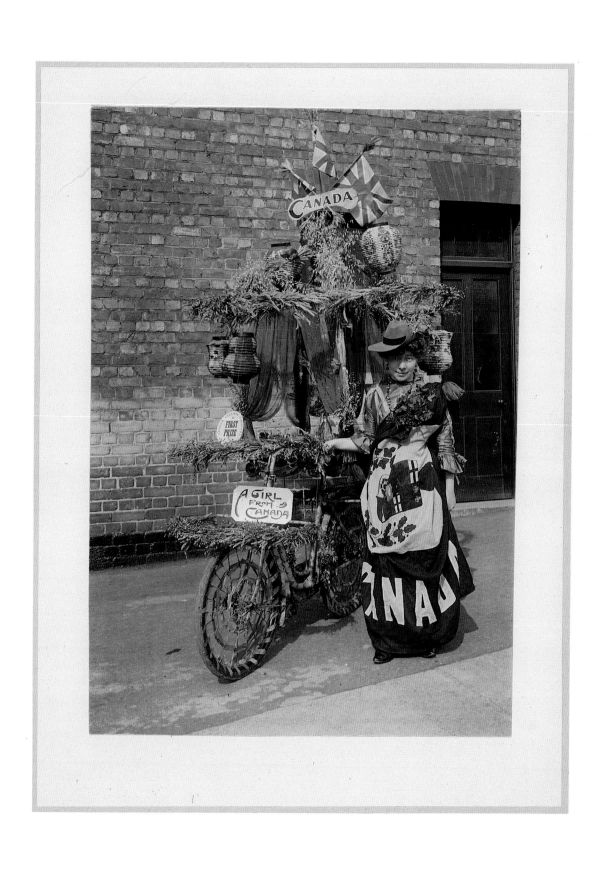

Photographic Records

The year 1989 marked the 150th anniversary of the announcement of thc first practicable process combining optics and chemistry to record permanently an image 'from nature.' Since that time, debate has raged over the nature of photography; however, whether art or science, craft or profession, photography is an archival medium borne of objectivity and selectivity, imagination and truth. At last count, there were more than fifteen million photographs in the National Archives of Canada. The photograph, whether taken one hundred years ago or last week, conveys essential, often unique information not only about a given subject, but also about the society that fashioned it. Prints, negatives, and transparencies, in black and white and in colour, old and new, faded or pristine, individually and collectively, document Canadian history and society, its diversity and development.

The examples in this section were selected to represent the geographical, chronological, and thematic diversity of the National Archives' photography holdings. They also suggest the range and development of photographic technology, demonstrating the way in which the visual record evolved in response to changes in cameras, lenses, emulsions, and processing. Included are daguerreotypes, an oil painting over a photograph on paper, a salt-paper print, albumen prints from both wet- and dry-plate negatives, a dry-plate glass negative, a Kodak circular snapshot, nitrate negatives, and Cibachrome prints. The selection also presents a range of formats from cased items to card-mounted prints, from stereoscopic views to leather-bound albums, from lantern slides to exhibition prints. It is also clear from the selection that the condition of the prints and negatives varies. However, archives collect photographs primarily to document a person, place, or event, and not necessarily to reproduce or exhibit them. Consequently, photographs that are faded or stained or torn – for example, the salt-paper print of the Great Western Railway disaster of 12 March 1857 – only some of which may benefit from conservation treatment, can nonetheless be important sources of information.

In the mid-nineteenth century, photography gave the world a new way of seeing itself, a new means of recording itself for posterity. Photographs have elicited metaphorical comparisons with mirrors, windows, and doors, suggesting in graphic terms a way of coming face to face with the past. In the modern world of archives, photographs allow us to examine that reality and reflect on our identity. Treated as a document, studied as a source of information, the photograph, like any other archival document, may answer some questions and pose others. Yet there is more to photographs than meets the eye. They convey not only facts, but also evidence and contemporary opinions. Many embody and reveal the values and aspirations of our society, its diversity, and its evolution. Understood in context and used in conjunction with other evidence, photographs are a rich source for the study of Canada's past.

For 150 years, photography has given us a way of preserving the present and viewing the past. From Pierre-Gaspard Gustave Joly de Lotbinière to Yousuf Karsh, Canadian photographers have recorded for posterity the image of people and places with both accuracy and artistry. The photography collection of the National Archives, so rich in images from government projects and commercial concerns, private individuals and public figures, talented professionals and dedicated amateurs, is an unparalleled reflection of our opinions, our hopes, and our motivating ideals. This selection celebrates the unique and enduring value of the photograph in documenting Canada, Canadians, and the Canadian experience.

In the beginning: the daguerreotype

Introduced in 1839, the daguerreotype was an image formed through the action of sunlight and mercury vapour on a silver-coated sheet of copper. It was the first practicable photographic process which, at long last, permitted the faithful representation of images from nature. Daguerreotypes were taken with a camera, essentially a wooden box with a lens at one end that focused the image on a sensitized plate inserted across the opposite end. The quality of its detail, often enhanced by hand-tinting, rivalled the art of the portrait and rendered accessible to the middle classes the opportunity to be recorded for posterity, a privilege until then reserved for the well-to-do. In the 1840s, daguerreotypes sold for between one and five dollars, roughly the cost of a pair of trousers and much less than a painted portrait. In any photography collection, daguerreotypes hold special pride of place, not unlike the position reserved for the painted miniatures they supplanted and which they resemble in physical format.

The National Archives holds more than 150 daguerreotypes. The majority come from family collections and are unidentified; those where both the daguerreotypist and the subject are known are rare. However, many historically interesting daguerreotypes have been preserved, including some of prominent politicians, unusual subjects, and outdoor scenes. Among the finest daguerreotypes in the Archives are these five unique cased images on the following pages; their rarity contributes significantly to their value as both document and artifact. The portrait of an Ojibwa chief offers a rare, early representation of a native Canadian. Prized as much for its subject as for its presentation is the gold locket portrait of Sir John A. Macdonald before he rose to national importance as a Father of Confederation and Canada's first prime minister. The daguerreotype showing the ruins of the Molson Brewery after the fire of 1852 is one of the few outdoor scenes.

Also unusual and valuable is the portrait of costumed boys produced by leading Montreal daguerreotypist Thomas Coffin Doane in 1855. Commissioned by a local tailor, Alfred Chalifoux, to symbolize the relations between France and New France, the daguerreotype was taken to be presented to the Empress Eugénie by Paul-Henri de Belvèze, commander of *La Capricieuse*, the first French warship to visit Canada after the Conquest of 1760. An inscription reads:

> These small characters who take part in Montreal's national celebrations call to mind all the religious and patriotic memories of the French Canadians. St. John the Baptist, the patron saint of Canada, Jacques Cartier, who discovered the country in the sixteenth century and brought the gospel with him, and the Indian Chief, who greeted the French at Hochelaga [Montreal]. Finally, to link the past with the present, a young Canadian, wearing the colours of France, is ready to join his older brothers at Sebastopol.

While the vast majority of daguerreotype portraits in the National Archives' holdings are of one or two individuals, the final portrait shows a group of Yarmouth merchants. A written description inside the case and behind the plate, signed by one of the subjects, identifies the sitters, the date, and the daguerreotypist.

Superseded by the negative-positive process during the 1850s, the daguerreotype was by 1860 almost obsolete. These few examples testify to the popularity enjoyed by the daguerreotype in Canada and to the quality achieved by its practitioners, as well as to their documentary, historical, and artifactual value.

Maun-gua-daus,
also known as George Henry, c. 1846–8
Creator: unknown
Daguerreotype, half-plate, 140 × 108 mm
PA 125840

John A. Macdonald, c. 1845–50
Creator: unknown
Daguerreotype, medallion, 28 mm (diameter)
PA 121571

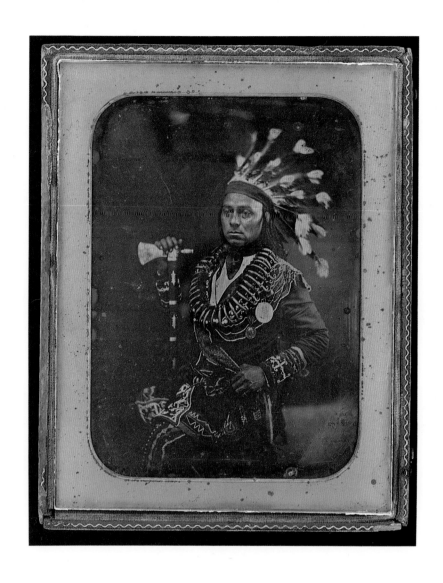

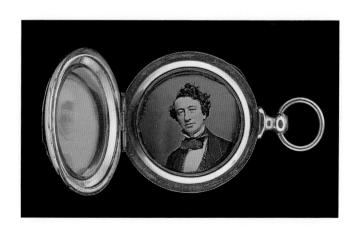

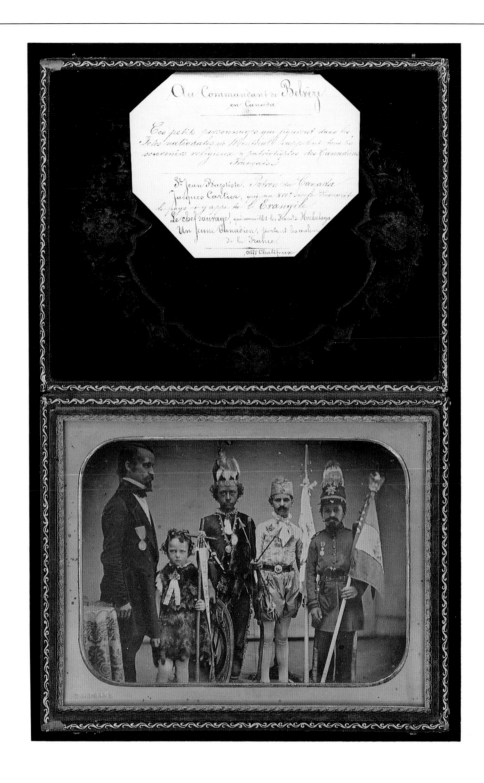

Alfred Chalifoux and four boys
dressed in historical costume,
June–July 1855
Creator: Thomas Coffin Doane
Daguerreotype,
half-plate, 108 × 140 mm
PA 139333

Group of merchants, Mason Hall,
Yarmouth, Nova Scotia, 1855
Creator: Wellington A. Chase
Daguerreotype,
half-plate, 108 × 140 mm
C 18097

Molson's Brewery after the fire,
Montreal, Canada East, 1852
Creator: unknown
Daguerreotype,
half-plate, 107 × 140 mm
C 89689

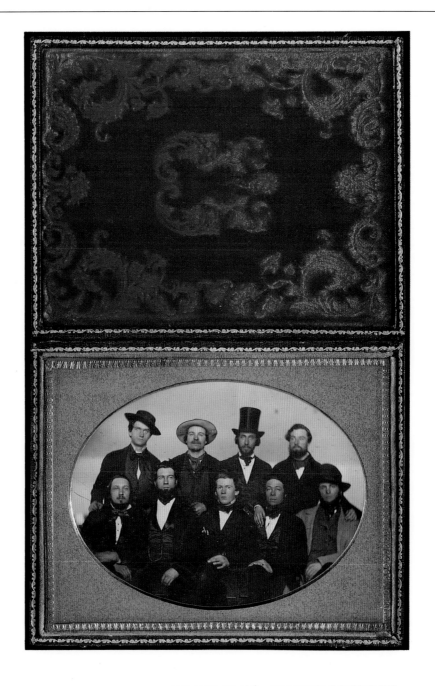

Photography and art

The visit of Edward, Prince of Wales (later Edward VII) to Canada in 1860 provided an opportunity for photographers to market his portrait in a variety of formats to a doting public. Carson Brothers (active in Toronto 1857–65) were noted for their ambrotypes, coloured photographs, and photographs on ivory. They produced this oil painting over a photograph on paper, thus creating an image with the cachet of an original work of art yet at an affordable price, while at the same time exploiting the detail and perspective of photography.

The connection of this new image-making process with art was a powerful attraction. It expressed itself not only in portraits using photographs as the basis for overpainted work, but also in collages and montages. These art works incorporated cut-out photographs in painted scenes or in paintings or engravings. Although they were produced entirely by hand, they were in fact composed with one or more photographs as models.

How strongly such models influenced the artistic community in Canada can be gauged from the pre-eminent roles now assigned to William Armstrong's watercolours of pre-Confederation Ontario, John Fraser's monumental canvases of the Canadian Rockies, George Harlow White's pencil sketches of the interior of British Columbia, and Lucius O'Brien's engravings in *Picturesque Canada*, all work which relied heavily on photographs. Such images, although questionable in fact and detail, speak to the aspirations of their creators and their audiences, thus documenting that most elusive of truths – the beliefs and ethical preferences of a vanished generation.

The National Archives contains other seminal documents of the cross-fertilization between art and photography in such publications as *Notman's Photographic Selections*, volumes I and II, perhaps the earliest subscribed art publication in Canada to use photographs of works of art, including two photographs 'from nature,' to disseminate the cultural icons of European taste.

Edward, Prince of Wales, 1860
Creator: Carson Brothers
Oil over paper photograph,
463 × 375 mm print, 650 × 545 mm frame
C 133732

315

Colonial souvenirs

What better souvenir of a posting in the colonies than a handsome leather-bound album of selected photographs, carefully arranged, titled, often annotated, and elaborately decorated, to be prominently displayed in the typical Victorian drawing room. Posted to Montreal in 1865, Captain Thomas J. Grant, district inspector of musketry for North America, compiled such an album. In it he arranged hundreds of gem-sized portraits of his fellow British officers around photographs of diverse subjects encountered during his travels throughout eastern Canada, including views of Halifax, Quebec City, Montreal, Ottawa, and Niagara Falls. The pages show Grant's interest in Indians, industry, and landscape, and include small portraits of the Prince and Princess of Wales.

While some military officers were trained in the use of the camera, before the advent of the Kodak in 1888 and the popularization of photography there were few amateur photographers in Canada. Albums were usually compilations of views and likenesses by professional photographers who were commissioned to record specific subjects and who displayed in their studios a large selection of images from which prints could be ordered.

The Grant album is one of many that serve as a visual journal of a colonial posting and an account of everyday events. Sir Charles Hastings Doyle, who arrived at Halifax in 1861 to assume command of British forces in Nova Scotia, also owned a photograph album; its contents include rare interior views of his Halifax residence Belle Vue House, as well as events such as military parades and funerals, and views of Halifax, Saint John, and Bermuda. The album of Sir John Glover, governor of Newfoundland from 1875 to 1881 and 1883 to 1885, includes photographs of the family dog Fogo, Glover's yacht *Nooya*, and landscapes of Newfoundland imbued with romantic notions of rural England. In British Columbia, frontier life during the Cariboo gold rush of the 1860s becomes almost tangible in the album of Arthur Birch, colonial secretary to Governor Frederick Seymour. The expression of a past that was both intimate and public, the many albums of British officers and officials like Grant, Doyle, Glover, and Birch, now preserved by the National Archives, constitute not an official record, but a personal record of official life in colonial Canada.

Two pages from an album compiled
by Captain Thomas J. Grant, c. 1865–70
Photographs by William Notman and others
Pp. 7 and 8, each page 510 × 353 mm /
11 albumen prints, 725 × 510 mm
Acc. 1960-051

Portraits for everyone

Yes, This is my album, but learn ere you look,
that all are expected to add to my book.
You are welcome to quiz it but the penalty is,
that you add your own portrait for others to quiz.

This doggerel poem, frequently found at the beginning of photograph albums, testifies to the nineteenth-century enthusiasm for exchanging and collecting photographic portraits of celebrities, family, and friends. Adorned in finery sometimes borrowed, Canadians presented themselves at one or more of the rapidly expanding number of photographic studios where an assortment of props and painted backdrops was available to create elaborate settings, from winter scenes to fashionable parlours. There, the sitter was immobilized by chair and head-clamps to ensure a steady exposure. Some establishments offered special retouching, adding flourishes of colour to enhance the prestige and artistic value of the final portrait. A variety of formats – *cartes-de-visite* and later cabinet cards – provided a mount for the small paper prints. On the verso of the mount was the photographer's logo or trade mark, studio name, address, and the range of photographic services offered, providing publicity for well-known portrait photographers and small-town itinerants alike.

Photography flourished, becoming not only cheaper for the public but more easily practised by photographers. *Cartes-de-visite* and cabinet cards, collected and arranged in specially made albums, document how the low cost and reproducibility of glass negative/paper print technology made photography accessible to the average Canadian and encouraged portraiture of and for almost everyone.

The advent of such formats coincided with a new awareness of social status and mobility: a large number of the *cartes* were collected and arranged in special albums that juxtaposed portraits of modest Canadians, their families, and friends alongside mass-produced and mass-marketed likenesses of the Royal Family and popular celebrities of the period. These portraits, although often of unidentified sitters, offer a vibrant reflection of the period through choice of costume, pose, and setting. *Carte* and cabinet portraits are now preserved in the collections of both the individuals who bought them and the studios that created them.

A montage of selected cased, carte-de-visite, cabinet and boudoir portraits of identified and unidentified sitters by known and anonymous photographers, c. 1855–90

Salon photography

Pictorialism was a style of photography defined by broad compositional effects, diffused focus, art-imitative techniques, and subject matter derived from the traditions of painting. It reached Canada chiefly through the efforts of Sidney Carter (1880–1956), a Montreal photographer and art dealer. Carter achieved international acclaim in the salon movement, was made an associate of the prestigious Photo-Secession in New York, and played a major role in ensuring that Canadian achievements in pictorialism were noted in international circles through articles published in the international annual, *Photograms of the Year*. This pictorialist portrait of Rudyard Kipling is one of an impressive series of portraits of such prominent personalities as Serge Prokofieff, Bliss Carman, Percy Grainger, John Singer Sargent, and Joliffe Walker among more than four hundred prints in the Sidney Carter collections in the National Archives of Canada.

As photographic aesthetics continued to evolve, salon photography became less painterly and more oriented towards design. An excellent example is *Creations of Man* by the Dutch-Canadian photographer John Vanderpant (1884–1939), whose west coast gallery was a locus for emerging movements in painting, photography, and art theory during the 1920s and 1930s. Vanderpant's lectures, publications, and workshops, his correspondence with prominent American photographers and distinguished Canadian painters, his sponsorship of international and local photographic exhibitions, and his active participation in the development of the local arts community made him an important figure in contemporary art movements in Canada during this period. The John Vanderpant collection contains nearly two thousand of Vanderpant's negatives and other photographs, correspondence with leading photographic societies, exhibition catalogues, medals and ribbons, financial records, clippings, and other memorabilia. It documents Vanderpant's professional career as an internationally recognized art photographer, and represents the achievements of one of Canada's most distinguished photographic practitioners and advocates.

Photographs by many other talented pictorialists, including Vanderpant's distinguished peers Johan Helders and Harold Mortimer-Lamb, are also preserved by the National Archives. Their work is an important resource in the study of photography, art, and aesthetics during the first decades of the twentieth century. From the raw negatives to exquisite salon prints adorned with the awards of international exhibitions, these works offer an unparalleled opportunity to examine the growth and achievements of the pictorialist movement in Canada.

Rudyard Kipling, 1907
Creator: Sidney Carter
Silver print, 249 × 187 mm
PA 135434

Creations of Man, 1934
Creator: John Vanderpant
Glass lantern slide, 82 × 102 mm
PA 179552

Photography and the printed page

Published in 1865, the third series of Sir James MacPherson LeMoine's *Maple Leaves: Canadian History and Quebec Scenery* contained a number of original photographs. At the time, and until the development of the halftone screen, a publisher could use photographs as illustrations in one of two ways: the slow and expensive process of 'tipping in' or glueing photographs by hand directly into a publication, and the more popular method of using the photograph as the basis for an engraving.

In the foreword to this volume, LeMoine praised the photographer Jules Isaï Benoit *dit* Livernois, the founder of Quebec City's Livernois dynasty of photographers. 'The Illustrations ... speak for themselves ... Should an indulgent public continue to this series the favor extended to the two that preceded, the writer will feel that to Mr. Livernois' portraying of localities is due a fair portion of that success.' The Livernois studio operated in Quebec City for 120 years from 1854 to 1974 and stretched over three generations of Livernois: Isaï Benoit, his son Jules-Ernest, and his grandson Jules. They photographed the people, politicians, and religious leaders of Quebec City and vicinity and the cityscape, landscape, and monuments of the area. The number and content of prints varied from copy to copy. This volume contains twenty-five different prints of stately homes in Quebec.

Maple Leaves was the first book in Canada illustrated with photographs.

Just four years after the appearance of *Maple Leaves*, engraver William Augustus Leggo of Quebec City and publisher George Edward Desbarats of Montreal patented the leggotype process, which produced 'electrotype plates of pictures, ready for common printing, like ordinary type printing, without engraving or other hand work.' The first magazine in the world to use halftone reproductions of photographs was Desbarats's *Canadian Illustrated News*, the first issue of which featured William Notman's portrait of HRH Prince Arthur as its cover illustration. It was widely believed that the camera did not lie; as a result, the words 'from a photograph,' accompanying engravings in the pictorial press such as the cover illustration of sports hero Ned Hanlan, served to strengthen the public's faith in the truthfulness of the printed image. Gradually methods of picture reproduction improved, using leggotypes, wood engraving, lithography, and ultimately the halftone. These developments, linked with the steam-powered press, married photography to the printed page and dramatically increased the mass production and diffusion of visual information during the second half of the nineteenth century.

'Edward Hanlan, Champion Sculler of America. – From a Photograph by Notman & Sandham.'
Canadian Illustrated News, vol. XVIII, no. 15, p. 225, 12 October 1878
Creator: Notman & Sandham
Engraving from an original photograph, 248 × 218 mm on page 405 × 283 mm
C 68307

Clermont, photographic frontispiece and title page, *Maple Leaves. Canadian History and Quebec Scenery.* (Third Series) J.M. LeMoine. Quebec: Hunter, Rose & Company 1865
Creator: Jules-Isaï Benoit *dit* Livernois
Albumen print, 122 × 89 mm
PA 181358

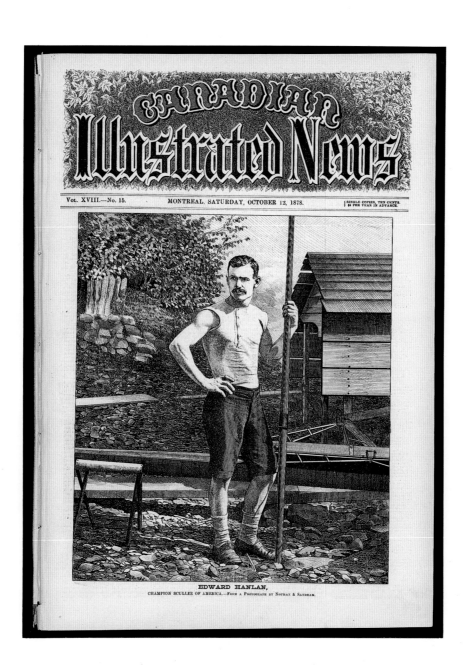

CANADIAN
Illustrated News

Vol. XVIII.—No. 15. MONTREAL, SATURDAY, OCTOBER 12, 1878. { SINGLE COPIES, TEN CENTS. } $4 PER YEAR IN ADVANCE.

EDWARD HANLAN,
CHAMPION SCULLER OF AMERICA.—FROM A PHOTOGRAPH BY NOTMAN & SANDHAM.

CLERMONT.

MAPLE LEAVES.

CANADIAN HISTORY

AND

QUEBEC SCENERY.

(Third Series.)

BY J. M. LeMOINE, ESQ.,

AUTHOR OF "L'ORNITHOLOGIE DU CANADA," "LES PÊCHERIES DU CANADA," "ÉTUDE
SUR LES EXPLORATIONS ARCTIQUES DE MCCLURE, DE MCCLINTOCK, ET DE KANE,"
ETC., MEMBER OF THE LITERARY AND HISTORICAL SOCIETY OF CANADA.

(COPYRIGHT.)

Quebec:
HUNTER, ROSE & COMPANY ST. URSULE STREET.
1865.

Vision of the West

H.L. Hime's *The Prairie, looking west* demonstrates that, if the camera does not lie, it often veils the truth. The view shows the aftermath of a brush fire, with no distinguishing features save a human skull grinning in empty mockery. It was hardly an accurate view of a land which was rich, fertile, and full of promise. Rather, it was more a mirror of Hime's own emotions at the end of an expedition marked by failure. Yet it has guaranteed Hime a place in Canada's visual history and is an example of the way in which the camera became an essential tool in the opening of the Canadian West.

Photography commissioned by the Canadian government documented the reality and created a vision of the West. The Assiniboine and Saskatchewan Exploring Expedition of 1858 was the first in Canada to use the camera to illustrate 'all objects of interest' encountered on the exploration. The photographer, Humphrey Lloyd Hime (1833–1903) of Toronto, used the awkward wet collodion process to make a series of excellent photographs of the settlements and 'native races.' Other photographers followed with the Royal Engineers in the North American Boundary Commissions of 1860–1 and 1872–5. At the time of British Columbia's entry into Confederation in 1871, Benjamin Baltzly (1835–83) accompanied a party of the Geological Survey of Canada on an expedition through British Columbia with instructions to 'secure accurate illustrations of the physical features of the country and of other objects of interest' as part of the work to determine the best route for the transcontinental railway. At about the same time, Charles Horetzky (1838–1900) began taking 'views of objects of interest, illustrative of the physical features of the country' for the Canadian Pacific Railway surveys, 1871–9. George Mercer Dawson (1849–1901) and Joseph Burr Tyrrell (1858–1957) made photography an integral part of their work with the Geological Survey of Canada during the 1870s and 1880s. The scientific application of photography to surveying culminated in the use of photogrammetry in the topographical surveys of the Rockies by Surveyor-General Edouard Deville (1849–1924); Deville also produced a thorough photographic record of his own trip west in 1886.

Wet-plate technology, such as Hime used, involved awkward and heavy equipment and messy and time-consuming procedures. Chemical preparation of the negative immediately before and after exposure required that a photographer working outdoors travel with a portable darkroom, boxes of glass plates, chests of chemicals, and large quantities of fresh water. Forced to carry all this paraphernalia, the intrepid itinerant was unable to venture far from the beaten path, and, in pursuing landscape photography had to contend with heat, cold, rain, wind, and ever-present dust. Estimates of the weight of the wet-plate photographer's equipment vary from 120 pounds to 500 pounds. In 1872, A.R.C. Selwyn, director of the Geological Survey of Canada, wrote to Sandford Fleming, chief engineer of the Canadian Pacific Railway, explaining the costs of the photographic work performed by Baltzly on the 1871 geological survey through British Columbia: 'The great weight of the photographic apparatus has made the cost of the photographic branch of the expedition proportionately larger than that for geological purposes.'

Glass-plate negatives, albumen prints, and photographic albums by the Royal Engineers, Hime, Baltzly, Horetzky, and Deville are preserved by the National Archives as an enduring testimonial to western exploration and surveying, a record of the transformation of the West by the hands of the white man, and a significant contribution to the history of photography in Canada.

The Prairie, looking west, September–October 1858
Creator: Humphrey Lloyd Hime
Albumen print from a wet collodion negative,
132 × 178 mm on mount 277 × 366 mm
c 17443

Exploration of the North

Working in temperatures that reached −64°F, Thomas Mitchell (c. 1833–1924), assistant paymaster on board HMS *Discovery* and his colleague, George White, engineer on board HMS *Alert*, used both the wet-plate and dry-plate process to produce a remarkable visual record of the 1875–6 British Arctic Expedition under the command of Captain George S. Nares. Photography, regarded as an important facet of the scientific program of the expedition, provided ethnographic, topographic, and geographic data. It also provided valuable documentation of ice conditions which had to be seen to be believed in England. The achievements of the Nares expedition photographers were considerable. Despite the technical problems caused by sub-freezing temperatures and vast expanses of light-reflecting ice and snow, not to mention the bulk and weight of the equipment, Mitchell and White took more than 100 photographs. In these they managed to capture the activities of the expedition and to convey some sense of the vastness, isolation, and austerity of arctic topography.

Explorers had previously illustrated their reports with paintings, sketches, and engravings. With photography, the visual record of arctic exploration became more scientific and objective. Canada's control over the Arctic was established under the watchful eye of photographers on the notable northern voyages of William Wakeham on the *Diana*, A.P. Low on the *Neptune*, and Joseph-Elzéar Bernier on the *Arctic*.

The photographs taken on these first great Canadian arctic expeditions reflect not only the concrete achievements of the explorers, but also the special interests of the photographers. The camera was used to record topographical landmarks, geological observations, ice conditions, weather stations, and anthropological and ethnological data. Both white and native peoples captured by photography bear witness to the spirit and perseverance that made survival possible in this inhospitable land. These photographs, which stirred the explorer and captured the popular imagination, are an invaluable aid to the study of Canada's last great frontier.

No. 62. Lat. 81° 44′ N. Winter Quarters.
H.M.S. Discovery. *The Smithy and Theatre.*
Ellesmere Island, NWT, 2 April 1876
Creator: Thomas Mitchell
Albumen print, 157 × 200 mm
C 52573

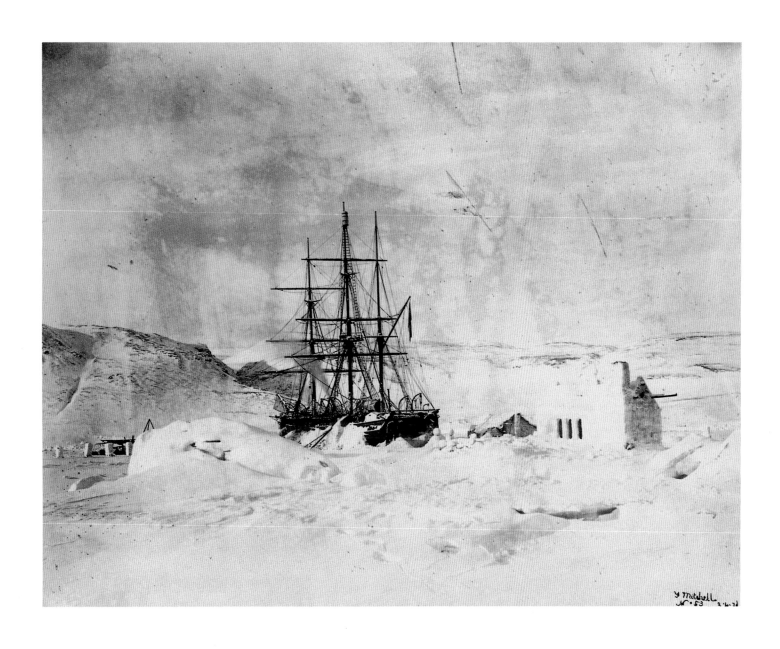

Documents of native life

A remarkably fine bright morning. went round to Indian village
& took three photos. of it.

GEORGE MERCER DAWSON
26 July 1878

During the 1870s and 1880s, George Mercer Dawson (1849–1901) took a large number of historically and ethnographically important photographs of British Columbia Indians. Using the faster and more reliable gelatin dry-plate process, he produced a remarkable series of negatives of the west coast Haida villages of Tanu, Cumshewa, Skedan, Skidegate, and Masset. Dawson was aware of the significance of these photographs, noting in his report that the totem poles 'had not before been photographed, and owing to the rapid process of decay it will be impossible to obtain satisfactory illustrations of them in a few years time.'

From early daguerreotypes of Indian leaders and *carte-de-visite* portraits of Vancouver Island tribes, from Micmac wigwams in Newfoundland to Haida lodges in the Queen Charlotte Islands, from studio portraits of an eastern Arctic Inuit couple on a visit to New York City in the 1860s to the portraits of Inuit women and children by Geraldine Moodie, an amateur photographer and wife of a North-West Mounted Police officer at the turn of the century, the nineteenth-century fascination with aboriginal peoples was responsible for extensive visual documentation of the Indian and Inuit of Canada, especially in those areas where exploration and photography went hand in hand. The beautiful and complex art of the west coast Indians made them subjects of particular interest.

In addition to the extensive photographic record of the Department of Indian and Northern Affairs, the National Archives holds negatives, prints, and slides produced by Donald Ben Marsh, an Anglican missionary and later bishop of the Arctic; Arthur H. Tweedle, an optometrist who travelled throughout the eastern Arctic to examine the eyes of the Inuit on trips sponsored by the Canadian National Institute for the Blind; and by such professional photographers as Richard Harrington, Richard Finnie, and John Reeves. Portfolios by contemporary photographers include John Flanders's record of daily life among the Cree of James Bay, Serge Jauvin's documentation of the Montagnais of Quebec, and Judith Eglington's photographs of the sculptors and graphic artists of Cape Dorset.

Skidegate Indian Village,
Queen Charlotte Islands,
British Columbia,
26 July 1878
Creator: George Mercer Dawson
Dry-plate glass negative, 165 × 216 mm
PA 37756

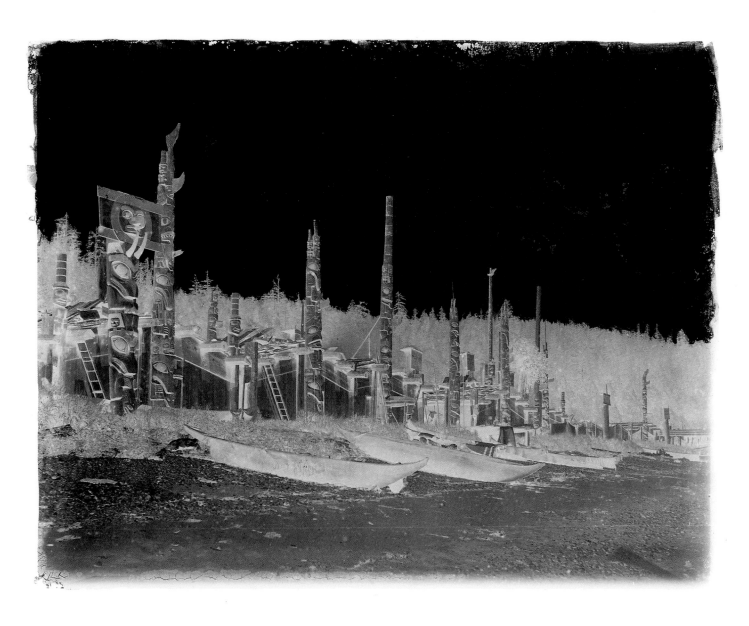

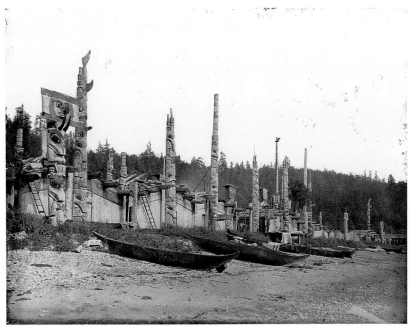

The New Amateur

You press the button. We do the rest.

EASTMAN KODAK ADVERTISING SLOGAN

Early in 1889, Robert Wilson Reford, scion of a Montreal shipping magnate, set off for British Columbia with one of the first Kodak box cameras in Canada. For the next two years, Reford lived in Victoria working as a clerk for the Mount Royal Rice Milling and Manufacturing Company to gain experience before joining the family business. More than eight hundred snapshots in five albums reveal that, whether in Victoria or travelling around British Columbia, whether at work or at play, Reford was seldom without his camera. Both a tourist and a businessman, he exemplified the 'New Amateur' of the 1890s, photographing 'ordinary' subjects, infrequently chosen by professional photographers, in a manner distinguished by freshness and spontaneity: native people, ethnic groups, women, people at work, even friends having an ostentatiously bibulous picnic.

The small, circular format of these images reveals that Reford (1867–1951) used a point-and-shoot Kodak No. 1 box camera, already loaded with a 100-exposure roll of celluloid film, developed by George Eastman and commercially available in late 1888. The change in technology nurtured an important transition away from the professional photographer and towards the amateur snapshooter and led to a significant change in attitude about what could be photographed. The need to set up a camera or pose a subject no longer defined the limits of photographic subject matter. Reford's snapshots of precarious situations, spontaneous actions, and unstudied moments in time offer a more revealing 'slice of life' than ever before possible. The convenience of commercially processed roll film also encouraged a significant rise in the volume of photographs taken, often in series or showing the same subject from a number of vantage points.

The original price of the Kodak Camera (most popular in the period 1888–9) and the No. 1 Kodak (1889–95) was twenty-five dollars. The camera was sold factory-loaded with roll-film and came with an instruction manual. When the one hundred exposures were made, the Kodak was returned to the Eastman Company. For ten dollars, the negatives were developed and printed, the camera was reloaded and the prints and camera were returned to the owner. The simplicity and portability of the Kodak camera, and the benefits of commercial processing that separated the simple act of taking a photograph from the more complex task of developing and printing it, contributed substantially to the growth of popular, non-professional photography in Canada beginning in the 1890s. The National Archives preserves thousands of negatives and prints, the work of countless amateurs like Reford whose photographs constitute an unrivalled source of information about daily life in Canada since that time.

Interior of Mount Royal Rice Milling and Manufacturing Company, showing Chinese worker and sacks of rice, 66 Store Street, Victoria, British Columbia, 1889
Creator: Robert W. Reford
Silver gelatin print, 60 mm diameter on paper 69 × 71 mm
PA 118183

Residents of 'The Kraal' boarding house having a picnic at the Gorge, Victoria, British Columbia, 1889
Creator: Robert W. Reford
Silver gelatin print, 60 mm diameter on paper 69 × 71 mm
PA 127398

Chinese seamstress, Victoria, British Columbia, 1889
Creator: Robert W. Reford
Silver gelatin print, 60 mm diameter on paper 69 × 71 mm
PA 118195

Louis Henry Feiling's crockery and glassware store, 58 Fort Street, Victoria, British Columbia, 1889
Creator: Robert W. Reford
Silver gelatin print, 60 mm diameter on paper 69 × 71 mm
PA 164640

330

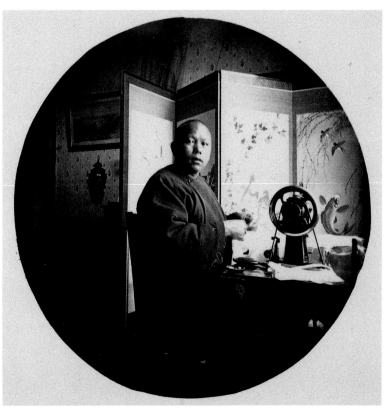

Legacy of a master collector

This remarkable photograph shows the building of the 'Trevithick,' the locomotive used to power the train that carried Edward, Prince of Wales (later Edward VII) on a tour of Canada in 1860. Standing by the forward driving wheel is Frederick Henry Trevithick, the first locomotive superintendent of the Grand Trunk Railway and son of Richard Trevithick, who had built the world's first railway engine in 1804. In response to the great burgeoning of railways in British North America in the 1850s, the Grand Trunk Railway set up shops at Point St Charles, near the north end of the Victoria Bridge in Montreal, and by May 1859 produced the largest (48 1/2 ton) locomotive then in use in Canada. Although photographic technique had developed considerably by the 1850s, it was still a considerable feat for the photographer to capture a large group inside a building.

The photograph is just one of many historically significant transportation images compiled by an anonymous collector and pasted into an album entitled *Canadian Scraps No. 1*. The album came to the National Archives in the collection of Andrew Merrilees, a Toronto businessman with an abiding interest in marine and railway transportation. Merrilees acquired more than 330,000 photographs, 10 metres of papers, and thousands of journals, magazines, broadsides, and ephemera, all of which he bequeathed to the Archives. Included in his collection is systematic documentation by professional photographer Andrew Young of the canals and shipping at Sault Ste Marie over a forty-year period; a series of file photographs from railway equipment manufacturers comprehensively documenting types of rolling stock; and a variety of other nineteenth-century albums portraying the development of railways in Canada. This mass of material, much of it unique, constitutes an incomparable resource for the study not only of rail and marine transportation but also of the industries that depended on them, and stands as a memorial to a master collector and transportation connoisseur.

Grand Trunk Railway Erecting Shops,
Point St Charles, Canada East, 1858
Creator: William Notman
Albumen print, 235 × 288 mm
PA 181359

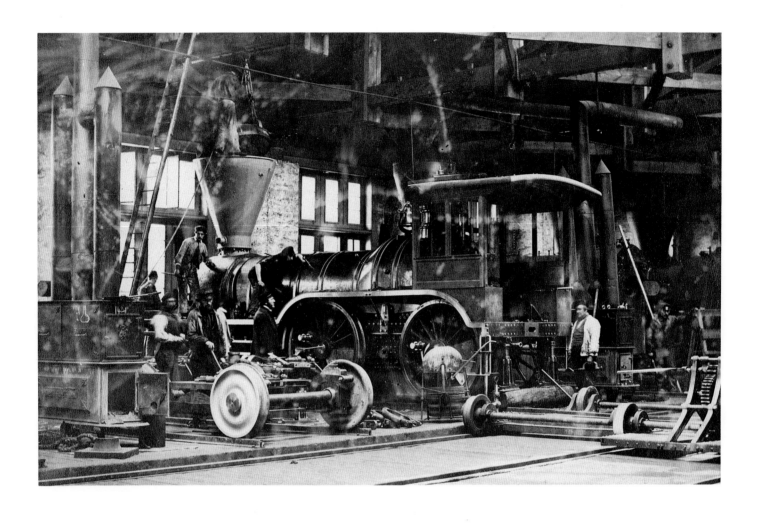

A view of Canada from the outside

In 1933, German photographer Felix Man (1893–1985) spent seven months in Canada on an assignment for a Berlin publishing house. Shaped by the demands of his publisher, the expectations of his audience, and the romance of his own vision, Man's photographs reduced Canada to several quintessential themes. Predictably, the Royal Canadian Mounted Police, the Canadian Pacific Railway, Indian Days at Banff, and wild animals formed a significant part of his Canadian imagery. His photographs of the snowy wastelands of Hudson Bay and of combines on Manitoba wheatfields reinforced the European perception of Canada as 'so many acres of snow' and 'breadbasket to the world.' Prospectors, sled-dogs, floatplanes, and riverboats in the Northwest Territories, the forest-fire service in northern Manitoba, and a boys' camp in the Laurentians all showed life in Canada as a struggle against the wilderness.

By his death in January 1985, Man had achieved international renown for his photo-essays and reportage-portraits. The Felix Man collection of more than six hundred black-and-white negatives and almost two hundred prints was acquired in 1986. Man's representation of our country was neither objective nor balanced. His portrayal of Canada was not a record of its cities, its development, or its scenery, nor did it chronicle the ravages of the Depression. It was not the signs of civilization but the vastness and wilderness that overwhelmed this visitor; Man's photographs attest to preconceived European notions of Canada as a young, vast country challenged by nature – notions he brought with him, sought out, documented, and perpetuated. His work, like that of other visitors carrying cameras, amateur and professional, reveals popular perceptions of Canada that, when image is compared with reality, when the view from the outside is set against the view from within, offer Canadians a glimpse of themselves as others see them.

Train guard distributing goggles
to protect passengers in an open
observation car against the dust
of the engine, 1933
Creator: Felix Man
35 mm negative
PA 145952

334

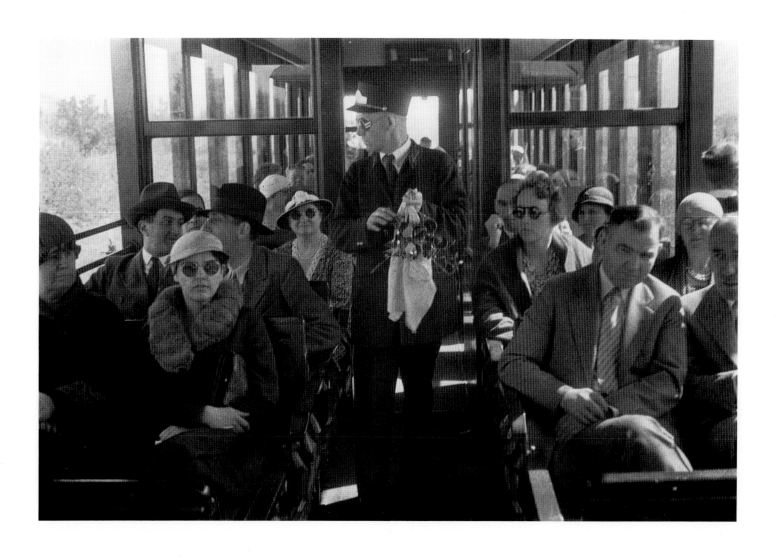

Photojournalism

On the evening of Thursday, 12 March 1857, a little more than a mile outside Hamilton, Canada West, the westbound train out of Toronto plunged through a timber swing bridge on the Great Western Railway line and plummeted sixty feet into the Desjardins Canal. It was the worst railway accident in the history of the colony. The public was voracious for news of the disaster and views of the accident had a ready audience. In the absence of illustrated newspapers, a spate of engravings hit the market, and it is clear that photography formed the basis of several of them. As such, a faded, creased, and torn view of the disaster marks the beginning of a long documentary tradition in Canadian photography.

Like disasters, elections have held an abiding fascination for photographer and public alike. The oval print offers a remarkable record of the controversial race in the riding of Montarville, Quebec, for the first representative in the Legislative Council. It depicts a crowd gathered in front of the hustings where candidates Alexandre-Édouard Kierzkowski, John Fraser, Marc Amable Girard, and Basile Bissonnette were nominated. The polling, although hotly contested, was not marked by riot or civil disorder; however, a protest was lodged that Kierzkowski, the successful candidate, did not meet the qualifications for office. The investigation of charges and counter-charges continued for two years, during which voters and the public at large followed the proceedings with great interest. Ultimately, a by-election was called and nominations, polling, and more protests ensued. While portraits of candidates are common, this view is a remarkable record of a pre-Confederation election. Together, these rare salt-paper prints constitute the cornerstone of photojournalism in Canada.

The oval albumen print by premier Quebec photographer Jules-Ernest Livernois (1851–1933) was the basis of an engraving that appeared on the cover of the 21 June 1879 issue of *Canadian Illustrated News* (XIX, 25) over the title, 'The Vice-Regal Visit to Quebec. Inauguration of Dufferin Terrace by the Governor-General and Princess Louise. From a Photograph by Livernois.' The arrival of Canada's new governor general, the Marquis of Lorne, and HRH the Princess Louise provoked great enthusiasm and much hard work in Quebec City. The vice-regal couple arrived from Montreal to the cheers of an enthusiastic crowd gathered on the wharf. Five days later, surrounded by officials and throngs of onlookers, they officially declared the Terrace open to the public.

From these beginnings, photography grew to be an increasingly important component of news reporting. Technical innovations such as portable cameras, faster films, flashbulbs, and ultimately the motor drive, as well as improved printing methods, made the flowering of photojournalism possible in the twentieth century. In recognition of their documentary value, the National Archives preserves millions of news photographs from major daily newspapers, weekly journals, agencies, and such distinguished photojournalists as Duncan Cameron, whose photograph of a defeated René Lévesque portrays another Quebec election significant in Canadian political history. From the single print to millions of 35 mm negatives, photojournalism has produced a comprehensive record of the people, places, and events in the news.

Ted Grant's image of Ben Johnson's victory gesture epitomizes the photojournalist as consummate thief, stealing for posterity a fleeting moment in time and space. It was not a matter of luck and a motor drive. To record the moment of victory of a race that lasted less than ten seconds, Grant studied the track during the heats the day before the final, then claimed a vantage point on a low wall near the finish line five hours before the race began. With the eye of an artist, the concentration of a surgeon, and the reflexes of a cat, Grant produced this quintessential portrait of what, for at least a short time, was a proud moment for Canadian sport.

Bridge over the Desjardins Canal
near Hamilton, Canada West, after
the Great Western Railway accident,
12 March 1857
Creator: unknown
Salt paper print, 246 × 328 mm
PA 135158

Meeting to nominate final candidates
for election to the Legislative Council,
Longueuil, Canada East, 2 October 1858
Creator: unknown
Salt paper print, 190 × 232 mm
PA 149346

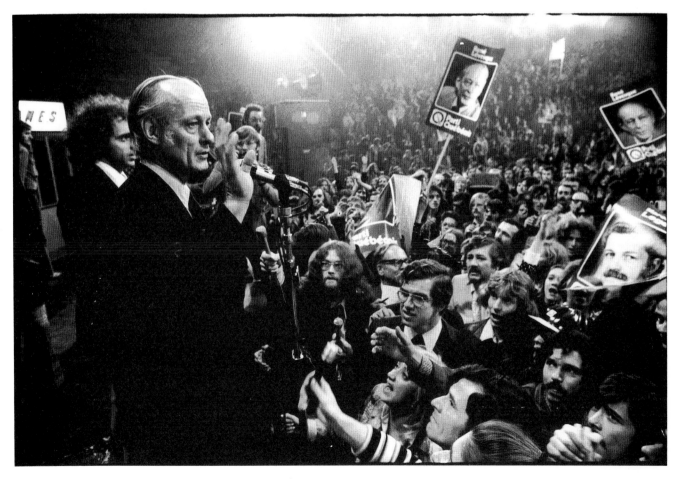

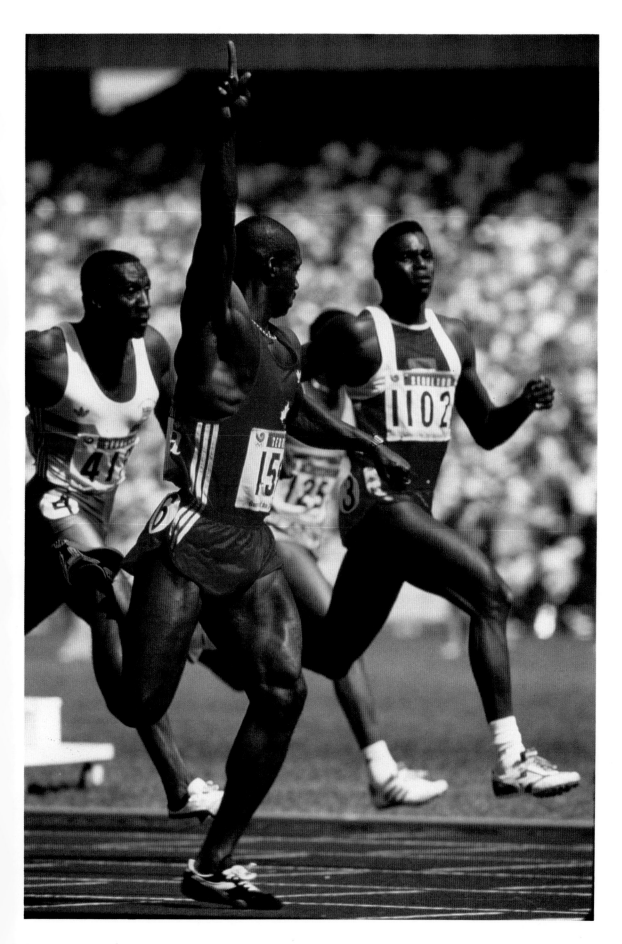

Inauguration of
Dufferin Terrace,
Quebec City,
Quebec, 1879
Creator:
Jules-Ernest Livernois
Albumen print,
206 × 254 mm
PA 118201

René Lévesque
at the Paul Sauvé
Arena, on provincial
election night,
Montreal, Quebec,
29 October 1973
Creator: Duncan Cameron
35 mm negative
PA 115039

Ben Johnson winning
the 100-metre sprint
event in the record
time of 9.79 seconds,
XXIV Summer Olympics,
Seoul, South Korea,
24 September 1988
Creator: Ted Grant
35 mm slide
PA 175370

The mud of Passchendaele

Passchendaele was a treacherous place for a camera man – or anybody else, for that matter.

WILLIAM RIDER-RIDER (1889–1979)

The Canadian Corps suffered 15,654 casualties and advanced less than five miles during the month-long battle of Passchendaele. Reaching the battlefield for the first time on the day it ended, the chief of staff of the British Expeditionary Force, Lieutenant-General Launcelot Kiggell, burst into tears and muttered, 'Good God, did we really send men to fight in that?'

Private Reginald Le Brun, the machine-gunner closest to the camera in this photograph, recalled, 'We were right out in front of the line, and the mud was so deep in our shellholes that we had to put at least six boxes of ammunition underneath us ... just to stand on to get out of the mud.'

The photographer, Lieutenant William Rider-Rider of the Canadian War Records Office, wrote: 'Always one had to pick one's way carefully through deep mud and shell holes filled with murky slime. I went up to obtain a series of pictures depicting life in the front line. Eventually we arrived at a post held by a dozen or so men existing in shell craters, from which they had baled the water. I took several photographs ... The ground was in a terrible state, all churned up.' He considered that this image, which so graphically documents the conditions in which Canadian soldiers fought on the Western Front, to be the best of all the 2500 photographs he took during the First World War.

The National Archives preserves more than half a million negatives by Rider-Rider and other official military photographers, extensively documenting the operational activity, the units, the personnel, and the equipment of the Canadian Army, the Royal Canadian Navy, and the Royal Canadian Air Force. From tanks in action at Courcelette in the First World War, to the liberation of the Netherlands in the Second World War, to United Nations peacekeeping operations during the Korean conflict, the Department of National Defence collection is a vital source documenting Canadian military history in the twentieth century.

Personnel of the 16th Canadian Machine Gun
Company holding the line in shell holes during the
Battle of Passchendaele, Belgium, November 1917
Creator: William Rider-Rider
Glass-plate negative, 104 × 130 mm
PA 2162

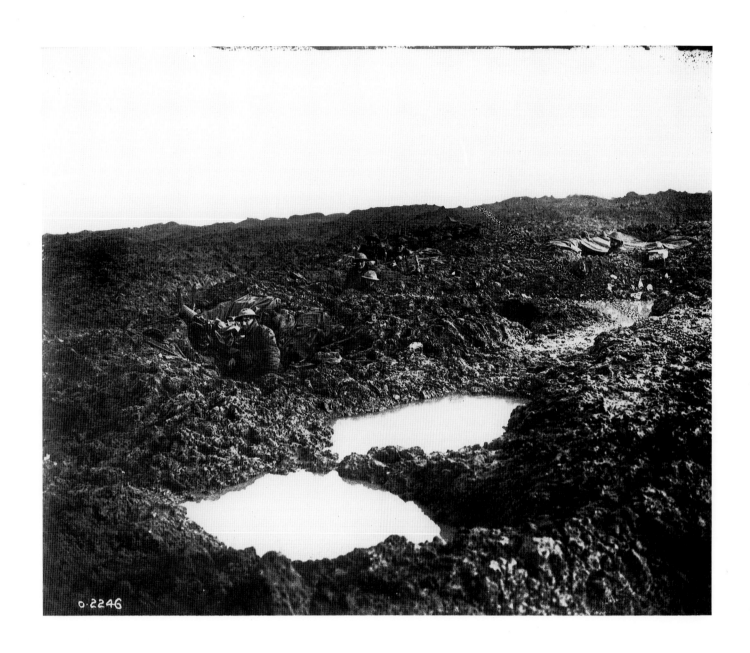

o·2246

Promoting Canada at home and abroad

Canada only needs to be known in order to be great.

J. CASTELL HOPKINS, 1898

This woman, costumed by H.M. Murray, the Canadian government agent in Exeter, England, to represent Canadian prosperity, won first prize in the Exeter Carnival parade of 1907. Her picture is just one of the ways in which photography was used as a vehicle to promote Canada by the Immigration Branch of the federal government. During the first decades of this century Canada was portrayed as a rich, young country offering hope to prospective settlers to improve their family prospects; bounty and achievement were recurrent themes in the government's efforts to project Canada as a prosperous destination.

The National Parks collection of photographs and negatives dates back to the turn of the century and documents the growth of Canada's national park system, park activities, outdoor recreation, and tourism. The view of the town of Banff from Tunnel Mountain is typical of the promotional photographs produced in the 1920s and 1930s by the National Parks Bureau. Its photographers concentrated heavily on the popular western parks, creating an image of a scenic playground, of innumerable recreational opportunities set against the spectacular backdrop of the Canadian Rockies.

Photography has also been instrumental in the work of other branches of government. The extensive collections of the National Film Board and its predecessors, the Canadian Government Motion Picture Bureau and Exhibits and Publicity Bureau, were instrumental in federal efforts 'designed to interpret Canada to Canadians and to other nations.' With a mandate to 'promote travel to and within Canada,' the Canadian Government Travel Bureau, now Tourism Canada, has produced enormous photograph collections dating back to 1934. The photographs of the Canadian Government Exhibition Commission demonstrate the way in which it represented Canada at international fairs and expositions for more than a century.

These photographs were an integral part of promotional campaigns that included illustrated lectures, pamphlets, posters, and guidebooks. Carefully worded accompanying texts sang the praises of cities, scenery, and natural resources and underscored scenic splendour, ease of access, agricultural potential, and vacation opportunities. This visual record of Canada not only documents federal government efforts to encourage immigration, trade, and tourism; it offers insight into the evolving image of Canada in the public mind, both at home and abroad.

'A girl from Canada,' September 1907
Creator: T.A. Chandler
Silver gelatin print,
140 × 980 mm on card mount 250 × 191 mm
c 63256

Banff from Tunnel Mountain,
Banff National Park, October 1929
Creator: W.J. Oliver
Silver gelatin print, 205 × 255 mm
PA 57241

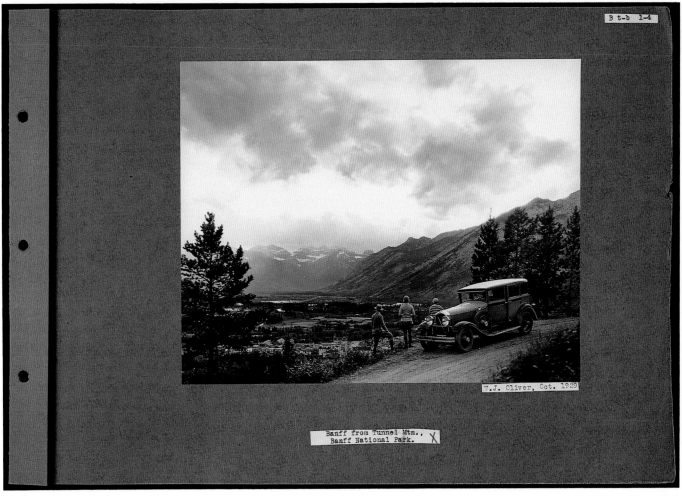

W.J. Oliver, Oct. 1929

Banff from Tunnel Mtn.,
Banff National Park.

Observing architecture

From hundreds of time-worn stereoviews of nineteenth-century buildings to Fiona Spalding-Smith's colour-saturated portraits of corporate habitats of glass and steel, Canada's architectural heritage has been observed through the camera lens almost since the introduction of photographic techniques to this country. Photographs of buildings, both public and private, are an important source for understanding historical and contemporary architecture, the ways in which such structures have been perceived by contemporary society, and the built environment of which they are an integral part.

A wealth of photographic documentation on Canadian architecture exists in the collections generated by the federal Department of Public Works, which has employed photographers, often of exceptional talent, to record the architectural and engineering achievements of the Canadian government. The Archives also holds photographs of domestic architecture, from this stereo view of A.F. Stoneman's residence in Yarmouth, Nova Scotia, to snapshots of sod houses on the prairies. Architecture, as a medium of aesthetic expression, has also inspired photographers working within a fine-art tradition. Exploration of the clean, modern lines of twentieth-century architecture may be found in many collections held by the National Archives, including works by contemporary Canadian photographers: Victor Pilon's documentation of urban wall murals, Fiona Spalding-Smith's 'portraits' of corporate architecture, and Mark Ruwedel's panoramas of grand movie-house interiors restored to their former opulence.

These images, and countless others in the collection that explore the human-built structures of Canada's past and present, embody both physical facts and contemporary attitudes. The study of these images as archival documents sheds light on the relationship between architecture and history in Canada.

Residence of A.F. Stoneman, Yarmouth,
Nova Scotia, c. 1870
Creator: Llewellyn G. Swain
Albumen print, 80 × 156 mm on mount 87 × 176 mm
PA 181110

Roy Thomson Hall, Toronto, Ontario, built by
Arthur Erickson/Mathers & Haldenby
Associated, Architects, 1982
Creator: Fiona Spalding-Smith
Colour transparency from original colour negative,
280 × 355 mm
PA 135205

Portraits of the prominent

Contemporary portraits of established or emerging figures in Canada's political, social, scientific, and cultural pantheon constitute a vital link to the ongoing function of the National Archives as the nation's portrait collection, from pre-Confederation to the present. V. Tony Hauser poses leading Canadian artistic figures in front of spare, studio-fabricated environments and his resulting sophisticated large-format images focus on the palpably creative presence of his sitters. A fine example is his portrait of Jackie Burroughs, a theatre, film, and television personality, who first achieved prominence in the 1960s. She has appeared at the Shaw Festival and the Stratford Festival, and has won Genie Awards for her outstanding performances in the films *The Grey Fox* (1983) and *The Wars* (1984).

Photographs in the national portrait collection may be formal studio portraits or impromptu glimpses of distinguished Canadians taken by leading portrait photographers. This *galerie contemporaine* provides us with the human face of history by presenting Canadians significant in their endeavours. The pantheon is by no means confined to a narrowly selective who's who: the collection is wide-ranging, from Harry Palmer's portraits of Companions of the Order of Canada, to Andrew Danson's lively 'self-portraits' of prominent Canadian political figures, to avant-garde cultural figures in Toronto by Susie King and David Hlynsky, to Pamela Harris's 'faces of feminism.' Informal and more personal glimpses of celebrated (and notorious) public figures taken by amateurs as well as professional photographers are preserved in personal collections. The portrait of Paul-Émile Cardinal Léger comes from Palmer's collection of Companions of the Order of Canada. Ordained in 1929, Léger became archbishop of Montreal (1950–67) and was named a cardinal in 1953. In 1967, he stepped down to become a missionary among the lepers and handicapped children of Cameroon, Africa. Cardinal Léger received the Grande Croix of the Légion d'honneur of France in 1958 and the Order of Canada ten years later.

Photographs in the national portrait collection represent a diverse range of styles reflecting changing fashions in portraiture, from the elaborate props and furnishings of the Victorian studio parlour to the spare, dramatically lit portraits revealing the inner psychological states of the subject. Contemporary portraiture by such celebrated photographers as John Reeves, Ted Grant, Walter Curtin, Michael Torosian, and Robert Mapplethorpe brings to the collection dynamic and innovative approaches, maintaining the vitality of this connection to our present history.

Jackie Burroughs, Toronto, Ontario, 1988
Creator: V. Tony Hauser
Silver gelatin print, 450 × 450 mm
PA 180954

Paul-Émile Cardinal Léger, 1984, from
a series of portraits of Companions
of the Order of Canada
Creator: Harry Palmer
Silver gelatin print, 350 × 275 mm
PA 181601

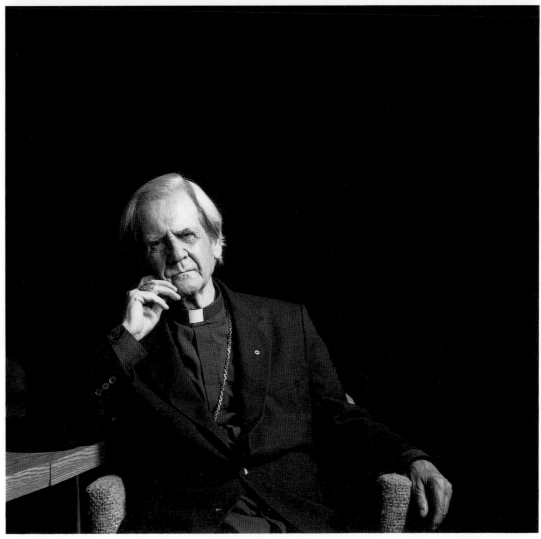

Master of the portrait

Yousuf Karsh's friend and patron, Prime Minister Mackenzie King, arranged the encounter between the irascible Churchill and the anxious young photographer. The result is legend: at the crucial moment before snapping the shutter, Karsh suddenly pulled a cigar from Churchill's lips and caught the politician's defiance. This image, published on the cover of *Life* magazine in February 1942, became an icon of the wartime leader and launched the photographer's reputation in the international arena.

Although emblematic of Karsh's unparalleled career as a portraitist to the twentieth century's scientists, philosophers, artists, politicians, musicians, and captains of industry, the portrait by no means typifies the breadth of the Karsh collection. Acquired by the National Archives from the photographer in 1987, the Karsh collection comprises some 250,000 negatives, 12,000 prints, and 50,000 transparencies, and documents Karsh's career over five decades.

Karsh's distinctive style captures public personas through dramatic lighting, emphasis on expressive hands, and meticulous attention to surroundings. His heroic representations are formed both in the camera and in the darkroom, through advance study of his subject, and subsequent attention to details.

Beyond the original negatives and master prints of prominent Canadian and international figures, the Karsh archive contains glimpses of unexpected aspects of the master photographer's career: images pertaining to commercial, advertising, and philanthropic campaigns, to the production of film and television projects, to the documentation of Canadian cities and architectural sites around the world; there is also a selection of daybooks and personal photographs. The collection is of national significance, both for its portraits of thousands of Canadians who sat for Karsh's camera and for its importance as a major *œuvre* created by an internationally recognized Canadian citizen.

Winston Churchill, 30 December 1941
Creator: Yousuf Karsh
Silver gelatin print, 278 × 217 mm
PA 165806

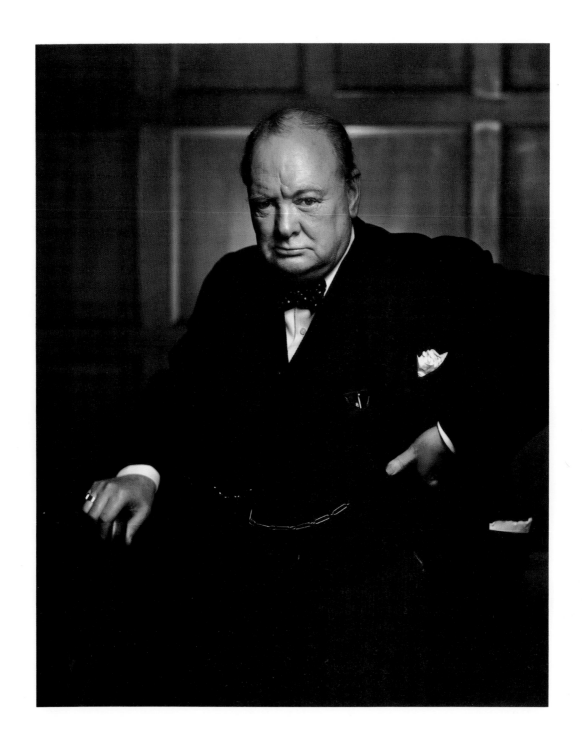

Master of the cultural landscape

Canadian artist, writer, book designer, and photographer [Wilfred Roy] Roloff Beny (1924–84) achieved international recognition for his lavish volumes of colour photographs. Like the fine nineteenth-century albumen prints taken on the Grand Tour of the Holy Land and the Lands of Antiquity, his photographs capture the art and architecture of far-off places and set them before the imagination of the Western world. His nineteen published works were translated into as many as seven languages and won the highest awards in the international book publishing industry. Beny's paintings and graphic art together form part of major public and private collections around the world, and his photographs and articles have appeared in Canadian, American, English, and European publications. His celebration of Canada, *To Everything There Is a Season*, enjoyed five printings and was one of the books chosen by the Canadian government for presentation to heads of state and government leaders who were invited to Canada for the centennial festivities of 1967.

The Beny photographic archive of some 75,000 negatives and 25,000 prints provides extensive documentation on India, Persia, Italy, and Greece. He was court photographer for the Pahlavi family of Iran, and the Beny collection is reputed to contain the only surviving photographic archives of Iran's last royal family. Much of the ancient world that Beny recorded has changed dramatically in the last two decades through development or destruction.

This image of Venice is typical of Beny's documentation of art and architecture. Beny approached his subjects with the critical eye of both scholar and artist. Expert in capturing and revealing both overview and details, he did not simply create engaging, picturesque travel photographs; rather, he produced an invaluable visual record of the buildings and ruins, gargoyles, and faces of countries both old and exotic. In so doing, Beny used the power of colour photography to distil and define national identity, transforming his subjects into lasting impressions of place.

Multi-coloured, marble-fronted Palazzo Dario
(centre), built in 1487, Venice, Italy
Reproduced as plate 279 in *Roloff Beny in Italy*, published by
Thames and Hudson, Ltd. 1974
Creator: Roloff Beny
Colour transparency, 84 × 57 mm
PA 175783

Canadian mosaic

Photographs offer vivid documentation of the Canadian mosaic: cultural and regional diversity, social and ethnic diversity, urban and rural diversity. Portfolios of work by contemporary photographers document the everyday activities, folk traditions, costumes, and festivals that constitute the distinctiveness of communities from Black Duck Brook, Newfoundland, to Kaslo, British Columbia. Louise Abbott's *The Coast Way: A Portrait of the English on the Lower North Shore of the St Lawrence* is a visual record of a remote part of Quebec where nearly five thousand anglophones live in scattered fishing villages from Blanc-Sablon, near the Labrador border, to Kegaska, some 235 miles to the west. The photographs document the community, with its distinctive culture derived from Newfoundland, Indian, Inuit, French-Canadian, and Jersey influences.

Orest Semchishen's photographs of Ukrainian churches in Alberta bear witness to the imprint of cultural and ethnic diversity on the Canadian landscape. The familiar domes rising above the prairie show the way in which the spiritual beliefs of a distinctive community manifest themselves on the land. Just as the camera has captured the spires, steeples, and domes that announce community church affiliations, so too has it recorded the geographical, cultural, and ethnic diversity of domestic architecture, from the saltboxes of Newfoundland outports to the sod houses of the prairies to the California bungalows in Vancouver. These and other photo-documentation projects – including studies of urban Chinese in Montreal by Marik Boudreau and Suzanne Girard, of the Italian community in Toronto by Vincenzo Pietropaolo, and of rural life in the Margaree Valley, Cape Breton, by George Thomas – offer insight into the sense of community, the regional distinctiveness, and the cultural and ethnic traditions that constitute the Canadian mosaic in all its richness and diversity.

Camille Griffin transferring cod to
his father Ernest's stage, Salmon Bay, Quebec.
From the portfolio, *The Coast Way: A Portrait
of the English on the Lower North Shore of
the St Lawrence,* 1983
Creator: Louise Abbott
Silver gelatin print, 205 × 255 mm
PA 181606

Ukrainian Catholic Church, Angle Lake (near
Derwent), Alberta, October 1974, from a portfolio on
Ukrainian Orthodox churches in Alberta, 1970–5
Creator: Orest Semchishen
Silver gelatin print, 405 × 508 mm
PA 181605

Contemporary fashions and concerns

This stark, simple image was created by Toronto photographer Struan Campbell-Smith for an advertising campaign for Quinto Shoes. Though never used as intended, it was published repeatedly as an example of Struan's fashion photography.

Examples of advertising imagery are well represented in the National Archives' photographic collections, recording gradual shifts in merchandising, from convincing an audience through factual representation, such as William James Topley's 1875 storefront views promoting local businesses, to optimistically detailed representations regaling prospective buyers with the benefits of miracle products of the 1950s. Such documents chronicle the material aspect of the Canadian economy, past and present.

The juxtaposition of a female torso dramatically hovering over a high-fashion shoe epitomizes the increasing propensity to sexualize material consumption in contemporary Canadian advertising. More than a document of a particular fashion trend in footwear, the ostensible subject of the image, this photograph transmits cultural values and mores codified into the language of 'sell.' Beyond any representation of the product, the image seeks to seduce the viewer by its symbolism: sophistication, youth, sexuality, power.

Advertising is just one of a larger spectrum of social issues that photography may address more convincingly than words alone. In photography, where there is a fact there is usually also a message, fleeting and variable as the society that created it, and, consequently, there is a document of inestimable value to history. As such, photographs have found a valued place in the Archives.

Quinto Shoe, published in *Art Directors Index to Photographers*, 6, Spring 1978 and *Canadian Photography*, November 1979
Creator: Struan Campbell-Smith
Colour print from original 35 mm colour transparency, 340 × 496 mm
PA 181604

IX

Preserving the Record
of the Past

Archives have traditionally been the treasure houses of recorded history. Centuries ago, archival holdings consisted primarily of vellum, parchment, and cherished books. Today's archives contain vast collections, including traditional media as well as photographs, government files, caricatures, videotapes, blueprints, computer tapes, prints and drawings, sound recordings, fax copies, motion picture films, optical discs, and postage stamps. Thus, archivists and conservators have to contend with a bewildering array of modern plastics, metals, and chemical compounds.

Whatever their media, however, all of these archival records are inherently transitory. The acids added during the manufacture of modern paper or produced through contact with air pollutants eat away at the fibres of pages. Inks fade. Photographs curl, their emulsions crack and fall away. Watercolours discolour. Blueprints exposed to light disappear. The signal on computer tapes weakens over time and it becomes impossible to read the data. Audio and videotapes shed their oxide coatings and their images and sounds are substantially impaired. Motion picture films shrink and embrittle to the point where they cannot be projected. Phonographic discs become brittle and crumble. The metals in optical discs react with oxygen in the air over time and their data becomes irredeemably garbled. It is the task of today's 'treasure keepers,' the archivists and conservators of modern-day archives, to preserve Canada's documentary heritage for as long as possible as our collections move from vellum to video and beyond.

The first keepers of the records were artisans who were skilled in book-related crafts and who had practical expertise in book structures and paper. Many of the manual restoration techniques used by these artisans have been refined but not changed. There has been a tremendous growth in scientific understanding, and conservators now perform treatment techniques that not only preserve the visual impact of archival documents but also meet the inherent physical needs of these fragile records of our past.

The growth in conservation knowledge at the National Archives of Canada from its beginnings in 1872 has resulted in an integrated program to protect the varied richness of our documentary heritage. Collections management begins with preventive conservation which encompasses storage, copying, handling, and mass deacidification. This 'preventive medicine' starts as soon as records are brought into the Archives, so that any possible harm to the records in the institution's custody is reduced to a minimum. The prevention of damage or deterioration is infinitely preferable to painstaking, labour-intensive repair of damaged records.

The earliest example of the conservator's art in the National Archives was the bindery operation in which bound materials were restored. By 1967, when the staff and collections were moved to its present location, the bindery had grown into a full paper conservation laboratory with the addition of conservators skilled in the treatment of archival prints, drawings, and oil paintings. As well, the department had a photographic reproduction laboratory and a centralized microfilming unit. These services continued to expand as more modern records became part of the department's acquisition mandate. In 1968, the Archives began to systematically preserve sound recordings, while in 1969 the department started to collect nitrate motion picture film and copy it onto stable safety stock. By 1973, the Archives had extended its conservation program to the preservation of the valuable computer tapes generated by the federal government.

One of the most important jobs of archivists and conservators is ensuring that appropriate storage is provided for archival records. Archivists place paper documents – government records, private manuscripts, and maps – in acid-free folders and archival boxes. Photographs are put into polyester sleeves or special envelopes. Watercolours are housed in protective custom-designed boxes. Motion picture films are stored in polypropylene plastic cans. Videotapes are kept in self-sealing flame retardant containers. Sound discs are inserted into acid-

free sleeves lined with polypropylene and foil. Magnetic tapes are precision rewound onto plastic take-up reels, then stored in sturdy plastic tape canisters. In addition, special cases may be constructed by conservators for some of the more fragile and rare items such as daguerreotypes and miniatures. Customized cabinets are built to permit maps and oversize documents to lie flat and secure, while specially designed sliding racks are used to support oil paintings.

Once the records are housed in proper archival containers and storage systems, they are placed in secure stack areas. The Archives tries to provide, as far as space and resources permit, the best possible storage environments for its collections, because uncontrolled temperature, relative humidity, airborne pollutants, light, and vibration can all damage archival records. Even the exceptionally sturdy optical disc can be damaged irreparably by repeated violent changes in environmental conditions. Archivists and conservators have to be vigilant in their monitoring of the storage areas to ensure that the appropriate standards are met and that any dangerous fluctuations are reported and remedied as soon as possible. Thermohumidigraphs, which measure temperature and humidity, and other types of monitoring systems are placed in all storage areas to warn of problems. Staff regularly patrol the stacks to look for signs of water leaks, insects, and evidence of poor housekeeping. Storage areas are locked, with access possible only to authorized personnel. A high-security storage facility is provided for nitrate motion picture and photographic films which, if not maintained in rigorously controlled environments, can emit toxic gases or spontaneously burst into flame. Similarly, a very secure centre provides safe storage for the vital records on paper, microfilm, and computer tape that would be essential to the re-creation of the Canadian state should disaster befall the country.

The monitoring of archival records is not limited to their storage environments. Whenever archival records are handled, for whatever purpose, they run the risk of damage, and it is therefore crucial that care be taken in the handling of records by and for the public. Environmental monitoring is carried out in all exhibition spaces. Light levels during exhibitions are carefully checked to ensure that the archival documents being displayed are not exposed to high light levels that will cause fading and possibly irreparable damage. Researchers are provided with guidance on the safe handling of archival records by pamphlets and on-the-spot advice in the research rooms. For some of the documentary art and microfilm collections, researchers are given white cotton gloves to wear so that the very oils on their fingers will not damage these sensitive records.

The National Archives strives to balance its mission to preserve the documentary heritage of Canadians with its responsibility to make these archival records available as

These magnetic tapes wrapped in self-closing plastic bags are kept in a controlled storage area where environmental conditions are continuously monitored with automated thermohumidigraphs.

Microfilming is one solution to the problem of storing and handling records. With this copying method the Archives can also preserve fragile original records from too much handling.

This oversized photo of Parliament Hill required a customized storage cabinet so that it might lie flat, secure and protected from exposure to light.

Before mass deacidification, books must be vacuum dried, or the magnesium solution used to neutralize the acidity would react with the humidity in the books and compromise the neutralizing process.

The mass deacidification unit with its processing tank (middle of the picture).

widely as possible to all citizens. One solution to this dilemma is to copy records, making these available to researchers across Canada. As well as preserving the original records from the damage created by handling, copying preserves the information contained in the documents.

The most common type of archival copying is microfilming. Government records, private papers, and printed materials are reproduced onto 16 mm and 35 mm roll film that is then made available through the Archives' inter-institutional loan program to Canadians across the nation. In recent years, the Archives has begun a program to copy maps and plans on 105 mm film. Researchers may now view many cartographic records on black-and-white or colour microfilm. More traditionally, studio photographers provide high-quality black-and-white or colour copies of large documents and documentary art. Another traditional copying method is photocopying. In some instances, fragile or potentially contaminating records such as the highly acidic newspaper clippings frequently found in private papers are photocopied onto a more stable alkaline paper.

In the field of motion pictures, audio, and video records, various copying technologies are used. For preservation copying conservators normally reproduce the archival records onto the same type of medium. However, for public use, motion pictures are copied onto videotape and sound discs onto audiotape. In many instances conservators are able to change obsolete formats into the ubiquitous VHS videotape for public use.

Many of the documents selected for copying are very fragile, and the challenge of creating legible reproductions that capture not only the information, but the visual impact of the original records must be faced. Recent advances in computer technology offer the potential to enhance images so that the reproductions may often be clearer than the originals. Through the use of optical disc technology, for example, information contained in such valuable archival records as census manuscripts and passenger lists might be digitized and the latent images left by fading inks made visible again. Optical discs are now being used to store the information held on computer tapes. Magnetic tape, a quite fragile medium, must be rewound and recopied regularly and stored in a precisely maintained environment. It is far less expensive to preserve the sturdier optical disc, which is also being used in the scanning of caricatures and photographic records, to provide clear copies for public reference. Another recent example of computer technology employed to enhance an archival copy and return it to its original quality is the 'noise reduction' technique used in the duplicating of sound recordings. Through this technology, the background noises and imperfections in archival sound recordings are removed during 'premastering,' and clear, undistorted copies are produced.

Another preventive conservation activity is mass deacidification. In the late 1970s the National Archives was a pioneer in the development of the world's first operational system for the bulk neutralizing of acids in the paper of both historic and new books. By neutralizing acid in the paper, the lifespan of the books is extended by several decades, and the need for costly, time-consuming restoration in the future will be reduced considerably.

For all the energy devoted to preventive conservation in the National Archives, it is still necessary to treat many thousands of archival records each year. Many of the treatment methods have been used for decades with remarkably little change, while other procedures have been greatly enhanced by expanding scientific knowledge. As much as possible, conservators try not to change,

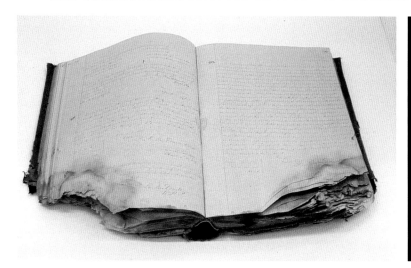

The bottom right corner of the sheets of a Warden's letter
book was missing following mould and water damage. With the aid of a leafcaster,
conservators were able to fill in the holes and missing areas.

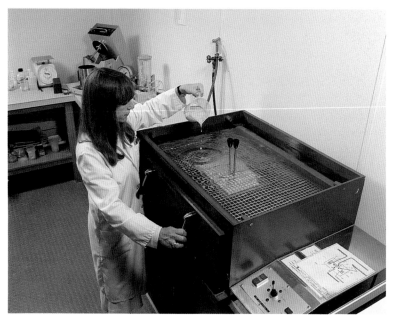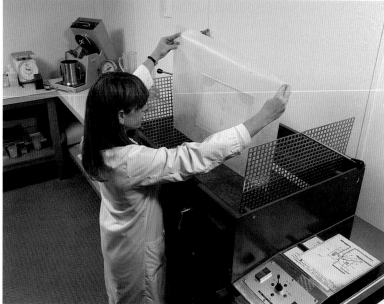

Once the cast sheet is removed from the leafcaster, it is sized, pressed, dried, and trimmed.
All the sheets will be collated and rebound.

visibly or physically, the archival materials being treated because the original state of the document as well as any intervening changes over time are an essential part of the document's history. However, for badly deteriorated documents, this basic respect for the original record may have to be set aside. It is sometimes necessary to make fundamental changes to the appearance and some of the physical characteristics of the archival record.

A wide variety of treatment options is available to archivists and conservators at the National Archives. Conservators clean documents, removing dirt, stains, mould, and mildew. Missing parts of pages are painstakingly filled in with carefully matched paper. Documents that are very fragile and have started to break along fold lines or crumble into little bits can be backed with tissue or acid-free paper. Acidic backings on maps are carefully removed and replaced with more stable supporting materials. Sometimes, fragile textual records are laminated, pressed between two thin layers of adhesive impregnated tissue. This treatment technique provides the document with sufficient strength to withstand handling by researchers without detracting from the basic information contained in the record. Particularly valuable books are often taken apart, their pages individually repaired, their covers replaced, using either the old boards and spines or new ones scrupulously matched to the original, with decorative titles stamped on in gold leaf.

Expert treatments are also provided for documentary art collections. Conservators meticulously clean prints, watercolours, and oil paintings, bringing back to life the original hues. Missing areas of paint are replaced through inpainting, loose, flaking pigments are secured to the canvas, and layers of disfiguring varnishes are removed from oil paintings. Embrittled posters that have fractured along fold lines are deacidified and backed with supporting tissue or paper. The conservator uses solvents to remove the image-carrying layer from the old support of some photographic negatives, then places it on a more stable support. Through the replication of historical printing methods, conservators gain insight into the stability of early photographic materials and choose more readily the appropriate treatment methods for these archival records.

But conservation treatment does not stop with the paper-based records. Glass negatives are carefully cleaned and cracks repaired. Extremely fragile nitrate motion picture films are meticulously repaired, frame by frame, so that they may be recopied onto safety film. Sound discs are scrupulously cleaned either by hand or in a chemical bath to remove the grime and oily deposits that make their replaying painful if not impossible. Videotapes and computer tapes are carefully run through tape cleaning machines, which draw the tape across fine scraper blades to remove loose deposits, then across non-abrasive tissues that gather up the debris. The wax seals found on state

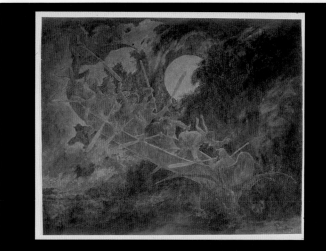

'La chasse-gallerie,' watercolour over graphite by Henri Julien, before and after its conservation. Following a condition report and spot testing, the drawing was removed from its secondary support, washed in water, deacidified, and resized. Tears were repaired, areas of missing support were replaced and toned with watercolour. The design layer was inpainted. Finally the drawing was matted.

An extremely fragile nitrate motion picture film is meticulously repaired, frame by frame, so that it may be recopied onto safety film.

documents and prestigious private manuscripts are painstakingly reassembled and reinforced.

Even in the tradition-grounded art and craft of archival conservation treatment, there is plenty of room for innovation. Recently the Archives has begun to use the leafcasting technique for repairing paper documents. With the aid of the leafcaster, conservators are able to speed up the process of filling in holes and replacing missing areas of damaged sheets and pages. The leafcaster, with the aid of computer technology, measures precisely the amount of paper pulp required to replace the missing parts of the document, matches the thickness and texture of the pulp to the original document, and, once the pulp has been mixed, deposits it via a suction process to fill in the missing areas. Surplus pulp mixture is then drained away, and the original document with its newly cast paper is dried under pressure. This advanced technique consistently results in a precise graft of the new paper fibres to the damaged record.

The National Archives also makes regular use of other treatment innovations. Suction tables are now used to flatten and dry documents. As well, they are used for the precise removal of stains on documents that cannot be immersed in cleansing solutions because their unstable inks and colours would run. Humidification chambers permit gentle, controlled relaxation of paper and parchment that has been tightly rolled, folded, or distorted through exposure to unregulated temperature and humidity.

The National Archives could not adequately preserve its treasures without a sound conservation research program. Conservators must know in detail the properties of archival records – what their components are, how these components deteriorate, and why. Once such scientific investigation has been completed, conservators are able to modify preventive conservation and treatment techniques as required. As well, conservation research assists archives in 'selling' preservation to manufacturers of the actual components of archival records. Manufacturers are understandably concerned with their current products, not the paper, film, tapes, or discs provided in the past. It is up to the archives to identify the best preservation techniques for older, sometimes obsolete, archival formats. This research scientifically documents preservation requirements and it can influence manufacturers to modify their production methods in the future. A recent example is the move by many paper manufacturers to the production of alkaline paper that will last far longer than the acidic stocks presently used. Conservation research at the National Archives is performed both internally and co-operatively with industry, as in the case of paper manufacturers, organizations like the Pulp and Paper Research Institute of Canada, and other cultural agencies such as the Canadian Conservation Institute.

Considerable progress has been made with research

A close-up view of a contemporary colour film showing damage associated with prolonged soaking in tap water.

into the properties of photographic records. One of the most vexing questions facing photographic archivists was what to do about water damage due to leaky roofs, broken pipes, or fires. Most photographic prints and negatives in Canadian archives consist of an image-bearing layer or emulsion resting on a paper base. When these records get wet, the emulsion becomes very soft and is exceedingly susceptible to physical damage. Researchers at the Archives found the best means of recovering photographic records; prints and negatives should be air-dried on a fibreglass surface, but if such emergency handling is not possible, then the records should be placed in plastic bags and frozen. Then, as time permits, the photographic documents can be thawed, a few at a time, separated, and air-dried. It was also found that such

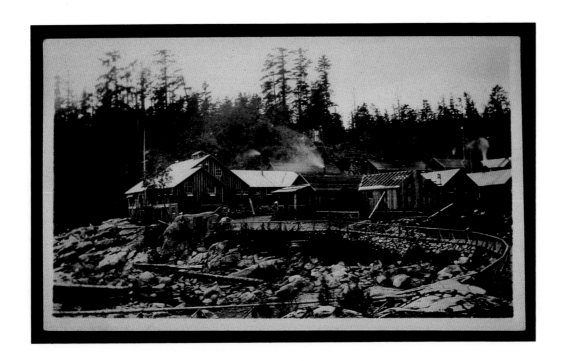

A yellowed black-and-white photofinishing print from the
1930s, before any chemical treatment.

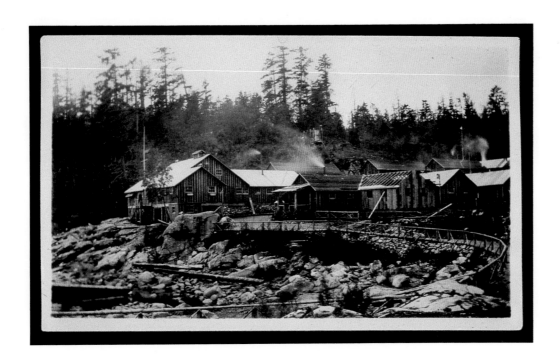

The same print after restoration in chemical solutions.

photographic records could be freeze-dried as long as the temperature did not rise about 0°C. Finally, the research project concluded that this response was not appropriate for specialty cased photographs like daguerreotypes, ambrotypes, and tintypes or glass negatives. Archivists are now aware that these types of photographic records require a higher degree of protection from water damage.

The discolouration of archival photographs is evidence of one of the most common types of degradation of these records. Silver halide, the light sensitive substance in photographic film, turns into silver particles when processed. Over time, degradation of the silver particles induces fading and staining. A silvery blush forms on the prints or yellow or brown discolouration becomes evident. Researchers at the Archives have been investigating ways to reverse this discolouration through the use of chemical solutions. To date, they have discovered that it is possible chemically to convert the silver particles back to silver halide and then redevelop the photographs back to black image silver. Although this procedure is still at the experimental stage, the results have been very promising.

Another recent research project has been carried out in conjunction with the development of the mass deacidification system. The results of the neutralizing of acids in book paper are being tested by artificially ageing treated samples to determine how long the benefits will last and if the book papers will become acidic again. This project is an example of the necessity to evaluate the effectiveness of conservation procedures.

Finally, the National Archives has become more and more involved in recent years in the question of 'permanent paper.' The most basic characteristics of paper now can be identified. Carefully calibrated testing equipment is used to determine the physical properties of paper – how many times a page can be folded before it breaks along the crease, how resistant the page is to tearing, and how much a page can be stretched before it pulls apart. Researchers also perform chemical analyses to determine the components of paper, for example, the quality of the fibres and the types of sizing and fillers added during manufacture. This information is used to study the stability of certain materials and to recommend modifications in treatment procedures and storage modes so that the lifespan of these records can be extended.

All of the conservation activities described here are carried out in the National Archives so that the treasures of our documentary heritage will be preserved for Canadians today and in future generations. As a result of the preservation of these unique archival records, Canadians will continue to be able to turn to their past to consider the roots of their society and the values of their nationhood.

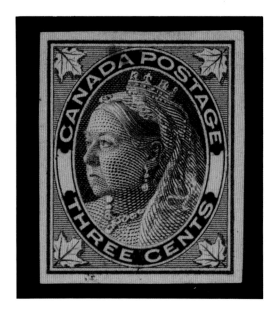

A die proof on paper of a Queen Victoria stamp. The second photo showing the detail of an accretion on the die proof was taken with a camera attached to a stereomicroscope.

Index